164°

160°

156°W

Area
Enlarged

Asia

North
America

P A C I F I C O C E A N

Australia

EQUATOR

I S L A N D S

Tern Island

French Frigate Shoals

Mokumanamana (Necker)

Disappearing Island

TROPIC OF CANCER

Nihoa

O C E A N

Ni'ihau

Kaua'i

O'ahu

Moloka'i

Ka'ula

Honolulu

Lāna'i

Maui

Kaho'olawe

Hawai'i

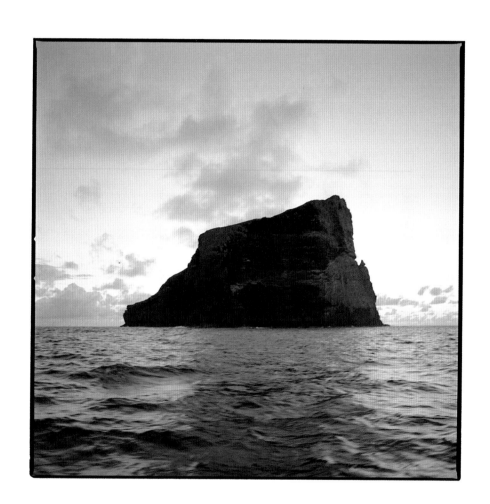

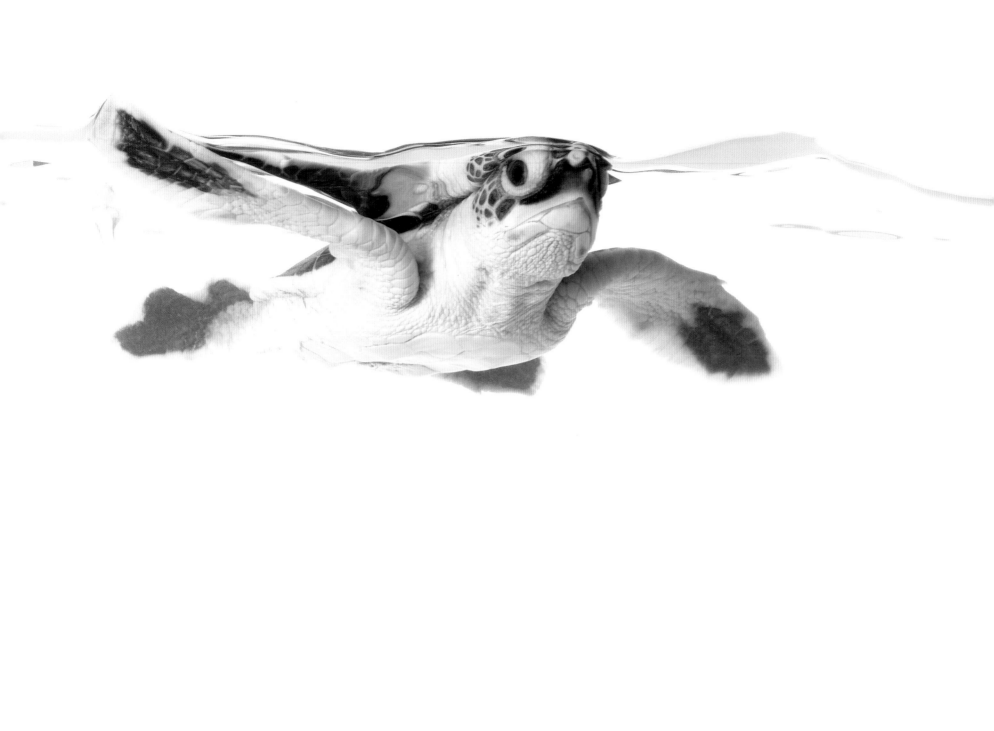

Hawaiian Green Sea Turtle hatchling ~ honu
Chelonia mydas

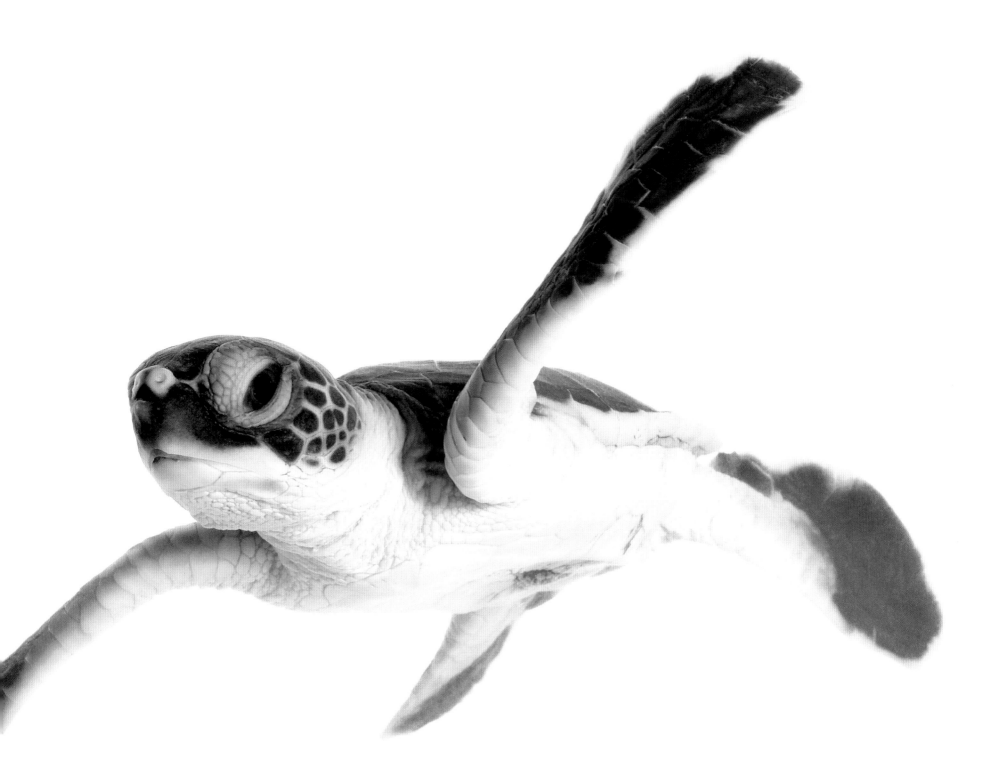

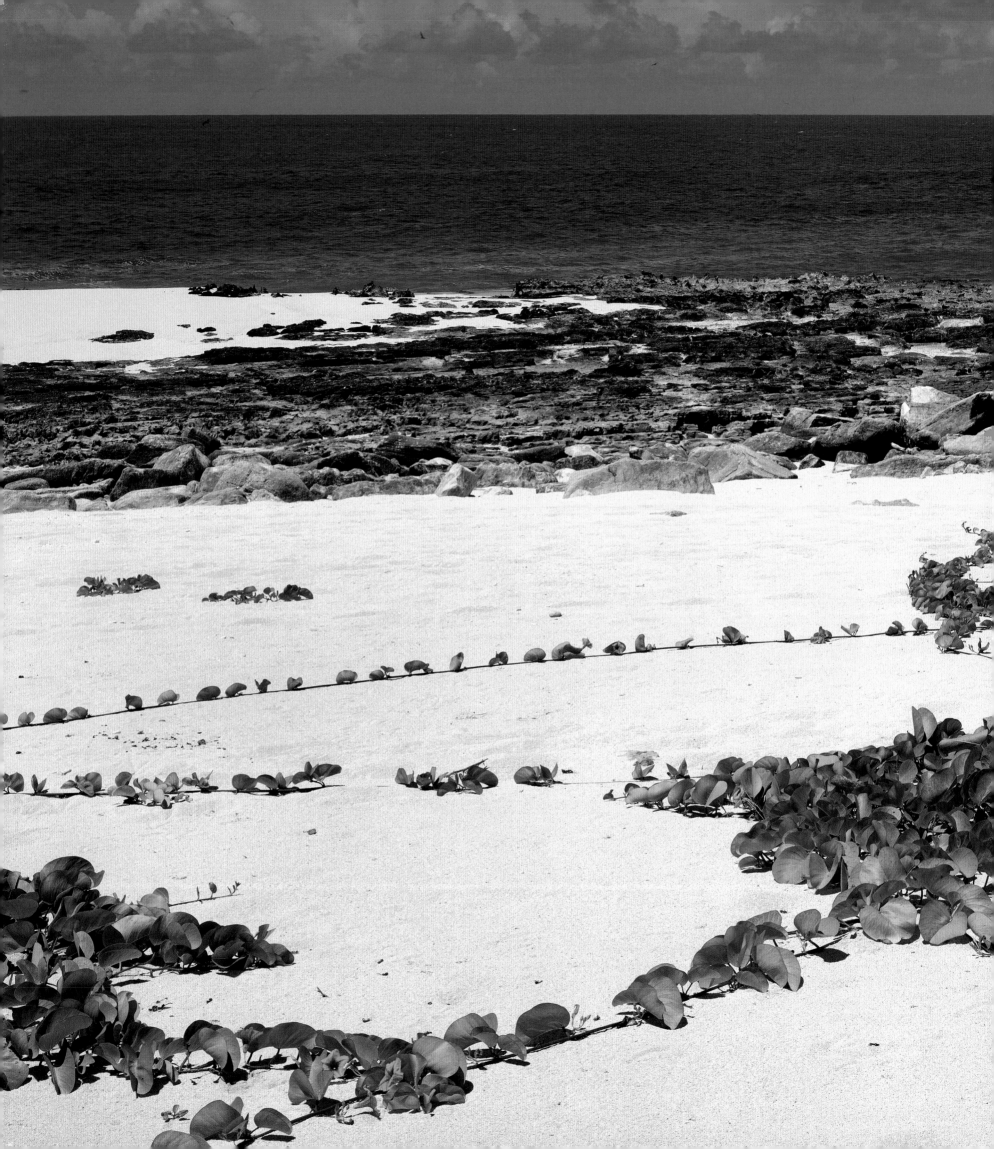

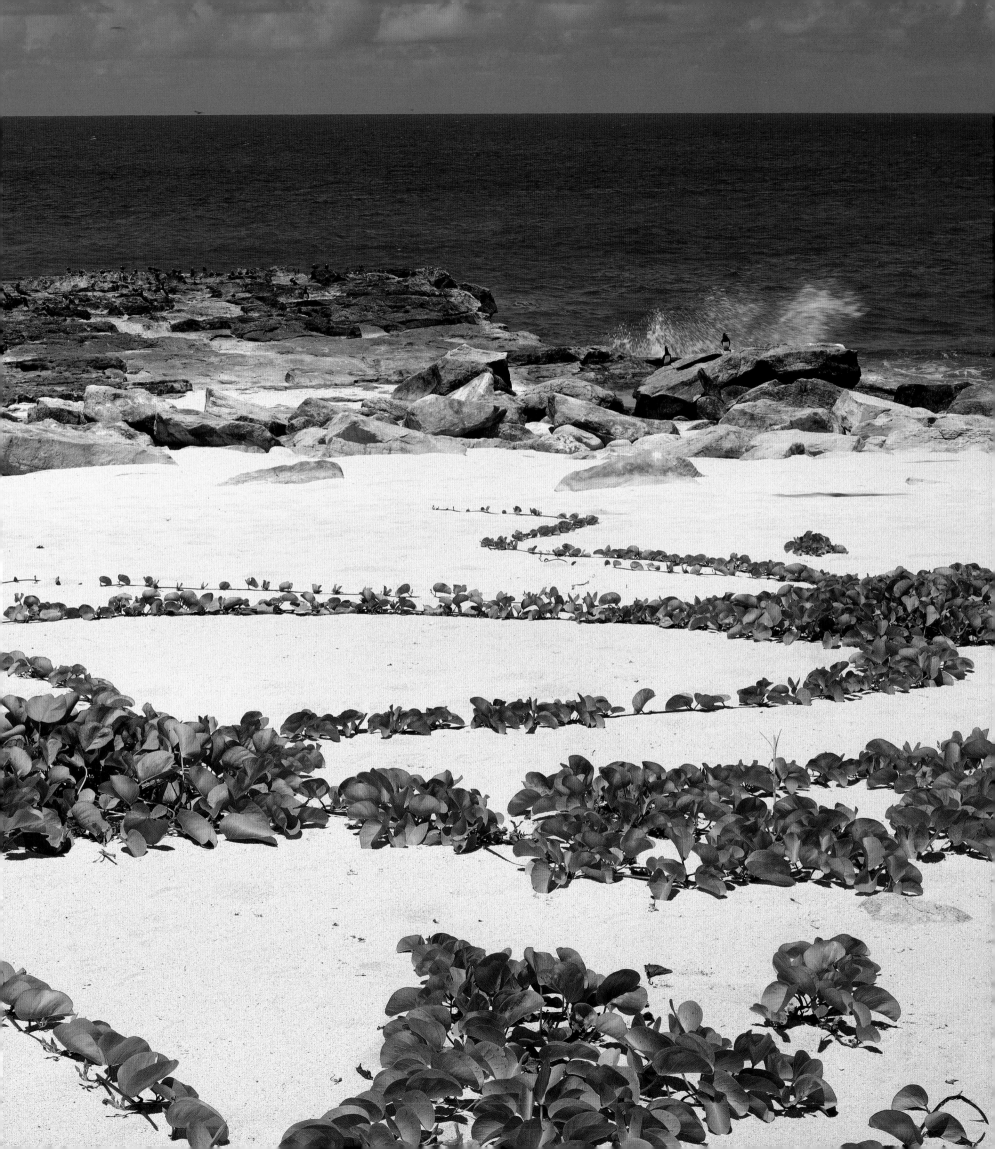

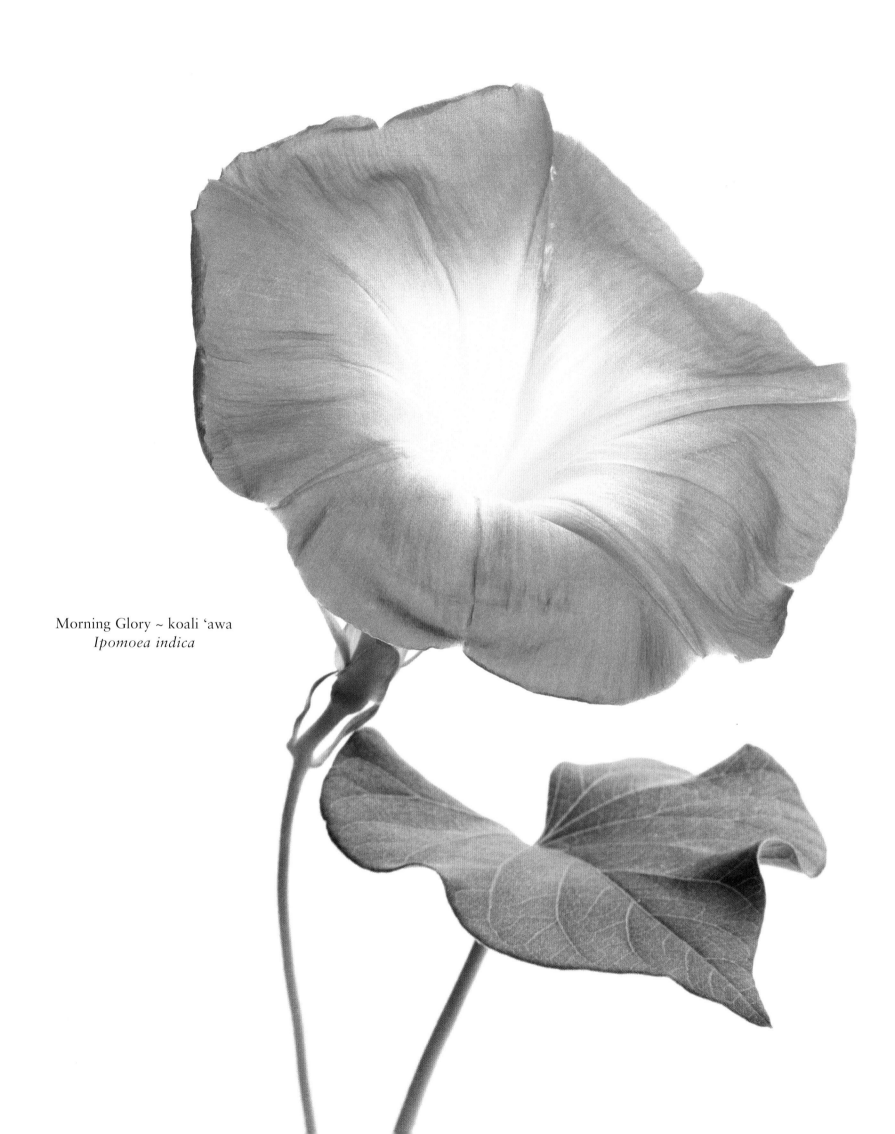

Morning Glory ~ koali ʻawa
Ipomoea indica

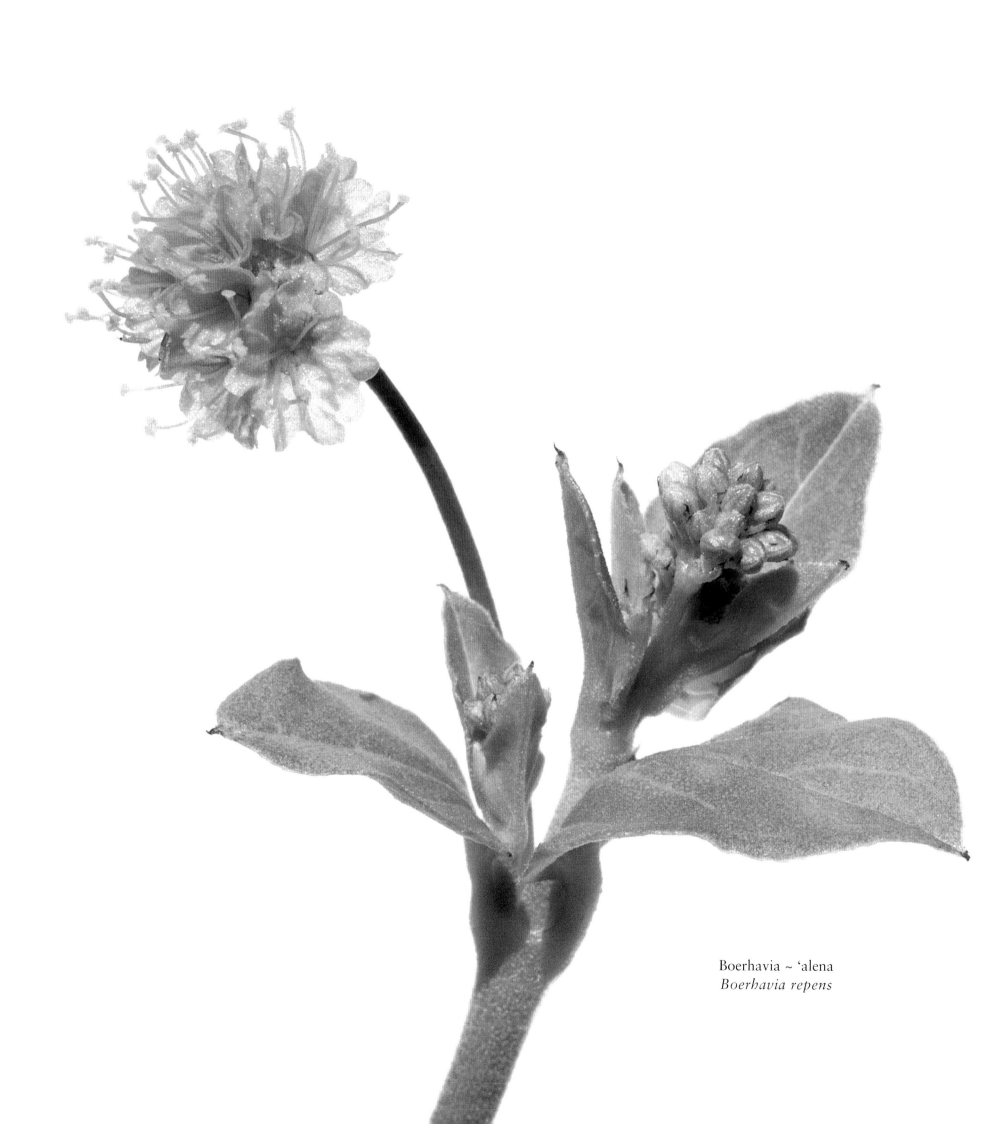

Boerhavia ~ ʻalena
Boerhavia repens

Hanau ka ʻUku-koʻakoʻa, hanau kana,

he ʻAkoʻakoʻa, puka

Hanau ka Peʻa. ka Peʻapeʻa kana keiki, puka

Hanau ka Weli, he Weliweli kana keiki, puka

Hanau ka Papaua, o ka ʻOlepe kana keiki, puka

Hanau ka Nahawele, o ka Unauna kana keiki, puka

Hanau ka Ekaha noho i kai

Kiaʻi ia e ka Ekahakaha noho i uka

He po uheʻe i ka wawa

He nuku, he wai ka ʻai a ka laʻau

O ke Akua ke komo, ʻaʻoe komo kanaka

O kane ia Waiʻololi, o ka wahine ia Waiʻolola

Hanau ka ʻAkiʻaki noho i kai

Kiaʻi ia e ka Manienie-ʻakiʻakin oho i uka

Born was the coral polyp, born was the coral, came forth

Born was the starfish, his child the small starfish came forth

Born was the sea cucumber,

his child the small sea cucumber came forth

Born was the mother-of-pearl, his child the oyster came forth

Born was the mussel, his child the hermit crab came forth

from the Hawaiian Creation Chant

Kumulipo, Chant One

Born was the Ekaha moss living in the sea

Guarded by the Ekahakaha fern living on land

Darkness slips into light

Earth and water are food of the plant

The god enters, man cannot enter

Man for the narrow stream, woman for the broad stream

Born was the tough seagrass living in the sea

Guarded by the tough landgrass living on land

Convict tang ~ manini
Acanthurus triostegus

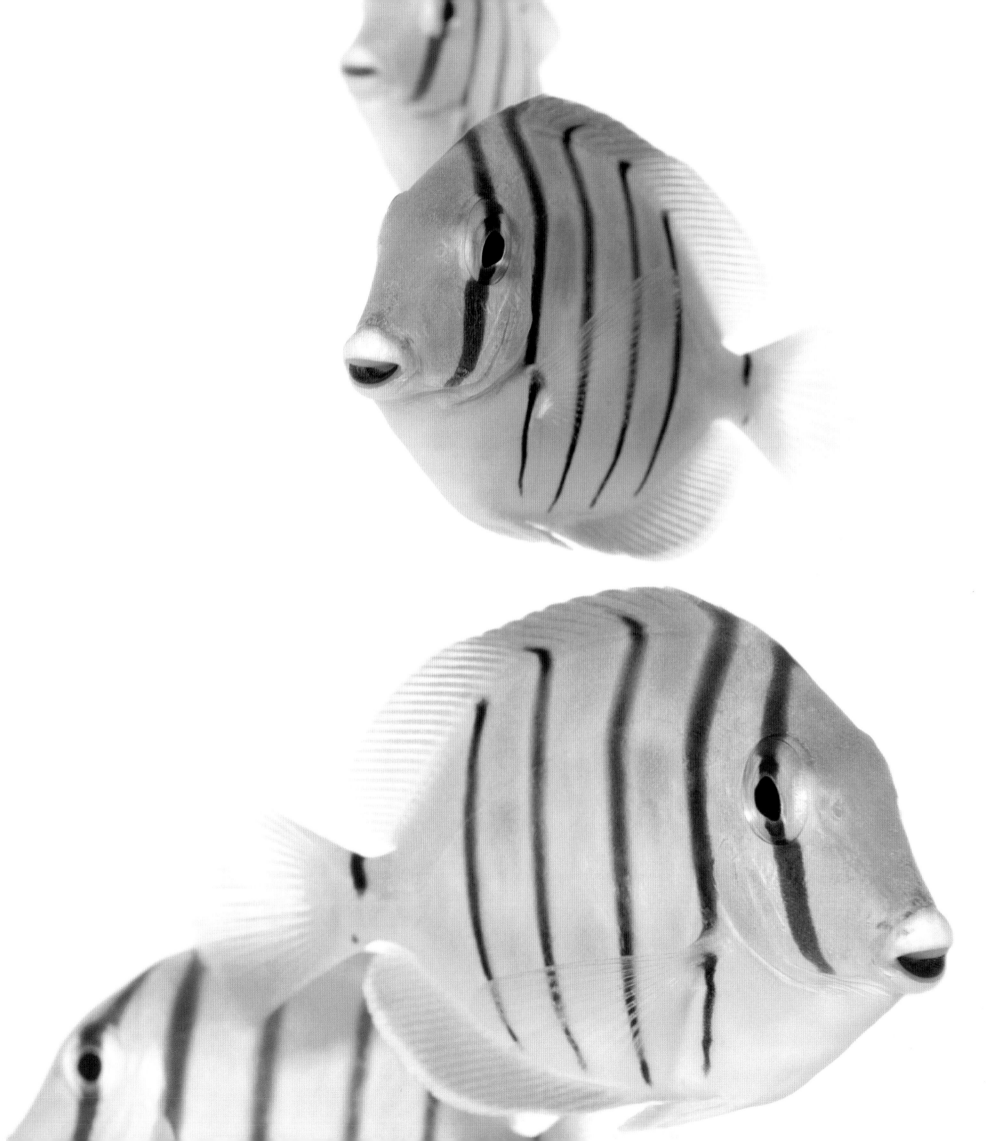

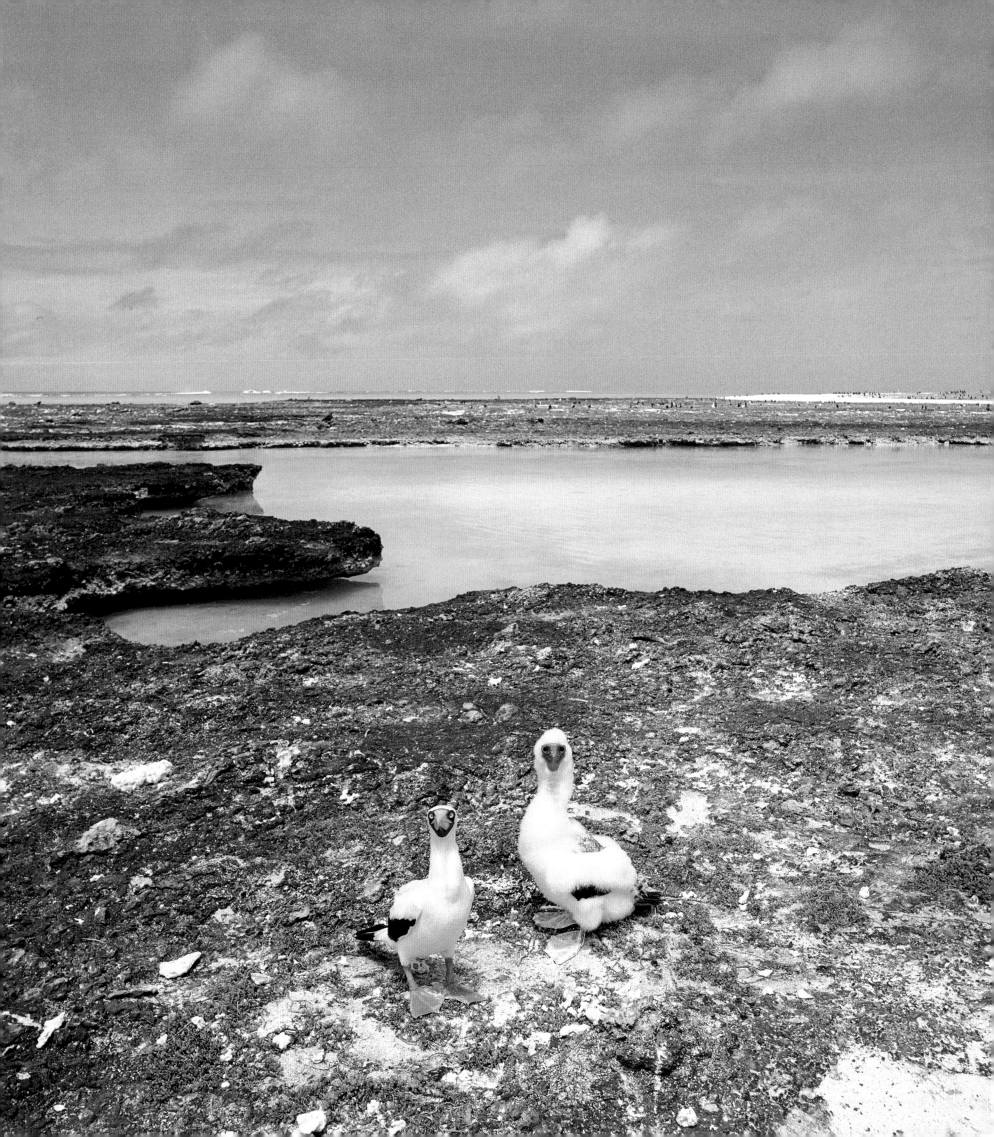

DAVID LIITTSCHWAGER AND SUSAN MIDDLETON

Archipelago

Portraits of Life in the World's Most Remote Island Sanctuary

NATIONAL GEOGRAPHIC

WASHINGTON, D.C.

PAGE 1: Nihoa Island: from the deck of the *Townsend Cromwell*

PAGES 2–3: Kure Atoll Lagoon: from Green Island, Kure Atoll

PAGES 6–7: Beach Morning Glory ~ pohuehue, *Ipomoea pes-caprae* subsp. *brasiliensis*, Laysan Island

PAGE 12: Masked Booby (parent and chick) ~ 'a, *Sula dactylatra*, Southeast Island, Pearl and Hermes Atoll

OPPOSITE: Laysan Albatross ~ moli, *Phoebastria immutabilis*, Sand Island, Midway Atoll

FOLLOWING PAGES: Sooty Terns ~ 'ewa 'ewa, *Sterna fuscata*, Eastern Island, Midway Atoll

for "Bandy" ~ a Laysan Albatross

Hatched: February 19, 2003 / 3:30 a.m.
Fledged: July 22, 2003 / 4:00 p.m.
Sand Island, Midway Atoll National Wildlife Refuge

USFWS identification band # 1517-56605

Many happy returns

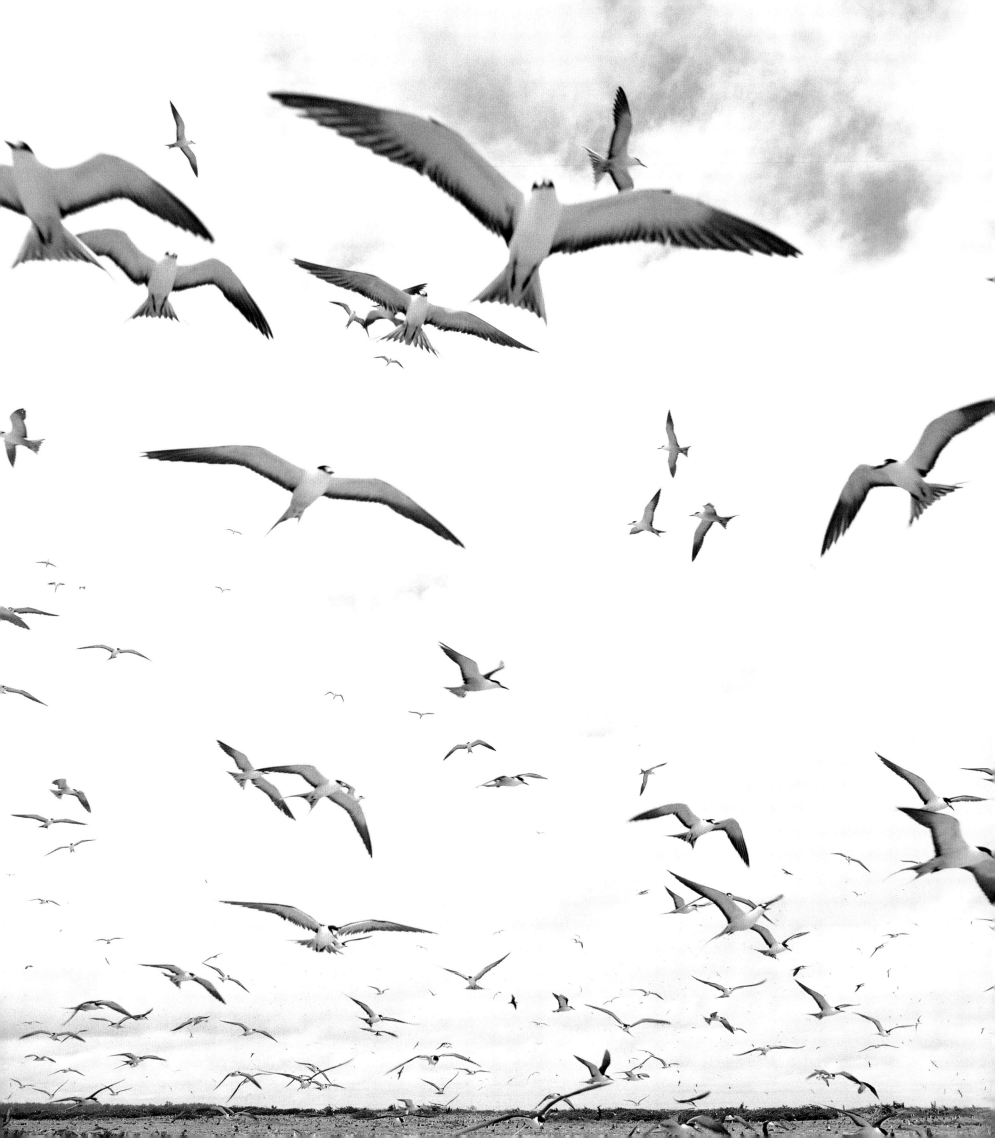

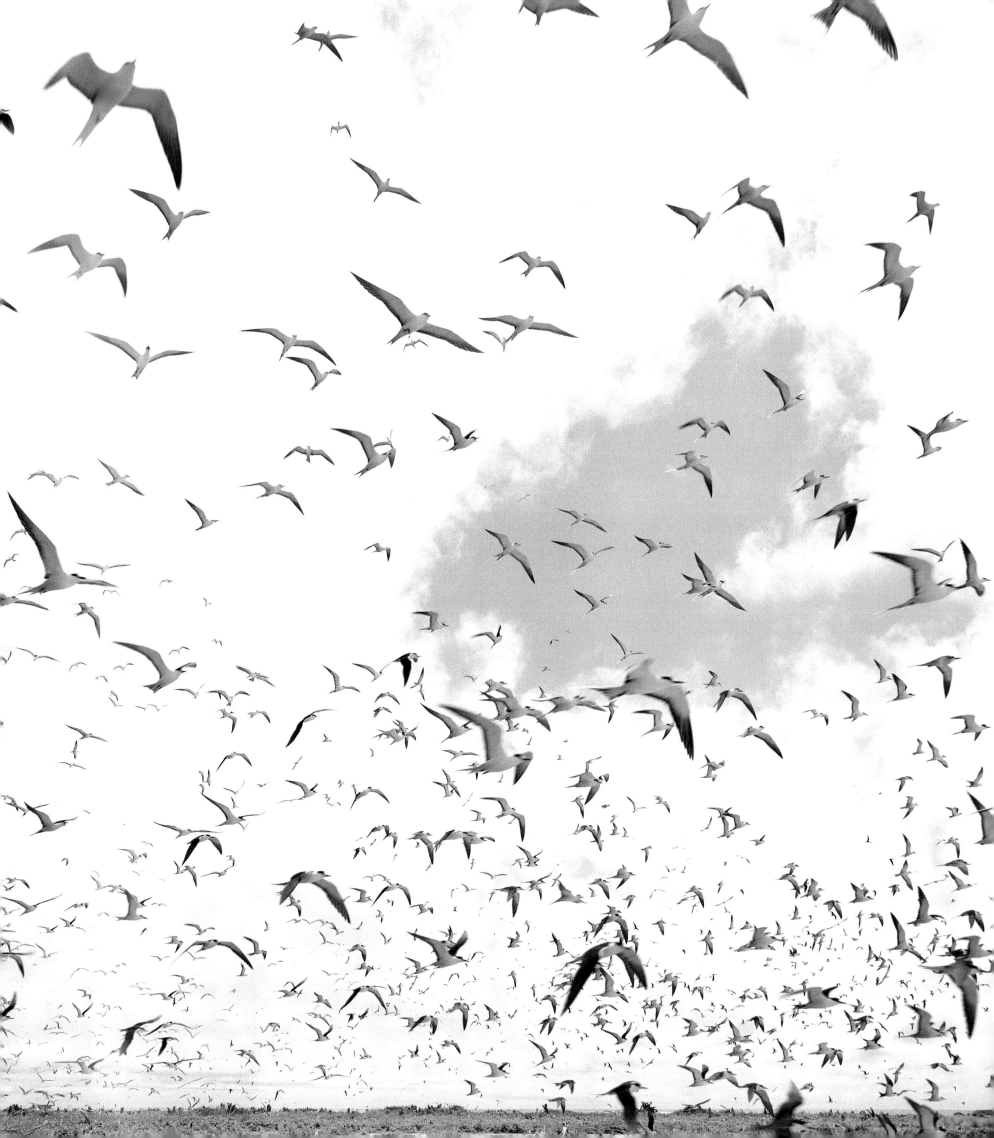

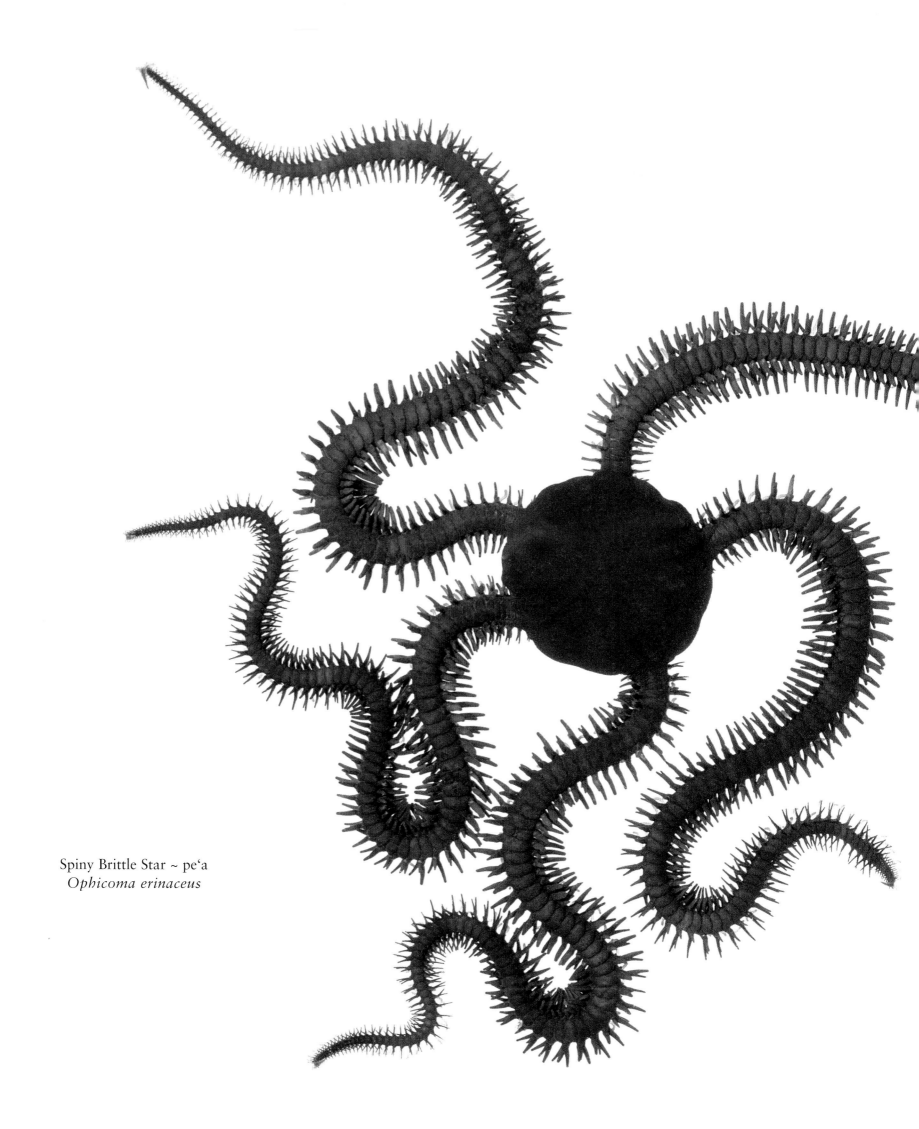

Spiny Brittle Star ~ pe'a
Ophicoma erinaceus

Contents

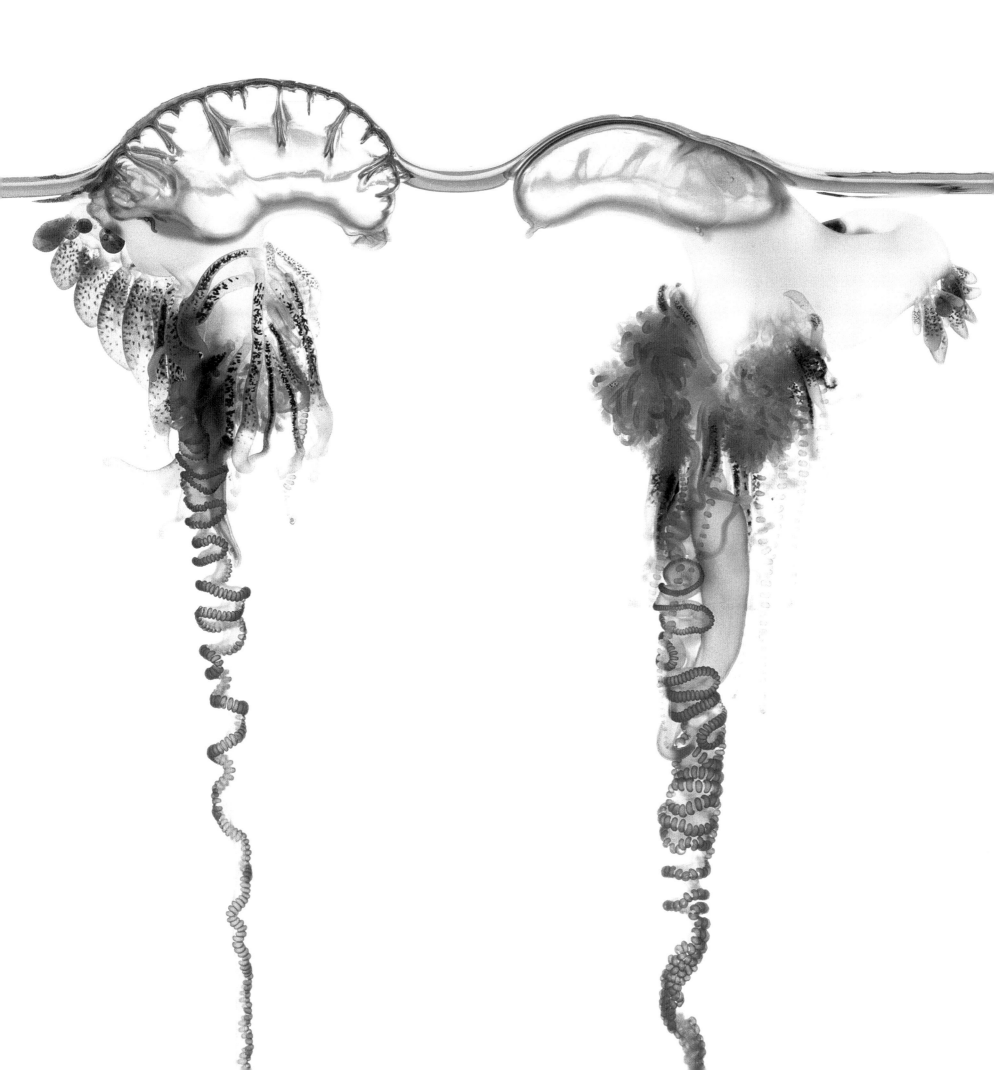

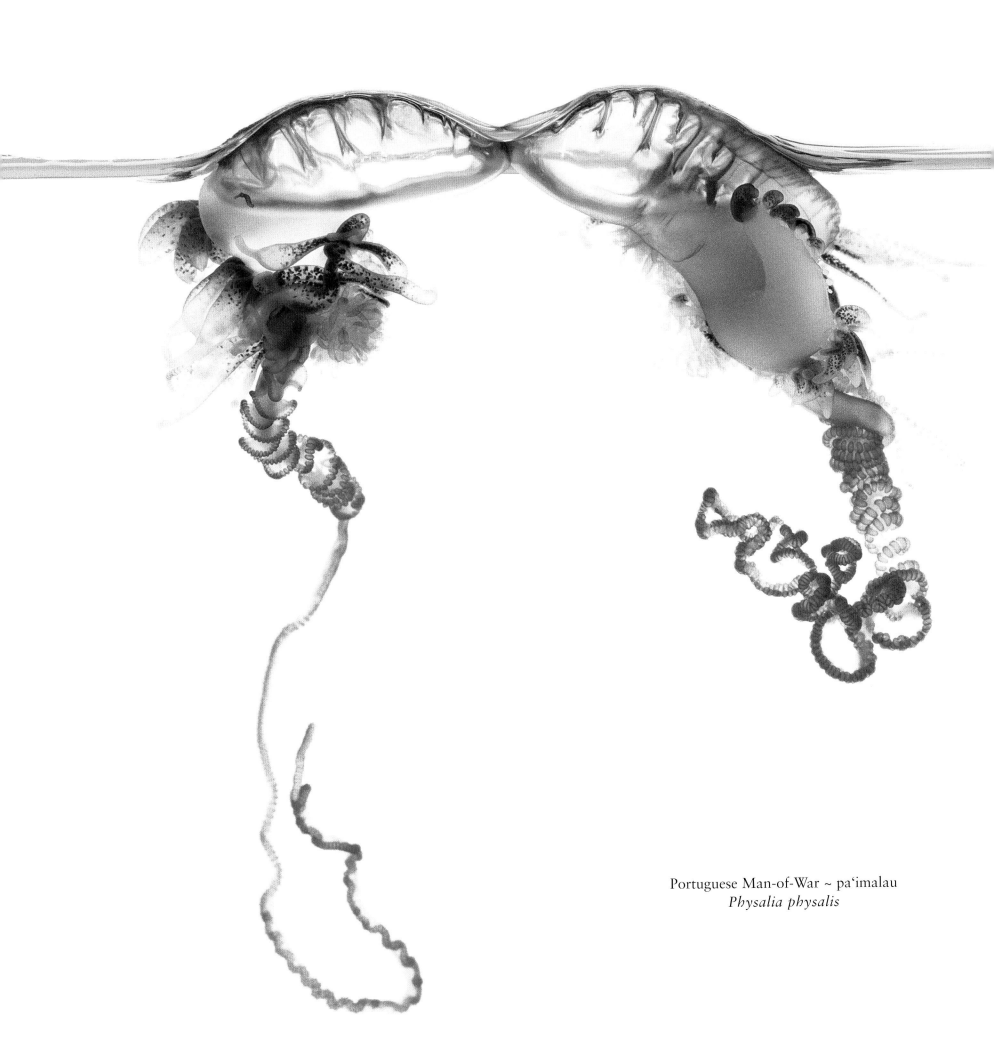

Portuguese Man-of-War ~ paʻimalau
Physalia physalis

Sporochnus ~ limu
Sporochnus dotyi

Bonin Petrel
Pterodroma hypoleuca

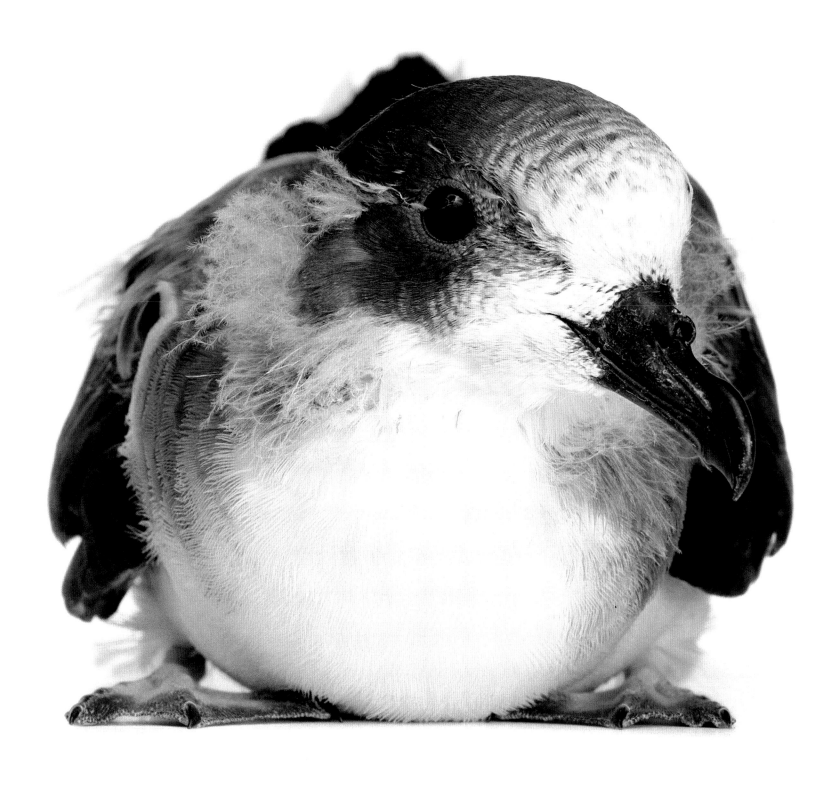

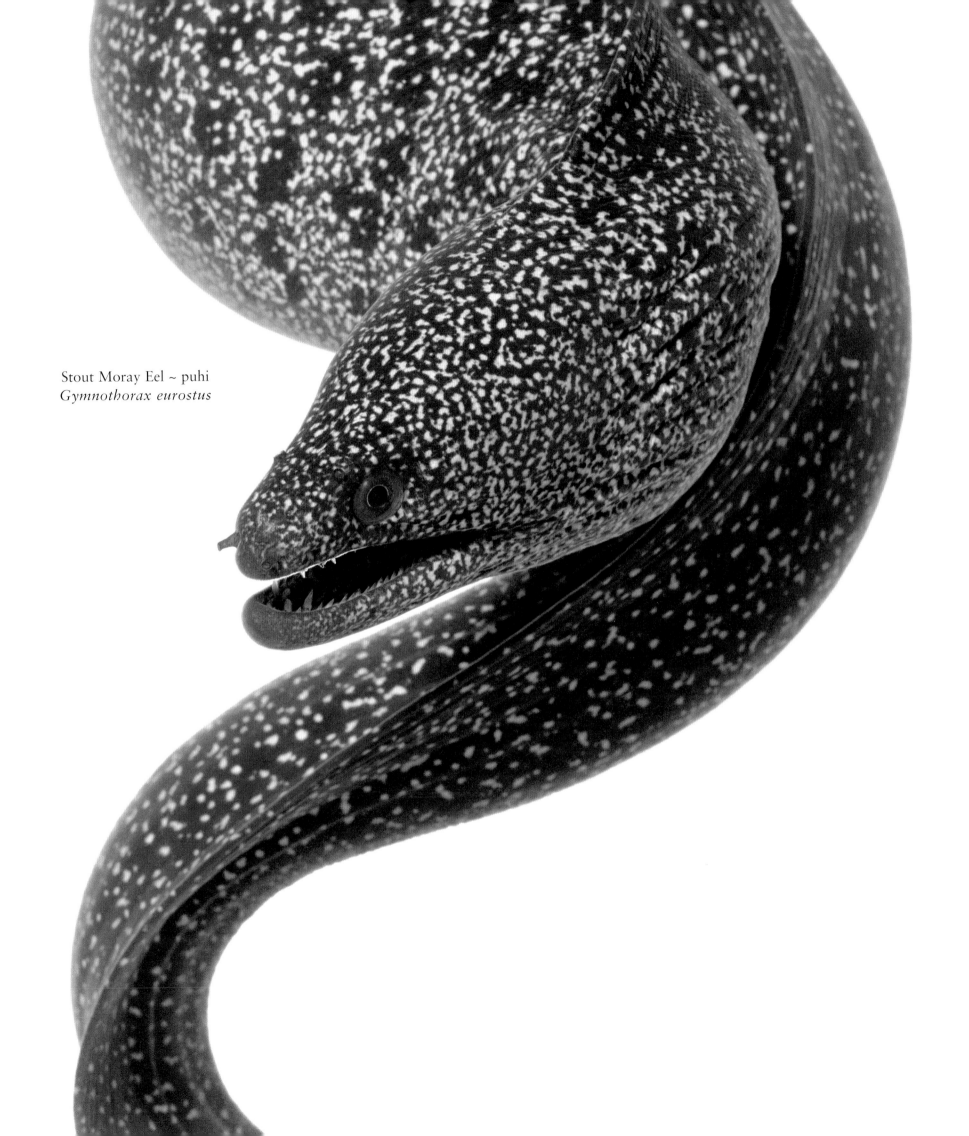

Stout Moray Eel ~ puhi
Gymnothorax eurostus

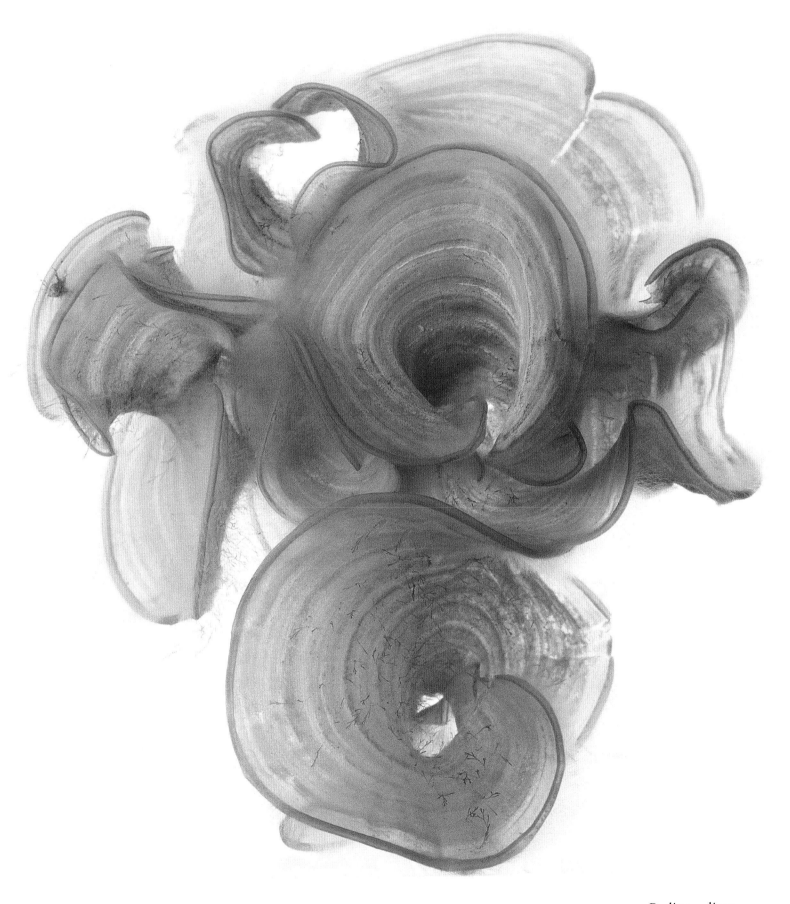

Padina ~ limu
Padina sanctae-crucis

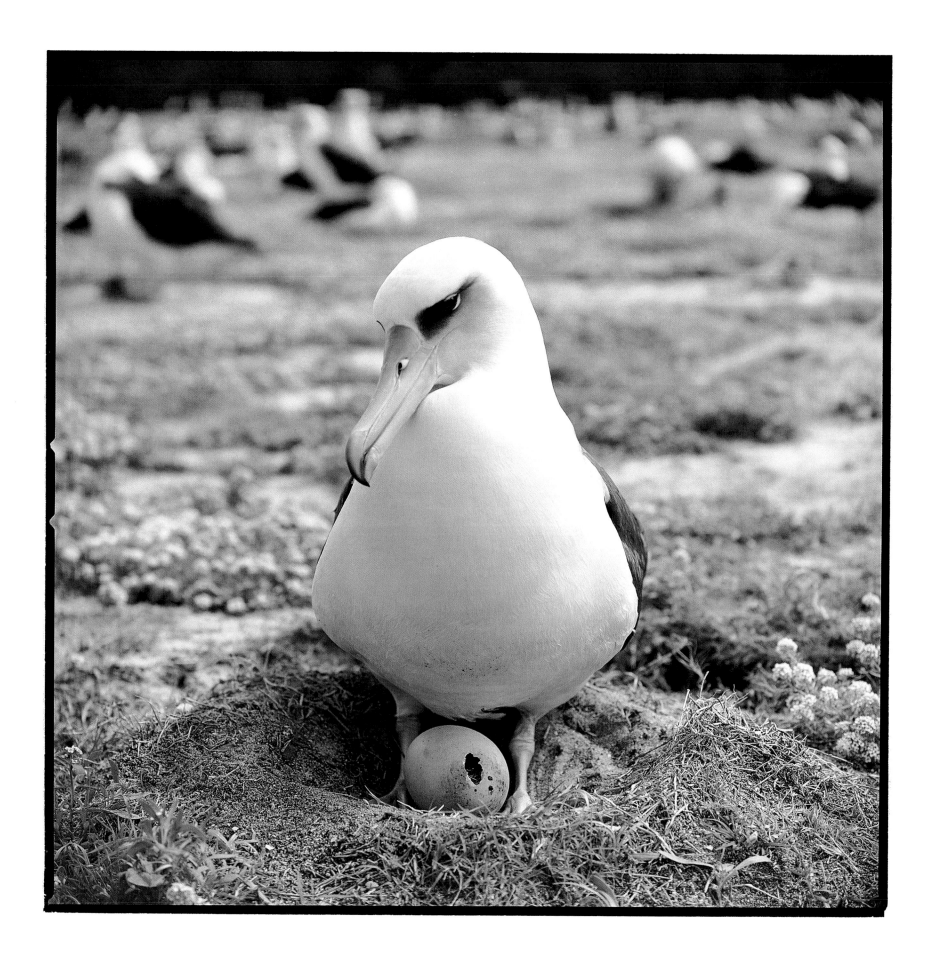

Introduction

by Susan Middleton

T he world's most remote chain of islands, the Hawaiian archipelago, emerges in splendid isolation from the middle of the Pacific Ocean. One by one, the islands of Hawai'i were born from the volcanic hot spot that still fires eruptions on the Big Island. In conveyor-belt fashion, the relentlessly moving Pacific plate has carried the islands to the northwest, while the forces of time and the sea have reshaped and leveled them into volcanic remnants, atolls, and shoals. Larger and geologically younger, the islands to the east—Kaua'i, O'ahu, Lāna'i, Moloka'i, Mau'i, and the Big Island of Hawai'i—are known as the main Hawaiian Islands and collectively represent what people generally think of as Hawai'i. These islands have been inhabited by people for over a thousand years, first by the early Hawaiians from Polynesia, and, after the arrival of Captain Cook in 1778, by waves of immigrants from around the world attracted to the natural and cultural beauty of Hawai'i.

But there is another Hawai'i, lesser known and unseen by most people. Extending northwest from Kaua'i are ten smaller and geologically older islands and atolls, often referred to as the Leeward, or Northwestern Hawaiian Islands. Comprising only one-tenth of one percent of the Hawaiian archipelago's land area, and yet extending for two-thirds the length of the chain, they provide refuge for vibrant natural communities including monk seals, sea turtles, vast numbers of nesting seabirds, plants, and insects. Human culture is not the dominant presence here. Wildlife reigns. The surrounding marine environment contains nearly 70 percent of our nation's coral reefs—altogether, one of the most intact coral reef ecosystems left in the world.

Like their famous sister-islands to the southeast, the Northwestern Hawaiian Islands have been graced with one of the most spectacular natural environments on Earth; ironically, this environment is also one of the most threatened. Through a succession of protective actions, beginning with Teddy Roosevelt establishing a bird refuge in 1909, and, most recently, Bill Clinton's creation of the NWHI Coral Reef Ecosystem Reserve in 2000, the Northwestern Hawaiian Islands have become virtually off-limits to people, with the exception of authorized research and conservation expeditions. Their inaccessibility and need for protection mean that

Laysan Albatross ~ moli
Phoebastria immutabilis
February 18, 2003, 11:00 a.m

The first in a photographic series of an albatross chick hatching and growing into a fledgling. We named it "Bandy" for its USFWS identification band.

Hanau ka Hualua ka makua

Puka kana keiki he Manu, lele

Hanau ka Ulili ka makua

Puka kana keiki he Kolea, lele

Hanau ka Moho he makua

Puka kana keiki he Moli, lele

Hanau ke Kioea ka makua

Puka kana keiki he Kukuluaeʻo, lele

Hanau ka ʻIwa ka makua

Puka kana keiki he Koaʻe, lele

Hanau ke Kala ka makua

Puka kana keiki he Kaula, lele

O ka lele anei auna

O kahakaʻI a lalani

O hoʻonohonoho a paʻa ka pae

Paʻa ka aina o Kanehunamoku

Hanau manu kaʻaina

Hanau manu ke kai

Hanau kane ia Waiʻololi,

 o ka wahine ia Waiʻolola

Hanau ka Noio noho i kai

Kiaʻi ia e ka Pueo noho i uka

—from the *Kumulipo*, Chant Three

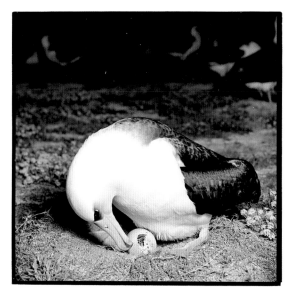

February 18, 2003, 11:45 p.m.

February 19, 2003, 3:30 a.m.

few people will be able to see and experience these islands and reefs directly. For us, this presents a unique challenge—the importance of sharing this national public treasure to help create the awareness, and the appreciation, that will be critical to its future protection. We hope to reveal the richness and value of the Northwestern Hawaiian Islands through the photographs and the voice of this book.

In the summer of 1999, we had the good fortune to visit Laysan Island and camp there for six days, in what would be our first exposure to the Northwestern Hawaiian Islands. Our project at the time focused on rare and endangered native plants and animals of Hawaiʻi, and we wanted to represent the Leeward Islands as well as the main Hawaiian Islands. After consulting with the U.S. Fish and Wildlife Service (USFWS), which oversees all of the Northwestern Hawaiian Islands except Kure Atoll (managed by the State of Hawaiʻi), we were advised to visit Laysan since it has the richest terrestrial ecosystem in the NWHI. Passage would be arranged for us by ship on one of the routine field camp resupply missions. The USFWS supported our work on the island by supplying camp gear and food, as well as the expert guidance of their field personnel.

Before departure, we underwent training in quarantine procedures, National Oceanic and Atmospheric Administration (NOAA) ship protocol, health guidelines and requirements, and emergency medicine techniques. We were embarking on an adventure, one that would take us to a place distinctively different from any of our field locations on the main Hawaiian Islands. The packing alone was an enormous ordeal. Laysan's quarantine requires that all soft goods, including clothing, backpacks, camera straps, shoes—anything that is not hard and smooth-surfaced—must be new, straight off the shelf, and frozen for 48 hours. These rules intend to prevent alien seeds and insects from hitchhiking to the island on visitors' gear. All "hard" items, including cameras, cases, and tripods, had to be carefully inspected and cleaned. Accustomed to the rigors of packing for fieldwork, we found that the strict quarantine regulations and the remote location added several complicated layers of mindfulness. Once established on Laysan, we would be simply out of luck if we discovered we had forgotten something. We knew we must arrive with exactly what we needed, plus backups in case something broke. At the same time, we couldn't

pack excessively, since everything would be transported by Zodiac from the ship to the island, often in rough seas, and then hand-carried to the campsite.

Adding to our preparations was the possibility that we might be able to visit Nihoa and Mokumanamana (Necker) after our stay on Laysan, on the way back to O'ahu. We would be picked up on Laysan by the NOAA ship, *Townsend Cromwell*, which—weather permitting—would ultimately dispatch a Zodiac carrying researchers to the islands to survey monk seals; if all worked out, we could go along. A lot of "ifs," but we thought it well worth the extra preparations to try to make a landing on either island. This basically meant complying with quarantine regulations three times: three separate sets of clothing and soft goods, all new, all frozen for 48 hours, and all sealed in plastic bags or buckets. Because each island is a distinct ecosystem, any visitor who inadvertently brings a seed or insect from one island to another could forever alter the recipient island's biological integrity.

For us, complying with the rigorous quarantine procedures began a process of understanding the uniqueness and fragility, and indeed the value, of the Northwestern Hawaiian Islands. In the past, when I worked in museums, I exercised a similar care and attention in the handling of precious cultural objects; I realized that the assemblages of life on these islands were no less precious and no less a part of our heritage.

That said, the quarantines still presented a serious packing challenge. We packed ship stuff, Laysan stuff, Nihoa stuff, and Mokumanamana stuff, most of it in five-gallon sealed plastic buckets, with extras of everything. We would be six days on Laysan, and a maximum of five hours on Nihoa and Mokumanamana. The rest of the three weeks we'd be in transit on the ship, with a couple of hours on Tern Island—not under quarantine due to the extensive human impact it sustained during its years as a Coast Guard Station. Full of anticipation, we boarded the *Townsend Cromwell*, which periodically traveled from Honolulu, up the Northwestern Hawaiian Islands chain to Kure, and back again. Always a welcome sight, it delivered provisions and relief personnel to all the field camps on the islands. We would be dropped off on Laysan as the ship headed up the chain, and retrieved on its way back.

Never before had I been to a place where wildlife so clearly reigned supreme. I knew of the USFWS refuge mission of placing "wildlife first," but here I actually experienced it. Every decision was guided by its potential impact on the resident island community: the birds, seals, and turtles, and the native plants. It affected every move we made, from the food we ate (nothing with seeds that might sprout, like tomatoes) to the places we walked (on the beach we could disturb resting monk seals, and inland we ran the risk of crushing the ubiquitous nesting burrows of various bird species). I had the overwhelming sense that I was a visitor in someone else's home. Fortunately we had expert guidance on the island, provided by USFWS camp leader Alex Wegmann, who understood the full spectrum of life here, and how the different elements of the ecosystem weave together; his infectious passion for the place spread to David and me, and helped plant the seed that grew into this book. Rebecca Woodward introduced us to Laysan ducks—the world's rarest—which live only on Laysan Island, and Brenda Becker taught us how to move around monk seals, who can so easily be disturbed by humans. The islands have historically been safe havens for the seals, a refuge from sharks and a place to raise their pups. The presence of people, especially if they come too close, can threaten that sense of security and drive the seals back into dangerous waters.

Born was the egg, the parent
Out came its child a bird, and flew
Born was the Snipe, the parent
Out came its child a Plover, and flew
Born was the rail, the parent
Out came its child a brown Albatross,
 and flew
Born was the Curlew, the parent
Out came its child a Stilt, and flew
Born was the Frigate bird, the parent
Out came its child a Tropic bird,
 and flew
Born was the migrating gray-backed Tern,
 the parent
Out came its child the red-tailed
 Tropic bird, and flew
Flew hither in flocks
On the seashore in ranks
Settled down and covered the beach
Covered the land of Kane's-hidden-island
Land birds were born
Sea birds were born
Man for the narrow stream,
 woman for the broad stream
Born was the Noddy (noio), living at sea
Guarded by the owl (pueo) living on land

 —from the *Kumulipo*, Chant Three

Nonetheless, I recognized the necessity for human intervention on the island to help correct our past and present blunders. In the past, Laysan suffered from a series of disastrous human activities, beginning with guano mining and exploitive feather hunting in the late 1800s, and the 1905 release of rabbits as a food source. The rabbits did as rabbits do, multiplying at their fabled rate and devouring vegetation. By 1920 they had transformed Laysan into a wasteland, and the once thriving ecosystem had crashed. The long process of restoration began with the elimination of the rabbits by the Tanager Expedition in 1923; it continues to this day under the management of the Fish and Wildlife Service. Much of the native vegetation is now restored, while alien weeds continue to be eradicated. What started as a tragedy has become a success story, and the rich native flora and fauna of Laysan today bear witness to a painstaking restoration program, repairing the extensive damage inflicted by human activities.

We photographed throughout our six days on the island, focusing on the rare Laysan ducks and Laysan finches, as well as native plants, many species of seabirds, and landscapes and seascapes, much of them littered with marine debris. We were shocked to see so much garbage, mostly plastic and glass bottles, ropes, nets, and lines washed up onto the white sand by ocean currents. This was our first exposure to marine debris in the Northwestern Hawaiian Islands, and it would not be our last. We visited Laysan in July—albatross fledging time—and we witnessed many outstretched wings in the wind, practicing for flight. We also watched chicks die and witnessed the mute testimony of their rotting carcasses, the exposed rib cages containing plastic disposable lighters, bottle caps, toothbrushes, toys, and other bits of plastic mixed with squid beaks and pieces of pumice. Sadness and outrage set in and I suddenly sensed that this remote island was not all that remote.

The refuge management protocols taught me to live lightly on Laysan and changed the way I think, adding an unexpected bonus to the whole experience. Every action had to be accompanied by conscious awareness of its effect on wildlife, and an effort to minimize that effect. This was not our place; we were only there to make it better for the species that do belong. If we could not do that, we had no business being there at all, and everyone permitted on Laysan bears that responsibility. I found it reassuring that places like this still exist on the planet, but it is only because we make it so. People are not the dominant species here, but our human will—in this case, the will to protect—prevails nonetheless. What a different reality from the main Hawaiian Islands, where humans are indeed the dominant species. On Laysan, surrounded by the strange and exuberant energies of the wildlife, by the sounds and cycles and vibrant forms of the island residents, my soul felt nourished.

During our voyage back, gentle seas allowed for successful landings on both Mokumanamana (Necker) and Nihoa, so our extensive quarantine preparations were not in vain! Several hours on each island gave us a vivid impression of these dramatic high basalt landforms—home to vast numbers of seabirds, seals, an array of thriving native plants, and, on Nihoa, two land birds which exist nowhere else in the world. Unfortunately, we had no time then to search out Nihoa's rare native invertebrates. Early Hawaiian culture powerfully expresses itself on both islands through archeological sites, many believed to have been sacred to the original inhabitants. Our visits to these islands, mostly spent climbing steep cliffs, gave us but a glimpse, and we yearned for more time.

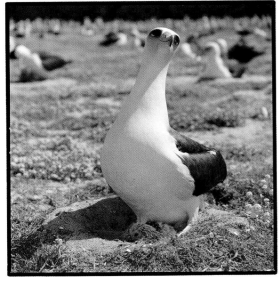 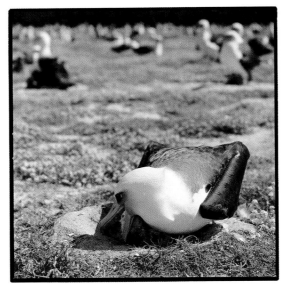 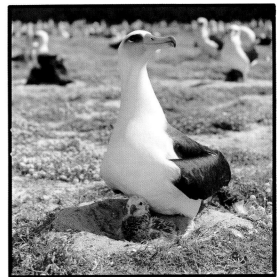

February 21, 2003, 1:30 p.m. February 21, 2003, 1:56 p.m. February 21, 2003, 1:59 p.m.

When we returned to Honolulu I felt as though we were returning from another world, and our pictures looked different as well. We knew then that we could not adequately represent this part of Hawai'i within the scope of our project, which focused on the main Hawaiian Islands. These older and more remote islands and their surrounding marine environments seemed to deserve more attention and a closer look. The region called out to be a project unto itself.

In the fall of 2001, our work in the main Hawaiian Islands came to fruition in a book, as well as a traveling exhibition, entitled *Remains of a Rainbow: Rare Plants and Animals of Hawai'i*. Except for the finch, duck, and *Mariscus* plant from Laysan, the Northwestern Hawaiian Islands are absent from this compilation. Most of 2002 was devoted to conceiving, researching, and developing a project proposal for the Leeward Islands, which I presented to the three agencies responsible for managing the region: the USFWS, the National Oceanic Service under NOAA, and the Department of Land and Natural Resources of the State of Hawai'i. Without the approval and logistical support of these agencies, gaining access to the NWHI would have been impossible. We needed special-use permits, transport, accommodations, and field guidance.

We also needed financial support, and we remain grateful to George Ellis for establishing the Honolulu Academy of Arts as the fiscal sponsor through which our fundraising could take place, and to those who contributed to the project and believed in its value. By January 2003, we were ready to begin two years of fieldwork, characterized by our readiness to leave at a moment's notice whenever we could get berth space on a ship or a seat on a plane. Advance planning could only take us so far, and we had to seize opportunities as they arose.

Our first expedition, to Midway Atoll, took place from February 2 to March 6, 2003; these dates represented times when chartered planes were scheduled to re-supply the island, with nothing in between. USFWS personnel in Honolulu offered us the opportunity to go, adding, "Do you think you can stand five weeks on Midway?" We didn't know, but we decided to give it a try. We mobilized quickly, assembling field gear, camera equipment, and film. Weight was a consideration on the plane, but photographers seldom travel light—camera equipment weighs a fair amount, and we used 35mm cameras, medium-format Hasselblads, an 8 x 10 camera, video cameras, and lighting equipment. The USFWS kindly accommodated our needs.

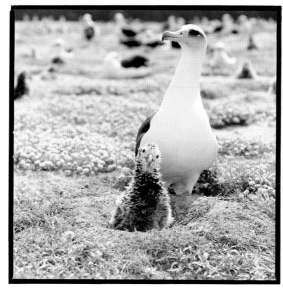
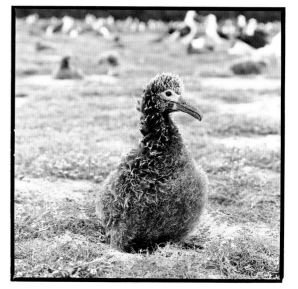

March 4, 2003 April 5, 2003

We were told that we were heading out at the best time of year, as there would be over a million albatrosses on the island raising chicks. Those five weeks provided a full immersion into the world of seabirds, especially albatrosses, and time flew by. We began a series of photographs showing an albatross chick hatching and at various stages of development. We also selected several chicks in different places on the island and followed them photographically as they grew into adulthood.

The next travel opportunity took me to Pearl and Hermes Atoll on the NOAA ship *Oscar Sette* during May 2003. I would have four nights on Southeast Island in a tent camp, housing three field technicians who were conducting monk seal surveys, habitat monitoring, and restoration. In a replay of the visit to Laysan, the ship would drop me off on its way up the chain, and pick me up on its way back. It was here that I began to understand and appreciate the marine environment of the Northwestern Hawaiian Islands, thanks to the persistence of Stephani Holzwarth, a marine biologist and one of my island camp mates. She convinced some of her colleagues on the marine debris team, based on a ship anchored outside the reef, to let us accompany them on one of their missions to recover derelict fishing nets. An Avon inflatable boat took us into the atoll toward another small islet called Seal Kittery. As we skimmed over the water's surface, I was enraptured by a spectrum of luminous blue-green colors whose shimmering existence I had never imagined—powder blue, lime, emerald, jade, turquoise, sapphire, lapis, cobalt, indigo, and violet. The varying but relatively shallow depths of the atoll, white sand bottom with occasional reefs, crystal-clear water, and bright sun set the stage for an intoxicating play of color.

We spent a few hours on the pure white sand of Seal Kittery, which required a separate set of quarantine clothes and gear. I saw firsthand the value of this precaution. A particularly invasive alien plant, verbesina, has taken hold on Southeast Island, where it is crowding out native vegetation. On Seal Kittery, with no verbesina, I was astonished to see a profusion of *Solanum nelsonii* plants, an endangered species, covering one lobe of the island. It was like an apparition, and I recognized the same sensation I experienced when I saw the Mona Lisa for the first time. David and I had photographed one of these extremely rare plants on Moloka'i, and I had seen a handful of them on Spit Island in Midway, and also some on Nihoa. But I'd never seen

this many anywhere. Imagine our setting foot on Seal Kittery with verbesina seeds stuck to the soles of our shoes—disaster! The lush profusion of *Solanum nelsonii* seemed like a precious relict from the past, when robust populations of this plant thrived throughout the Hawaiian Islands.

On our way back to Southeast Island, the calm waters allowed us to look over the side of the boat and see clearly the intricate and beautiful patch reefs beneath us, festooned with red pencil urchins, a variety of corals, algae, and fish. We even spotted spinner dolphins. I came away with the realization that an atoll may be more about what lies beneath the surface of the water than what can be found above. We knew our project was destined to move in a marine direction at some point, requiring additional research, new technical applications, and preparation. We planned to focus on the marine environment later that year, beginning on Midway, and then investigate the possibility of working aboard one of the NOAA research vessels during a coral reef ecosystem survey.

David and I each made separate field trips to Midway that spring, where we photographed seabirds, especially the chicks of different species, and terrestrial plants. We continued our series of the same albatross chick we had begun photographing earlier in the year; a small steel band placed on the right ankle of the bird ensured we'd be able to identify it. We named it "Bandy," and by this time we had become quite fond of it. Our fingers were crossed that its parents would continue feeding it to make it fat and healthy so it could successfully fledge, which, if all went well, would occur in early summer.

Returning to Midway in July, we saw and photographed Bandy fledging triumphantly: at first practicing with outstretched wings on the ground, feeling the wind, and then running to catch it, becoming airborne for a few seconds, then landing. Eventually everything came together, and Bandy appeared restless and ready to go. Running with full force, Bandy suddenly lifted off and ascended into the sky, flying higher and higher, and then out of our sight. "Bravo!" I cheered. We took a minute to wish Bandy a successful future, realizing that it was possible we might hear of this bird again; in two to five years, Bandy could very well return to Midway to dance, find a mate, and nest, still bearing the steel identification band. I couldn't help thinking that Bandy might also outlive me; albatrosses can sometimes live to be 50 years old!

We came to Midway with two large coolers containing aquariums in several sizes, and the assorted equipment we would need for our marine work. At last, our eyes delved underwater. Our first subjects were two Portuguese man-of-wars that I coaxed, very carefully, into a plastic bag as they washed ashore. David set up the aquarium, filtering fresh seawater for absolute clarity; he developed a strobe-lighting system to render the detail and beauty of our subjects. We collected more specimens on snorkeling trips and took full advantage of collections made by visiting coral reef biologists.

Soon we had the opportunity to travel to Kure Atoll aboard the NOAA vessel *Manacat*. We set up our marine studio in a tool shed and collected wonderful marine animals and plants with Cynthia Vanderlip, the manager of Kure Wildlife Sanctuary, and her daughter, Amarisa Marie. As it turned out, we were able to stay longer than we had planned, learning from Cynthia and Amarisa Marie and beginning to discover life on the reefs for ourselves. On Kure, quite unexpectedly, we hit our stride in the marine aspect of our work.

I stayed on at Midway until the end of October with the hope that I would get to see the return of the albatrosses, which begins about then. By the time I left, on October 25, only three

...With all its eyes the creature
sees the open. Our eyes alone are
as if turned back, and placed all around,
like traps, encircling its free escape.
What is outside we know only
from the animal's face; ...Free from death.
But death we alone can see: the free
animal always has its demise behind it
and God before, and when it walks it walks
into eternity, like the flowing of a spring.

—Rainer Maria Rilke,
from *Duino Elegies (NR.8)*

black-footed albatrosses had returned. The appearance of the first albatross always inspires great celebration on the island, and everyone had contributed to a betting pool predicting the date and time of the first bird's return. This is how seasons are defined on Midway—in fact, how life is defined. Birds have dominion over the island, and the arrival of nearly a million is a monumental occurrence, signifying that all is right with the world, or at least with their world. I asked John Klavitter, refuge biologist, "What happens if they don't come? What would that mean?" He replied, "We'd better all start praying; it would mean something was terribly wrong with the world." After I left, more albatrosses arrived every day until they covered the islands, with just a few feet of space between birds. Beth Flint, USFWS senior biologist, told us that the pure white breasts of so many birds make Midway appear covered with snow.

During the next few months, David and I hurried through a tight schedule—editing film, creating a portfolio to aid in fundraising for another year of field work, securing a publisher for the book and venues for the exhibition, and researching and scheduling field work for 2004, which would be our final window of field time. March 2004 found us back on Midway to do marine work. Harsh weather conditions prevented us from collecting outside the protected harbor, and what at first seemed like a setback became a fascinating opportunity to explore this finite area, with the assistance of Tim Bodeen, refuge manager. An experienced diver, Tim searched the harbor for creatures to bring before our cameras, discovering a plethora of native algae, invertebrates, and fish—all thriving in a harbor we had expected to be barren of native species, due to the extreme impact of dredging during Midway's years as a military base. The harbor contains no reefs, but still offers a hospitable environment for many marine species. We photographed Moray eels, an elaborate Spanish dancer nudibranch, several wonderfully bizarre crabs, and a dangerous but exquisitely beautiful blue-black sea urchin.

Back home in San Francisco, David and I enrolled in wilderness medical training as a requirement for living on Kure Atoll during June and July. We prepared for two months of photography in remote conditions, and arranged the necessary provisioning of food, water, and equipment for a life lived in tents. The NOAA ship *Oscar Sette,* with us onboard, traveled from Honolulu up the NWHI chain in May, stopping to re-supply stations on Tern, Laysan, and Lisianski Islands, and on Pearl and Hermes Atoll, before arriving at Kure. David and I received permission to land on each of the islands and photograph for several hours during the off-loading of supplies.

Two months on Kure became our deepest experience of the Northwestern Hawaiian Islands, due to the length of time we lived there and our total immersion in nature. Sleeping on the ground for two months, surrounded by noisy seabirds; helping Cynthia Vanderlip band birds and weed out invasive alien plants; and making frequent boat trips into the atoll to explore the flourishing coral reefs—all this provided an intimate connection to the place, with time and guidance to get to know it a little. We collected many wondrous marine animals and plants in plastic buckets of seawater, placed them in our aquariums to be photographed, and then returned them to their reef homes. On Kure, we came to fully understand the perils of marine debris.

We had e-mail access via Kure's satellite telephone, which allowed us to continue our field scheduling, including a ten-day voyage to Nihoa and Mokumanamana in late August and early September. We chartered the vessel *Searcher* in collaboration with the USFWS, and mounted an expedition with a twofold purpose: photography of native flora, fauna, and habitat, combined

All the beasts that roam the earth and all the birds that wing their flight are but communities like your own. They shall be gathered before the Lord.

—the *Koran*

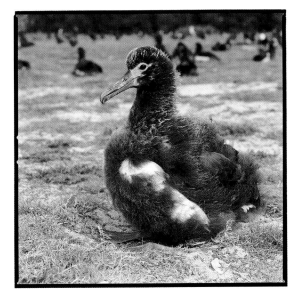

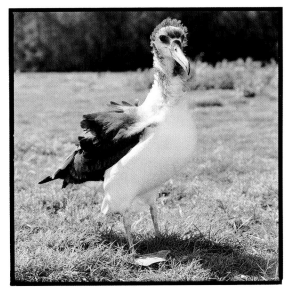

June 2, 2003 July 20, 2003

with a biological survey. And we finalized arrangements to work aboard the newly commissioned NOAA vessel, *Hiʻialakai*, during its 35-day inaugural cruise in the fall. August brought us cooperative seas, allowing for successful landings during our voyage to Nihoa and Mokumanamana. We had long hoped to spend more time on these high basalt islands, but now we were horrified to see Nihoa's lush native vegetation almost completely gone, having been eaten by a plague of invasive grasshoppers. The native finch and millerbird appeared to be thriving, however, and we saw and photographed many of the rare and unique invertebrates we had missed on our first visit.

Our project could not have evolved into its final shape without the voyage on the *Hiʻialakai*, which gave us a month at sea living and working with the coral reef biologists who surveyed the entire length of the reefs in the Northwestern Hawaiian Islands chain. We photographed the algae, fish, coral, and invertebrates they collected for us in the course of their surveys, relishing this exceptional access to the sunken kingdom I had glimpsed during my stay on Pearl and Hermes Atoll, over a year before. A shipboard photographic studio in the wet lab served us well during most of our waking hours on the *Hiʻialakai*, and we punctuated our work with occasional snorkels and dives to experience the exquisite complexity of the reef communities, and to assist in releasing our subjects back to their homes.

The great return of the albatrosses to Midway Atoll called me back for the month of November, and this time there were three Laysan albatrosses on the island when I arrived. Each day brought more birds, until the land teemed with over a million albatrosses dancing, mating, building nests, and laying eggs. An ideal place to celebrate Thanksgiving, immersed in this extravagance of life. If reality is made up of the perceptions of all creatures, then our experience in the NWHI opened us to a bigger world, a profound assemblage of energies beyond our own, that we have attempted to capture in our photographs and to share with you.

Hi'ialakai ~ NOAA RESEARCH VESSEL R334

by David Liittschwager

In 1984, the U.S. Navy launched the *Vindicator*, a T-AGOS (tactical auxiliary general ocean surveillance) vessel, to support its anti-submarine warfare mission. Fourteen years later, the U.S. Coast Guard took over use of the ship for high seas drug interdiction. Then, in 2001, the *Vindicator* was acquired by NOAA and given a new mission and a new name: the *Hi'ialakai*, Hawaiian for "embracing the sea."

We were fortunate to join the maiden voyage of the *Hi'ialakai*, a 35-day cruise through the length of the Northwestern Hawaiian Island chain, from September 13 through October 17, 2004. This cruise, intended to investigate the coral reef ecosystems of these remote islands and atolls, brought together many specialists to perform a number of biological surveys, as well as to determine the extent of threats to the reefs from human activity.

In its previous life as a T-AGOS surveillance vessel, the *Hi'ialakai* eavesdropped on submarines, and we learned that the high-tech spy equipment had been located in the section of the ship where the labs are now. We were told that the technology was so secret, it was guarded by armed sentries. The *Hi'ialakai* is now bristling with very different electronics to glean information about the natural world: cameras that are dropped at depths out of diving range, sonar systems that map the ocean floor, and instruments that can collect data about thousands of feet of the water column.

After each morning's safety meeting, I handed out buckets and plastic bags to the divers, who were kind enough to collect creatures for us to photograph. Then three or four small boats were launched into the surrounding area. We are grateful to the scientists who surrendered space to us from time to time in the wet lab—not only did they make room for us, they also brought us more specimens from their dives than we could handle. Over the course of 35 days, we shot 328 rolls of medium-format film, and worked with over 120 specimens. We are also grateful to the ship's engineers, who replumbed the saltwater supply to the wet lab in order to keep the creatures happy.

NOAA SHIP HI'IALAKAI

LENGTH: 68.3 M (224 FT)

BREADTH: 13.1 M (43 FT)

DISPLACEMENT: 2,285 LONG TONS

CRUISING SPEED: 11 KNOTS

RANGE: 8,000 NAUTICAL MILES

ENDURANCE: 30+ DAYS

COMMISSIONED OFFICERS: 6

LICENSED ENGINEERS: 3

CREW: 15

SCIENTISTS: 23 (MAX)

Lipspot Moray and Kallymenia ~ puhi and limu
Gymnothorax cf. *chilospilus* (juvenile) and *Kallymenia sessilis*

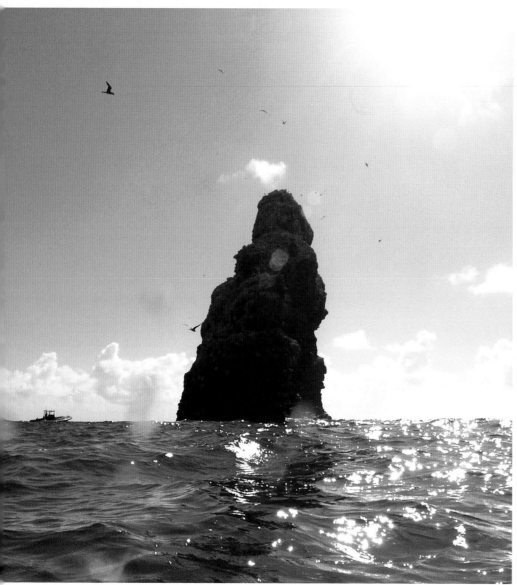

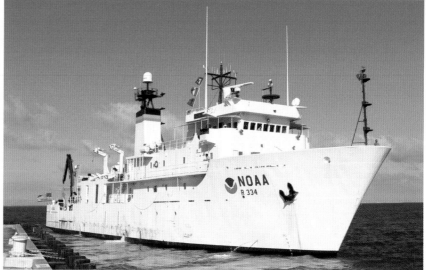

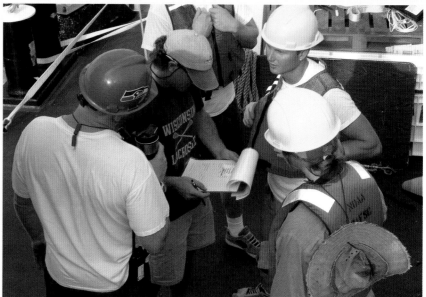

ABOVE, clockwise from left: the *Hi'ialakai*'s 10-meter (33-foot) launch boat is dwarfed by La Pérouse Pinnacle, a 120-foot tall basalt sea stack; the *Hi'ialakai* departs Sand Island, Midway Atoll; bosun and coxswains review the plan of the day.

Stephani Holzwarth tended to the animals and plants in their buckets and replenished the water as needed, mindful to keep predator and prey safely apart. In addition, some creatures have lethal chemical defenses and must be kept in a bucket of their own; they could potentially kill others around them. These culprits include the deceptively cute boxfish that can release poison, and the leaf scorpionfish that has venomous spines on its dorsal fin.

Look at a leaf scorpionfish head on, and it might appear to be moving in the way that a piece of plant material does when it's caught in a current. But in an aquarium tank with the filter turned off, where there is no current and nowhere to hide, the scorpionfish deliberately waves its body as if it were a piece of algae moving in the water. Other creatures react to potential threats by remaining absolutely still or attempting to escape, but the scorpionfish mimics a plant's motion in order to protect itself.

One day, I was busy photographing urchins when one of the divers brought us two masked angelfish. In the aquarium trade these fish would sell for around $5,000 a pair. Everyone was oohing and aahing over the fish when Randy Kosaki, a fish specialist, appeared with an octopus.

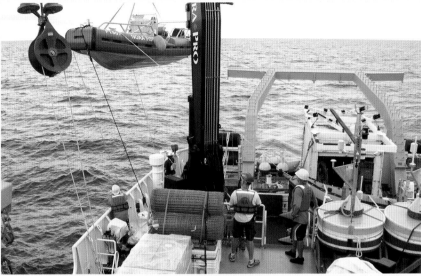

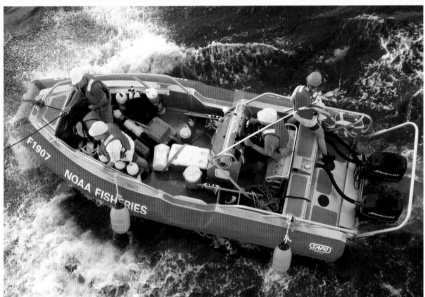

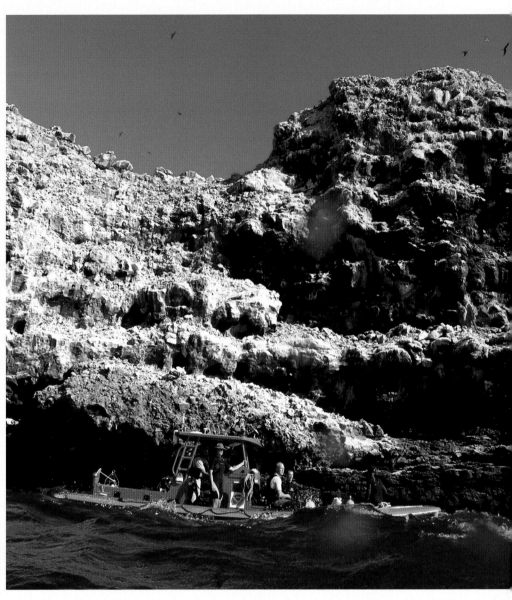

This remarkable creature quickly replaced the angelfish as the center of attention. Octopuses are excellent escape artists, and very hard to capture.

One thing I have noticed about octopuses is that they are highly alert to what's going on around them. An octopus will assess the limits of its surroundings immediately. This specimen circled once around the 15-gallon tank and then moved to the back, where it sat and watched. This contrasts greatly with fish behavior; many fish will swim around the aquarium tank over and over. They only stop, it seems, because they've grown tired, not because they have figured out their boundaries. In a natural environment, octopuses have the ability to change color to blend in with their surroundings. The photo of the octopus has a black background but it was taken in an aquarium tank with many lights surrounding it. As a result, the octopus remained the same pale color it was when it arrived in a white bucket.

When we place a creature in the tank with nowhere to hide, we get a great opportunity to look at it, but this set-up puts limits on what we are able to photograph. The logistics of containing a really large fish, so that we can use our lights and medium-format camera to make

ABOVE, clockwise from top left: the Towboard Team's 19-foot boat is lowered to the water by crane; the Mooring Team boat hovers alongside La Pérouse Pinnacle; the Towboard Team boat leaves the *Hiʻialakai* for the day's mission.

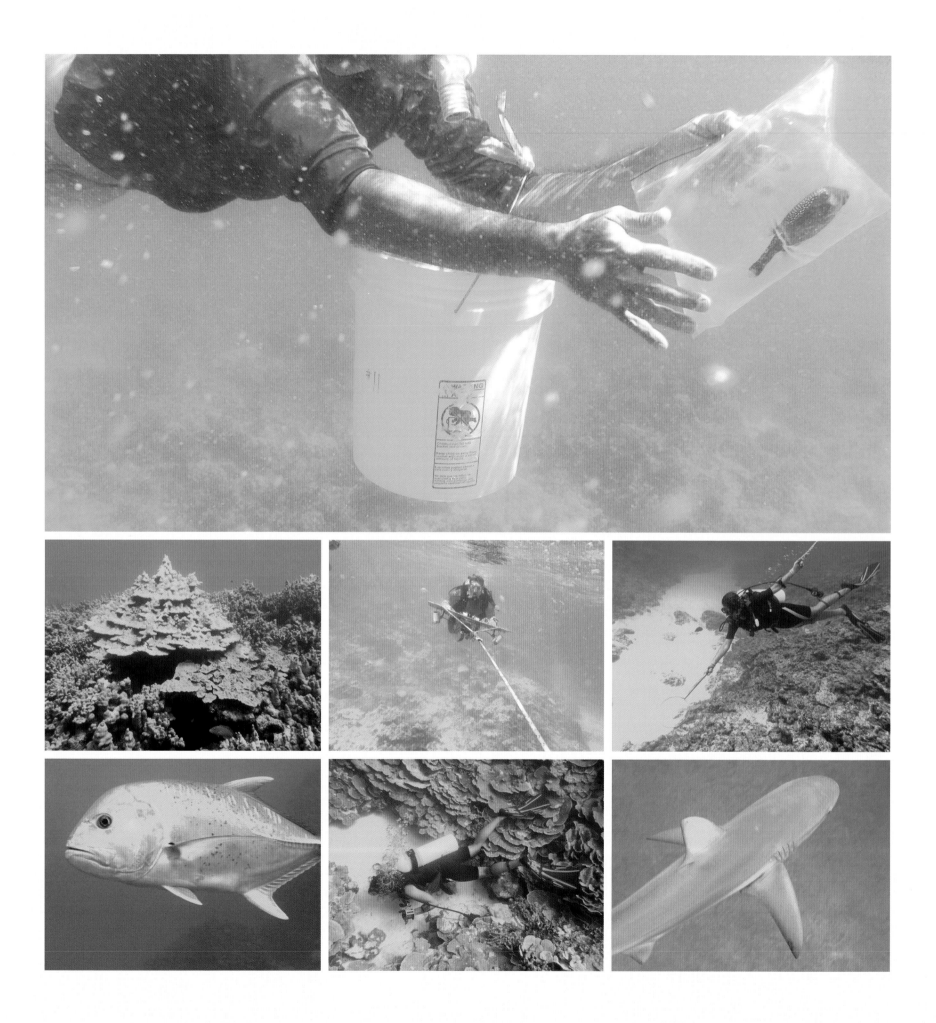

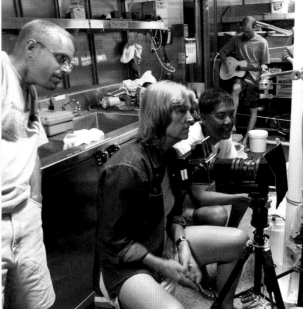
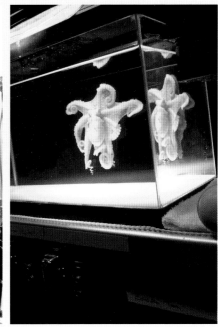

portraits, are pretty much impossible to manage: Certain fish are simply too big and too power-ful. We had to accept these limitations, but it's important to remember that the NWHI may be the last predator-dominated marine ecosystem left on the planet—some 55 percent of the total fish biomass here is made up of predator species, including huge jacks and sharks.

My last days on the *Hi'ialakai* were spent in a storm. Most of the people onboard had been at sea in bad weather before, and I was consoled by the fact that none of my shipmates seemed unduly nervous. We endured only minor losses, such as the espresso machine, which got tossed off a shelf in the ship's forward mess. (The chief steward of the *Hi'ialakai* has the most senior-ity in the NOAA fleet, which may explain how we came to have such elegance on board in the first place.) At the same time, a few people were sitting on a low couch; I learned that, during a particularly dramatic roll, the couch flipped. My job throughout the worst part of the storm was bucket-sitting: I needed to keep enough water inside the buckets, as opposed to splashing out, for the creatures within to remain alive. I called the bridge at one point to find out the angle of the ship's roll, and was told that 15 minutes earlier the clinometer had read 35 degrees. The roll I was inquiring about was bigger, but they hadn't looked at the clinometer then—they said they were all too busy holding on.

After seeing all of these islands and atolls over the course of five years, and getting a glimpse of the ocean from the *Hi'ialakai*, I believe the total ecosystem of the Northwestern Hawaiian Islands deserves the highest level of permanent protection. Although there is an abundance of wildlife in this vast stretch of ocean, the total landmass combined with the surrounding reef area is very small. This abundance is fragile and we must be mindful of what we take from this place.

OPPOSITE, top: David returns a spotted boxfish to its home at Maro Reef. Middle row, left to right: Variations of porites coral, Neva Shoals; Towboard Team member Casey Wilkinson operates a benthic habitat camera; Stephani Holzwarth collects specimens at Kure Atoll. Bottom row, left to right: An ulua (aka large jack or giant blue trevally), Neva Shoals; Stephani among table coral at Neva Shoals; a Galápagos shark at Gardner Pinnacles.

ABOVE, left to right: David adjusts the background for a portrait of the crosshatch trigger; Peter Vroom, algae specialist, Susan, and Randy Kosaki, fish specialist, are transfixed by the octopus, while Craig Musburger plays guitar; an octopus holds itself up on the back of the tank.

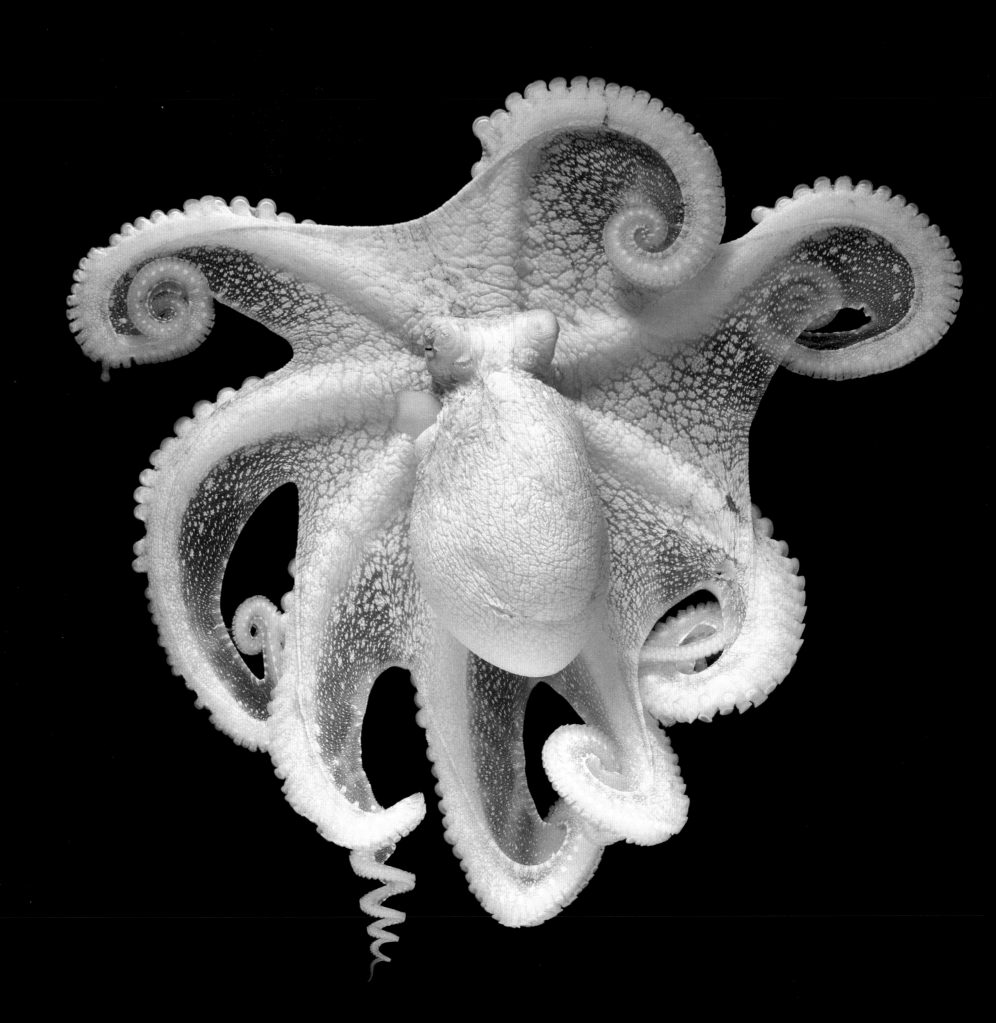

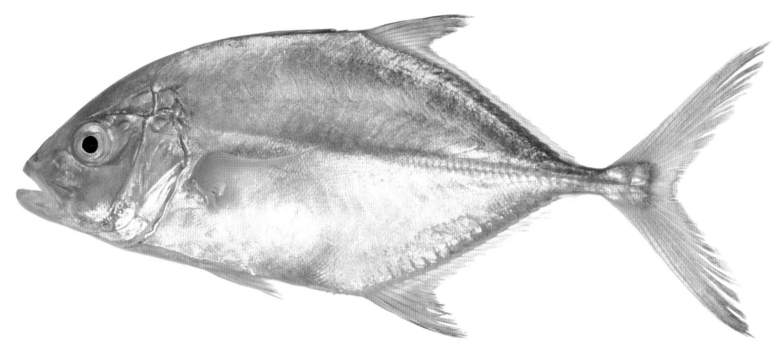

Bluefin Trevally ~ papio (juvenile), ʻōmilu (adult)
Caranx melampygus

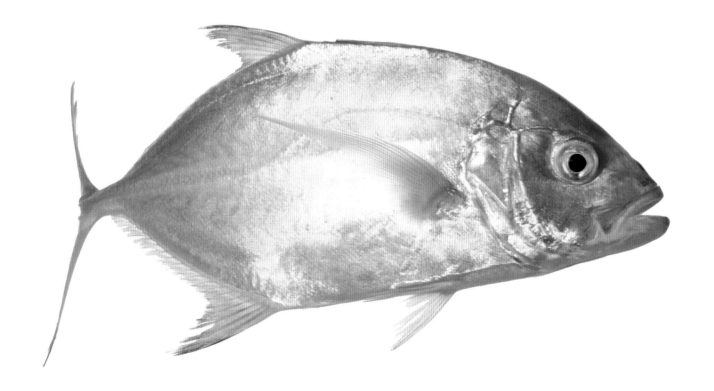

Day Octopus ~ heʻe maul
Octopus cyanea

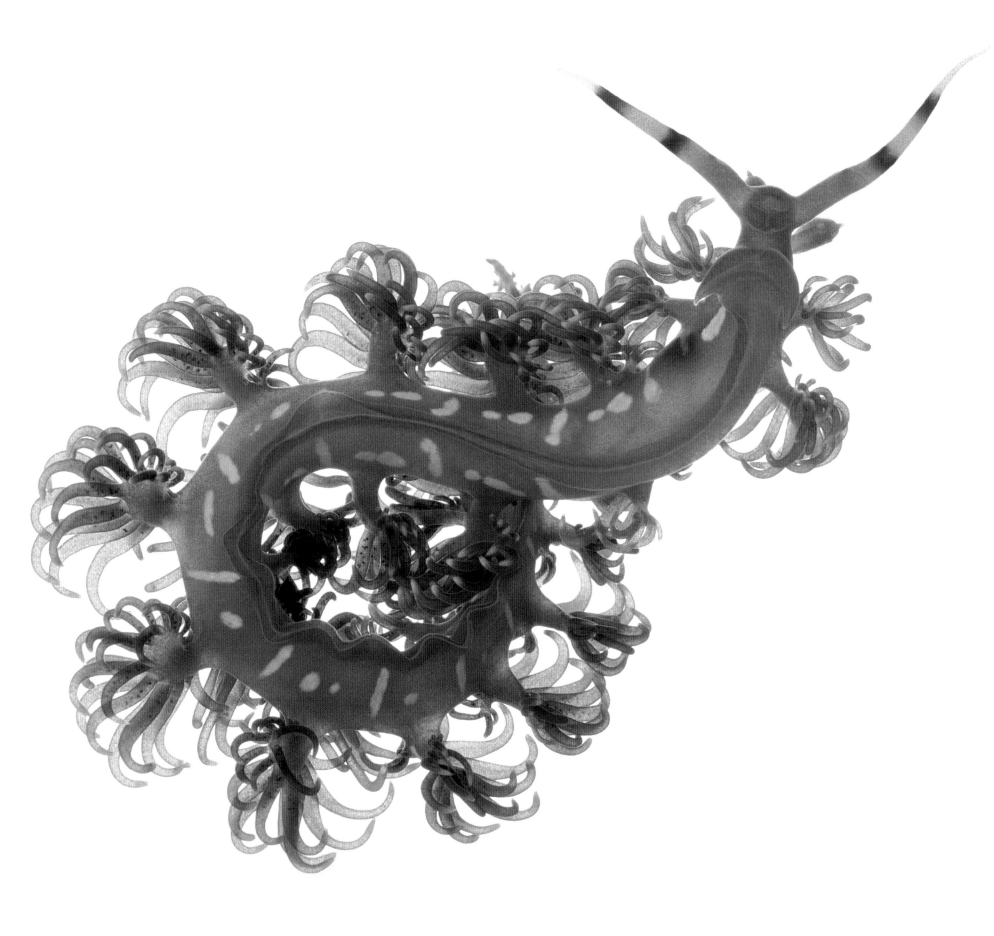

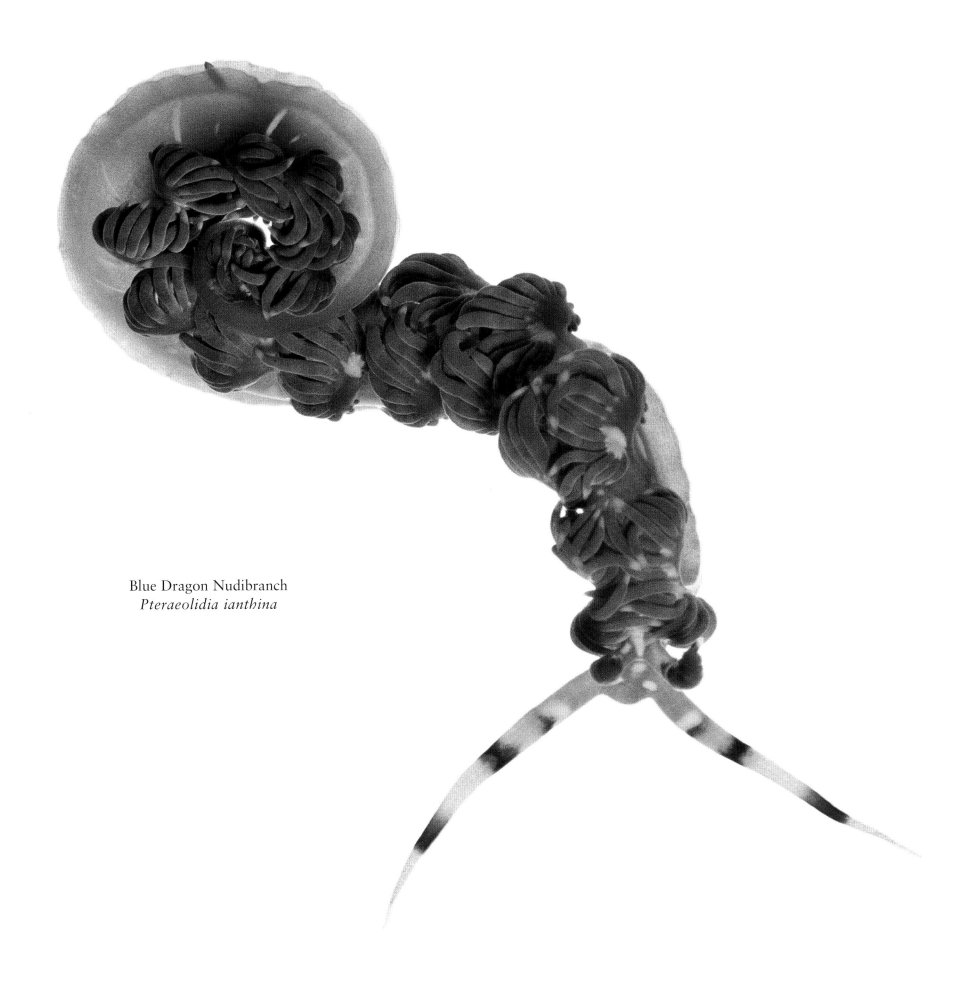

Blue Dragon Nudibranch
Pteraeolidia ianthina

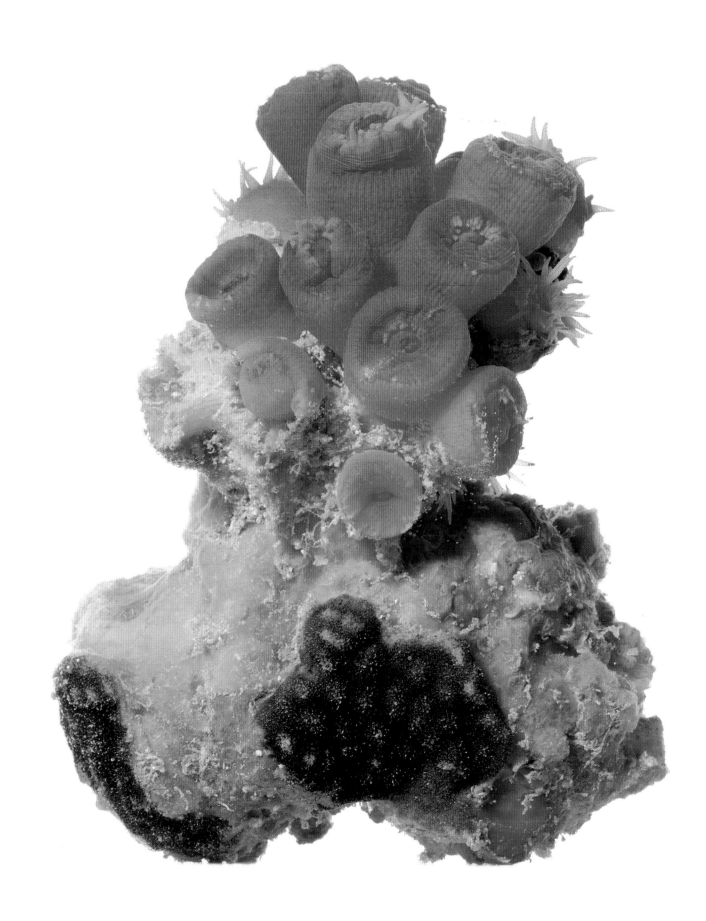

Colonial Tube Coral
Tubastraea coccinea
(closed and open polyps)

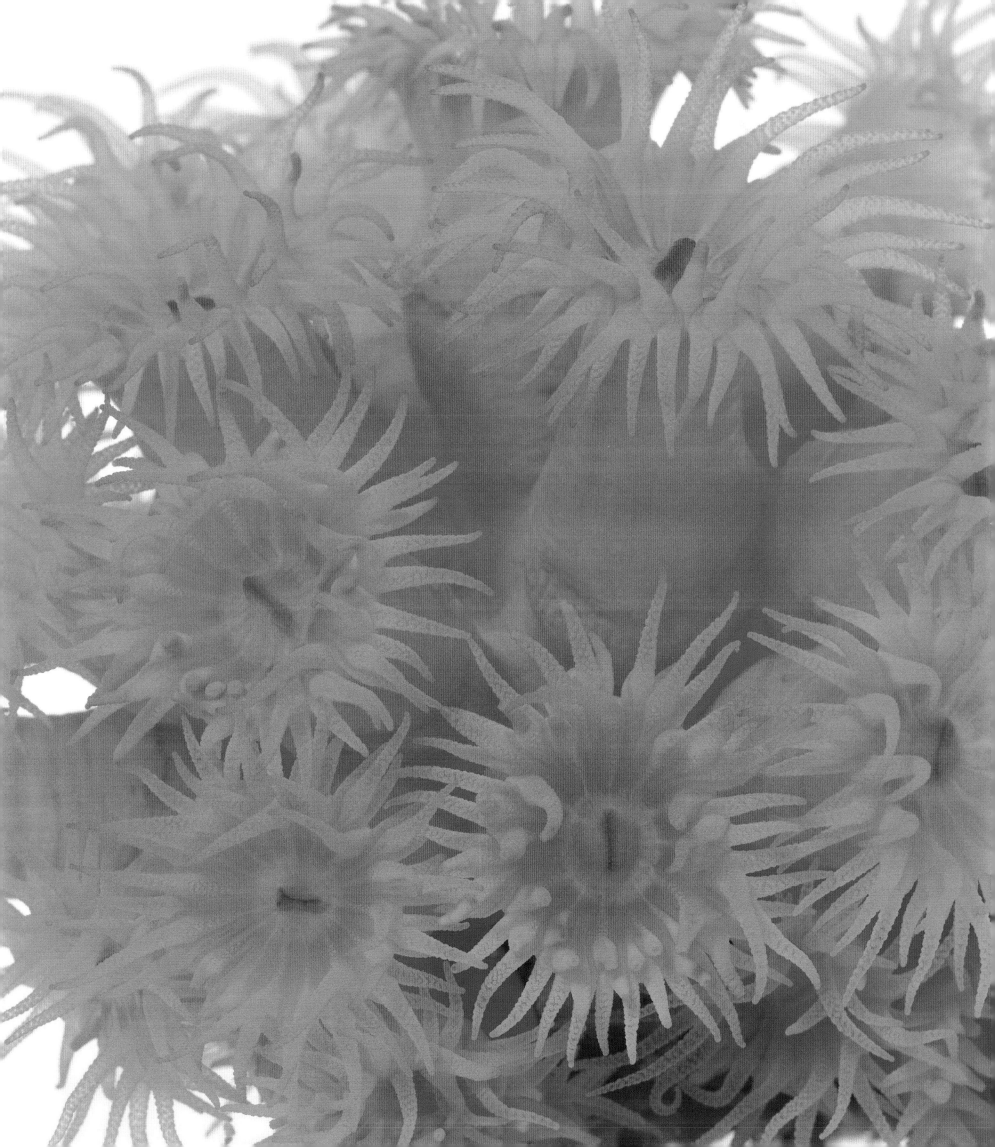

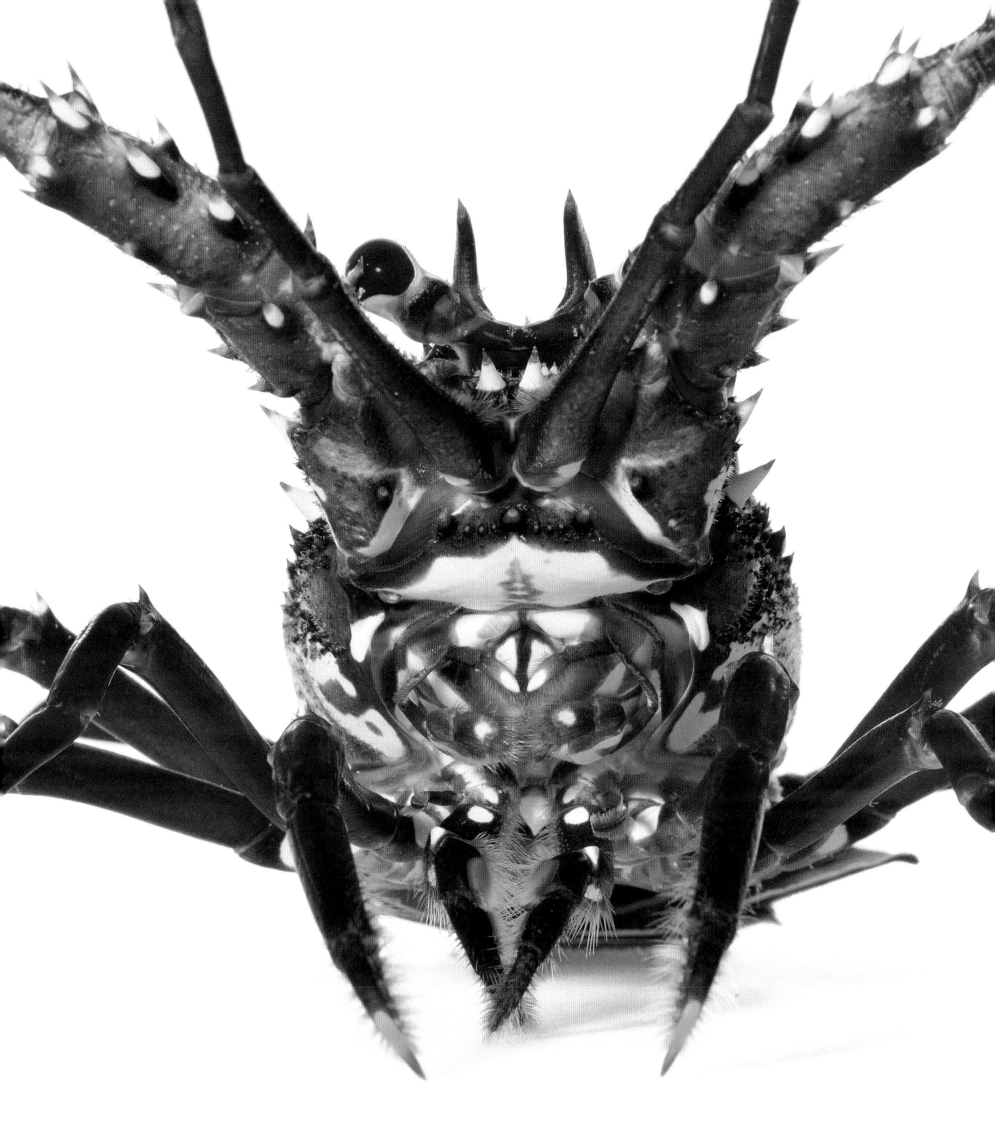

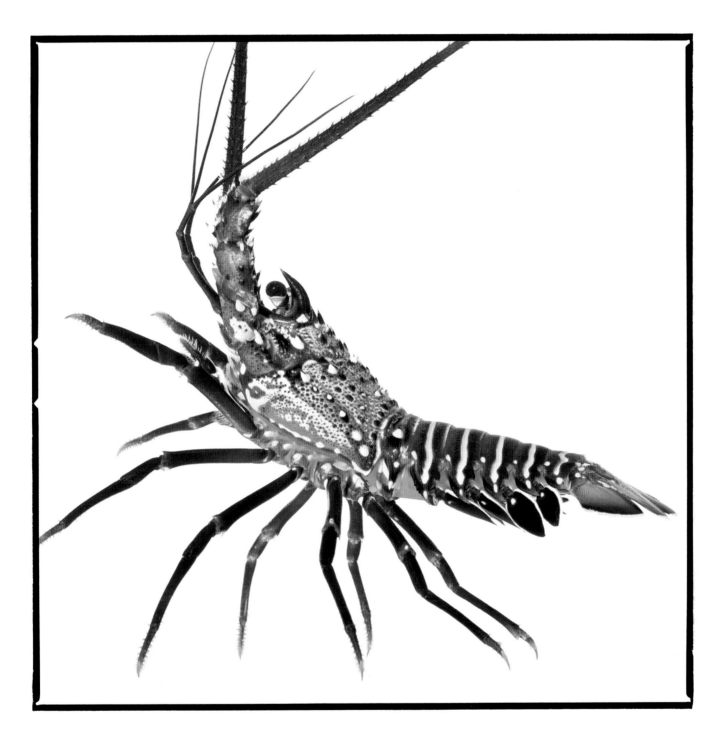

Banded Spiny Lobster ~ ula, ula poni, ula hiwa
Panulirus marginatus

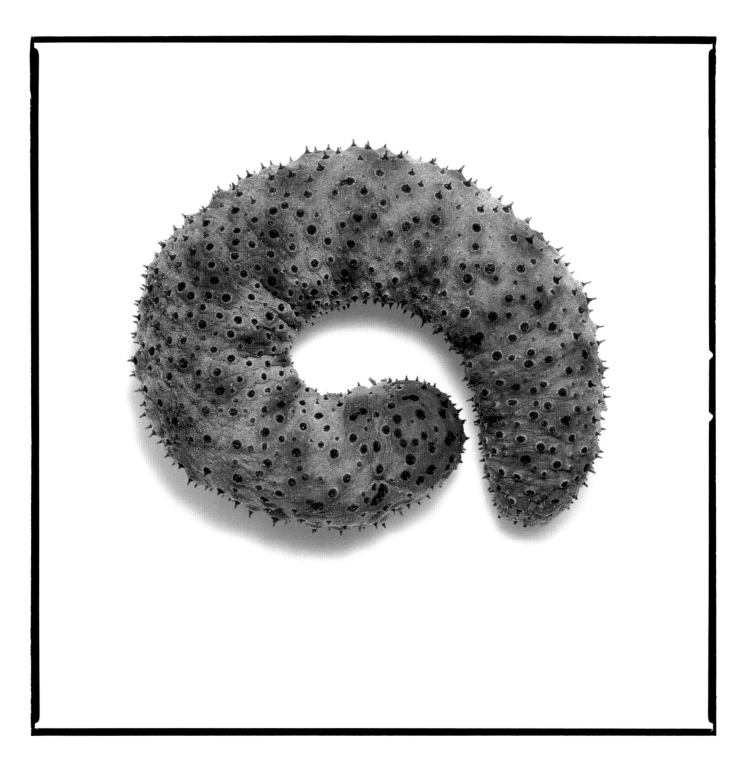

Chocolate Chip Sea Cucumber ~ loli
Holothuria sp.
(new species)

Halimeda ~ limu
Halimeda velasquezii
(non-reproductive phase)

Halimeda ~ limu
Halimeda velasquezii
(reproductive phase)

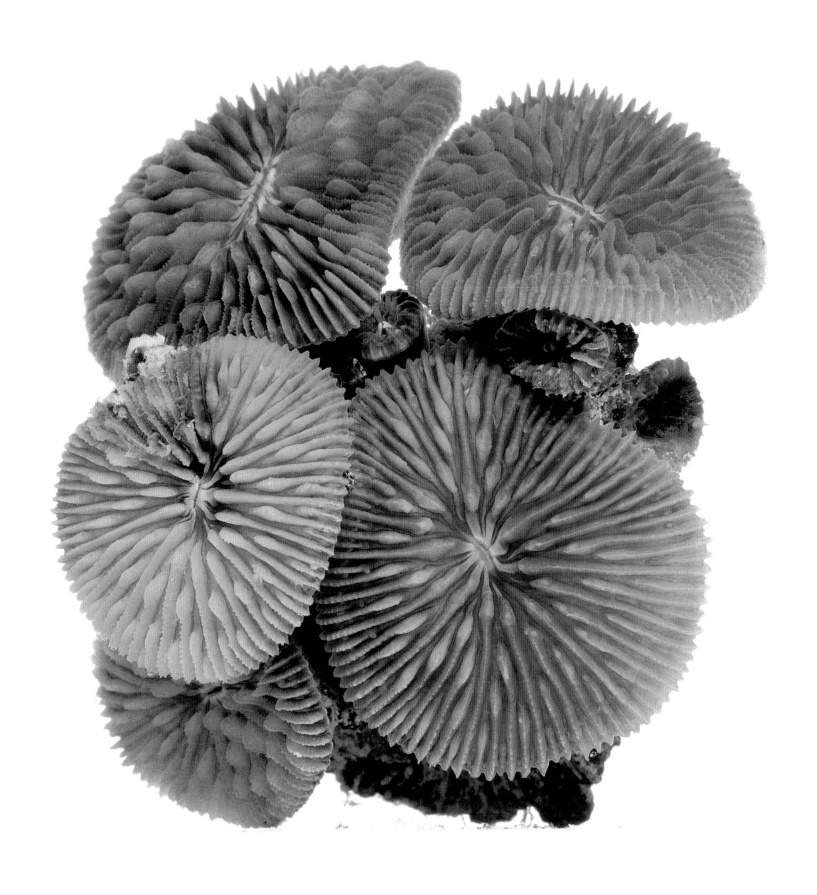

Mushroom Coral ~ ʻākoʻakoʻa kohe
Fungia scutaria
(detail opposite)

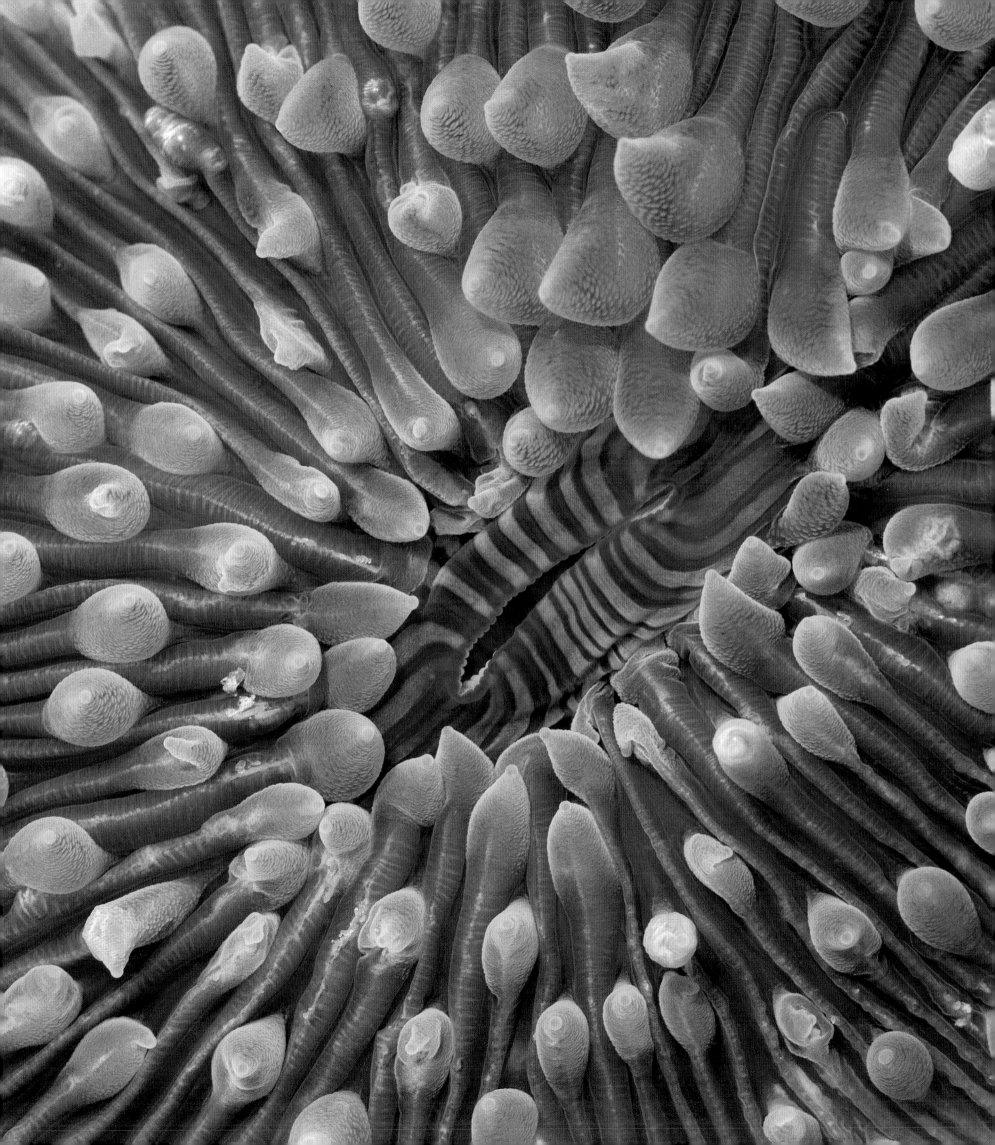

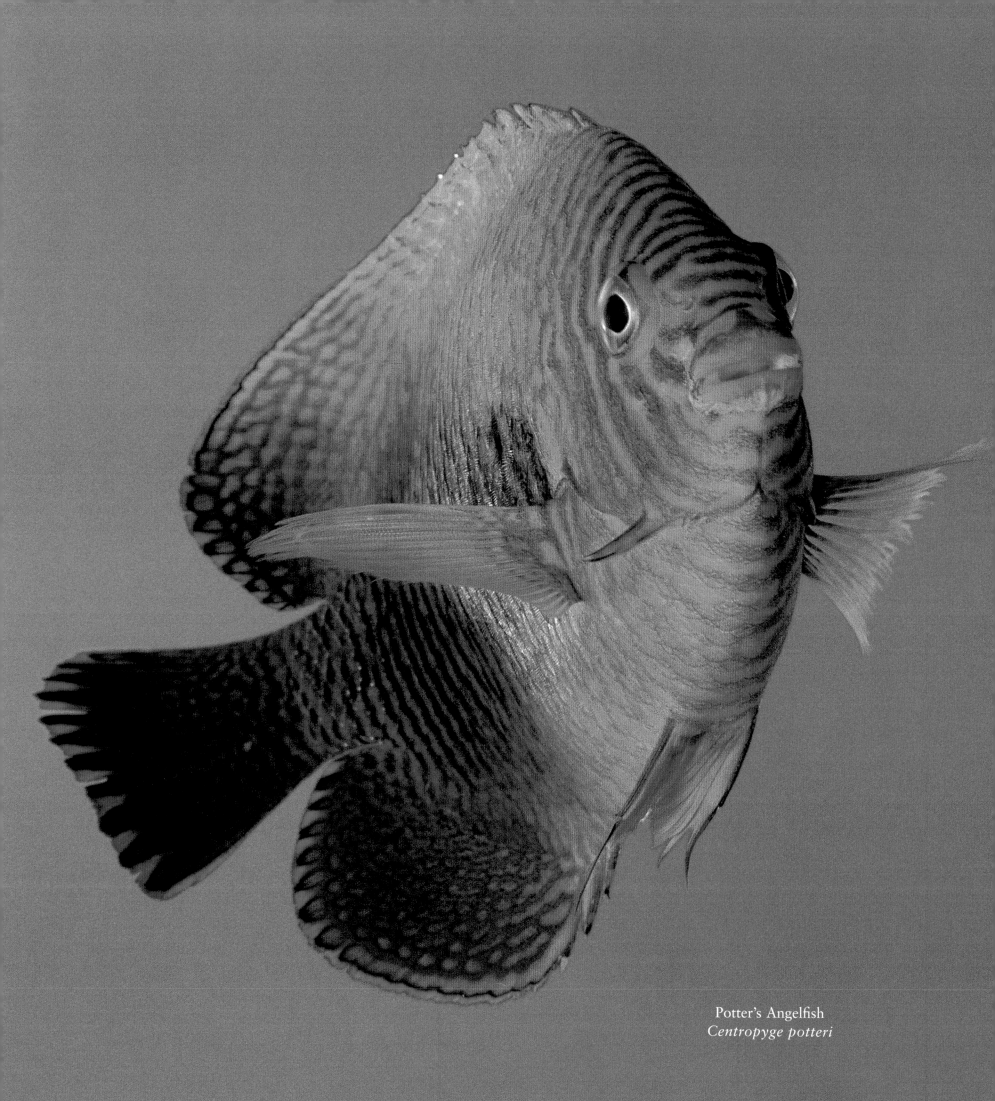

Potter's Angelfish
Centropyge potteri

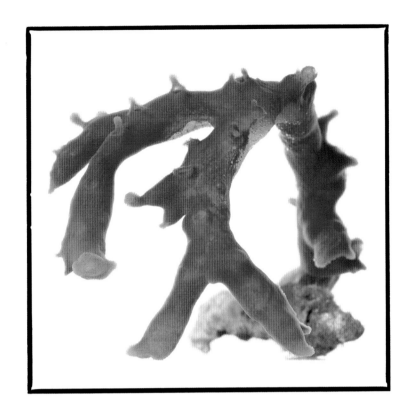

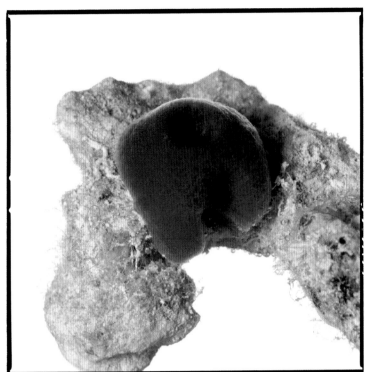

Tube Sponge ~ ʻupi, huʻe huʻekai
Phylum *Porifera*

Purple Sponge ~ ʻupi, huʻe huʻekai
Phylum *Porifera*

Boring Sponge ~ ʻupi, huʻe huʻekai
Phylum *Porifera*

Fire Sponge ~ ʻupi, huʻe huʻekai
Phylum *Porifera*

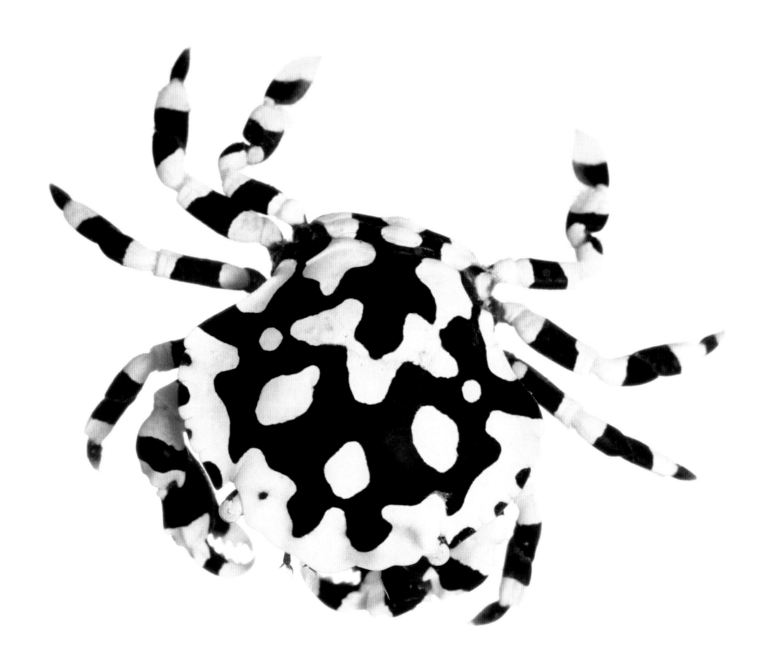

Harlequin Crab
Lissocarcinus orbicularis

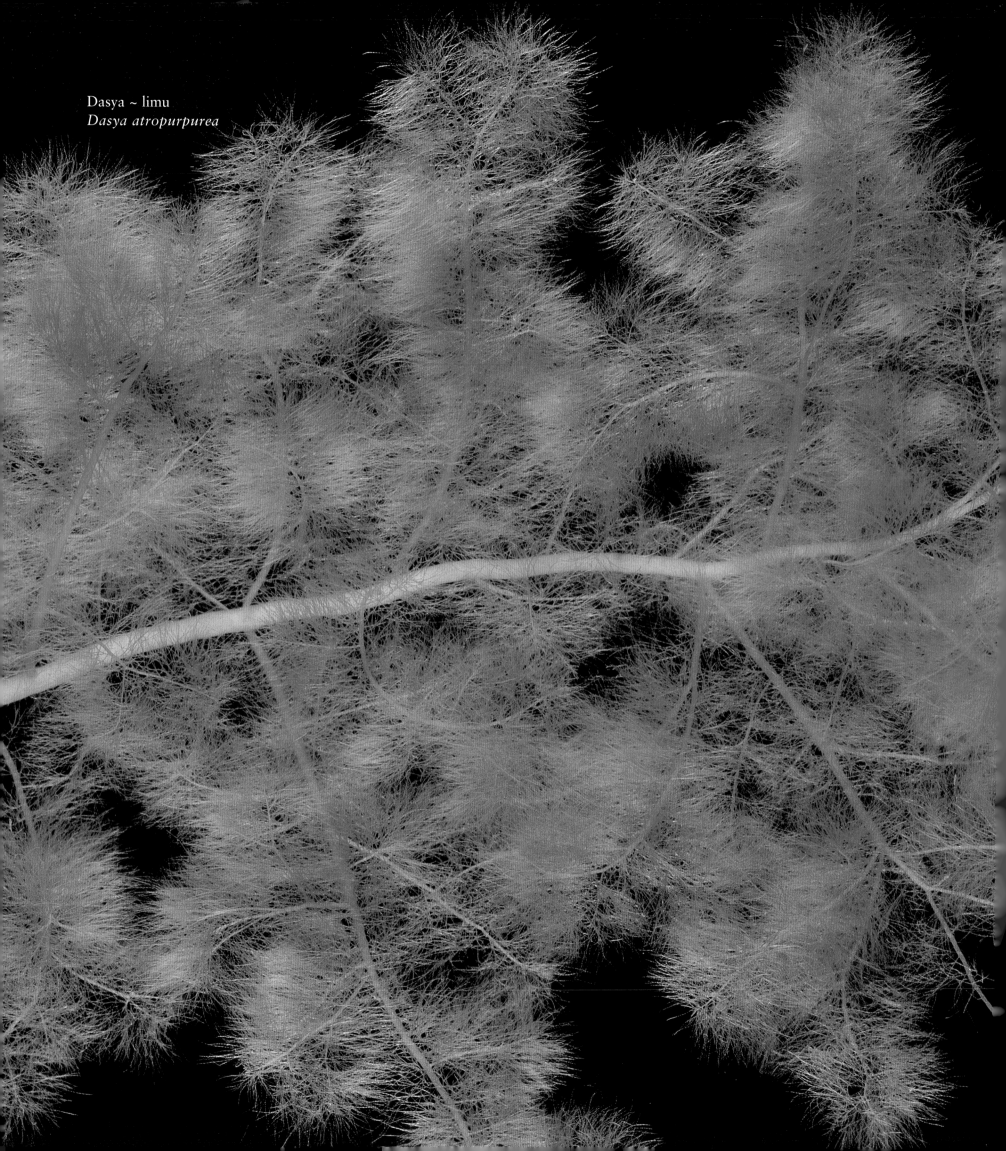

Dasya ~ limu
Dasya atropurpurea

Red Algae ~ limu
Plocamium sandvicense or *Portieria hornemannii*

Brainard's Red ~ limu
Acrosymphyton brainardii

Kallymenia ~ limu
Kallymenia thompsonii

Gibsmithia ~ limu
Gibsmithia hawaiiensis

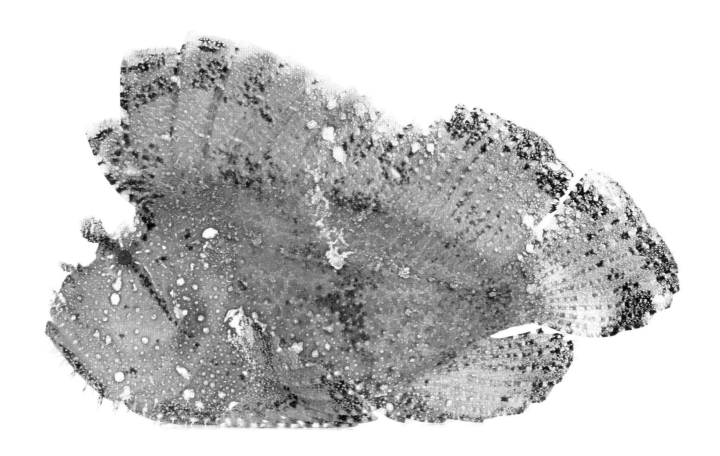

Leaf Scorpionfish
Taenianotus triacanthus
(three color phases)

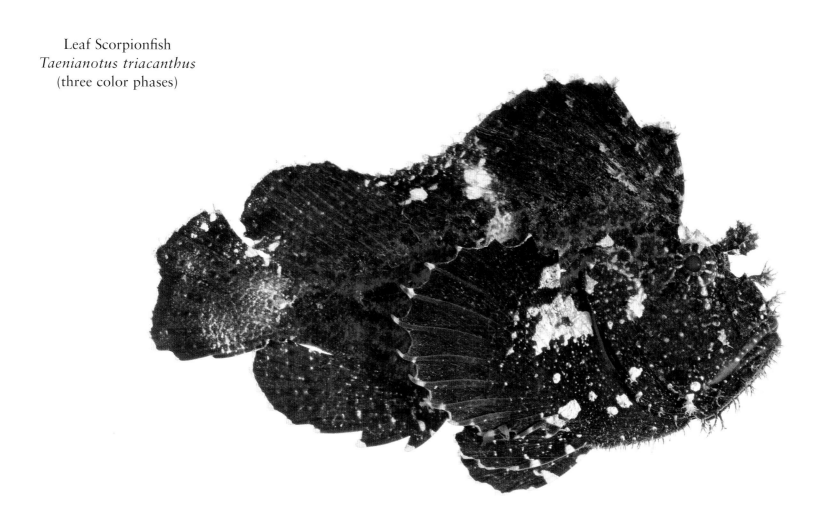

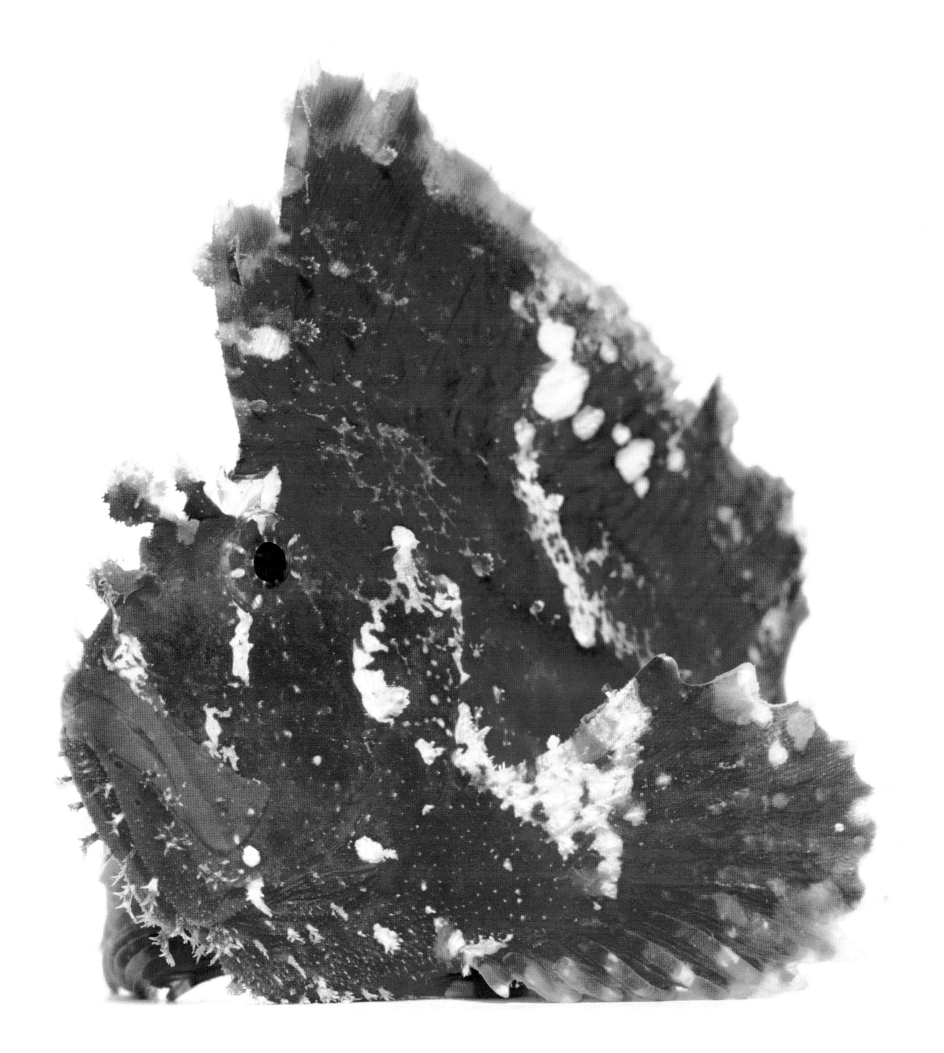

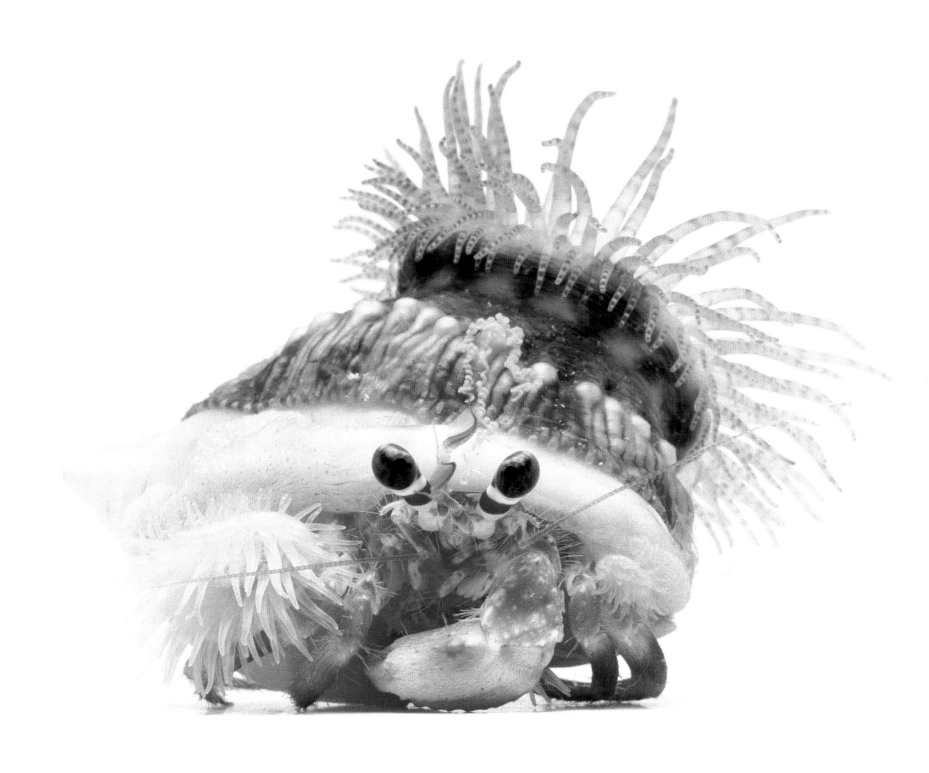

Pale Anemone Crab ~ unauna
Dardanus deformis

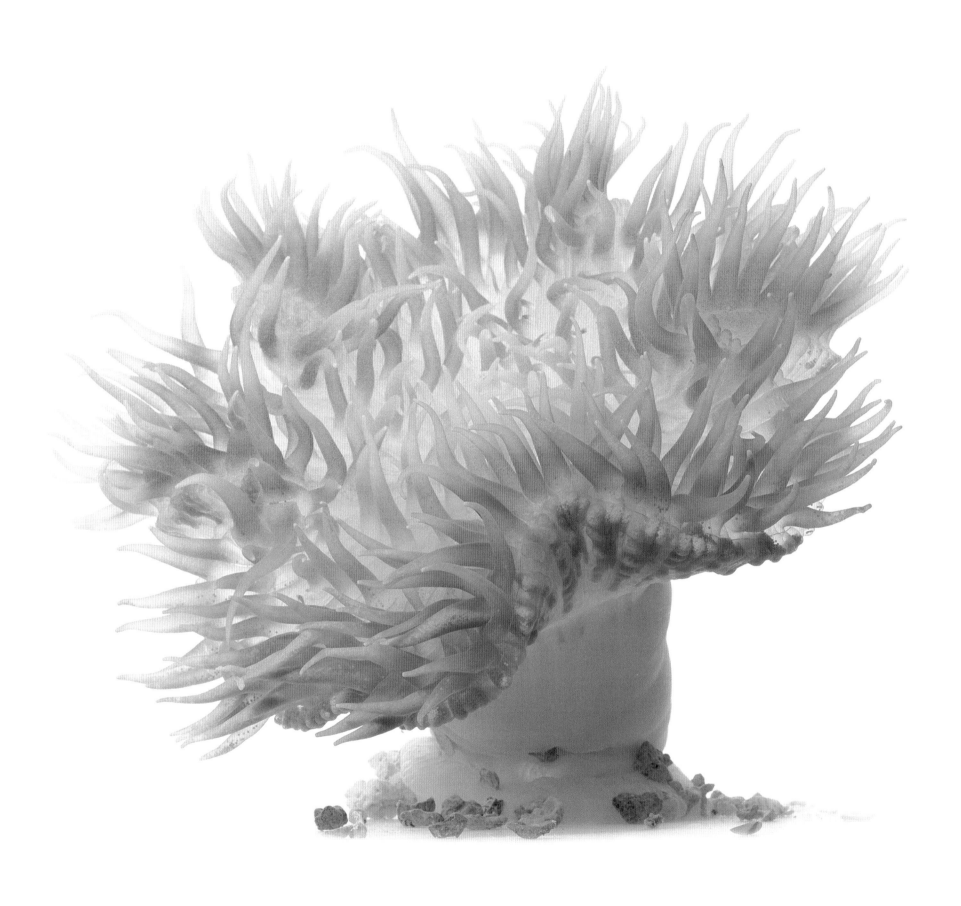

Sand Anemone ~ ʻokole, ʻokole emiemi
Heteractis malu

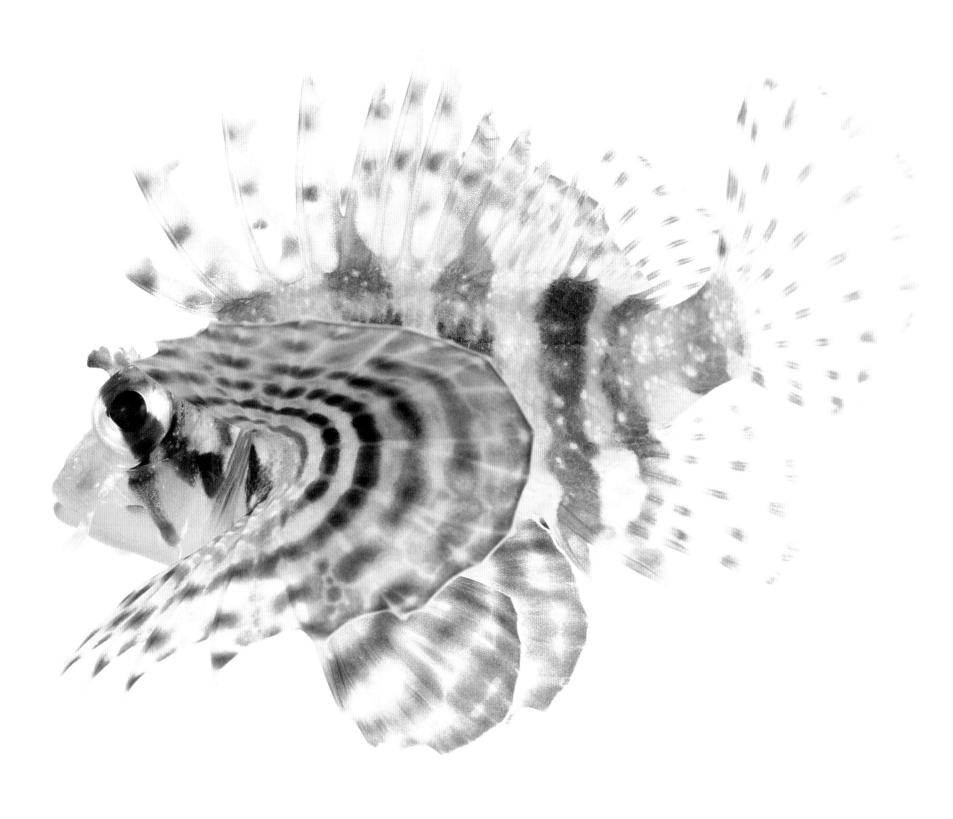

Green Lionfish ~ nohu
Dendrochirus barberi

Hawaiian Lionfish ~ nohu pinao
Pterois sphex

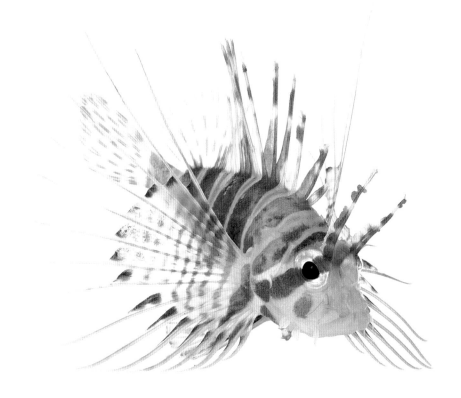

Redbanded Hawkfish ~ piliko'a
Cirrhitops fasciatus

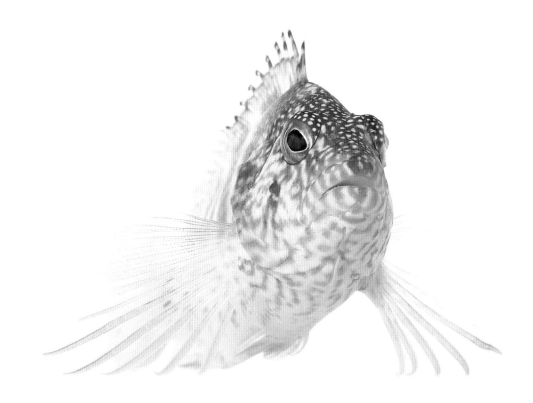

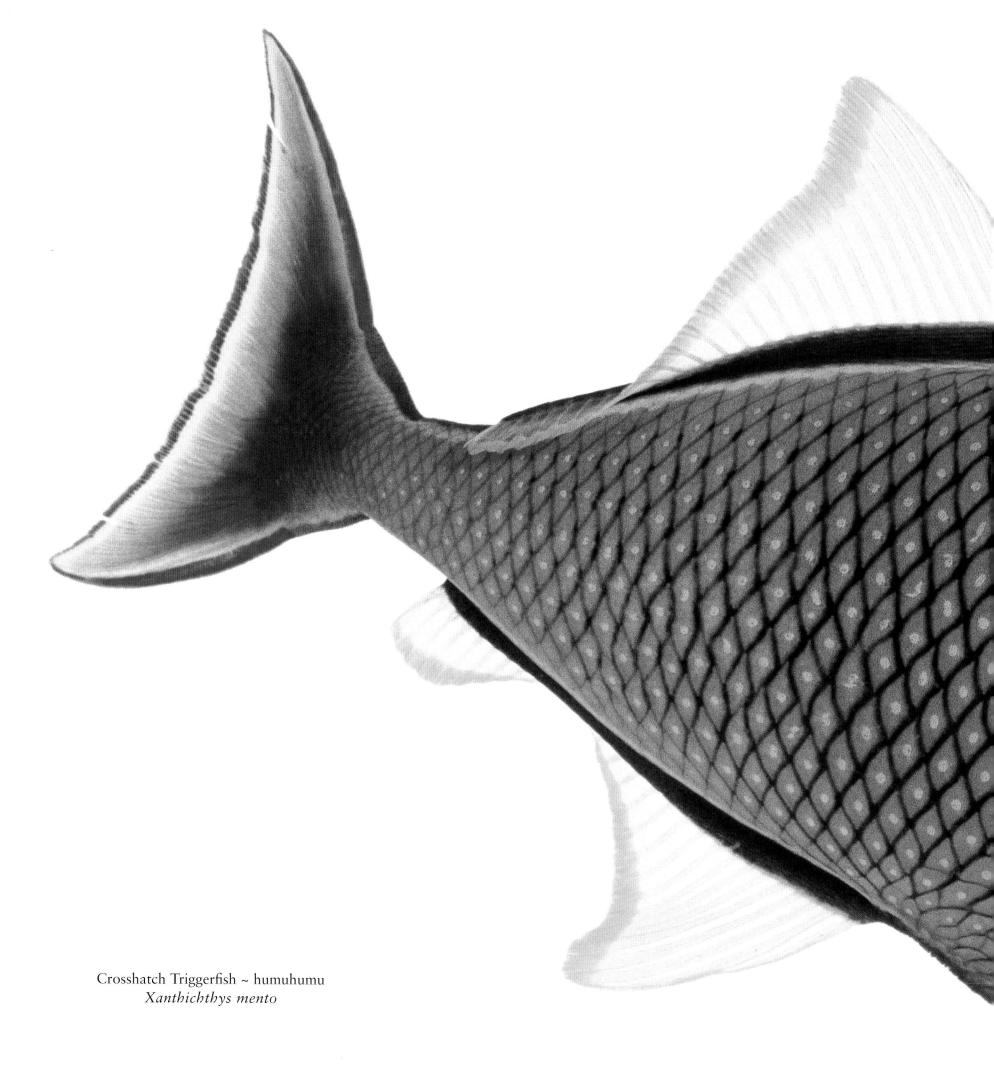

Crosshatch Triggerfish ~ humuhumu
Xanthichthys mento

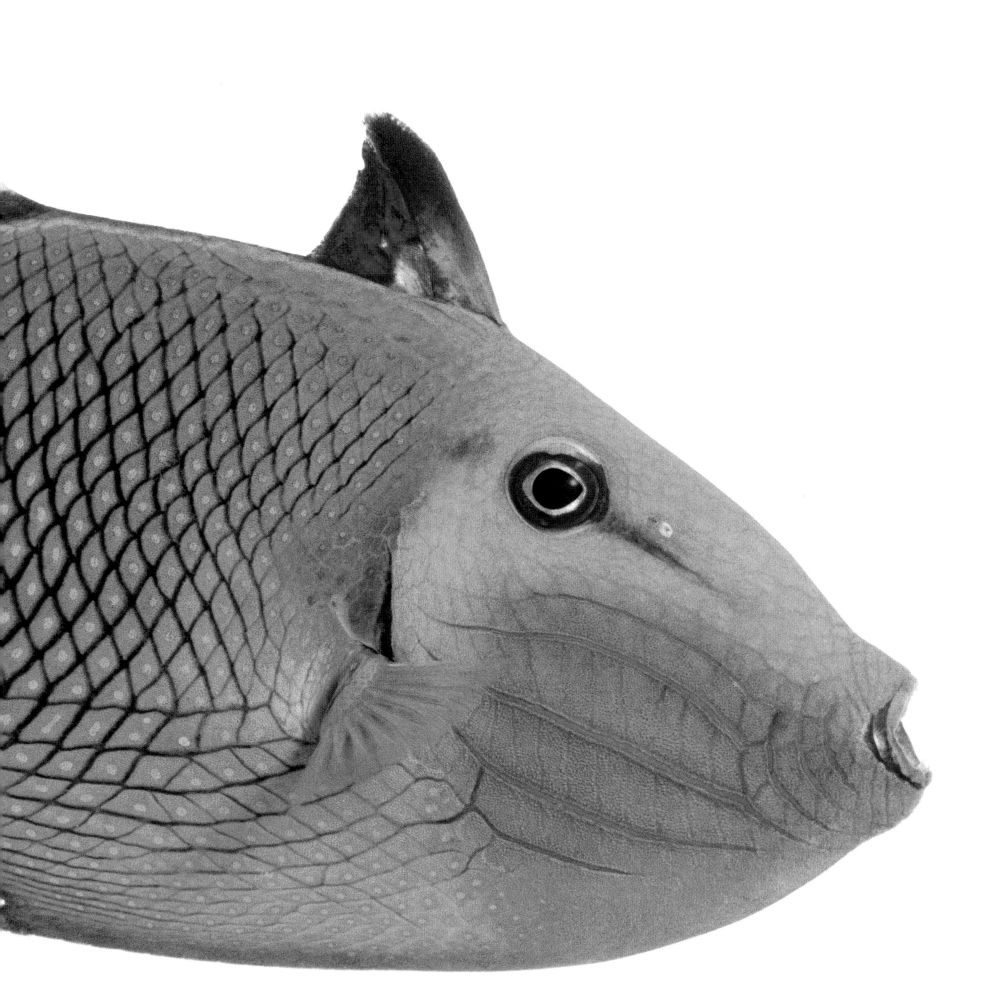

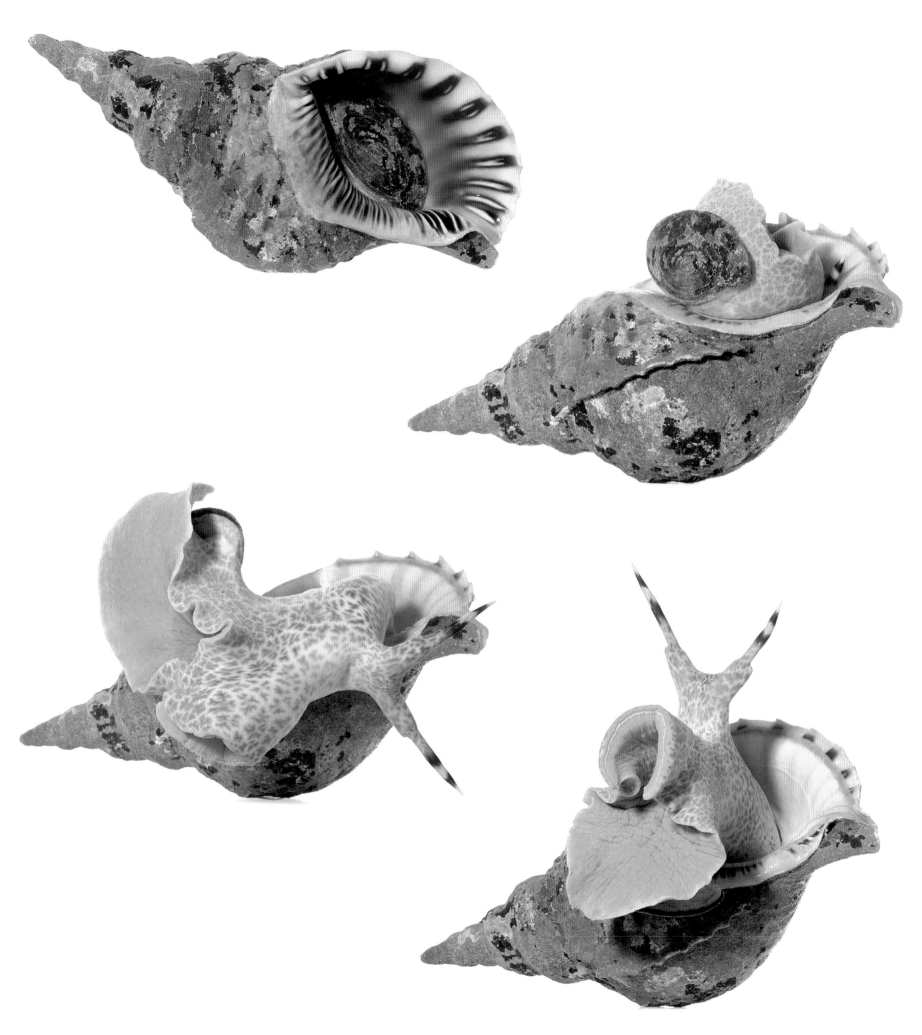

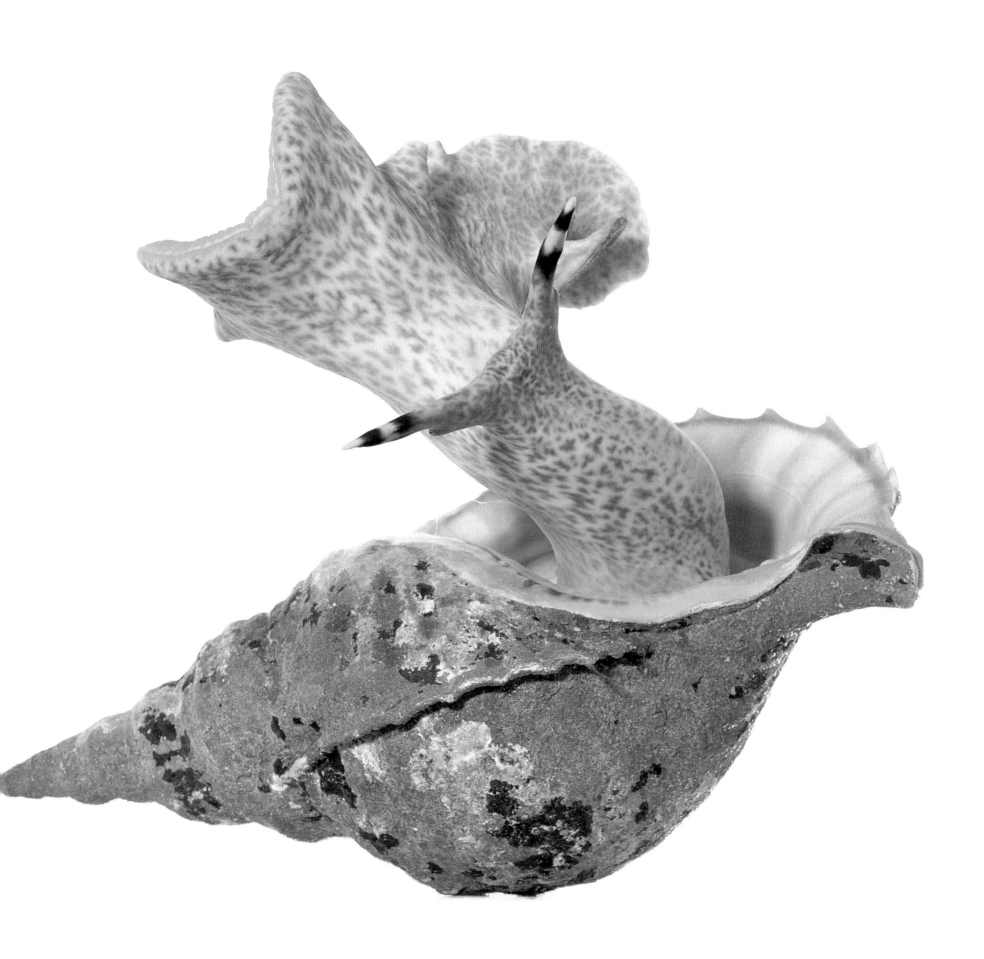

Triton's Trumpet ~ pū, ʻolē,
Charonia tritonis

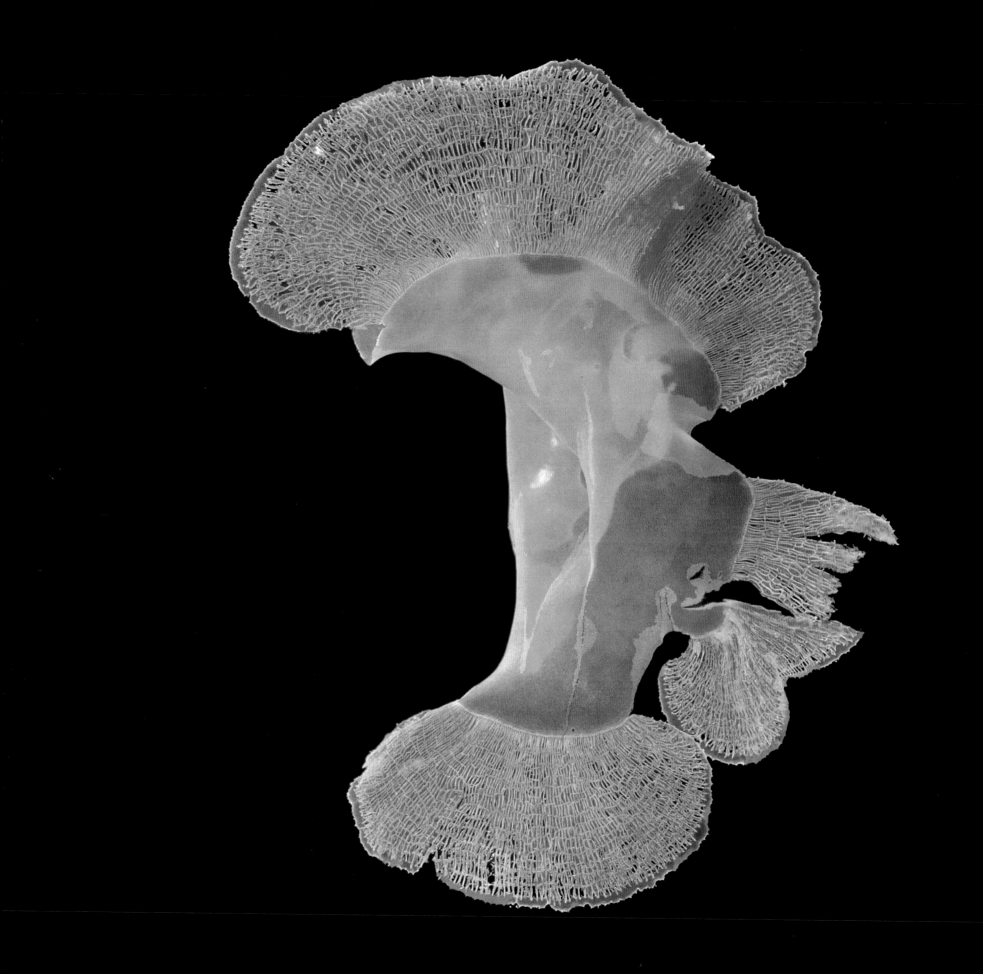

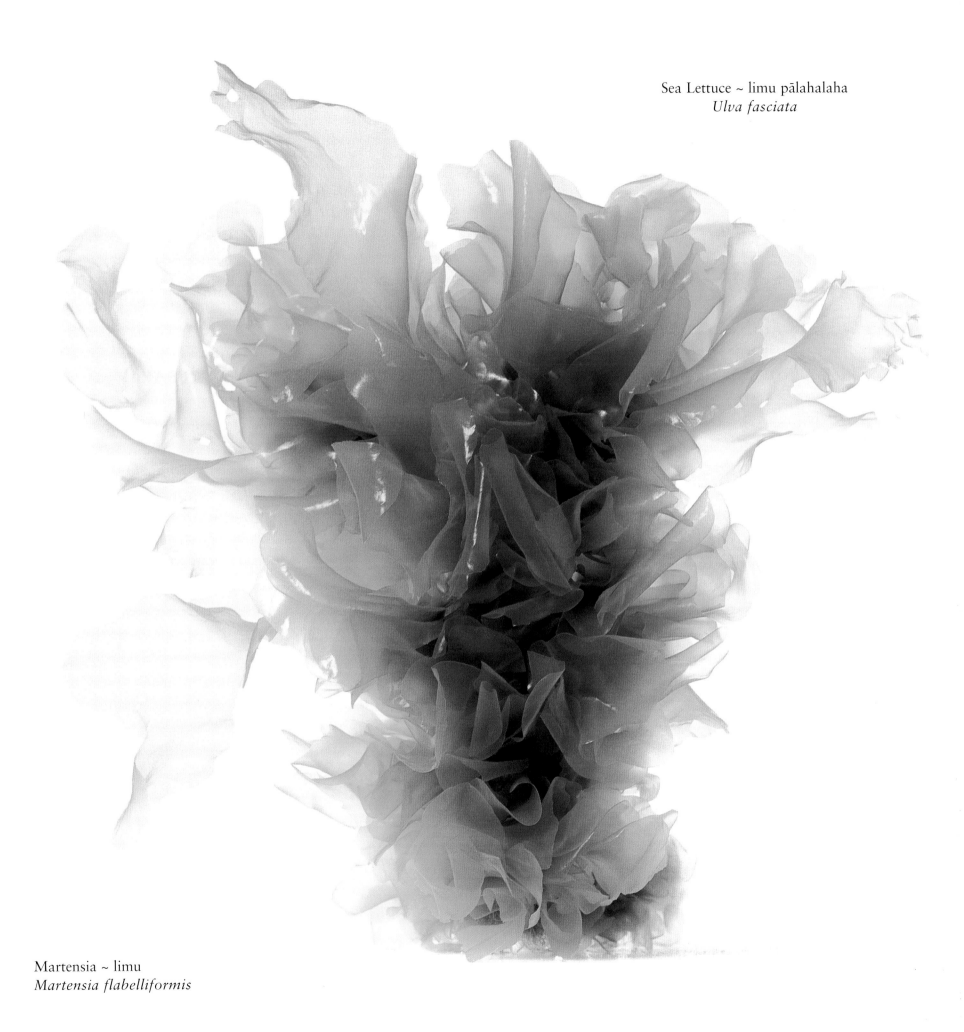

Sea Lettuce ~ limu pālahalaha
Ulva fasciata

Martensia ~ limu
Martensia flabelliformis

Bandit Angelfish
Apolemichthys arcuatus

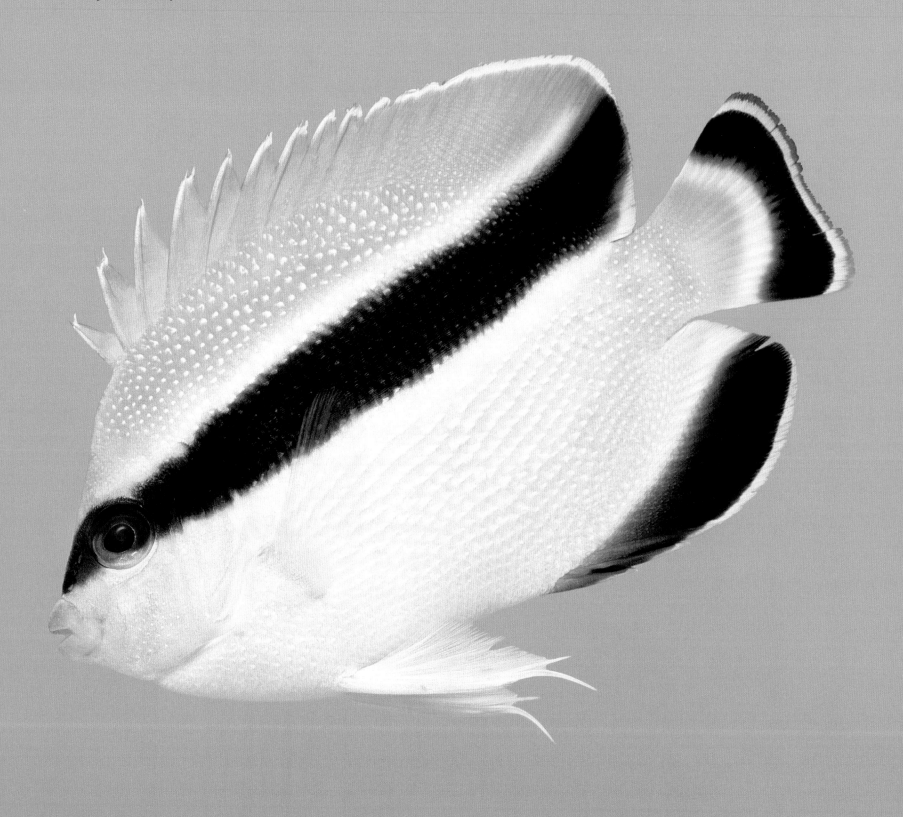

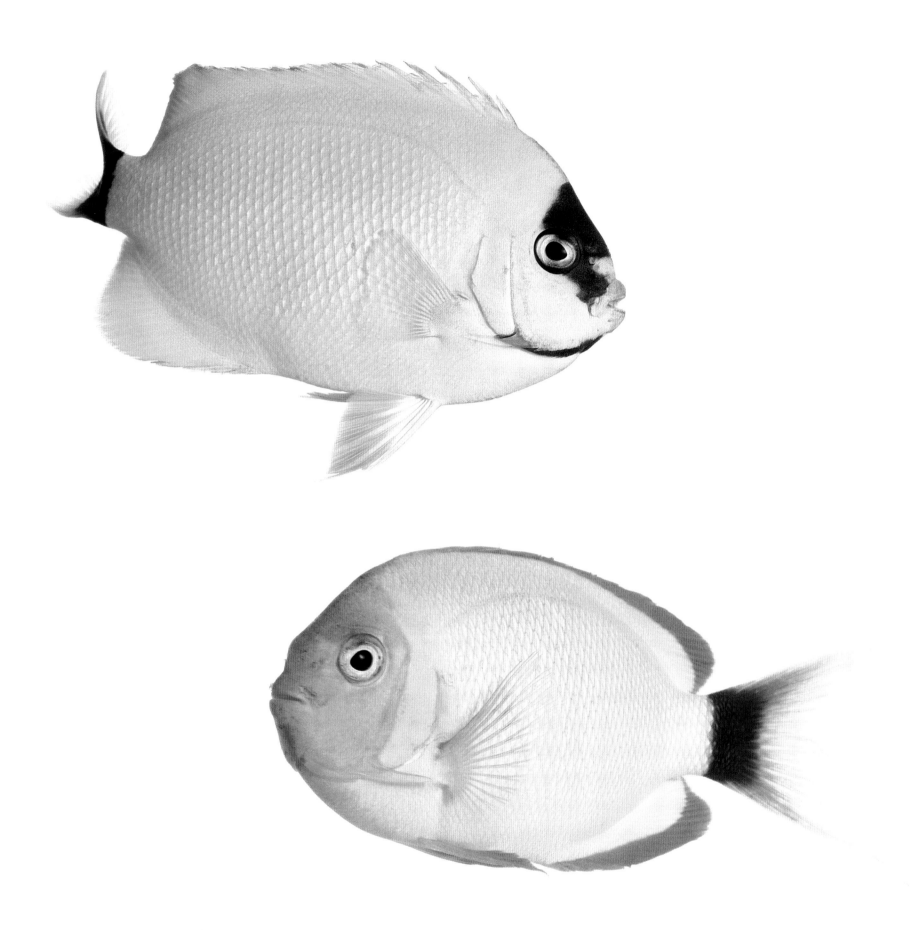

Masked Angelfish
Genicanthus personatus
(female above, male below)

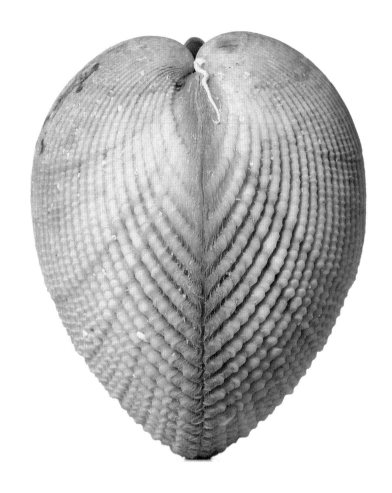

Rounded Cockle ~ ʻōlepe kupe, pūpū kupa
Trachycardium orbita

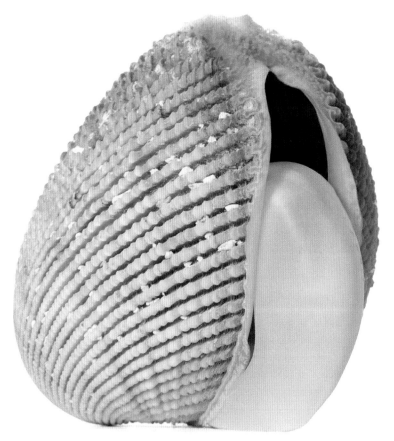

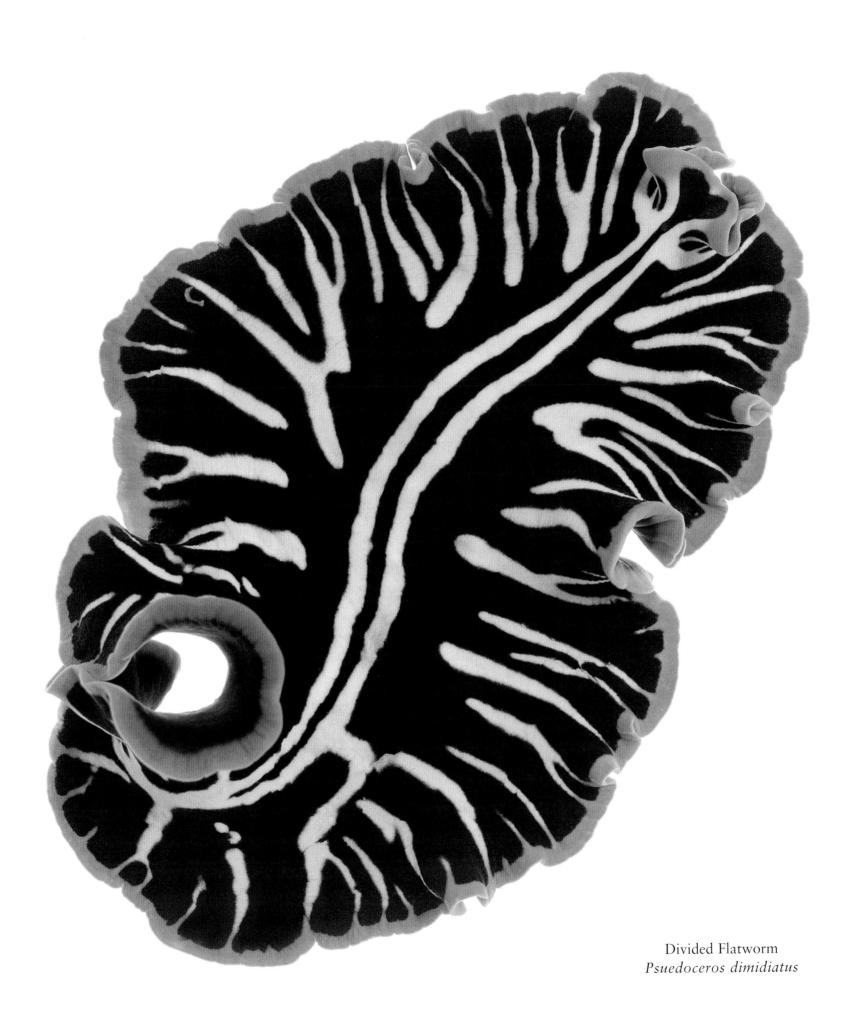

Divided Flatworm
Psuedoceros dimidiatus

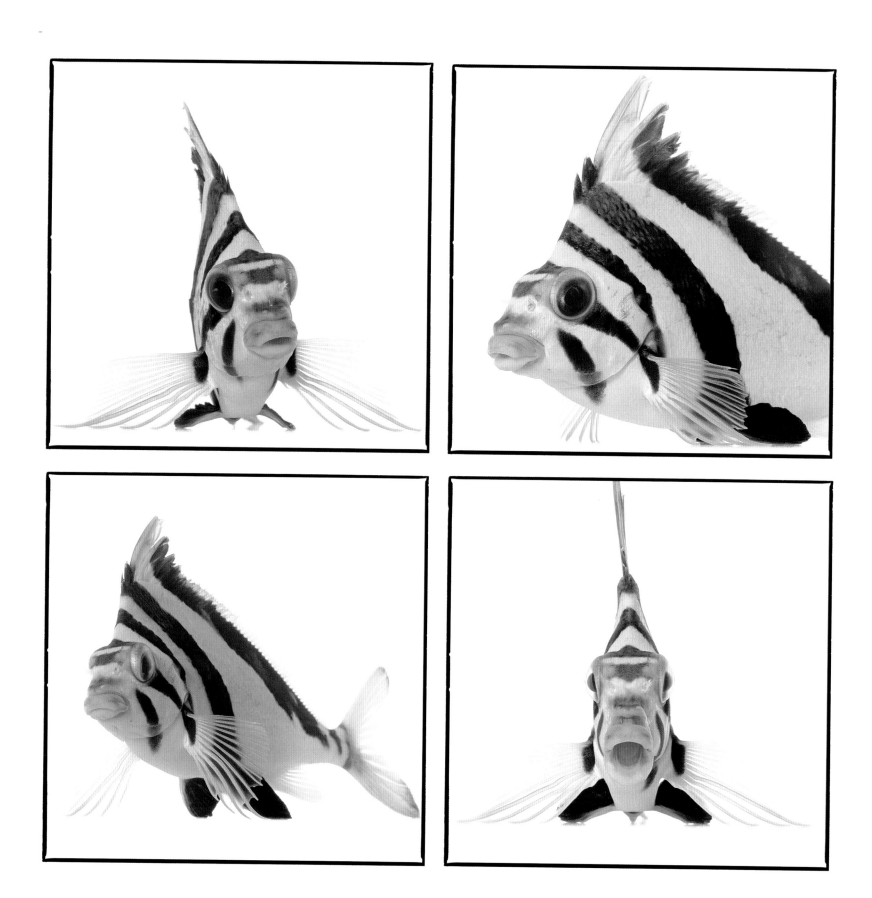

Hawaiian Morwong ~ kikākapu
Goniistius vittatus

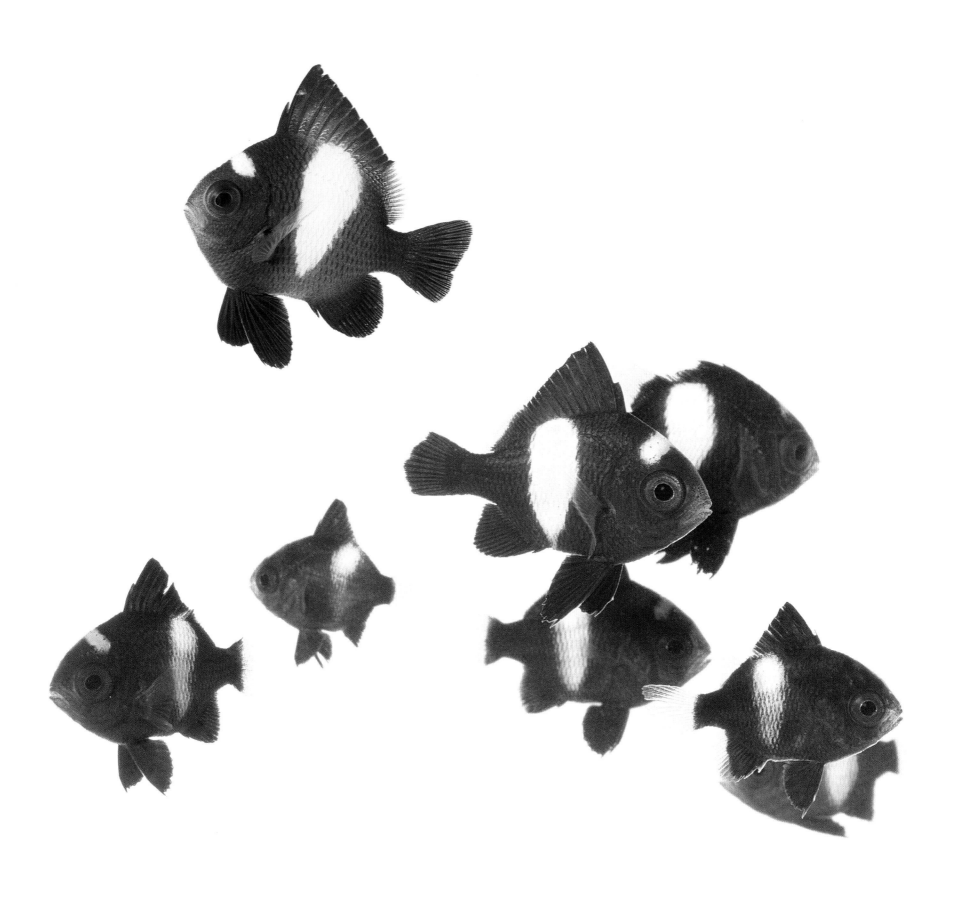

Hawaiian Domino Damselfish ~ ʻā or ʻaʻā (juvenile), ʻaloʻiloʻi (adult)
Dascyllus albisella

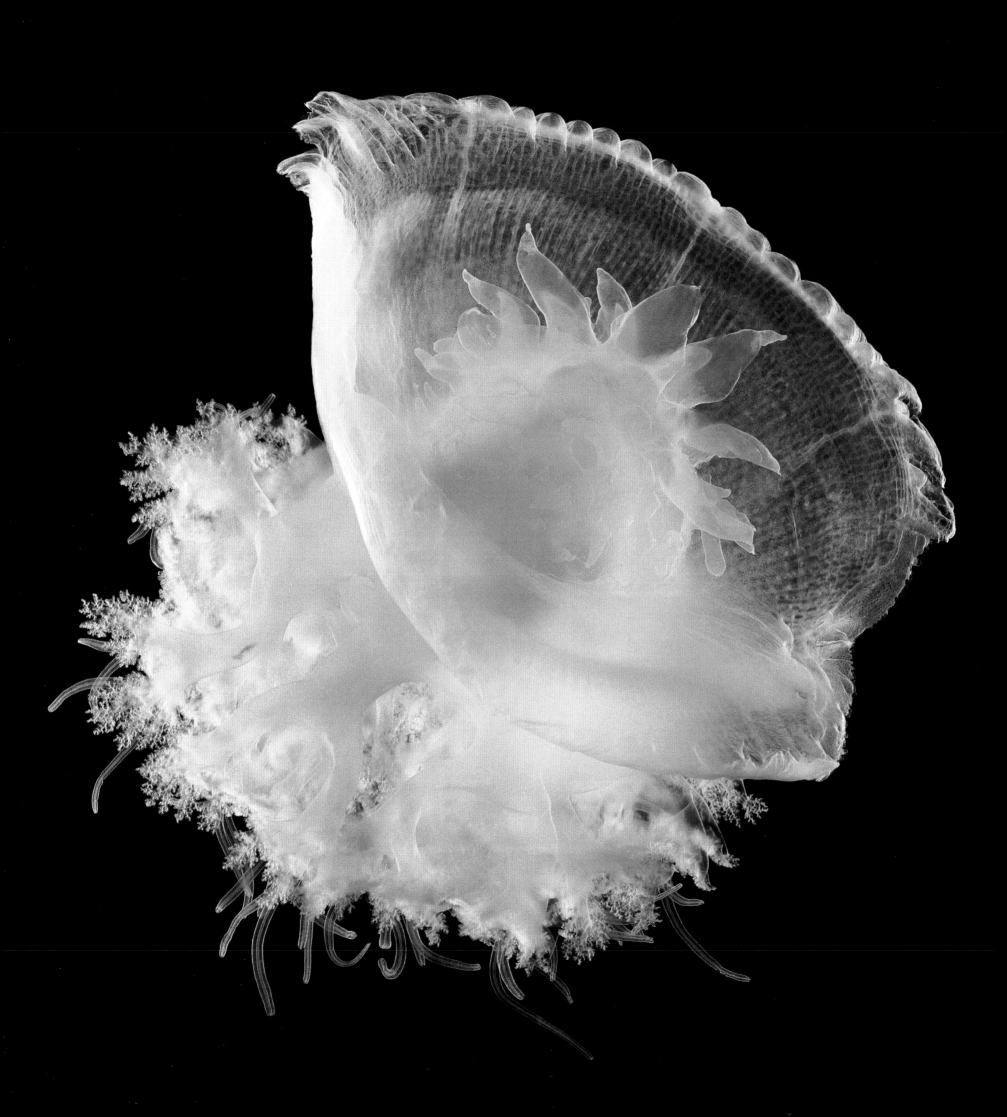

Keeled Heart Urchin ~ hāwaʻe
Brissus latecarinatus

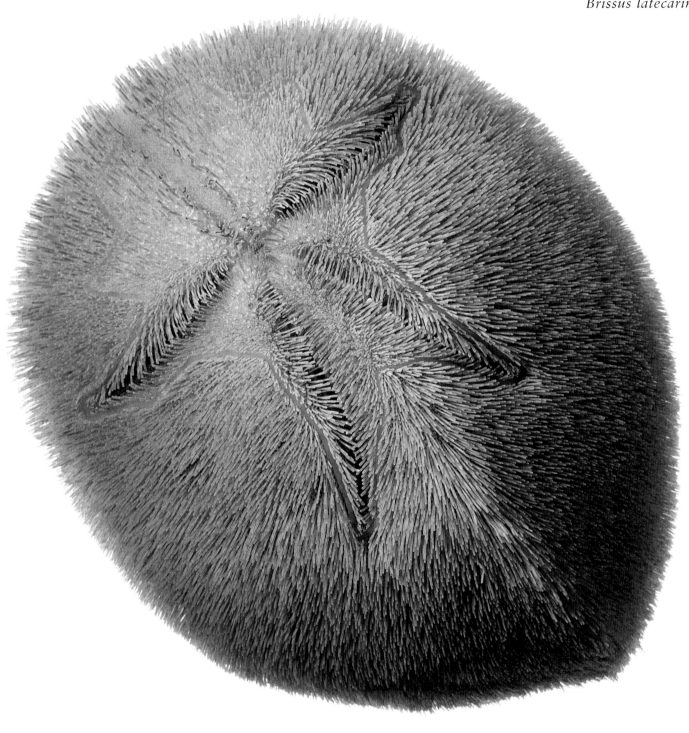

Crowned Jellyfish
Cephea cephea

Shortnose Wrasse ~ hinālea
Macropharyngodon geoffroy

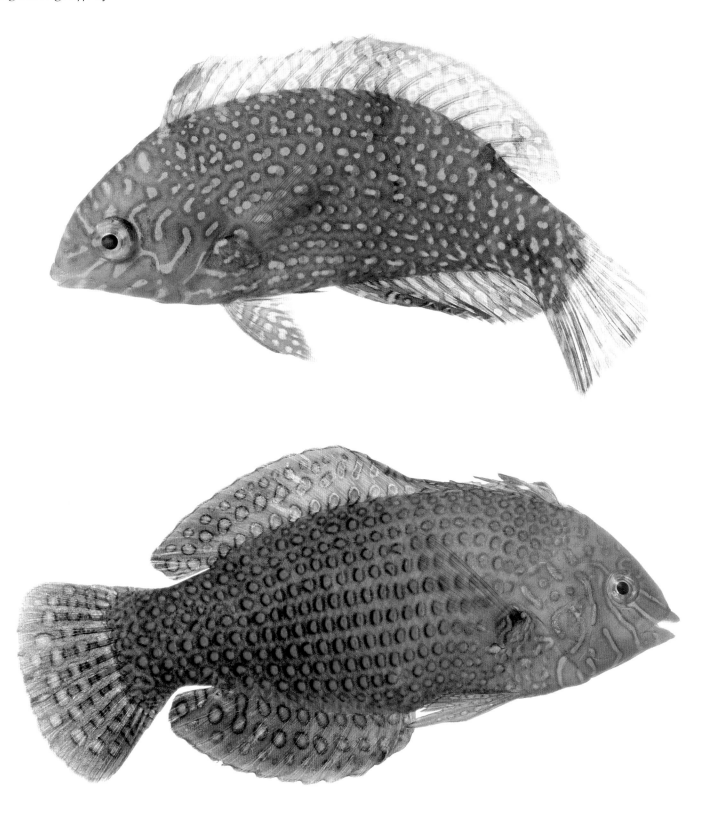

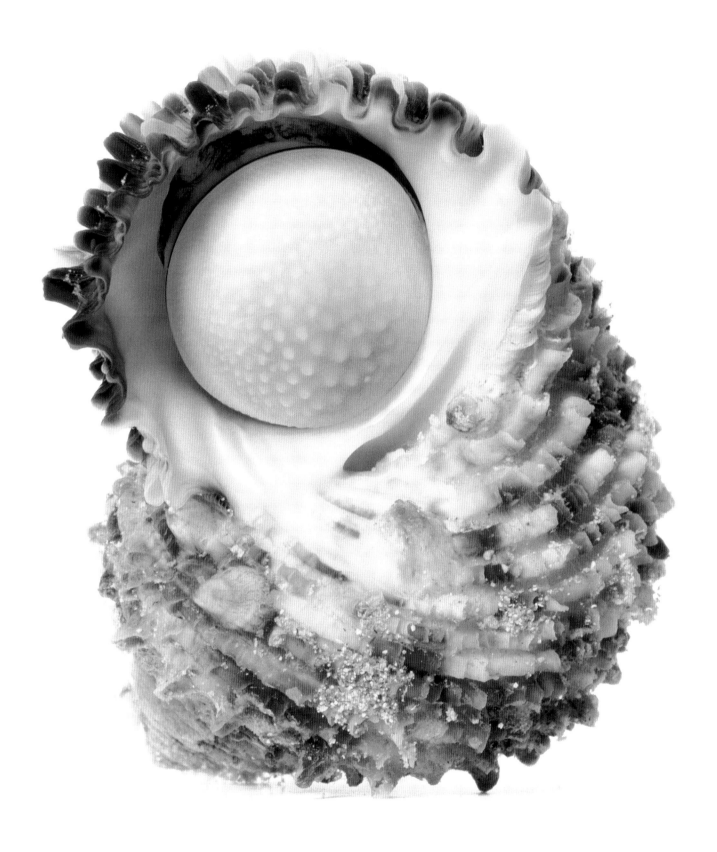

Hawaiian Turban Snail ~ ʻalīlea, pūpū mahina
Turbo sandwicensis

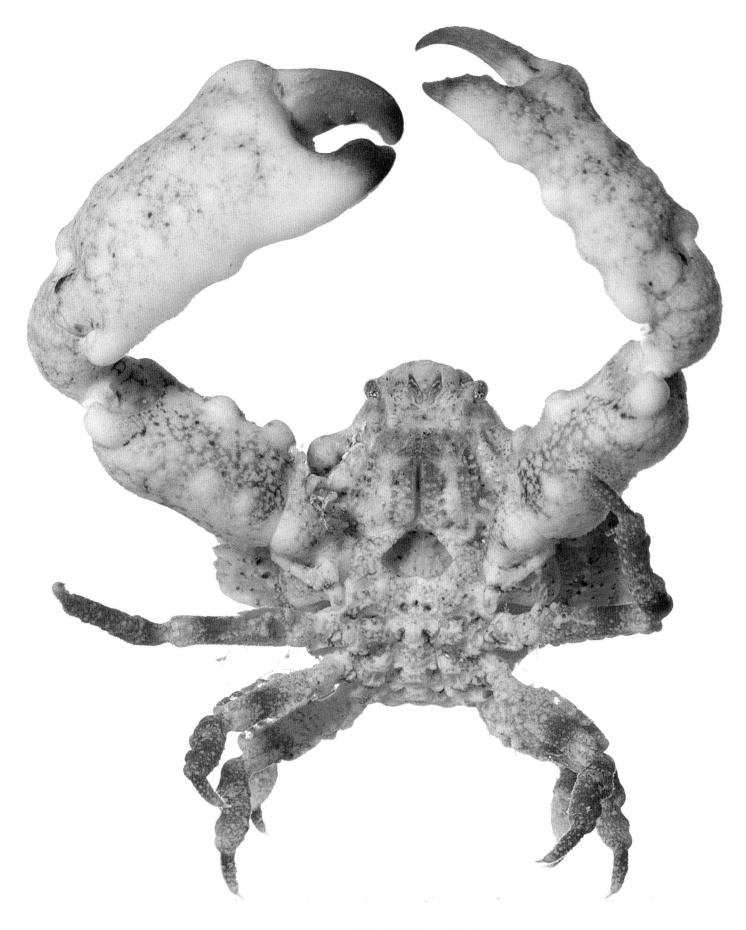

Horrid Elbow Crab
Daldorfia horrida

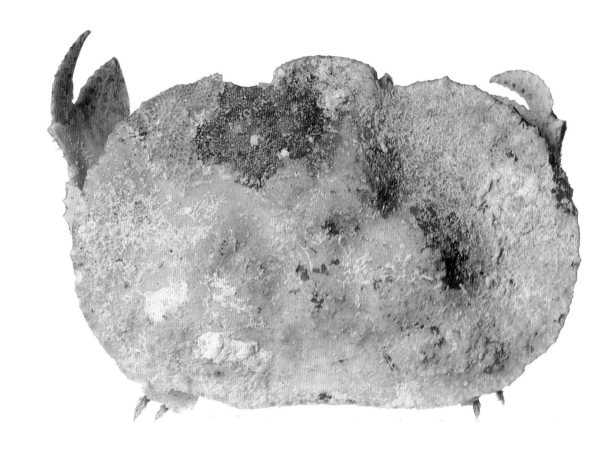

Flat Elbow Crab
Aethra edentata

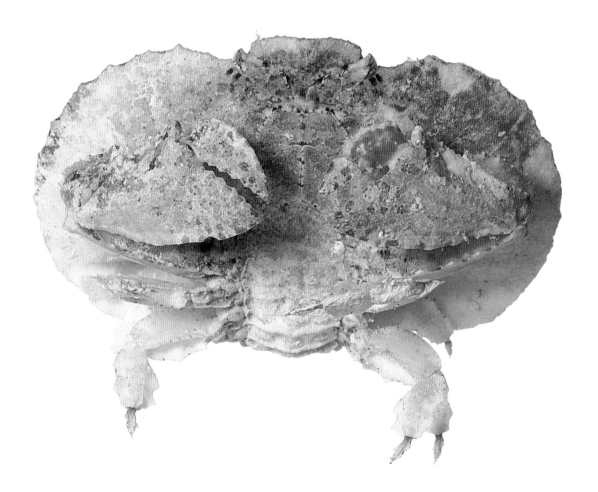

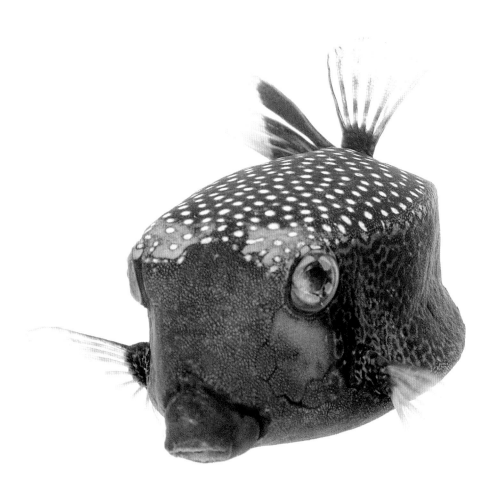

Spotted Boxfish ~ moa, pahu
Ostracion meleagris camurum
(male above, female below)

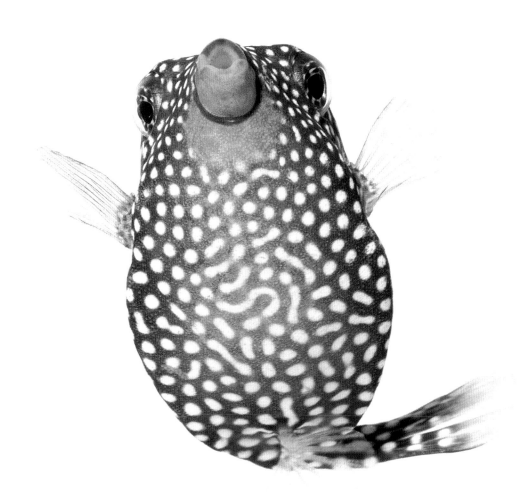

Spoon Worm
Phylum *Echiura* (likely *Ochetostoma* cf. *erythrogrammon*)

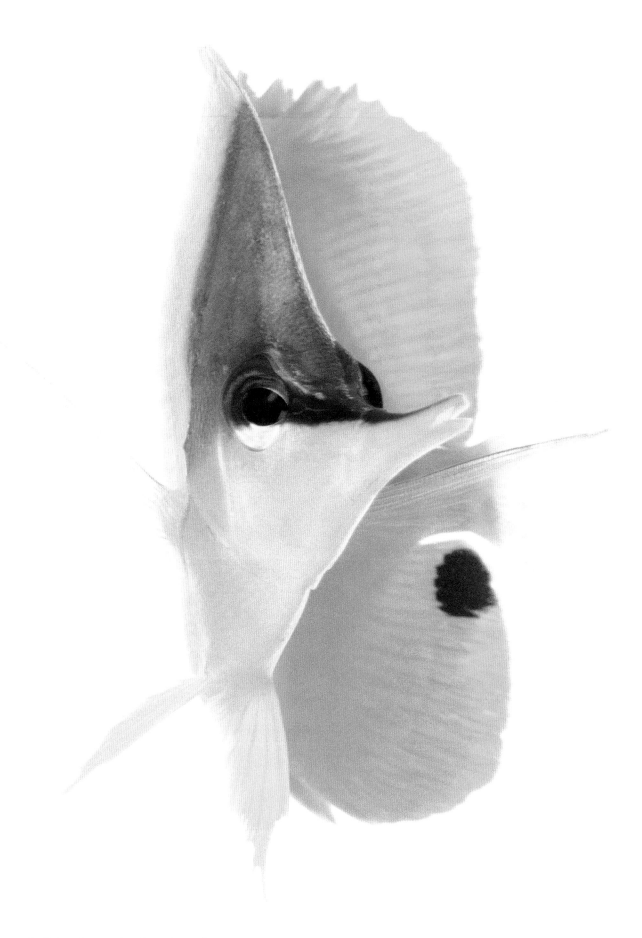

Common Longnose Butterflyfish ~ lau-wiliwili-nukunuku-oiʻoi
Forcipiger flavissimus

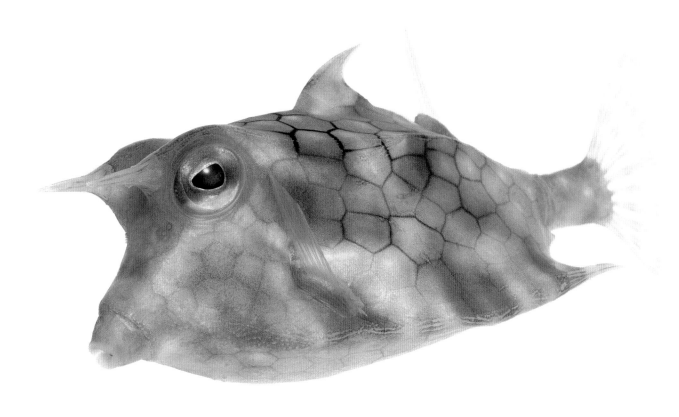

Thornback Cowfish ~ makukana
Lactoria fornasini

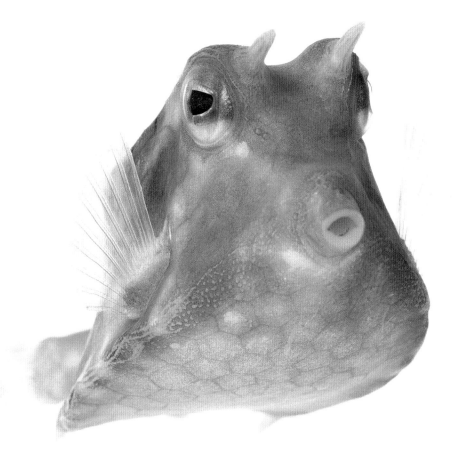

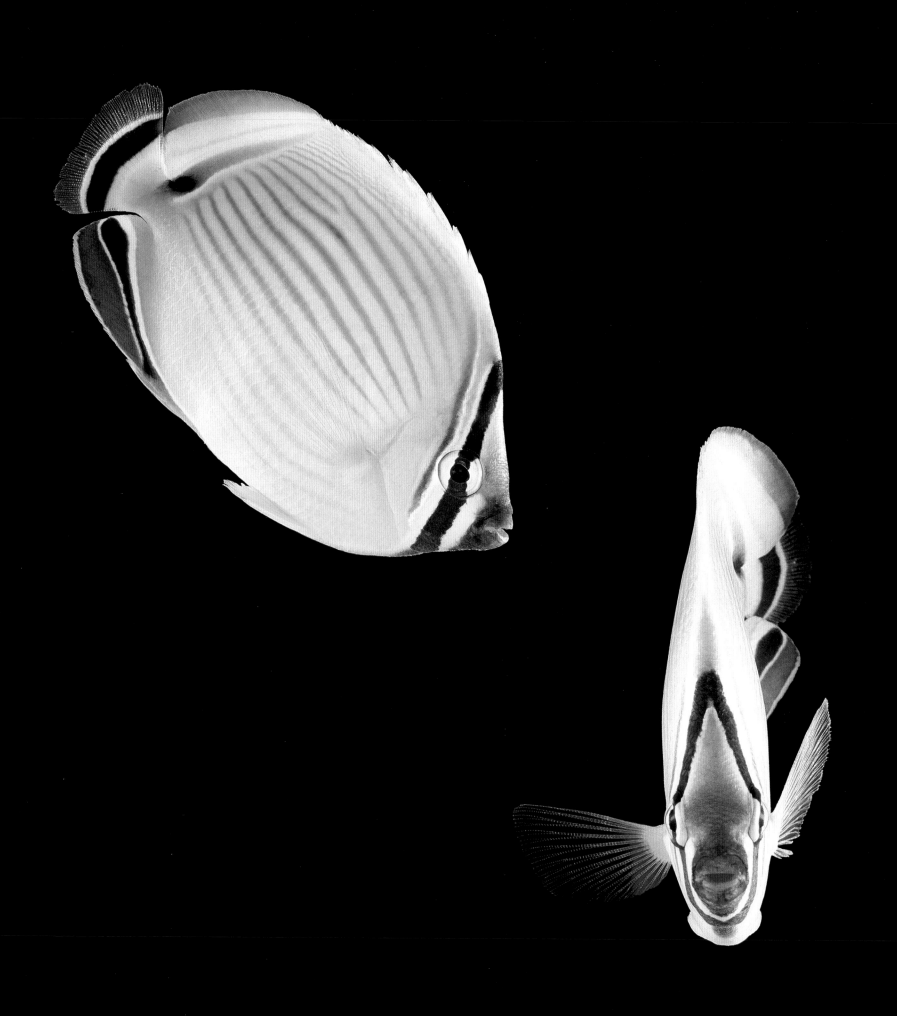

Oval Butterflyfish ~ kapuhili
Chaetodon lunulatus

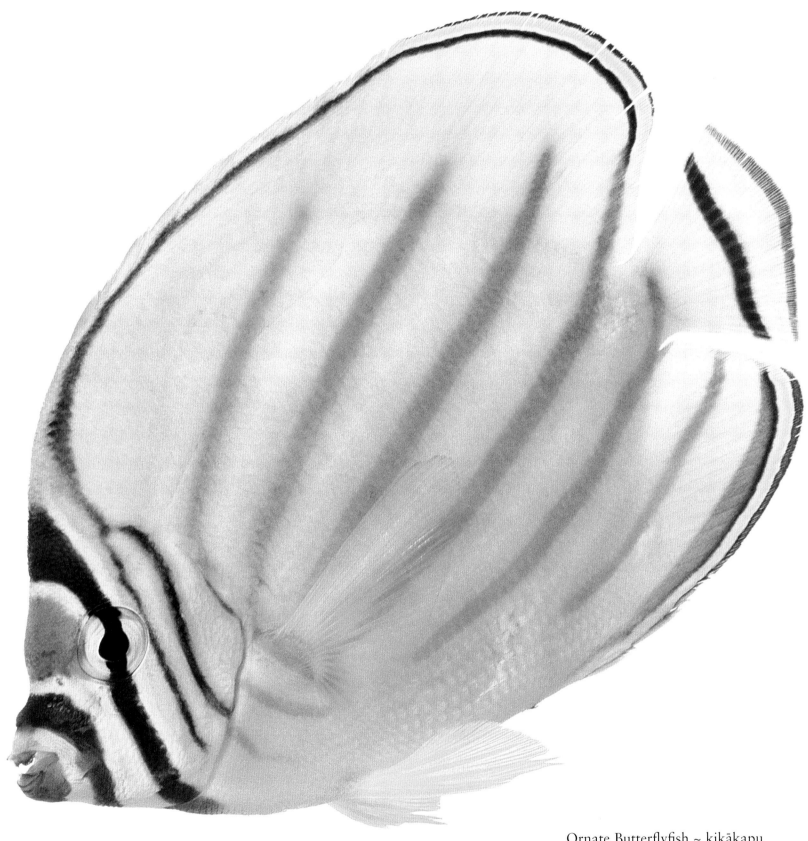

Ornate Butterflyfish ~ kikākapu
Chaetodon ornatissimus

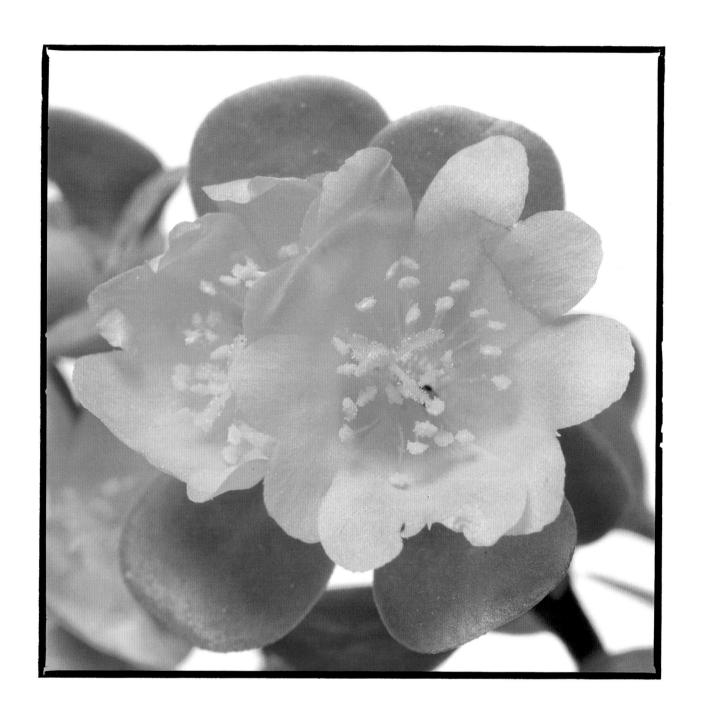

Portulaca ~ ʻihi
Portulaca lutea

Nihoa Island

23°03'N, 161°56'W

Mokumanamana

23°35'N, 164°42'W

by David Liittschwager

Nihoa appears on the horizon as a 900-foot-tall rock rising straight up out of the ocean. The chief bosun of the ship we sailed on called it "King Kong." Visitors to Nihoa need a special-use permit issued by the United States Fish and Wildlife Service (USFWS); this permit is required to visit all the Northwestern Hawaiian Islands except for Kure, where permission must be granted by the State of Hawai'i. Even NOAA needs permission from the USFWS to land, in order to ensure that biological quarantine procedures are followed, and to reduce the risk of physical damage to wildlife habitat.

Landing at Nihoa, or its neighboring island Mokumanamana (also known as Necker Island), is only possible about 50 percent of the time, due to sparse landing sites and difficult conditions—primarily a function of the height and direction of the swell. Since neither island has a fringing reef to protect it, the swell crashes relentlessly onto the rock, with the surge wrapping around the lee. Surveys can be scheduled, ships can be chartered, but if the conditions are not favorable, work may have to be postponed or cancelled altogether.

En route from Laysan to Honolulu, aboard the NOAA ship *Townsend Cromwell* in 1999, the swell was in our favor and we managed to land at Nihoa with our USFWS escort. We hiked to the summit, spotting the island's two endemic songbirds along the way, the Nihoa millerbird and the Nihoa finch. These birds are found nowhere else on Earth, not even in captivity. I also saw the most impressive intact community of native Hawaiian coastal plants, seedlings seemingly in the millions, particularly ohai (*Sesbania tomentosa*). A federally listed endangered species, ohai has become very rare on the main Hawaiian Islands, where its numbers are counted in terms of dozens of individuals, and, on certain islands, single remaining populations. Here on Nihoa, thriving ohai appeared in abundance—an amazing sight.

On my second trip to Nihoa in 2003, everywhere I looked I saw signs of devastation. A plague of grasshoppers, *Schistocerca nitens,* is consuming the plants on this island, and all the vegetation I saw had been chewed, with leaves either stripped or severely damaged. This situation poses a very real threat to the many endangered and endemic species of plants, insects, and birds on Nihoa.

Ohai
Sesbania tomentosa

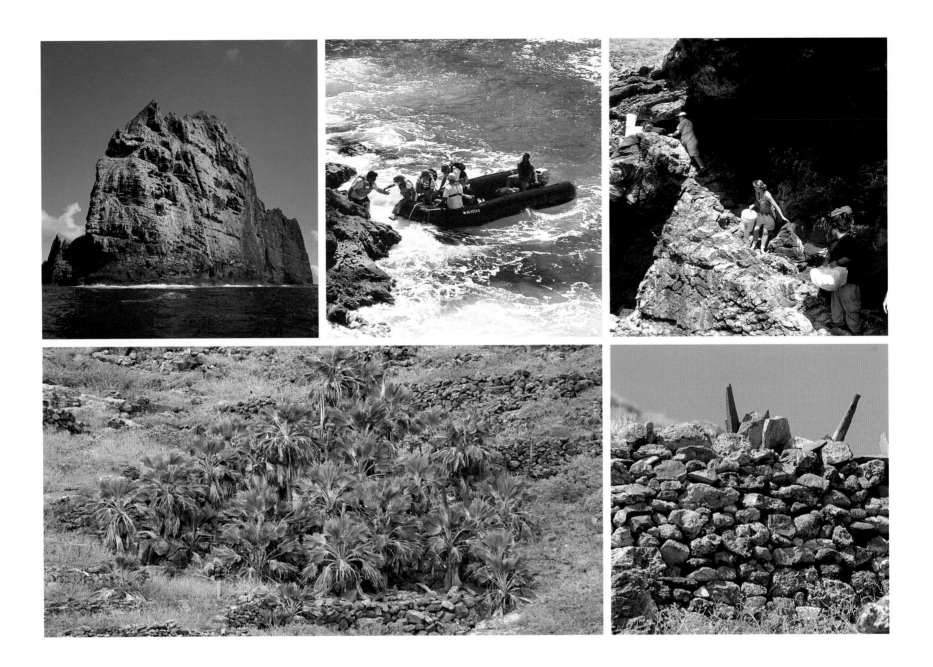

These voracious grasshoppers, aided by the wind, probably flew to Nihoa from Kaua'i, 150 miles away; they were originally introduced to Kaua'i by humans. The recent outbreak likely results from five years of drought followed by heavy rains; a dry/wet cycle that favors grasshopper biology can produce hundredfold increases within single generations. In one year, populations can expand significantly, particularly without the limiting factors that diminish the species elsewhere. The worst-case scenario for this outbreak? With continued loss of vegetation, the soil-moisture equilibrium may change Nihoa's ecology. Eradication is not possible; simply put, anything that could kill all the grasshoppers could destroy the natives as well. And even if the grasshoppers were eliminated locally, an ill wind from Kaua'i could deliver yet another infestation.

In order to choose the best possible course of action, and to reliably predict the consequences of undertaking it, researchers need some very specific information. What exactly is the defoliation threat to Nihoa's plants? What is the distribution and status of the island's arthropods; what is their susceptibility to various treatment options; and what is the distribution of the

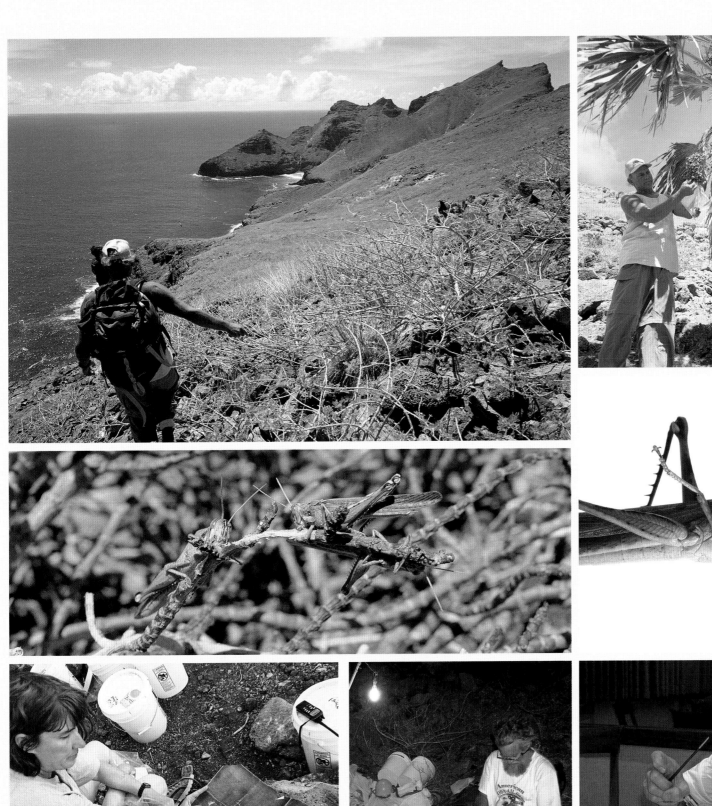
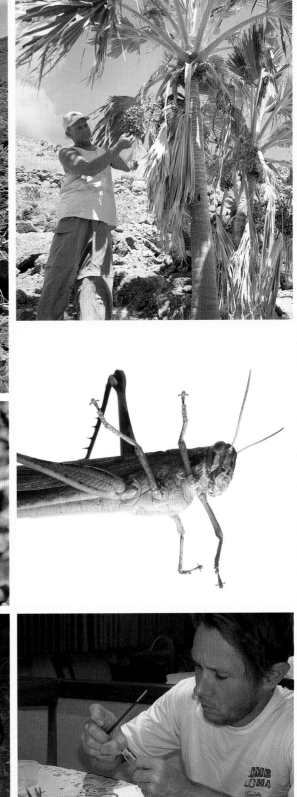
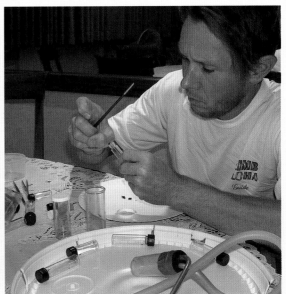

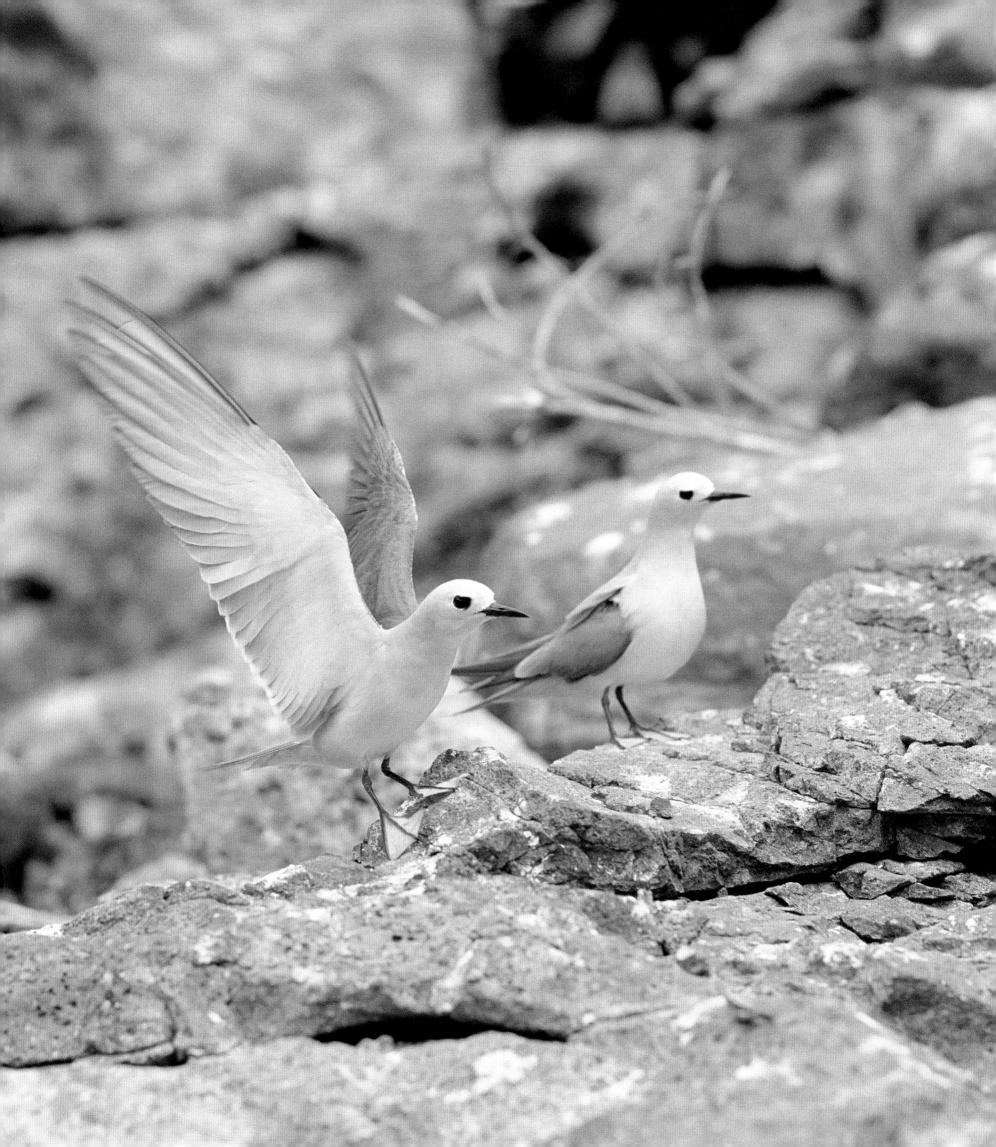

grasshoppers' eggs? Nihoa's fate lies in finding a way to slow the hoppers down, even if they can't be completely eradicated.

In 2004, Susan and I helped mount an expedition to make biological surveys of Nihoa and Mokumanamana in collaboration with the USFWS. Funding came from the National Geographic Expeditions Council as well as from the USFWS. We chartered a ship called the *Searcher,* an open-ocean research vessel operated by a private foundation that supports biological research. A sense of urgency drove the organization of the expedition. Assessment of the grasshopper damage by entomologists and botanists was very important to us. However, our main purpose was to photograph the native plants and animals. In our experience, the most interesting way to go about this is to eavesdrop on scientists while they go about their business of discovery.

To our great disappointment, the Nihoa vegetation had been so damaged by the grasshoppers that we were unable to make the kind of pictures we had hoped for. Our goal with close-up, formal portraits is to create an intimate connection between the subject and the viewer, and we try to choose a particularly fine example of a species to photograph. (I was, after all, trained by advertising photographers.) I took a lot of pictures of damaged plants, but I cannot hold them up as representative of those beautiful species. These plants have been ravaged in a particular place and time; the blemishes are not indicative of their long-term true nature.

The *Searcher* expedition provided an excellent opportunity to explore Mokumanamana as well. I was struck by how sparse this 200-foot tall island is—a relatively small speck of rock in the ocean. Made of the basalt remnants of the volcano that formed it, Mokumanamana is so old

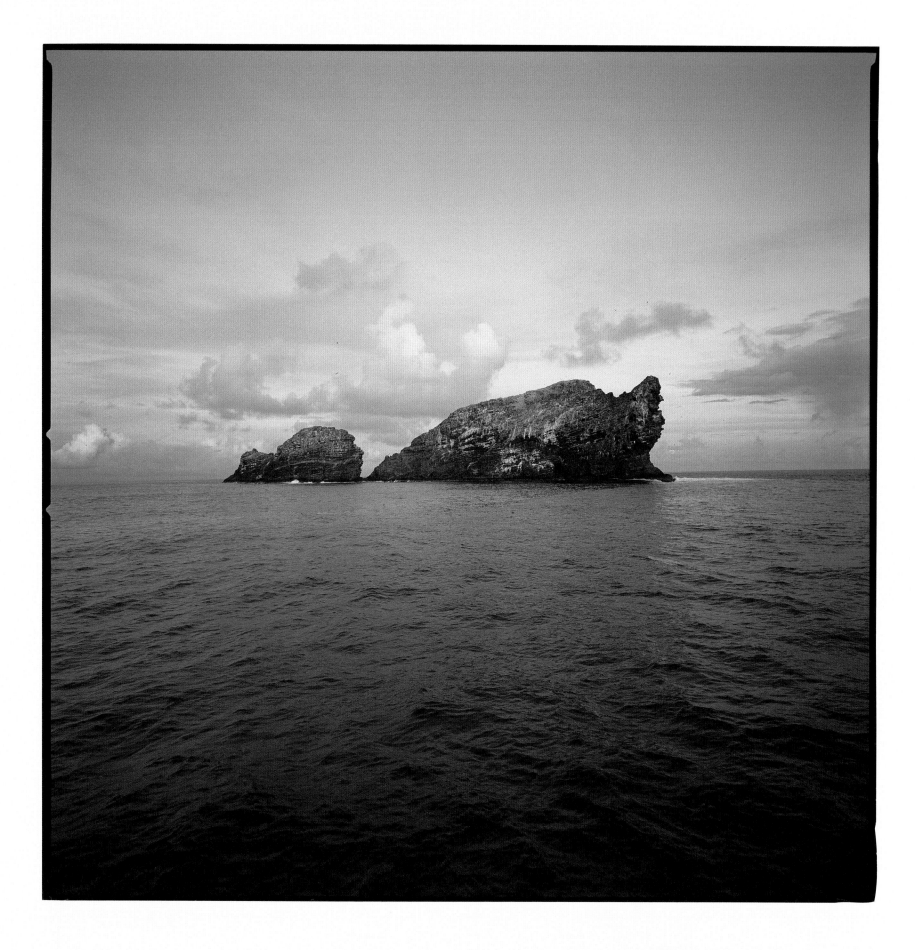

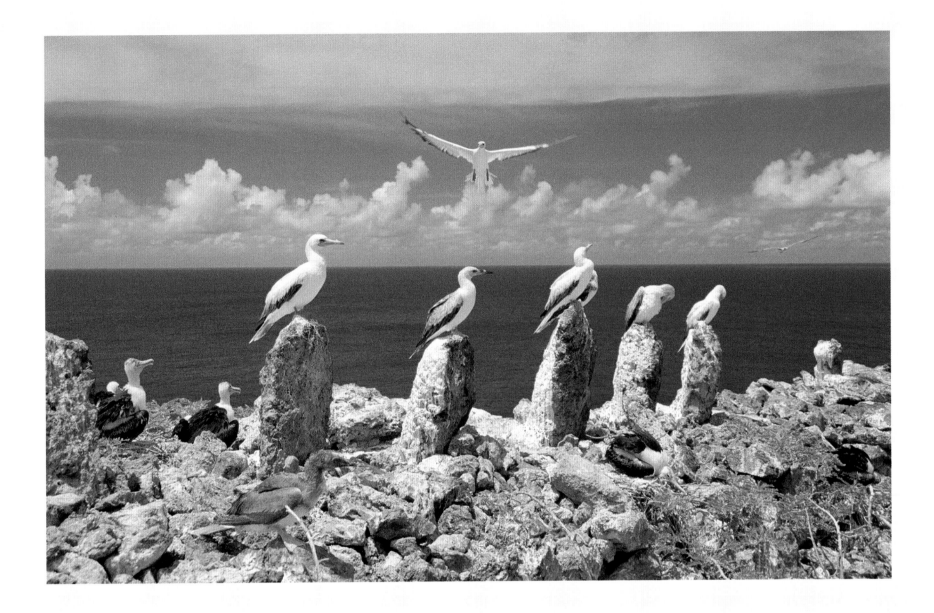

that it can crumble underfoot or within a grasping hand. The prehistoric people who came to this treacherous land must have been hardy souls.

Mokumanamana and Nihoa are both on the National Registry of Historic Places. People lived on these islands from AD 1100 to 1700; there are 88 cultural sites documented at Nihoa and 52 at Mokumanamana. Some 100 to 150 people probably inhabited Nihoa seasonally, with a smaller population residing there year-round. Mokumanamana—much smaller than Nihoa, and far too dry to support subsistence agriculture—was probably used for religious purposes.

I imagined how these people set out in wooden-hulled boats, exploring beyond the limits of their known world. And now we set out to explore these islands as well, to find new species, to discover how the world changes. A new species of moth on a remote atoll is the world making itself new. It's so basic—and the most awe-inspiring thing I have ever seen.

The plant and animal communities of Nihoa and Mokumanamana are thought to resemble portions of the main Hawaiian Islands prior to human contact. To preserve the plants and animals of these islands, starting by addressing the grasshopper problem, is to preserve biological communities that exist nowhere else on Earth.

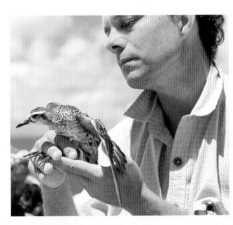

ABOVE, top: Boobies and frigatebird chicks occupy the summit of Mokumanamana. These upright stones are thought to be a religious shrine. Bottom: David is able to hold this Pacific golden plover, apparently paralyzed from exhaustion, on Mokumanamana. Beth Flint took over caring for this bird and released it a few weeks later on O'ahu.

Cone Casebearer
Hyposmocoma new sp. 28

Downy Casebearer Caterpillar
Hyposmocoma sp.

Endodontid Snail
Endodonta sp.

O'ahu Tree Snail
Tornatellides sp.

Wolf Spider ~ nanana ʻīlio hae
Lycosa sp.

Necker Click Beetle ~ kānepaʻina
Itodacnus novicornis

Nihoa Trap-door Spider
Nihoa mahina

'Ena 'ena
Gnaphalium sandwicensium

Native Hawaiian Sedge
Pycreus polystachyos ssp. *polystachyos*

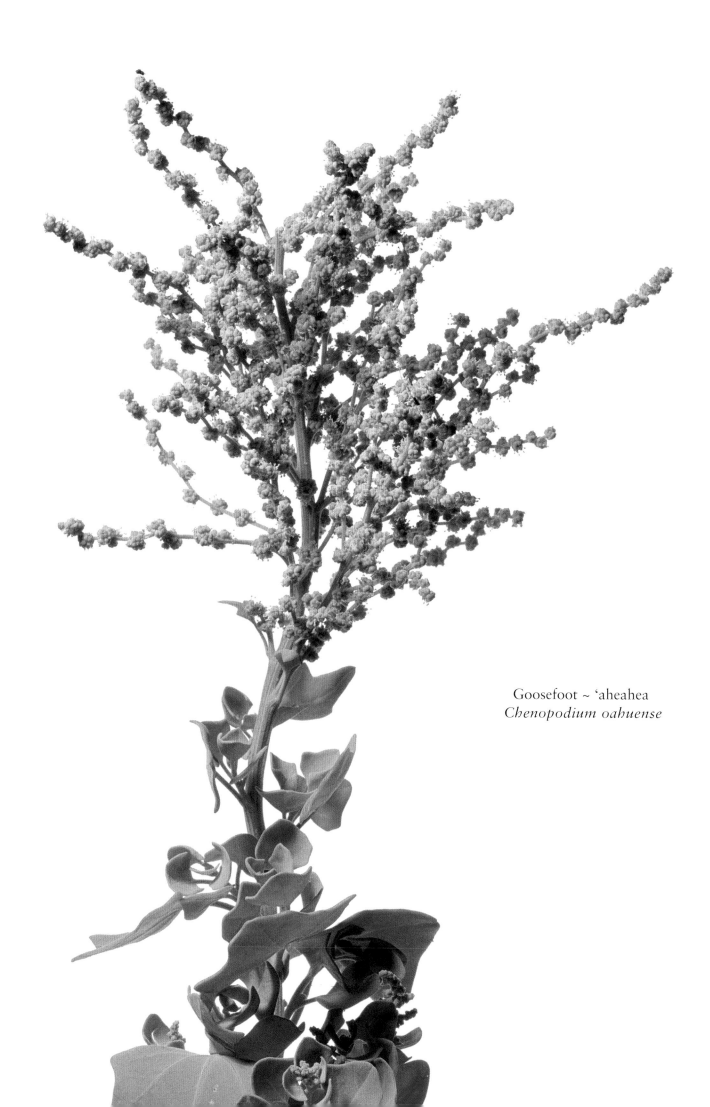

Goosefoot ~ ‘aheahea
Chenopodium oahuense

French Frigate Shoals ~ Kanemiloha'i

23°145'N, 166°10'W

including Gardner Pinnacles ~ Puhahonu, and Maro Reef ~ Ko'anako'a
25°02'N, 168°05'W, *and* **25°22'N, 170°35'W**

by David Liittschwager

In 1786 the French explorer La Pérouse skirted disaster when he discovered French Frigate Shoals; traveling at night, the two ships under his command nearly ran aground on the fringing reef. This atoll has seen many shipwrecks, although it has a deceptively benign appearance on an IKONOS satellite image, reminiscent of a curled monk seal pup. I visited here for the first time in 1999, arriving in the safety of daylight on the NOAA research ship *Townsend Cromwell,* courtesy of the U.S. Fish and Wildlife Service. She's a large vessel, and the surrounding waters off French Frigate Shoals are so shallow that only small boats can thread their way through the patch reef to get to Tern Island, the largest island in the atoll. It was a new experience for me—getting off a big ship onto a small boat, with hundreds of pounds of equipment. The wind and the chop gave us a wet ride to the island.

Our stop was dictated by NOAA's need to bring supplies and a change of crew to their research camp on the island, part of the National Marine Fisheries Protected Species Investigation efforts. Ships do most of the re-supply work here, as airplanes are less cost-effective. In addition, the runway at Tern Island is rather short and, most of the year, covered with seabirds. Just a few feet above sea level, Tern Island is basically all runway. The size of the island doubled when, in response to the Battle of Midway, the U.S. Navy dredged coral and placed it behind steel sheet pilings, forming a seawall.

On my first visit, I felt I had seen the whole island after walking along the runway, but that turned out to be a completely false perception. The seabird population differs every season. For example, most of the albatrosses have departed by mid-July. French Frigate Shoals supports the greatest variety of coral species in the Northwestern Hawaiian Islands, with 41 species of stony coral; in addition, it harbors over 600 species of invertebrates and more than 150 species of algae, which are especially diverse near La Pérouse Pinnacle, the last remnant of the volcano that

Red-footed Booby ~ a'
Sula sula rubripes

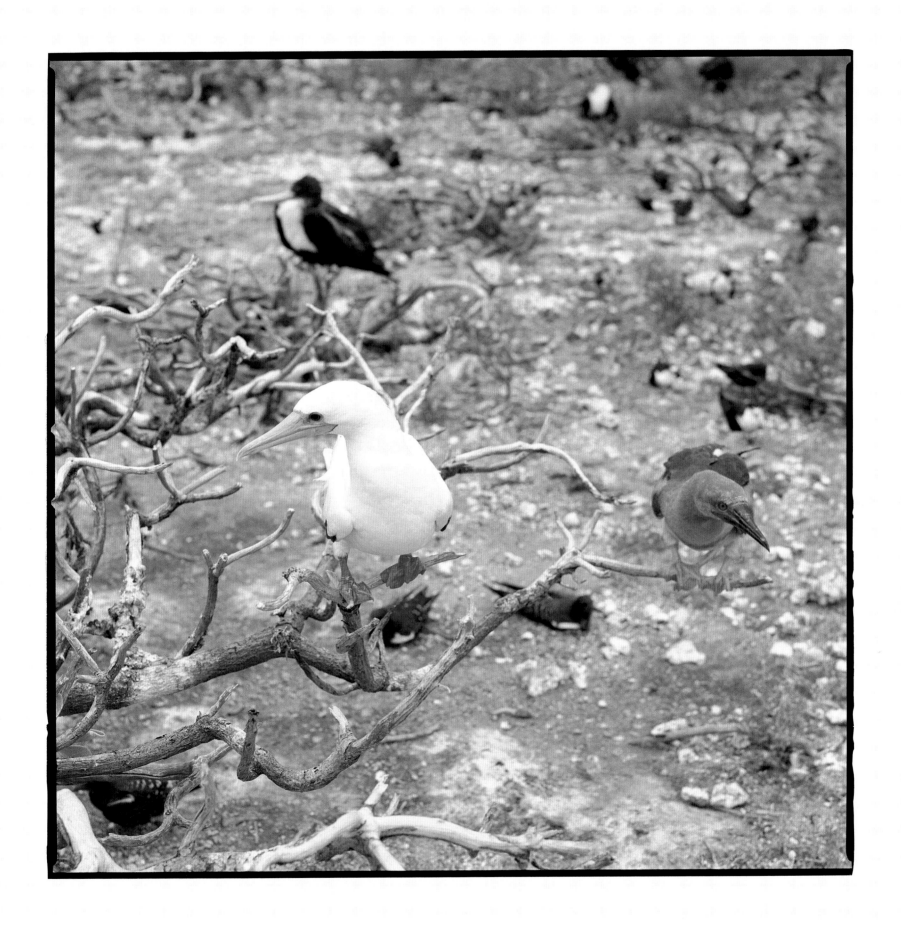

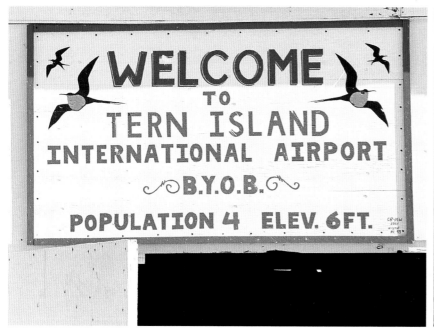

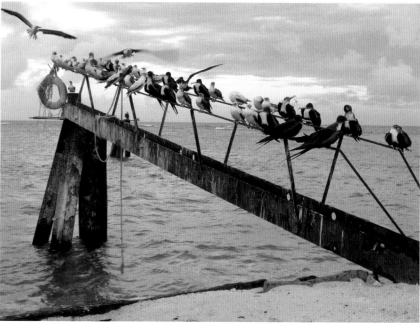

ABOVE, left: Four USFWS personnel live on Tern Island year-round, though the human population can explode to a dozen during research season. Right: On islands as small as Tern, frigatebirds and boobies will roost on any surface.

OPPOSITE, clockwise from top left: A pair of masked boobies stake out Tern Island's runway; La Pérouse Pinnacle rises straight up out of the ocean; frigatebirds and boobies share roosting space on tiny Tern Island; wedge-tail shearwaters hunker down on the runway that makes up most of Tern Island.

formed the atoll. Scientists believe the healthy algal community here results from high levels of nutrients in the water due to seabird guano.

I had never before seen such an astounding number of seabirds. The breeze off the ocean blows pretty constantly at Tern Island, so the smell's not too bad. I can only imagine what the odor would be like if the wind stopped blowing—overwhelming.

A small community of biologists lives and works on Tern, making it the only human-inhabited island in French Frigate Shoals. The buildings here, including the military-style cinderblock barracks, are remnants of the U.S. Coast Guard LORAN (Long Range Navigation) facility that was decommissioned due to obsolescence. Electricity comes from solar panels on the roof, and fresh water arrives courtesy of a catchment system that utilizes reverse osmosis. Untreated water in the presence of so many seabirds is not necessarily unhealthy; it's just rank, and a little fishy.

In 2004 Susan and I were working aboard the NOAA ship *Hiʻialakai*, photographing marine creatures collected by divers undertaking biological surveys. We wanted to photograph green sea turtle hatchlings on the island, so the assistant refuge manager, Chris Eggleston, invited us to spend the night. Our original plan was to set up the aquarium tank, the lights, and other equipment that evening, then get up early in the morning and go hunting for baby turtles.

The human residents of Tern keep ambient light to a minimum, as baby turtles find their way to sea by moonlight reflected off the ocean and get confused by artificial light, which also poses a problem for seabirds. If turtle hatchlings get up on the runway, past the barriers set alongside it expressly to keep them off, they can end up on the inland side of the seawall. Sand erodes through little gaps in the steel sheet piling, creating a lip the hatchlings cannot crawl over. Residents of the island check the seawall daily for entrapped creatures, placing any they find in the ocean.

That night I was finishing the set-up for our photography session, with Susan and Stephani sitting close by on buckets. Buckets are the building blocks of Northwestern Hawaiian Islands civilization: White five-gallon plastic buckets get pressed into service for everything from storage

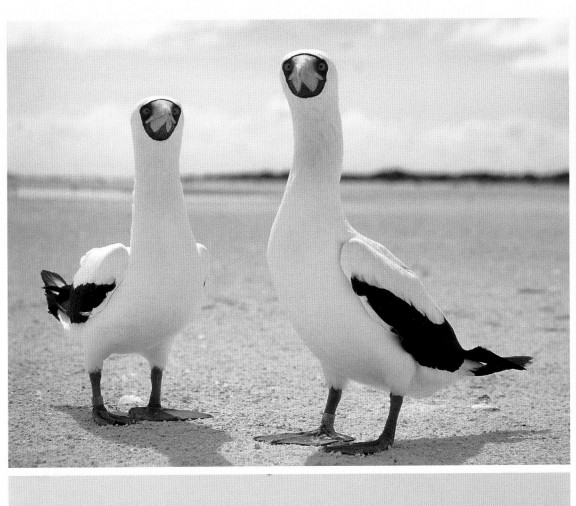

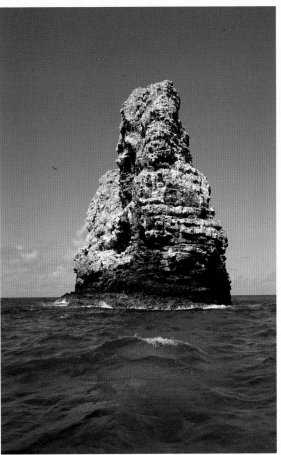

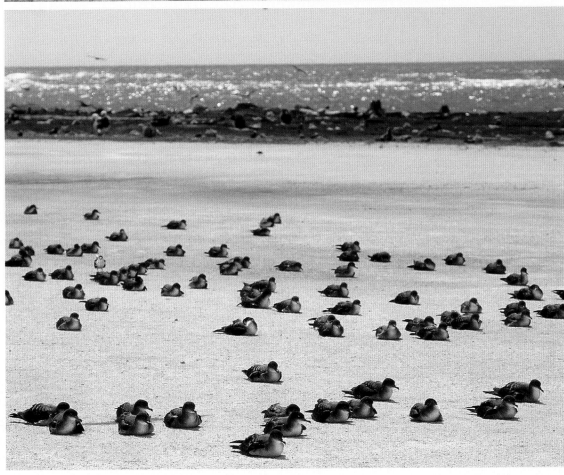

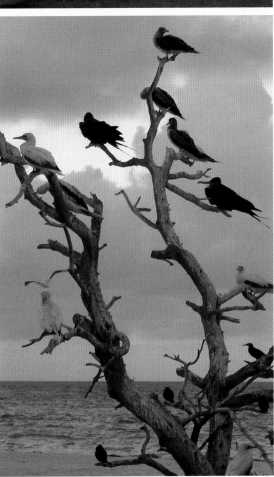

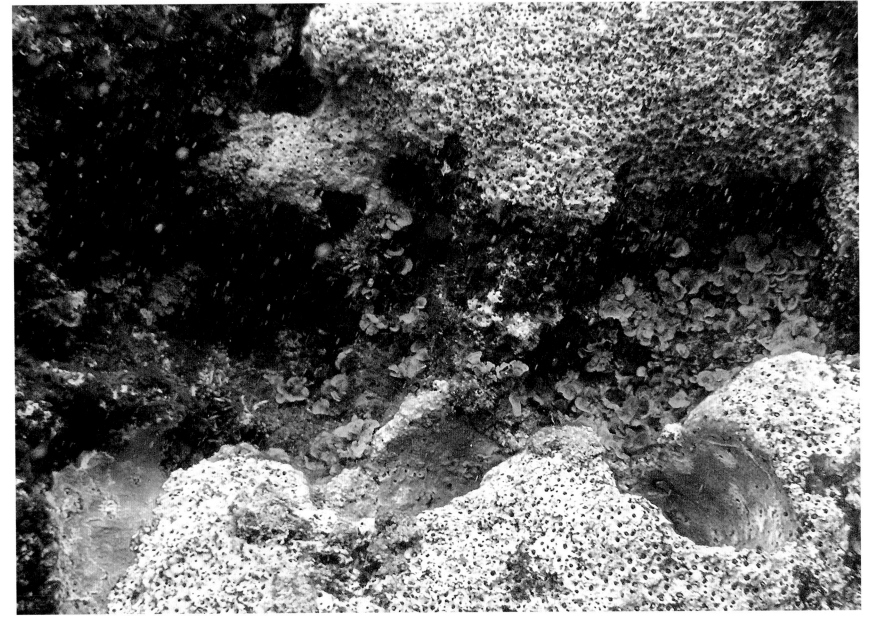

for food and clothes to dining-room furniture. We were only using one bare light bulb, but it was enough to attract a baby sea turtle from the outside. None of us noticed the little guy until it was right up against Susan's bucket. A volunteer had shown up to have its picture taken!

Stephani, in her role as Chief Turtle Wrangler, ran off to get Chris for advice on the proper way to handle a hatchling. Thanks to our good fortune, the plan changed and we were able to start work that night. Several other turtles were brought to us, and somewhere after midnight we were pretty sure we had a nice picture. We all went to sleep for a few hours, then got up and started taking pictures again. Shortly after sunrise we had actually finished our work, and all the hatchlings had been released into the ocean. With the rest of the day free, we spent our time photographing native plants until a small boat from the *Hi'ialakai* came to pick us up in the afternoon.

GARDNER PINNACLES

The next stop of the *Hi'ialakai* was Gardner Pinnacles, some 130 miles northwest of French Frigate Shoals. The sea was calm and we didn't see any breakers in the area surrounding the two peaks of this volcanic rock. I went out with the Rapid Ecological Assessment (REA) team of divers for a day to see what their work is like. I also wanted to touch the rock; I wanted to get close enough to have actually been to Gardner Pinnacles.

Big fish were everywhere—ulua, rays, a couple of small sharks—and a great variety of colorful algae decorated the rock face. The swell was moving along a flat wall of the pinnacle, and when I swam closer, the rise and fall of the water carried me up and down about 12 feet. It was as if I was on a child's circus ride—the whole scene was surreal. The coxswain of our boat thought I was being bashed against the pinnacle wall by the swell; worried that I might be in trouble, he sent someone over to check on me. I was, in fact, just bobbing up and down, having a blast, completely content.

The REA team is a group of biologists with different specialties who record the density and diversity of marine life; they're looking for fish, coral, algae, and other vertebrate and invertebrate animals. They repeat the process over time so data obtained can reveal trends toward improvement or loss. The divers count creatures along a short transect in the water, using still and video cameras to document their findings; they also take notes on waterproof paper. Once they had finished collecting their data, the divers were willing to bring us specimens from the reef to the ship. This is how we obtained most of the marine plants and animals we photographed. Of course, they were returned to the reef when we were finished.

Randy, the head fish scientist on the team, typically completed his work along the transect before the other team members. This gave him the opportunity to make collections of small, lovely things for us to photograph: Bright orange soft-bodied coral, a very small pale anemone crab, Hawaiian domino fish, a flat elbow crab, a keel heart urchin, and many others.

MARO REEF

A breaking wave holds secrets; if you know the formula, it can tell you the water's depth. A six-foot swell with breakers means the water is less than eight feet deep. Small-boat drivers (coxswains) use this formula, and an awareness of other differences in the water's surface, to navigate the unique geomorphology of Maro Reef. From above, Maro resembles a labyrinth of

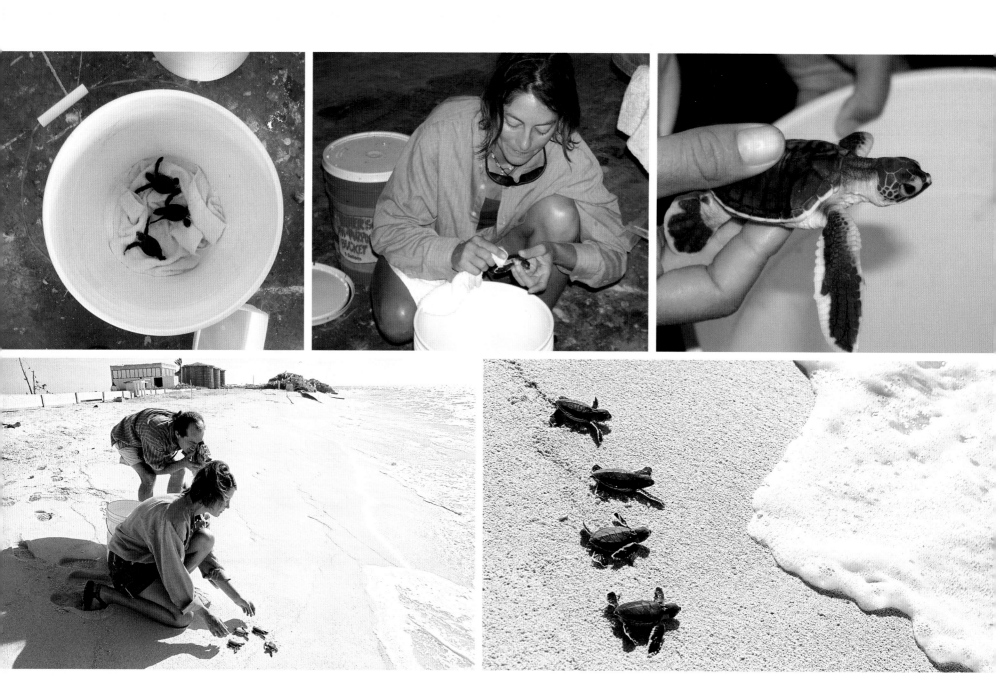

TOP ROW, from left to right: Hawaiian green sea turtle hatchlings awaiting their portraits. Stephani dusts off the next subject. She carefully handles each hatchling. Susan works with a turtle hatchling in the aquarium tank. Four cleaned-up turtles rest comfortably as they await their turn in front of the camera.

BOTTOM ROW, from left to right: After the photo session is over, Stephani sends our subjects on their way. The green sea turtle hatchlings head into the water. The first hatchling braves the waves. A tiny hatchling, in the center of the frame, swims out to sea.

linear reefs. Simply put, ships cannot safely be anywhere near here. Only occasionally does land emerge, and then only at extreme low tides when the water is calm.

My three days at Maro, in September 2004, were spent in a kind of fog. The divers, a dozen of them, brought us an overwhelming number of specimens to photograph. It was near the beginning of the *Hi'ialakai* trip and we were getting into a pattern of trying to do everything, often spending a long time with each creature.

I remember a lot of waiting at Maro Reef: waiting for the sand anemone to blow itself up, for the many different specimens of mushroom coral to come out and show themselves, for the colonial cup coral to feel comfortable enough in the aquarium tank to open up and let us have a look. There were green algae, male and female box fish, and lobsters. The divers sought

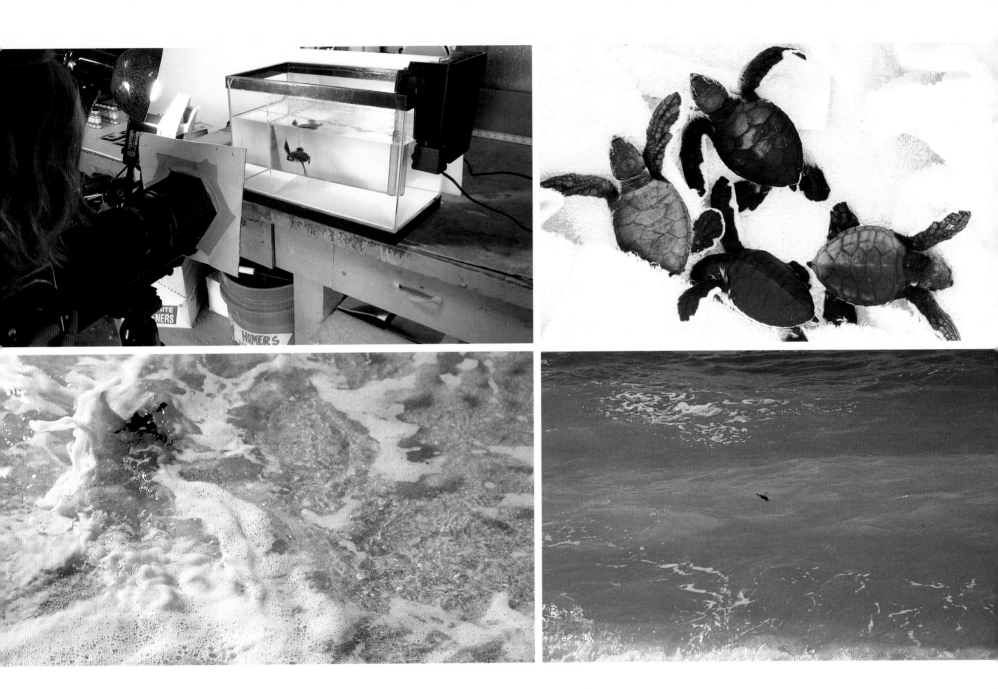

out particularly nice-looking lobsters, which we described as being "not too old and therefore too big, but big enough not to look like babies. Freshly molted would be nice. They need to have some character and nice bright colors."

During my stay at Maro Reef, the only time I got off the *Hi'ialakai* was in a small boat to release the specimens at the end. Creatures need to be returned to their proper habitat; you can't just dump them over the side of the ship. You have to take them back to the right kind of home, in the same vicinity from which they were borrowed. We wouldn't put an eel from French Frigate Shoals into the reef habitat of Gardner Pinnacles or Maro. This is simply out of respect for the integrity of these unique biological communities.

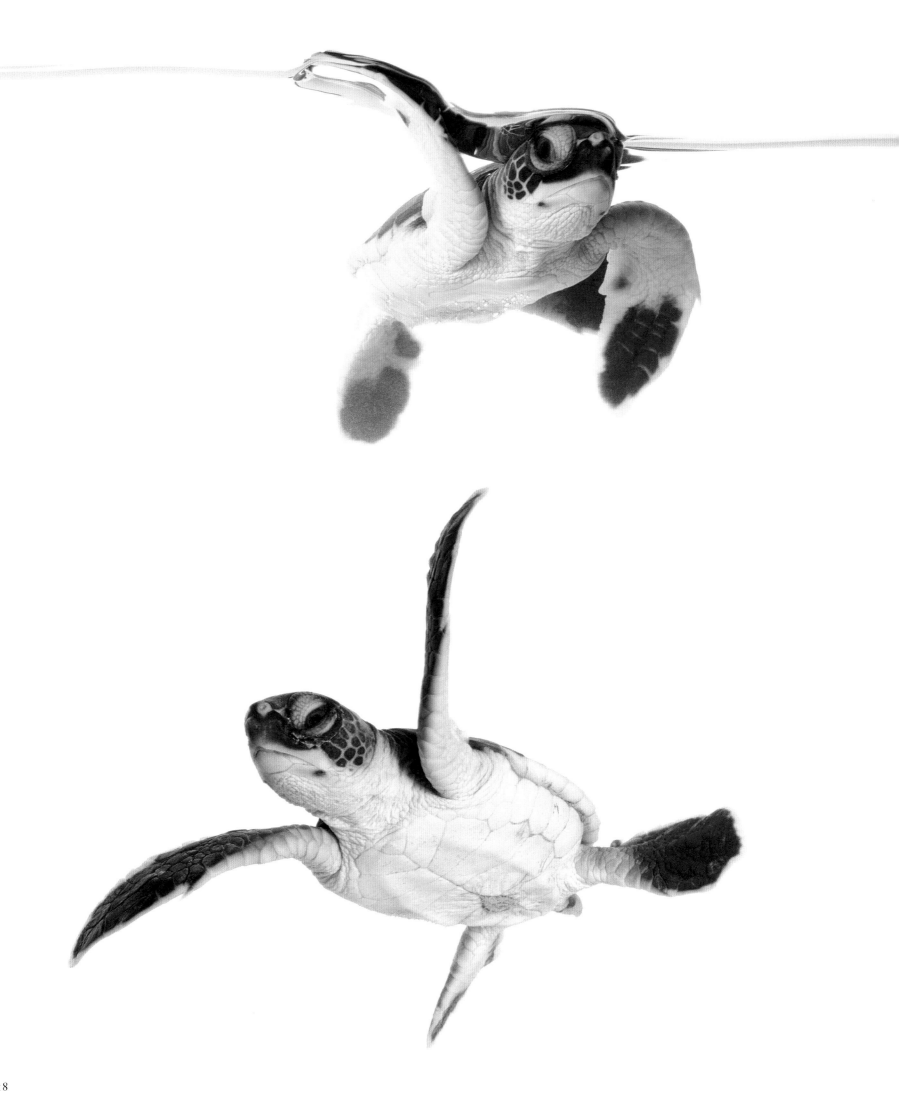

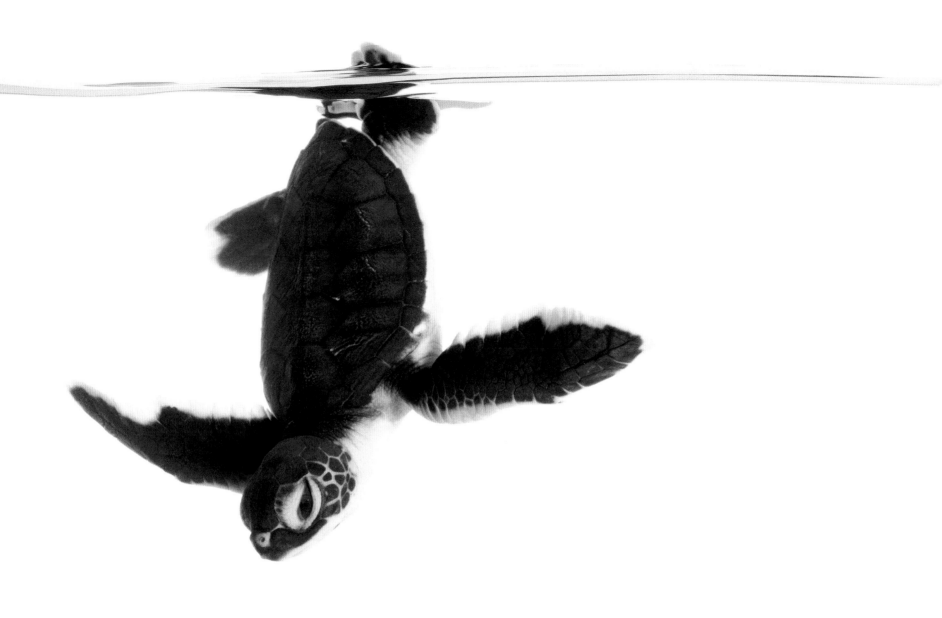

Hawaiian Green Sea Turtle hatchlings ~ honu
Chelonia mydas

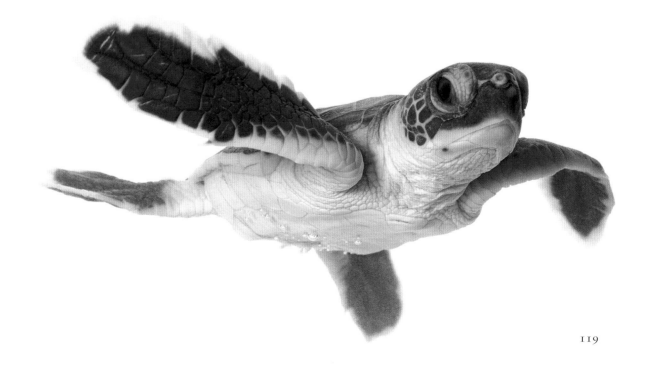

Puaokama
Sicyos maximowiczii

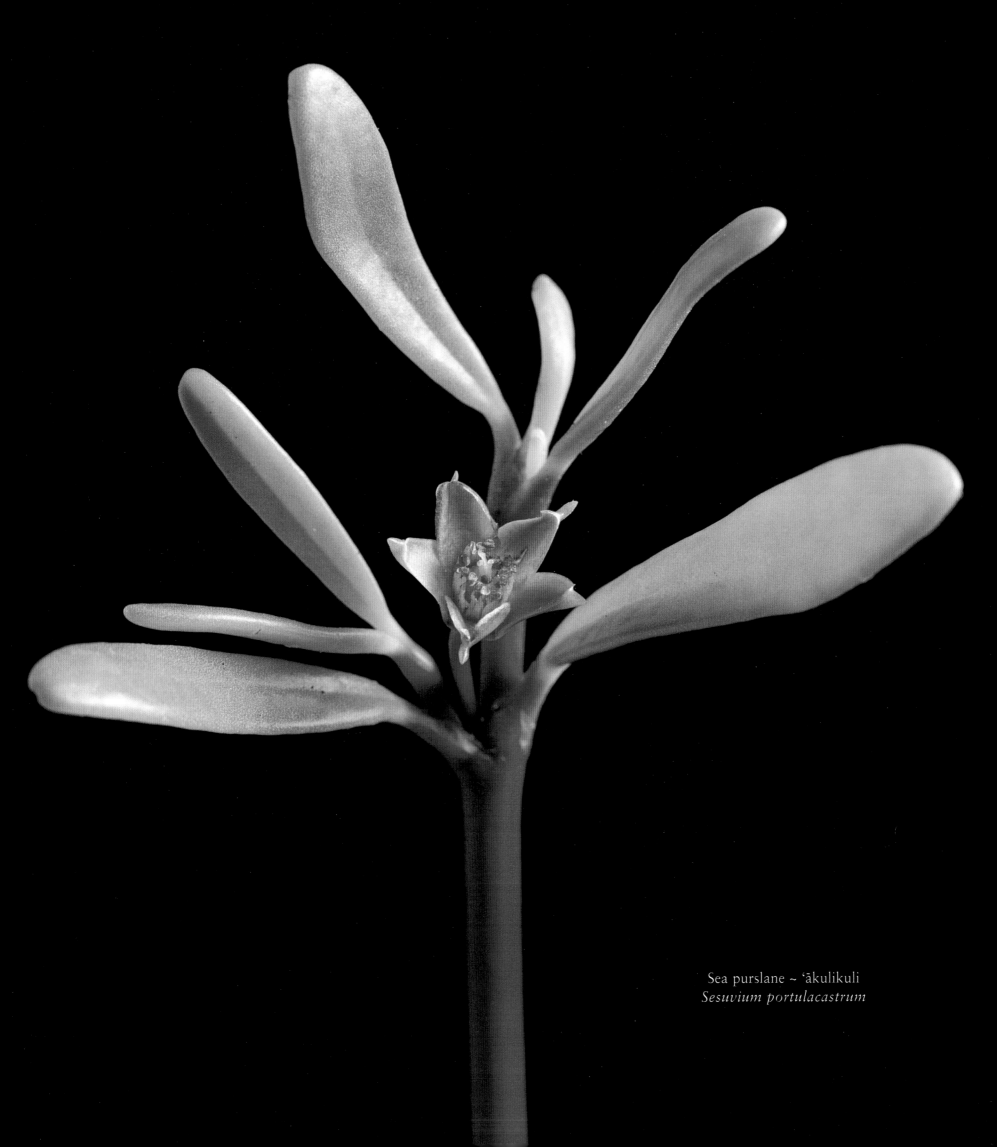

Sea purslane ~ ʻākulikuli
Sesuvium portulacastrum

Laysan Island ~ Kauo

25°46'N, 171°45'W

by Susan Middleton

Laysan Island is often thought of as the jewel of the Northwestern Hawaiian Islands, primarily because of its biological integrity. Two endangered species of birds exist here and nowhere else, the Laysan finch and the Laysan duck. Various native plants thrive on this remote island, including another endangered species, *Mariscus,* which lives nowhere else in the world. At one time there were even more native plants, among them a palm similar to the native palm on Nihoa (*Pritchardia remota*), and a delicate, lovely white flower called *Capparis.* The introduction of ants and the altered vegetation on Laysan have irrevocably affected the native insect fauna. But Laysan remains hospitable to many species of seabirds, which depend upon it for breeding, nesting, and raising young, and the island also provides refuge for monk seals and sea turtles. Second largest of all the Northwestern Hawaiian Islands (only Sand Island in Midway Atoll is larger), Laysan is a raised coral island, without a fringing reef and lagoon, but containing a hypersaline lake in its interior.

We camped on the island for six days in July 1999 in a U.S. Fish and Wildlife Service (USFWS) field camp. Luckily we were offered berths on the NOAA ship *Townsend Cromwell,* on one of its routine re-supply missions to the Northwestern Hawaiian Islands. Because Laysan is so important biologically, we had to comply with strict quarantine procedures to prevent any introduction of alien species, specifically seeds and insects. Zodiacs shuttled back and forth between the ship and the island, taking food, fresh water, gear, and field technicians. All hands helped haul provisions up the beach to the campsite. It was hot, the white sand was beautiful but blinding, and the five-gallon water jugs were heavy. We started first to sweat, and then to drown in our own juices, surrounded by flies seeking moisture. They congregated around our mouths and eyes; swatting them was futile.

Laysan Finch
Telespiza cantans

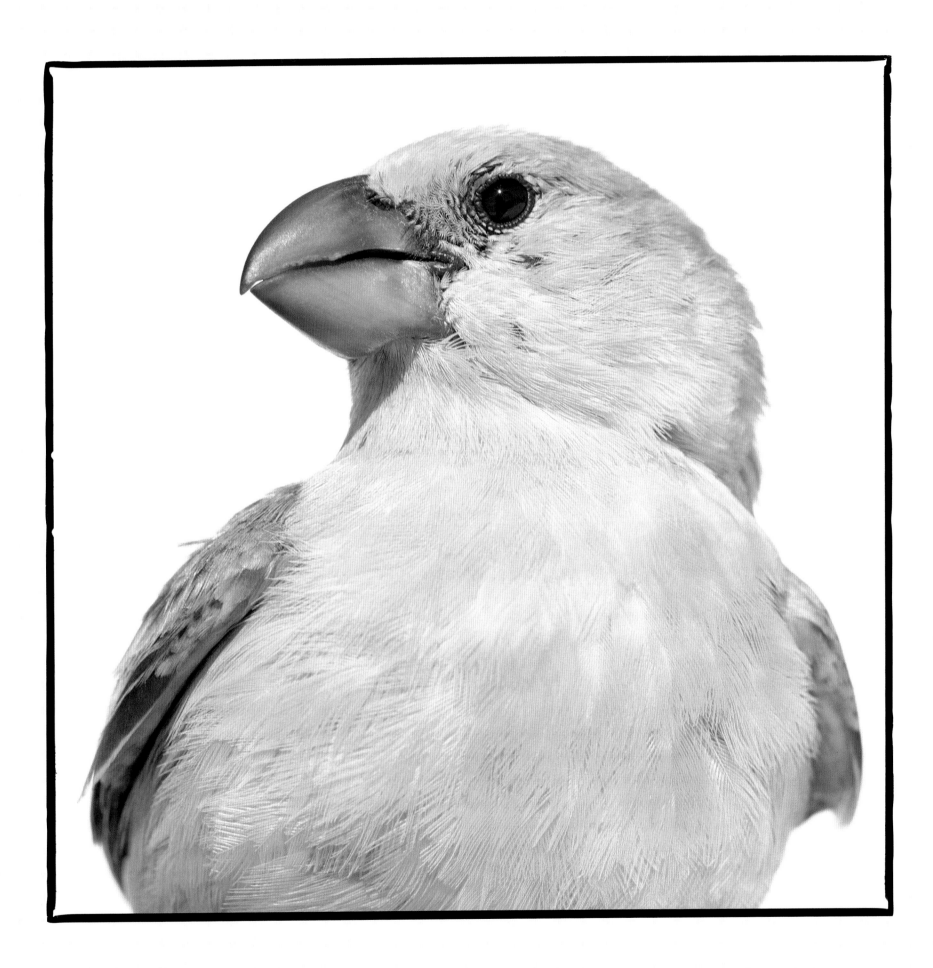

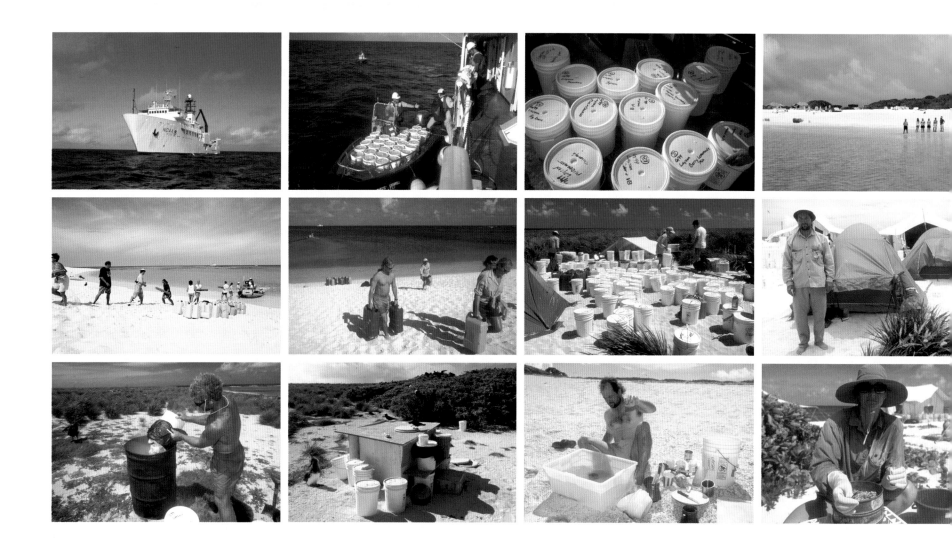

ABOVE: Camp life on Laysan involves offloading the NOAA supply ship *Townsend Cromwell*, hauling buckets of provisions and jugs of water to the campsite, setting up tents, incinerating trash, using the "long drop" (an alfresco outhouse), washing dishes, and, for Brenda Becker, analyzing monk seal scat.

OPPOSITE, top left: a Brown Noddy in profile. Right, top to bottom: the lovely *Capparis*, once native to Laysan, has been reintroduced. Shade houses aid in the cultivation of native plants. Mark Vekasy tends a young native palm (*Pritchardia remota*). Field technicians pull out an invasive plant, the common sandbur (*Cenchrus echinatus*).

We fled the unrelenting midday heat, seeking out the limited shady spots under shrubs and trees, only to discover we had to share the shade with hordes of flies, which were even more unbearable than the heat. Ants were another menace, most importantly to the native ecosystem but also to us. They invaded our tents, our sleeping bags, our clothing—virtually anything that was not sealed in a plastic bucket or Ziploc bag. I was shocked to see that more than 100 ants had managed to get inside the Polaroid back to our Hasselblad camera, apparently drawn by the moisture of the film-processing chemicals. We learned to seal everything, and we avoided the voracious avian ticks by sealing ourselves—with protective clothing, and especially with socks. We washed dishes, laundry, and ourselves in the ocean using biodegradable soap, and never felt completely dry. I found Laysan both fascinating and beautiful—an unforgettable first adventure into the Northwestern Hawaiian Islands—but it was not comfortable.

Birds provide the overwhelming presence on Laysan, producing a rich cacophony of sound and visual display; they have rightful possession of the island. Laysan is birdland, and in fact, birds so crowd the island that every available space is used for nesting. Boobies and frigatebirds compete for space on limited shrub and tree branches. Tropicbirds hide out on the ground under foliage; shearwaters excavate burrows underground; albatrosses make nest bowls in the sand all over the island. Terns and noddies lay their eggs just about anywhere, sometimes in precarious places. Laysan finches build nests in bunchgrass clumps, and Laysan

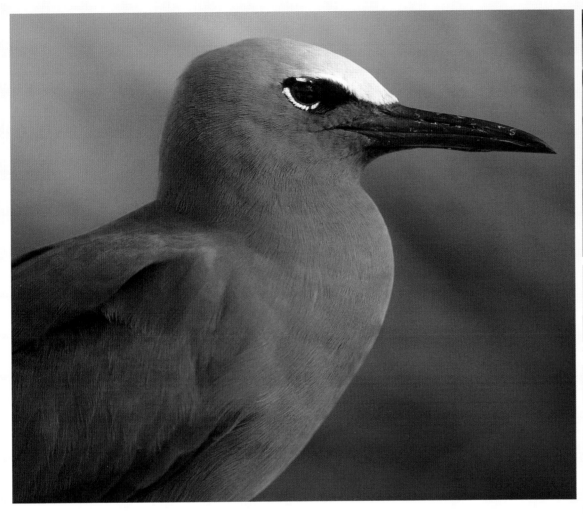

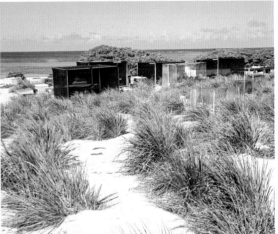

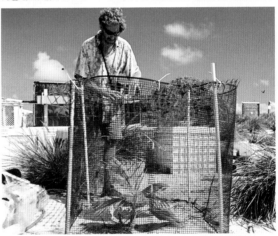

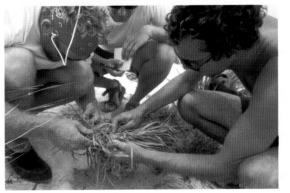

ducks hide in the vegetation near freshwater seeps by the lake. Birds are overhead; they are underfoot; they are everywhere you look.

During nonbreeding time, seabirds enjoy the wide-open space of the sea, but come nesting season they quickly adapt to the tight, crowded conditions on the small islands comprising the northwestern Hawaiian archipelago. I imagined it might be like going from the wilderness of New Mexico into downtown Manhattan for part of each year. So many birds of different species and races coexisting—breeding and feeding and raising young protectively; preening themselves and each other; competing for space and food and sometimes for mates; arguing and singing; displaying tenderness and violence—all this creates an ongoing drama of spectacular intensity, played out with complete indifference to humans. This visit gave me an opportunity to eavesdrop on their world.

One of the most remarkable aspects of Laysan is the near total devastation it suffered during the period between the late 1890s and early 1920s. Since then the island has undergone a massive restoration, but a series of human activities resulted in serious damage to its unique natural community. It began with guano miners, who brought alien plants and animals with them. Extensive feather collecting and egg harvesting followed, and then came the introduction of rabbits as a source of meat. The rabbits rapidly denuded the island of vegetation, turning it into a sand desert. By 1923, only four of the twenty-five known plant species survived on Laysan.

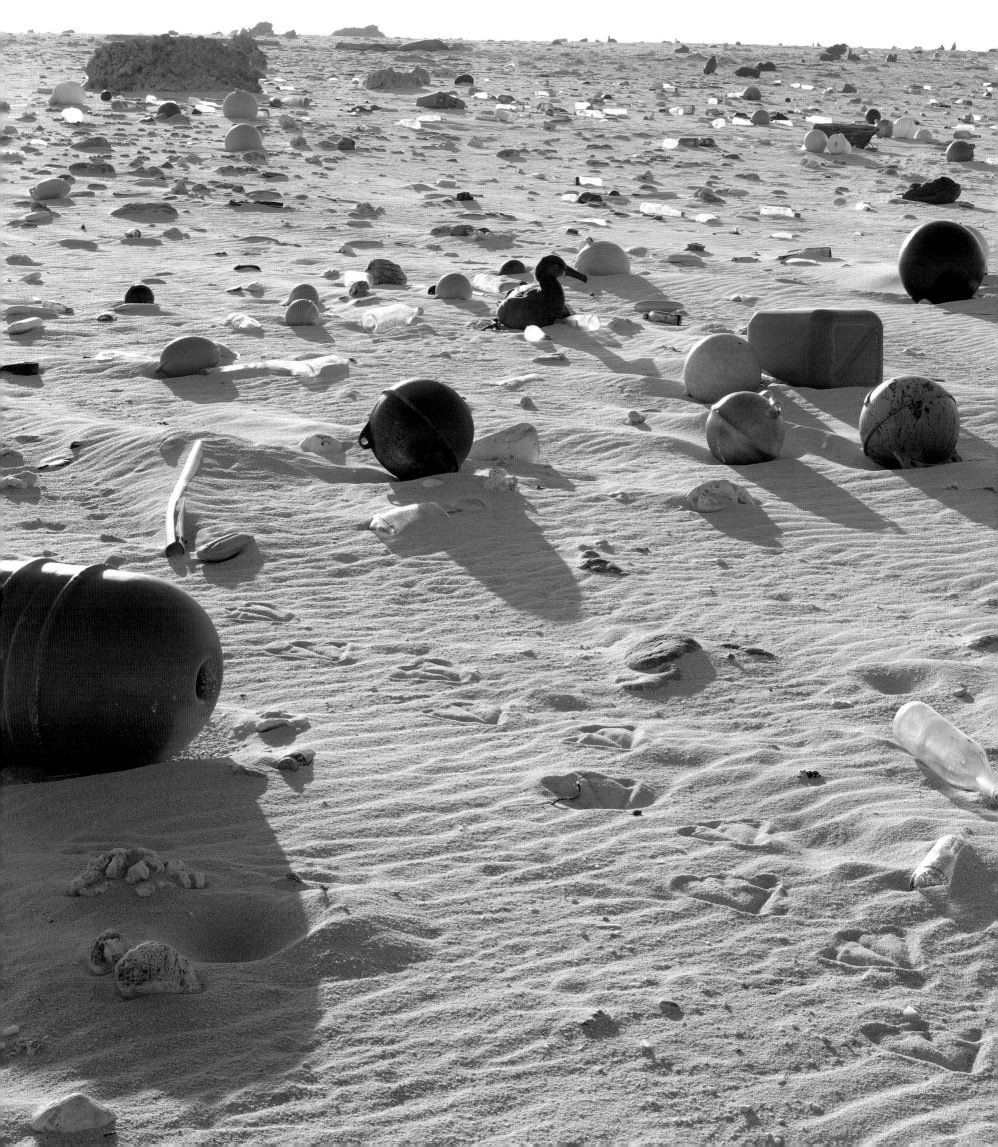

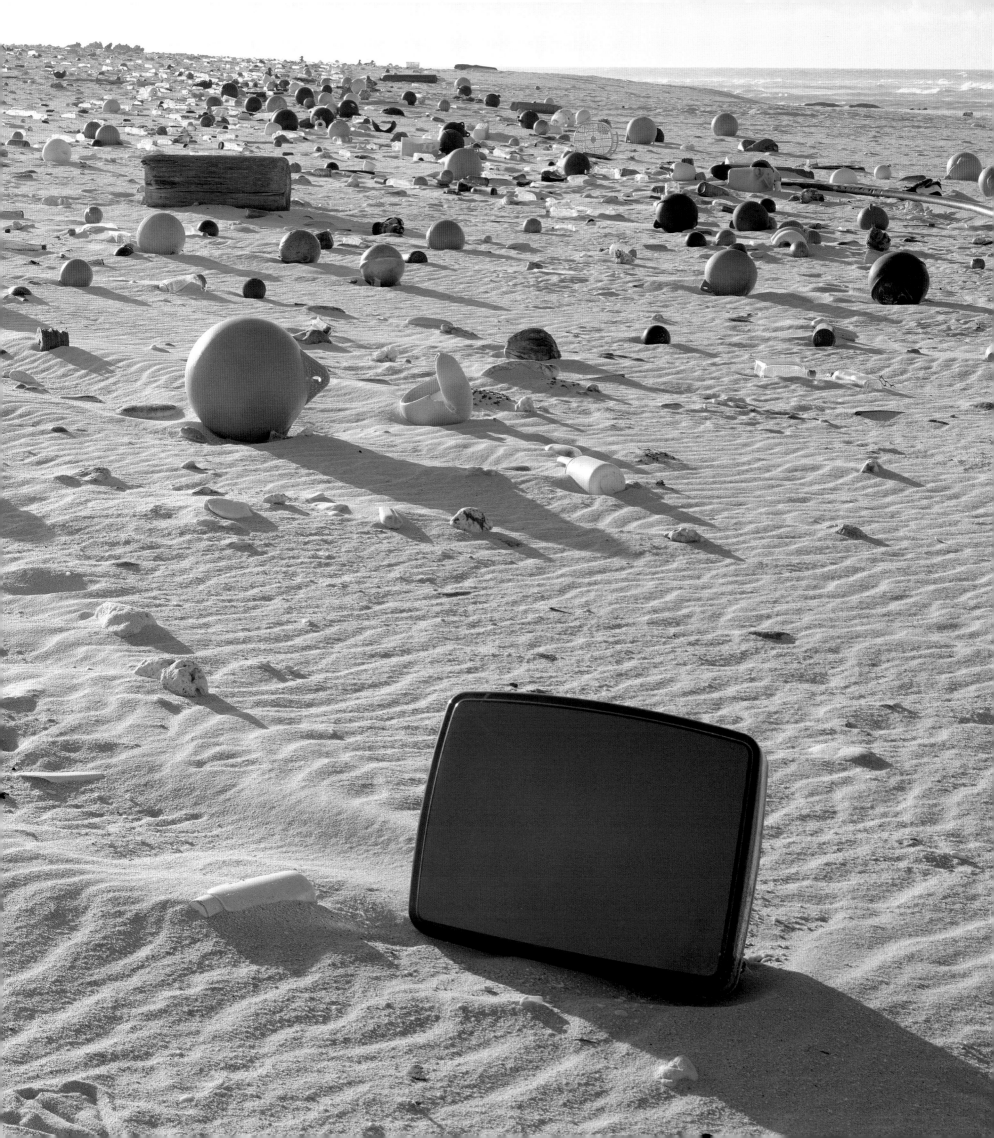

PRECEDING PAGES: As far as the eye can see, marine debris litters the windward side of Laysan. Items such as ropes, nets, and lines pose entanglement hazards to wildlife, and are quickly removed.

BELOW: All hands help to haul ropes, nets, and lines that threaten wildlife. This dangerous debris is collected into piles, dragged to waiting Zodiacs, and loaded into containers. Its destination? Honolulu, and ultimate incineration.

Three of the native birds—the Laysan rail, Laysan honeyeater, and Laysan millerbird—did not survive the devastation, and neither did countless invertebrates. The Laysan duck escaped narrowly, with less than ten birds reported. Then, in 1923, the Tanager expedition eradicated all the remaining rabbits, and the island began to revegetate. From Kure and Pearl and Hermes Atolls, biologists brought in roots of the native bunchgrass, *Eragrostis variabilis*, and reintroduced it to Laysan.

Starting in 1991, the USFWS has implemented an intensive ecological restoration of Laysan Island, with impressive results. Extinct species are extinct forever, but native plants can be encouraged, and alien weedy plants can be eradicated through the painstaking process of pulling them out by hand. The USFWS prevents new introductions of alien species by enforcing strict quarantine measures. Species of plants known to have grown on Laysan are being cultivated and transplanted, such as the lovely white-flowered *Capparis*, and others are being translocated, such as the loulou palm native to Nihoa, a close relative of the one that once thrived on Laysan. Biologists carefully collect seeds from the palms on Nihoa and transport them to Laysan, where they are planted and nurtured. It is immensely gratifying to witness a healthy ecosystem on Laysan, thanks to human devotion and commitment, and at the same time sobering to realize that it was nearly lost because of human ignorance. In spite of the losses, the Laysan biota is still one of the most intact in all of the Hawaiian Islands.

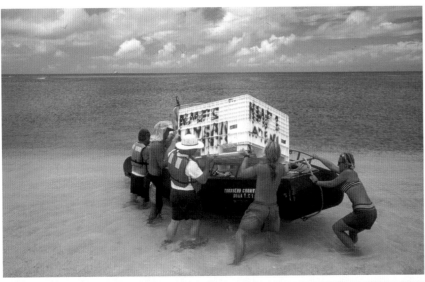

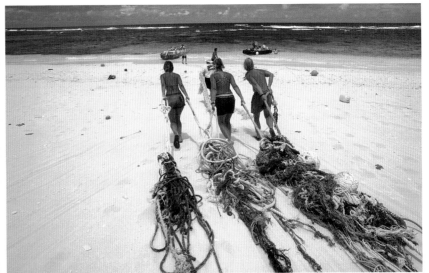

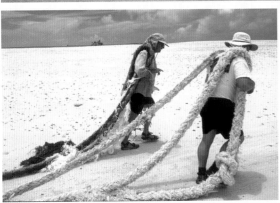

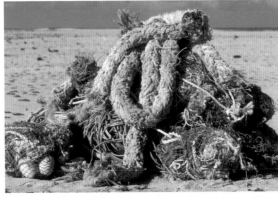

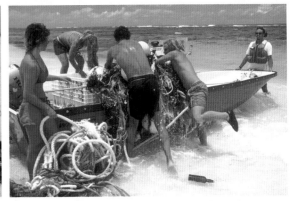

After three days on Laysan, time began to seem both compressed and elongated. It felt as if we had been there much longer, yet the time was passing quickly; we had only three more days to photograph before the *Cromwell* would arrive. We set up to photograph finches: David rigged a piece of white plastic with a small depression in the surface which, when water was added, created a little bird bath. Because fresh water is scarce on the island, this makeshift bird bath attracted plenty of finches to our field studio setup. Unfortunately, we didn't have any similar tricks up our sleeves for the shy and secretive ducks, which rely on freshwater seeps near the lake. Luckily we had an expert guide into their habitat, Rebecca Woodward, who was researching this rare and endangered species. Following Rebecca, we slowly crawled on our stomachs through a tangle of morning glory vines, cameras in hand, to get near the seeps where we could see and photograph the ducks without disturbing them.

On an evening walk with Alex Wegmann, David and I were shocked to see massive amounts of marine debris strewn across the beach: floats, plastic lighters, plastic shoes, toys, thousands of liquor bottles, television tubes, laundry baskets, light bulbs, plastic containers of all sizes and shapes, medical waste—the flotsam and jetsam of civilization. Ropes, nets, and lines present entanglement hazards to wildlife, including seals, turtles, and birds; everyone on the island systematically gathers this debris and places it in piles to be transported back to Honolulu for proper incineration. We decided to return with an eight-by-ten camera to document this

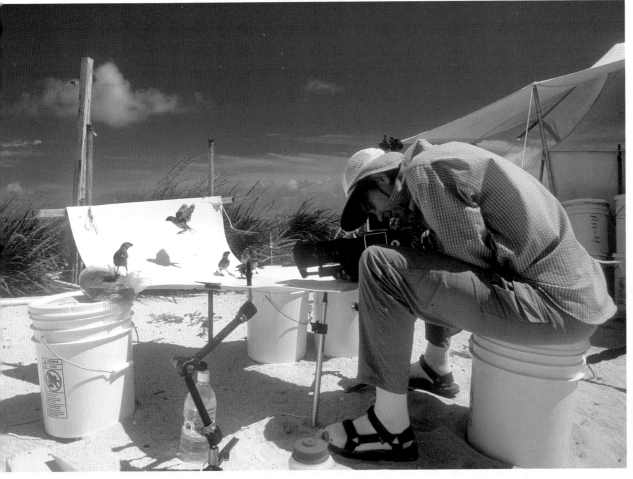

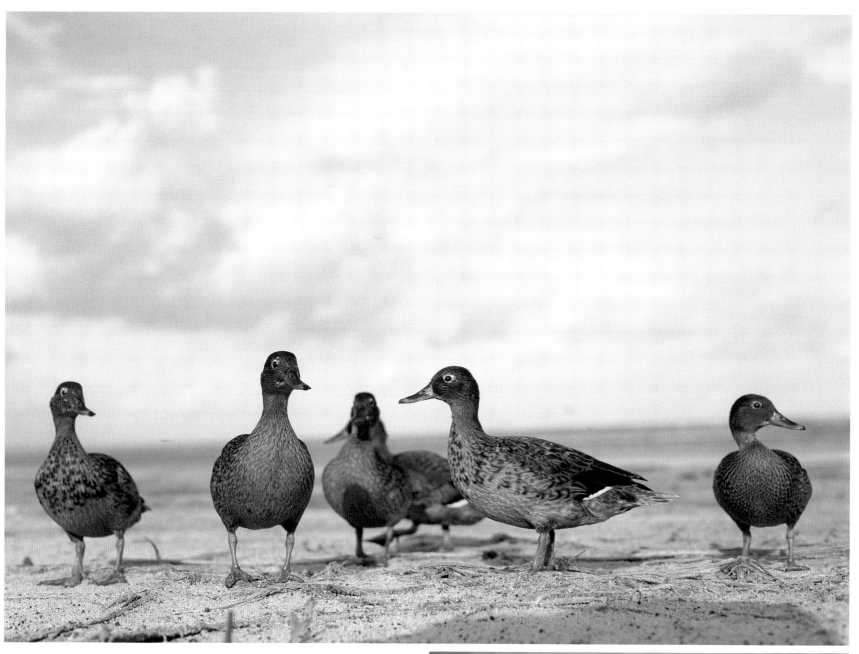

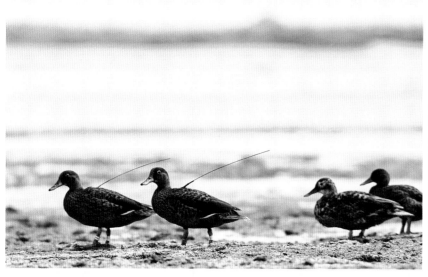

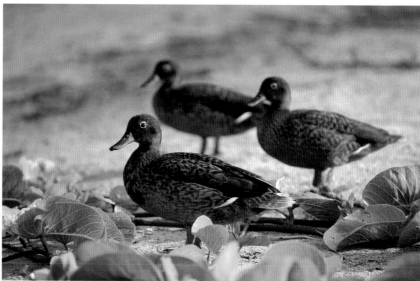

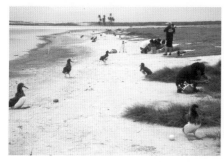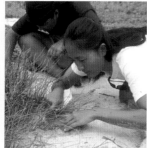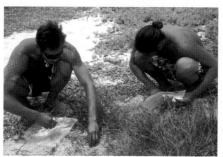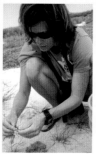

distressing sight. I knew we were in one of the most remote places on earth, but suddenly civilization seemed pressingly close. After witnessing this scene repeated on every Northwestern Hawaiian Island I visited, I came to learn that nowhere is remote.

On subsequent short visits to Laysan during 2003 and 2004, I saw healthy young *Pritchardia remota* and *Capparis* plants which had not been there in 1999, as well as many more thriving *Mariscus pennatiformis* plants. Native-plant shade houses had been constructed, and the pesky, invasive common sandbur (*Cenchrus echinatus*) appeared to be completely eradicated, a testament to vigilance and hard work. Two particularly exciting and important events converged with my visit in 2004: the arrival of the *Hokulea*, the Polynesian voyaging canoe on its way to Kure Atoll, and the Laysan duck translocation to Midway Atoll.

Through the devotion and persistence of Michelle Reynolds and her colleague Mark Vekasy, a carefully researched and planned project had begun to select and transport 20 young and healthy Laysan ducks to Midway, where temporary aviaries and suitable duck seeps were being created for them. This is the rarest duck in all the world, and establishing a second population could help save the species from extinction should anything happen to threaten the survival of the only existing population on Laysan. Mark guided me toward the lake so I could photograph some of the "chosen" ducks, indicated by the black aerials attached to the transmitters on their backs. I was lucky enough to be on Midway a few months later when the translocation team arrived by boat with these pioneer ducks.

The famous *Hokulea,* anchored near Laysan, created a spellbinding image. A replica of an ancient Polynesian voyaging canoe, *Hokulea* has sailed from Hawai'i throughout the South Pacific using celestial navigation, demonstrating what may have been the original exploration and settlement of Polynesia. Often used as a floating classroom, *Hokulea* was en route to Kure Atoll. The scale and grace of this canoe, moored alongside the low coral island, seemed balanced and right. Several of the *Hokulea* crew were on island when I was there, breathing it in—they performed a traditional Hawaiian blessing and helped Michelle collect seedlings of makaloa (*Cyperus laevigatus*) sedge, a common native plant on Laysan. The seedlings were safely stored aboard the *Hokulea* for transit to Midway, where they were planted around the seeps to make the ducks feel at home.

For me, Laysan embodies so much that is intrinsic to the Northwestern Hawaiian Islands: the unique and valuable biota, the toxic impact of misguided human activities, and the counterpoint of human ingenuity in the service of restoration, conservation, and healing. This is a story to learn from, a story that bears witness to the value of native ecosystems as quintessential expressions of place.

OPPOSITE: Laysan ducks congregate near the lake in the middle of the island; those with aerials attached to transmitters on their backs have been selected for transport to Midway Atoll as part of a program to establish a second population of the world's rarest duck.

ABOVE: Michelle Reynolds and members of the *Hokulea* crew collect seedlings of the native plant, makaloa, to transport to Midway Atoll for planting in the newly created duck habitat

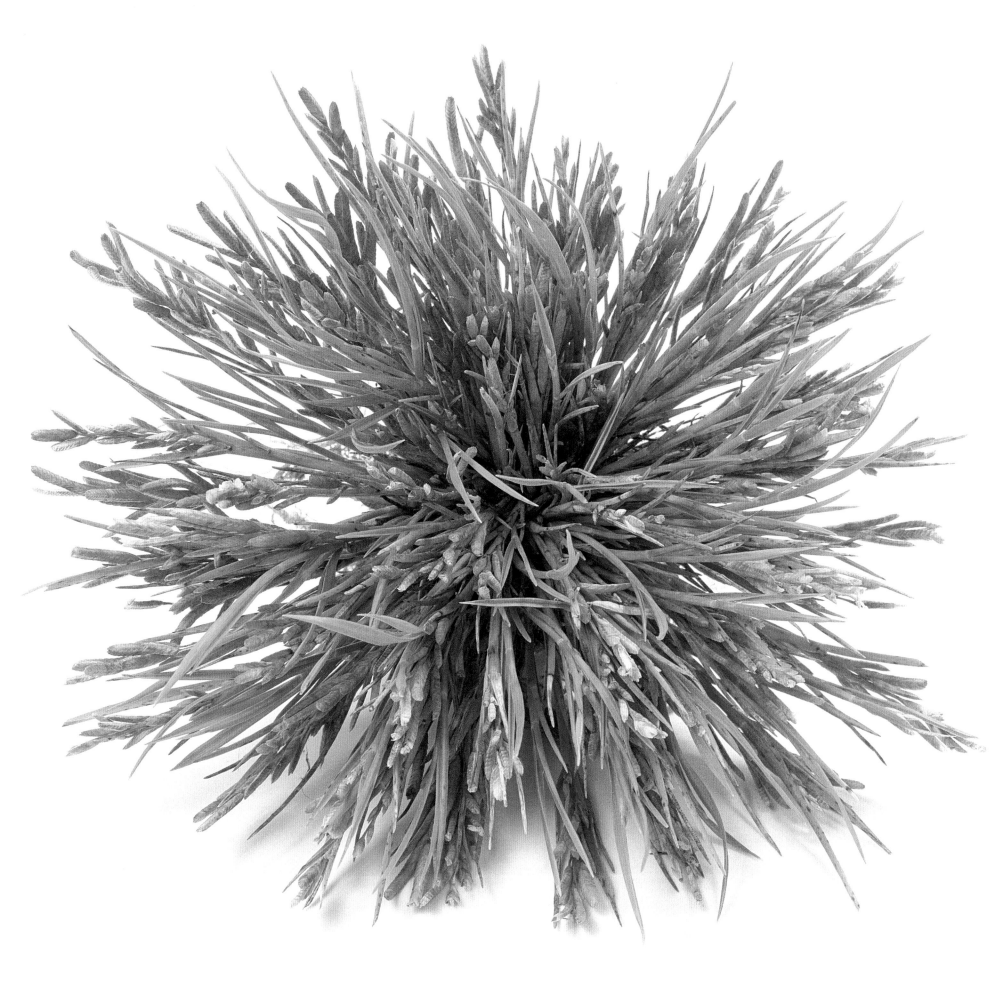

Dwarf eragrostis
Eragrostis paupera

Puʻukaʻa
Mariscus pennatiformis ssp. *byanii*

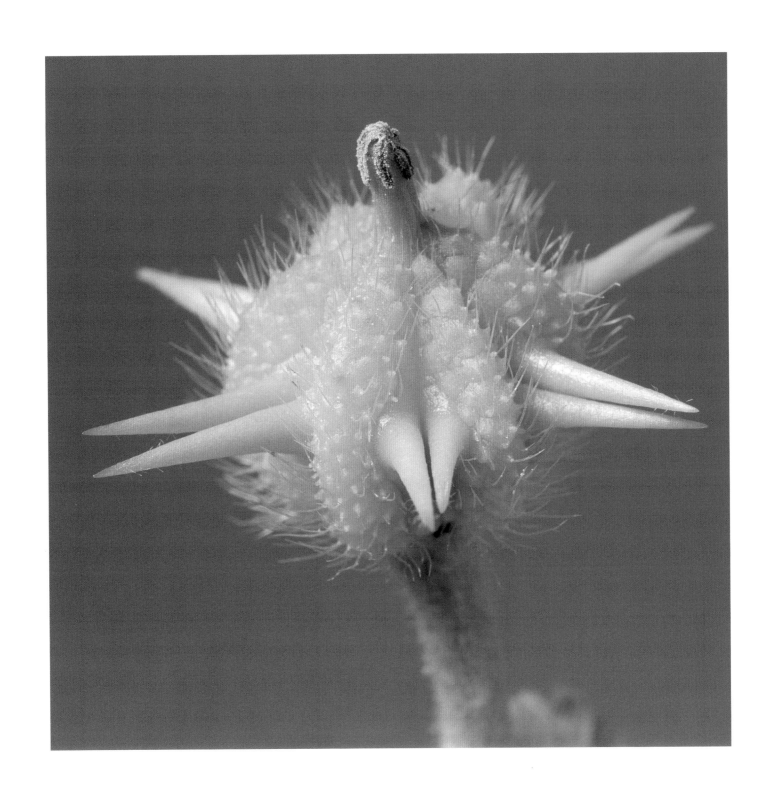

Caltrop ~ nohu
Tribulus cistoides
(fruit above, flower opposite)

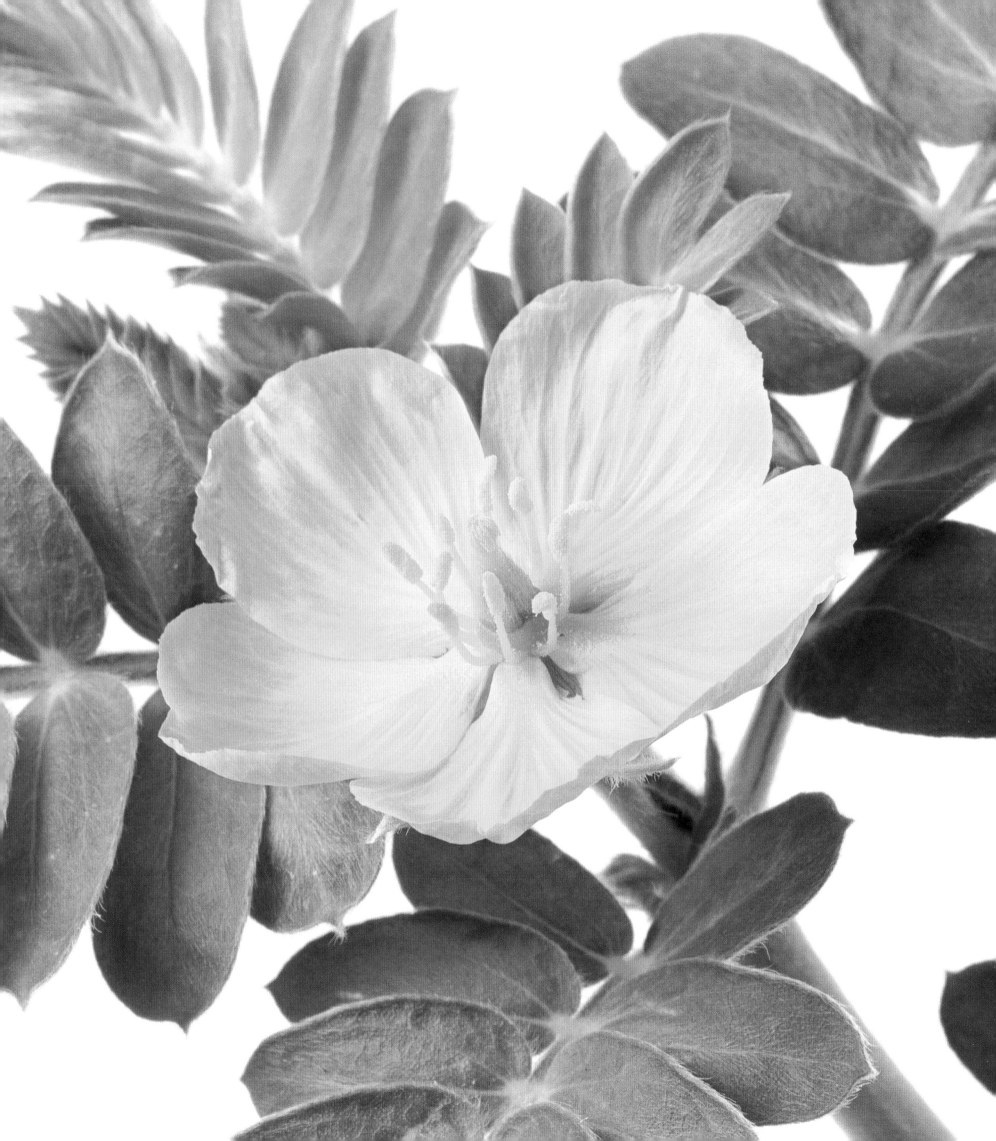

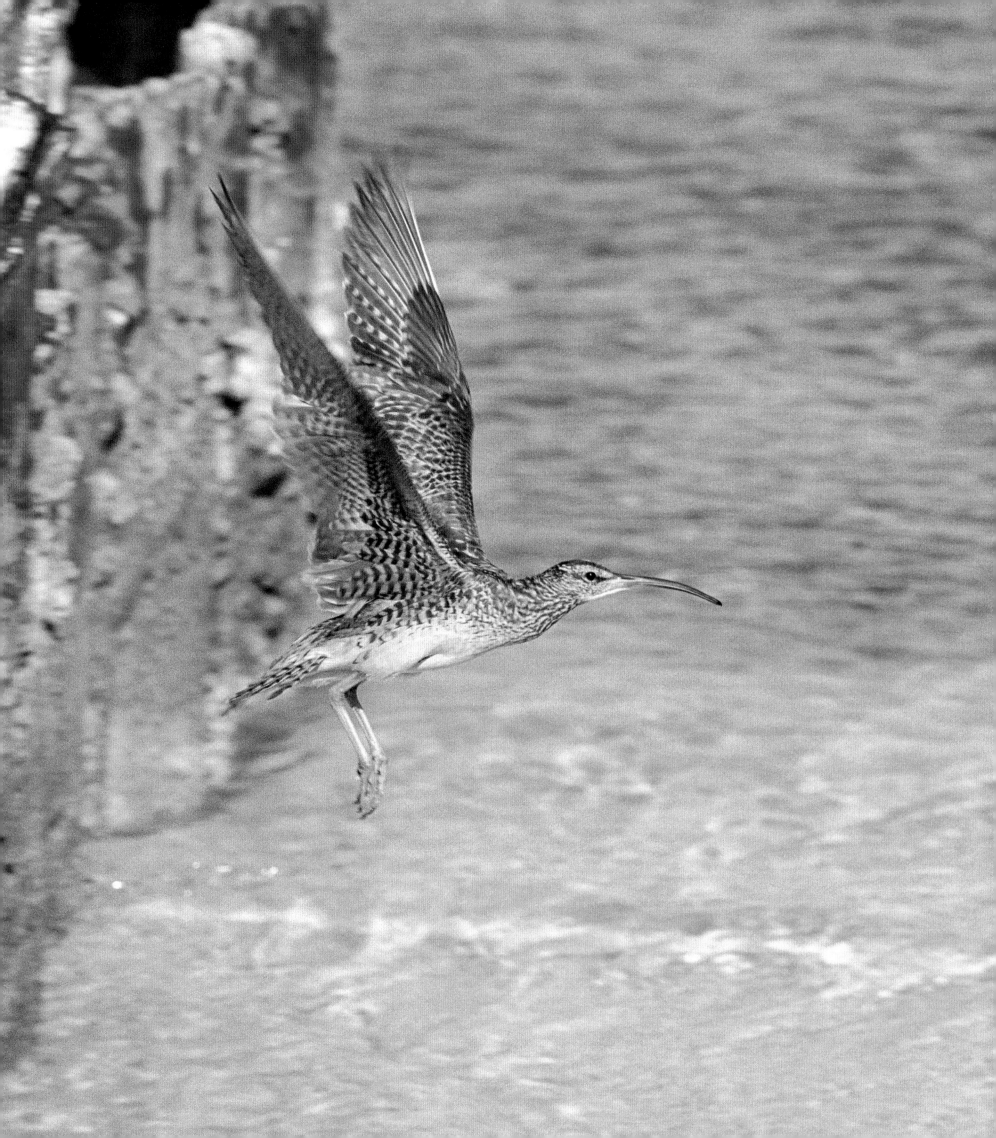

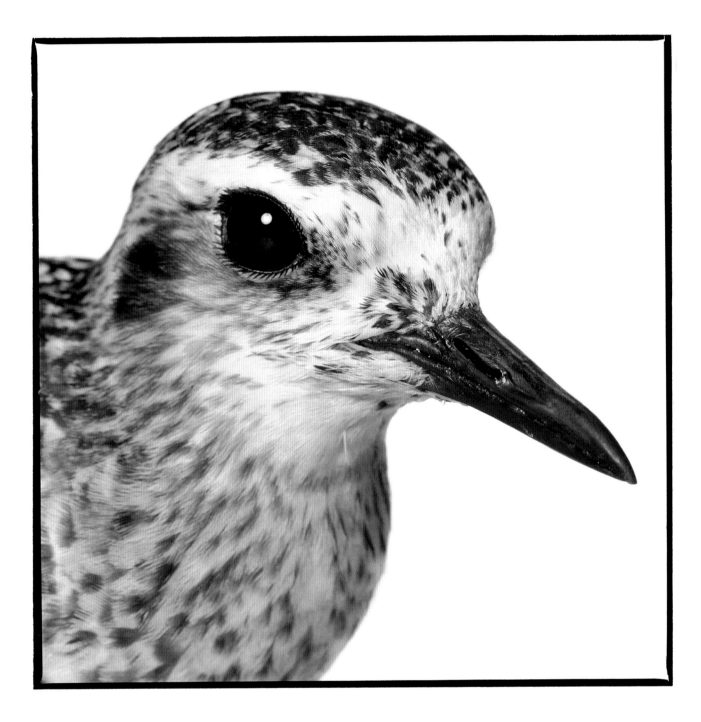

Pacific Golden Plover ~ kolea
Pluvialis fulva

Bristle-thighed Curlew ~ kioea
Numenius tahitiensis

Pearl and Hermes Atoll ~ Holoikauaua

27°50'N, 175°50'W

Lisianski Island ~ Papaʻapoho

26°04'N, 173°58'W

by Susan Middleton

The islets of Pearl and Hermes Reef
are a living museum, one which
shows that a nonuse of land can be
the best, most elegant use.

—Sherwin Carlquist
from *Hawaiʻi, a Natural History*

On May 19, 2003, the NOAA ship *Oscar Sette* arrived at Pearl and Hermes Atoll, and the crew mobilized to offload five people and enough equipment to set up a field camp: tents, food, water, and all the necessary provisions for a three-month stay. The camp would serve as a base for monitoring monk seals and Laysan finches along with native terrestrial plants and seabirds. I would stay for three days until the *Oscar Sette* returned to leave off Chad Yoshinaga, field camp leader. I wished for a week or more, but three days would have to do.

Our first day was consumed with unloading the Zodiacs and setting up camp. I learned how to tie bowline knots to secure the rain flies on the tents, helped sort and organize white plastic buckets labeled with food and supplies, moved my pack of quarantine clothes and equipment into my tent, set up a cot with bedding, and worked on dinner preparations. Before dark I found time to walk around the island, a flat expanse less than a quarter mile wide and about half a mile in length, with vegetation growing low to the ground. Wherever I went, I could be seen by anyone else on the island, and vice versa; that, added to the bright sun magnified by its reflection off the white coral rubble, made me feel a bit overexposed.

On my walk I saw a mummified carcass of a monk seal and a sea turtle carcass, both strangely beautiful. Where there is an abundance of life there is also an abundance of death, and I found myself fascinated by these animals in their natural death gestures. The islets of Pearl and Hermes Atoll provide refuge for sea turtles, monk seals, seventeen species of breeding seabirds numbering over 160,000 individuals, translocated Laysan finches, and a variety of native plants. Over 20 percent of the world's population of black-footed albatrosses nest here, and everywhere I went I saw lots of seabirds, especially fat albatross chicks begging for last meals from their parents before fledging.

Hawaiian Monk Seal Pups
Monachus schauinslandi

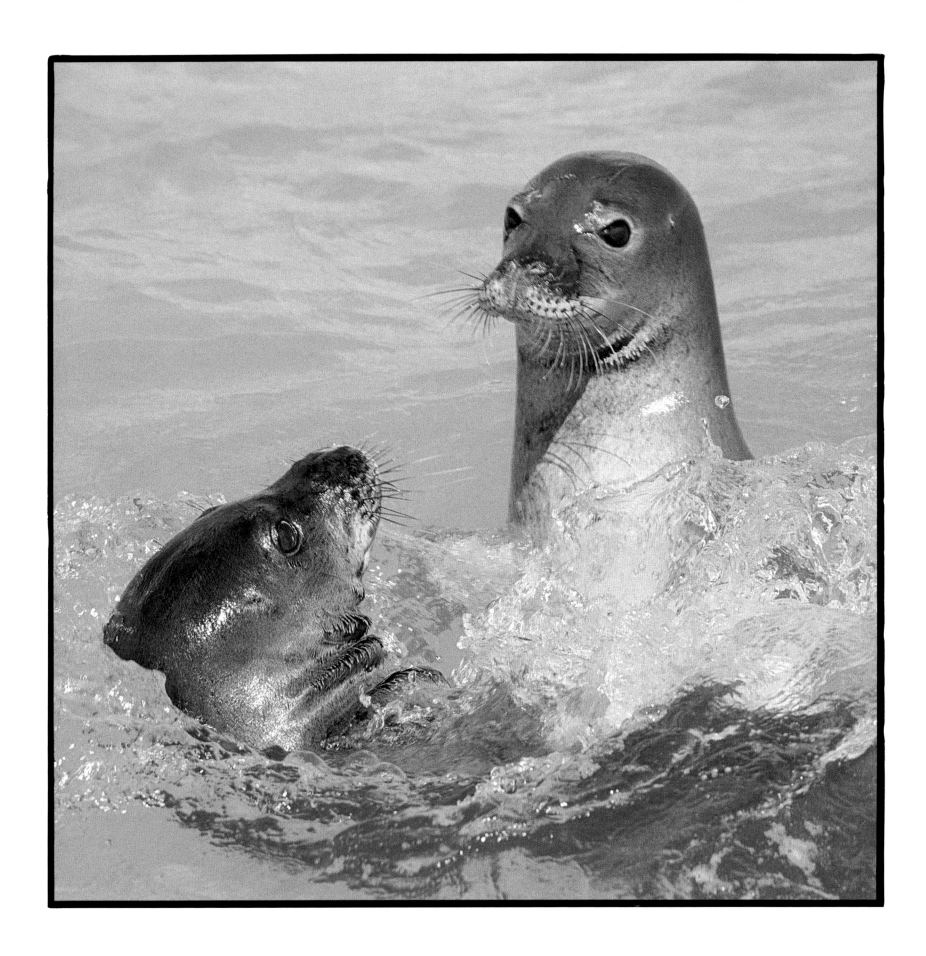

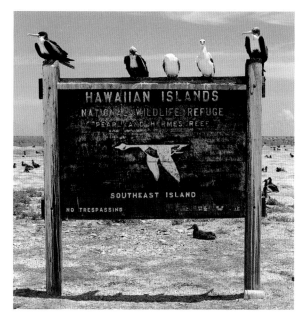

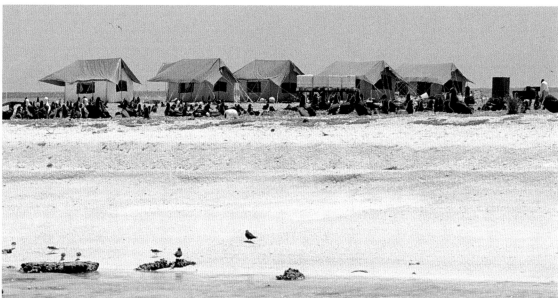

 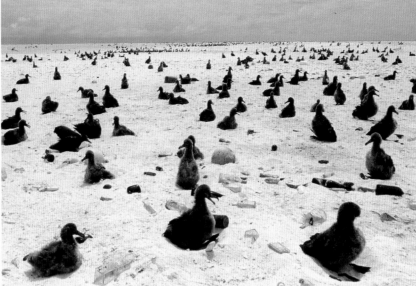

The vegetative assembly may be minimal, but it is noteworthy nonetheless: a lovely vine, the *Sicyos hispidus; Boerhavia repens;* lots of *Tribulus cistoides,* or puncture vine; *Sesuvium portulacastrum;* and a few stubby bunchgrass, *Eragrostis variabilis.* I was disheartened to see the invasive weed verbesina dominating the island's vegetation; though it grows low, it more than makes up for this with its pervasiveness. Historical accounts describe the dominant vegetation as *Eragrostis variabilis;* now there are just a few of these plants. Some believe the verbesina was transported inadvertently to the island during the mid-1990s, perhaps by field biologists. It is rampant on Midway and Kure but, as of now, has not migrated beyond Pearl and Hermes, and so far occurs only on Southeast Island.

As if to prove the complicated interconnectedness of nature, the introduced Laysan finches—members of an endangered species—use verbesina for nesting. Any actions that would disturb their nesting habitat are prohibited unless another acceptable habitat can be provided in its stead. With that in mind, the Fish and Wildlife Service has undertaken the task of establishing cinderblock finch "condos" as alternative nesting places. If their monitoring of the condo use indicates a successful alternative nesting scenario, this will clear the way for removal of the verbesina—an enormous task unto itself—and the restoration of the island to native vegetation. Restoration efforts do not always succeed. During the late 1920s, intensive harvesting of pearls and oyster shells nearly led to the extinction of the black-lipped pearl oyster. Despite prohibitions on oyster fishing, the oysters have never recovered.

By the next day, May 20, the three women in our camp had all begun suffering from the bites of small avian ticks, the color and size of a grain of sand. These stealth attackers are quite willing to feast on humans, and, in our camp, seemed to prefer women. They deftly bite and then fall off their victims, leaving a calling card that becomes evident later on when the bites swell, fester, and itch viciously. We couldn't resist scratching the bites, during our sleep if not while we were awake, and this caused the bites to erupt into welts. Mosquitoes began to seem like a minor menace in comparison. The tick bites took a long time to heal and created scars in the process, which I likened to atoll tattoos. One of my camp mates, Stephani, had the agony of

OPPOSITE: The only permanent structure on Pearl and Hermes Atoll, the USFWS refuge sign, top left, makes a prime roosting spot for seabirds. Top right, the seasonal field camp lines up on Southeast Island, where a gray-backed tern with egg, bottom, nests beside native pickleweed (*Sesuvium portulacastrum*).

ABOVE: Seal Kittery, left, an islet in Pearl and Hermes Atoll, is home to black-footed albatross chicks, right.

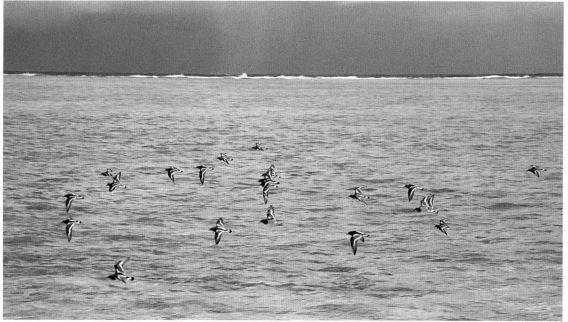

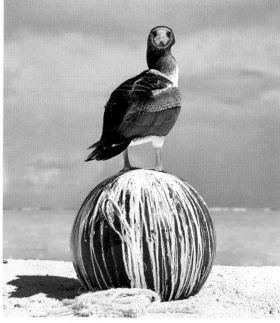

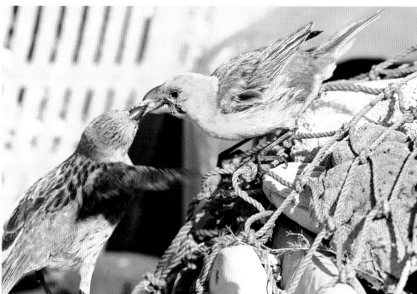

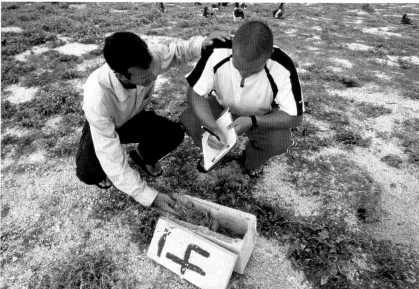

bites between her toes, which prevented her from putting on her dive booties. Without doubt, the ticks were a most unpleasant aspect of island life.

Heat and glare prevailed on our second day; there was no wind and the sea looked flat. Diving into the water provided our only relief; it felt wonderful, but we had to be on the watch for tiger sharks, while also taking care not to disturb monk seals swimming by.

In the morning I photographed the marine debris team in action pulling a net off the reef. This net had holes in it, and had been intentionally tied in knots and thrown overboard as waste. It was not lost, as some nets are, but rather discarded in a form of marine littering. The marine debris team was coincidentally working at Pearl and Hermes during our stay; based aboard the chartered vessels *Ocean Fury* and *Islander,* team members work off Avon inflatable boats which are dispatched from the ships. Later that day, I followed and photographed the Fish and Wildlife Service team setting up the finch condos, which we all hope will clear the way for

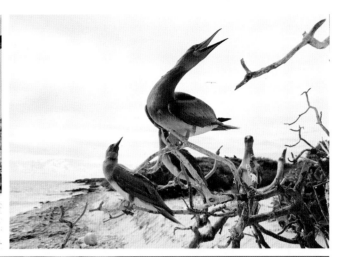

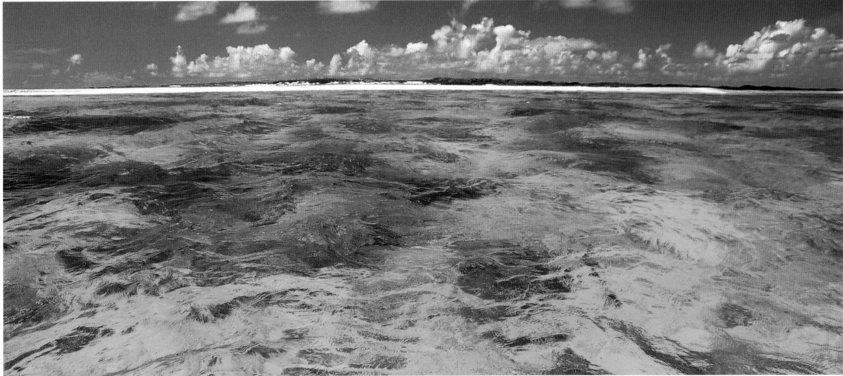

the verbesina to be systematically pulled out by hand. The good news: Condos set up the year before were currently occupied by nesting finches.

Still later, I returned to a brown booby nesting colony I had seen earlier, and lay down with my equipment to watch and photograph them. They are my favorite seabirds, with their elegant, dark-brown and white plumage. They have dark helmets, a straight horizontal line of demarcation between brown and white on their chests, and lovely, pale-green feet—all in all, a ravishing sight. Of all the seabirds in my experience, they are the least comfortable with the human presence, so I moved slowly and quietly, keeping my distance and staying close to the ground. Unaccustomed as they are to people, their incentive is to stay put when they are sitting on nests, and I didn't want them to feel threatened.

The following day, Stephani took pity on me and arranged for one of the debris team's Avons to transport us into the watery realm of the atoll. She seemed to feel that my time on

Pearl and Hermes would be impoverished unless I had a glimpse of the marine environment, with its own distinct life and energy. I was thankful for the chance to leave the island for a bit; perhaps I was experiencing a touch of island fever on this small, flat, hot, exposed piece of land, where the inside of my sweltering, airless tent provided the only shade.

We climbed into the Avon and entered the interior of the atoll, a place that would utterly change my understanding and appreciation of the Northwestern Hawaiian Islands. Skimming across the surface of calm, transparent water illuminated by blue-green light, we could see clearly the shapes, patterns, colors, and creatures of the reefs as we passed over them—my first look at the intricate, sunken kingdoms beneath the surface. This, for me, would be the defining experience of Pearl and Hermes. Through the looking glass I beheld another world, a tiny part of one of the planet's last large, healthy coral reef systems.

As the Avon hit shallow water, we jumped onto another islet in the atoll, Seal Kittery, which we explored and photographed for almost four hours. The island has two lobes, the largest being essentially barren (we counted four plants) but heavily populated by large albatross chicks. To my delight, *Solanum nelsonii,* a rare native plant on the endangered species list, covered the island's smaller lobe. This likely represents the largest population of the plant existing anywhere on Earth, and it provided an image of what Hawaiian coastal areas might have looked like in pre-human times. We happily collected mature seeds for propagation.

Several monk seal moms basked on the beach with their fat pups, so we walked quietly and kept our distance. Beautiful and pristine, Seal Kittery is also austere; its unrelenting sun and blinding white sand conspired with a total lack of shade to drive us into the crystal-clear water as we waited for the Avon. All too soon we were forced to evacuate when Stephani spotted a large tiger shark cruising toward us. She said quietly, "Susan, move toward me; we'll look bigger, and then we'll just back up onto the beach." Enough said.

LISIANSKI

On May 18, 2003, I visited Lisianski for the first time. The NOAA ship *Oscar Sette* was cruising up the Northwestern Hawaiian Island chain, re-supplying field camps with provisions and personnel, and I received permission to go ashore—with all-new quarantine clothing and gear—along with Alex Wegmann, who served as my guide. His chief concern, appropriately, was to protect the seabirds, monk seals, and turtles from our intrusion.

Lisianski instantly impressed me with its lush native vegetation, an ecosystem I recognized by this time. A vast prairie of characteristic bunchgrass, *Eragrostis variabilis,* dominated the landscape, along with the most vigorous bright green naupakas I had ever seen. The island struck me as one of the most pristine of all the Northwestern Hawaiian Islands; it is also one of the least visited by people. I was surprised to learn later that Lisianski had been devastated by rabbits during the early 1900s. Probably introduced via Laysan, the rabbits apparently consumed all the vegetation and then, inevitably, began to starve, leaving the island a desolate wasteland by 1915. With the demise of the rabbits, the resilient vegetation revived.

During our four hours on Lisianski, we walked nearly halfway around the perimeter carrying heavy packs in blistering heat and blinding sun. At a rock outcropping next to a small cove, I set up the Hasselblad on a tripod and made a series of images to create a panoramic vista—a scene that had been described to me as distinctly Lisianski. Most of the elements occur elsewhere, but

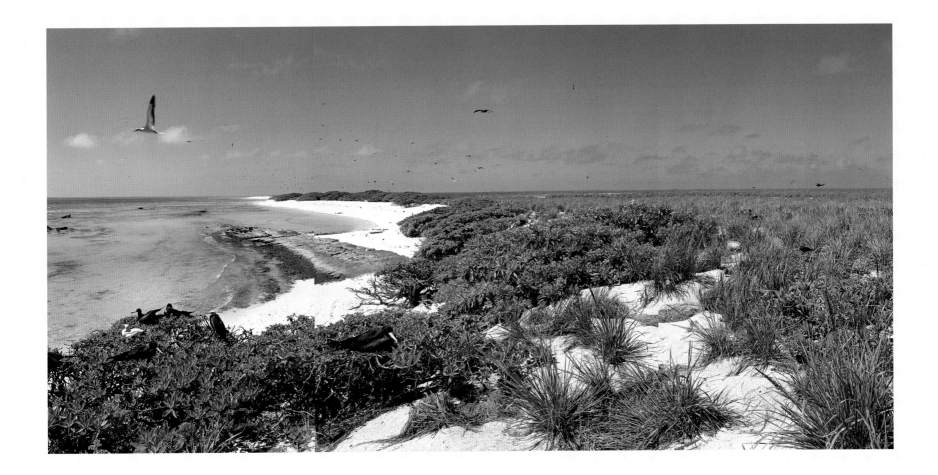

only here do they converge with such lushness, and only on Lisianski is the shoreline nipped into a cove. Frigatebirds flew overhead and nested in the naupaka bushes in front of the camera; on the beach below, monk seals drowsed in the company of sea turtles.

Our companions on the walk back included brown noddies, white terns, albatrosses, masked boobies, and red-footed boobies. A frigatebird even tried to steal my hat, and I noticed that, on Lisianski, these birds seemed to be more inquisitive than those on other islands, perhaps because they see fewer people. I would have liked to extend our visit here, but as it was we just made it back to camp in time to jump into the last Zodiac on its return to the ship.

Luckily, I had two more opportunities to visit Lisianski, during another cruise to Kure Atoll on the *Oscar Sette* in May of 2004, and again in September of that year, on the NOAA ship *Hiʻialakai.* Each visit lasted approximately three hours, and David and I were both able to go ashore to photograph, accompanied by the curious frigatebirds who swooped down to investigate our presence. I walked the circumference of the island on these visits, staying high enough on the beach to keep a respectful distance from the snoozing monk seals, and also taking care to avoid the veritable minefields of bird burrows that permeate the interior of the island. On the third visit, I was deemed sufficiently indoctrinated in island protocol to be trusted to act as my own guide. This privilege allowed me to be alone, fully immersed in the ensemble of life on this remote island—out of all those in the northwestern chain, perhaps the most intact, the least disturbed. I sensed being surrounded by a great symphony of life, where all the members of the orchestra were present, performing their parts to perfection. The miracle was feeling myself recede, and then recognizing myself in the plant and animal life unfolding all around me.

OPPOSITE: A masked booby chick sits on the beach at Lisianski island.

ABOVE: Nesting frigatebirds overlooking a peaceful cove, and a prairie of native bunchgrass (*eragrostis variabilis*) present a panorama distintively Lisianski.

FOLLOWING PAGES: Performing their intricate and curious courtship dance, black-footed albatrosses display precisely choreographed postures including bill touching, upward head thrusts while standing on their tiptoes, staring at each other, each partner nibbling under one wing simultaneously, bobbing and shaking their heads, walking around each other; all accompanied by an elaborate repertoire of sounds: whinneys, whistles, grunts, wails, sky moos (heard when their bills are thrust upward), and bill clappering which sounds like castanets. Black-footed albatrosses spend most of their lives over the waters of the Pacific Ocean, and come to land primarily to dance, establish a lifelong pair bond, breed, and raise their young. Finding a compatible partner to engage in the energetic and sometimes aggressive courtship dance establishes a successful pair bond.

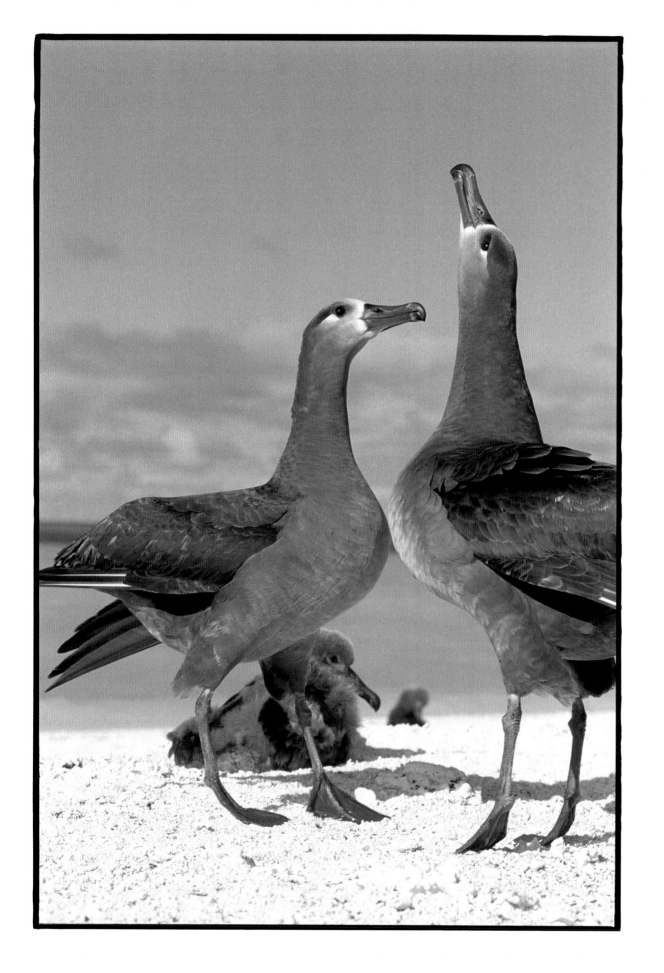
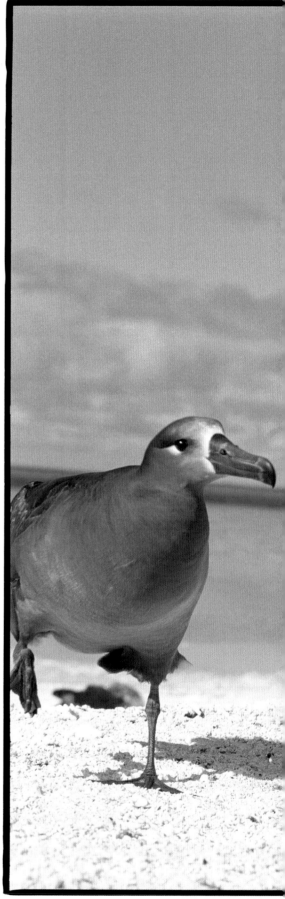

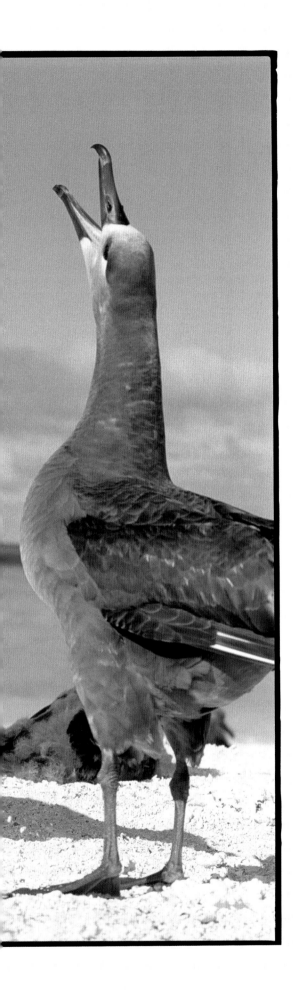

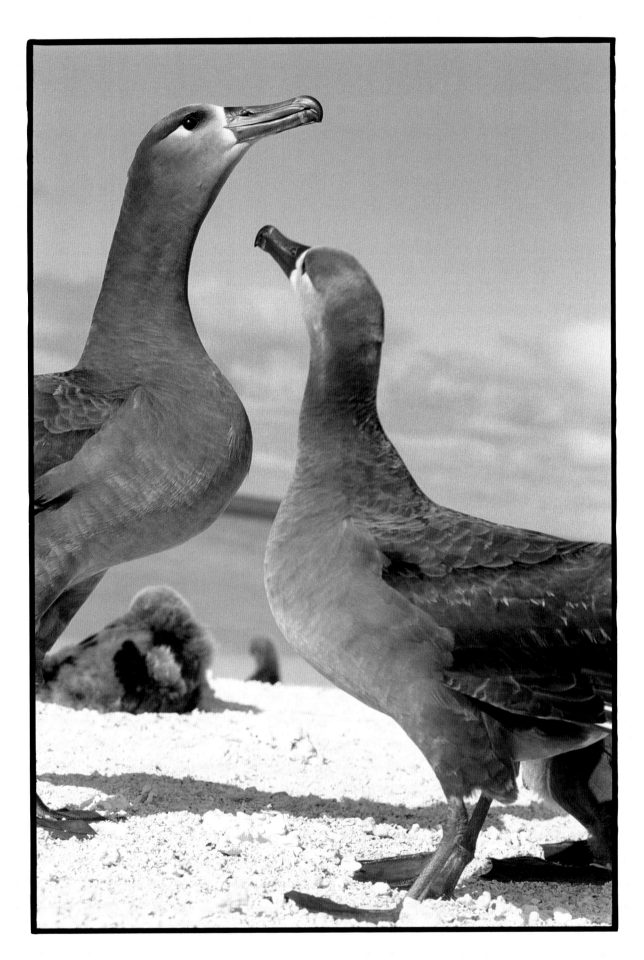

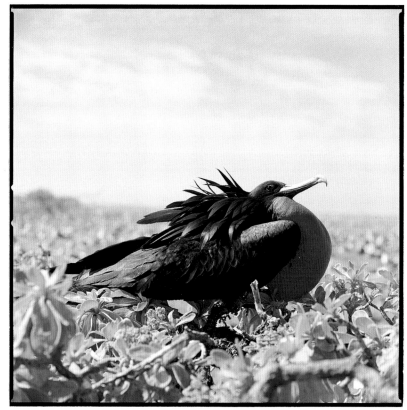

Great Frigatebird ~ 'iwa
Fregata minor palmerstoni
(males this page, juvenile opposite)

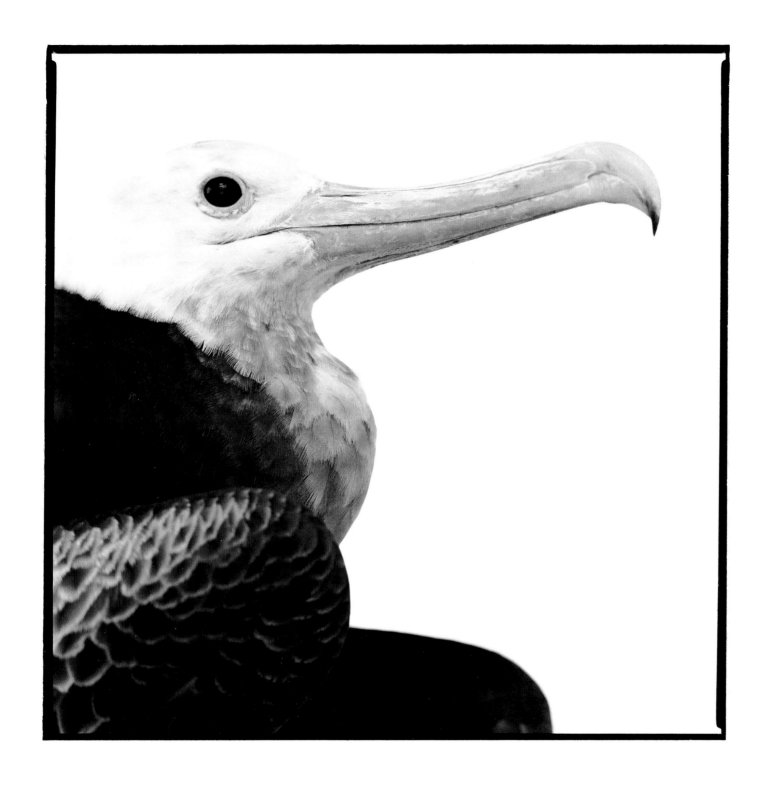

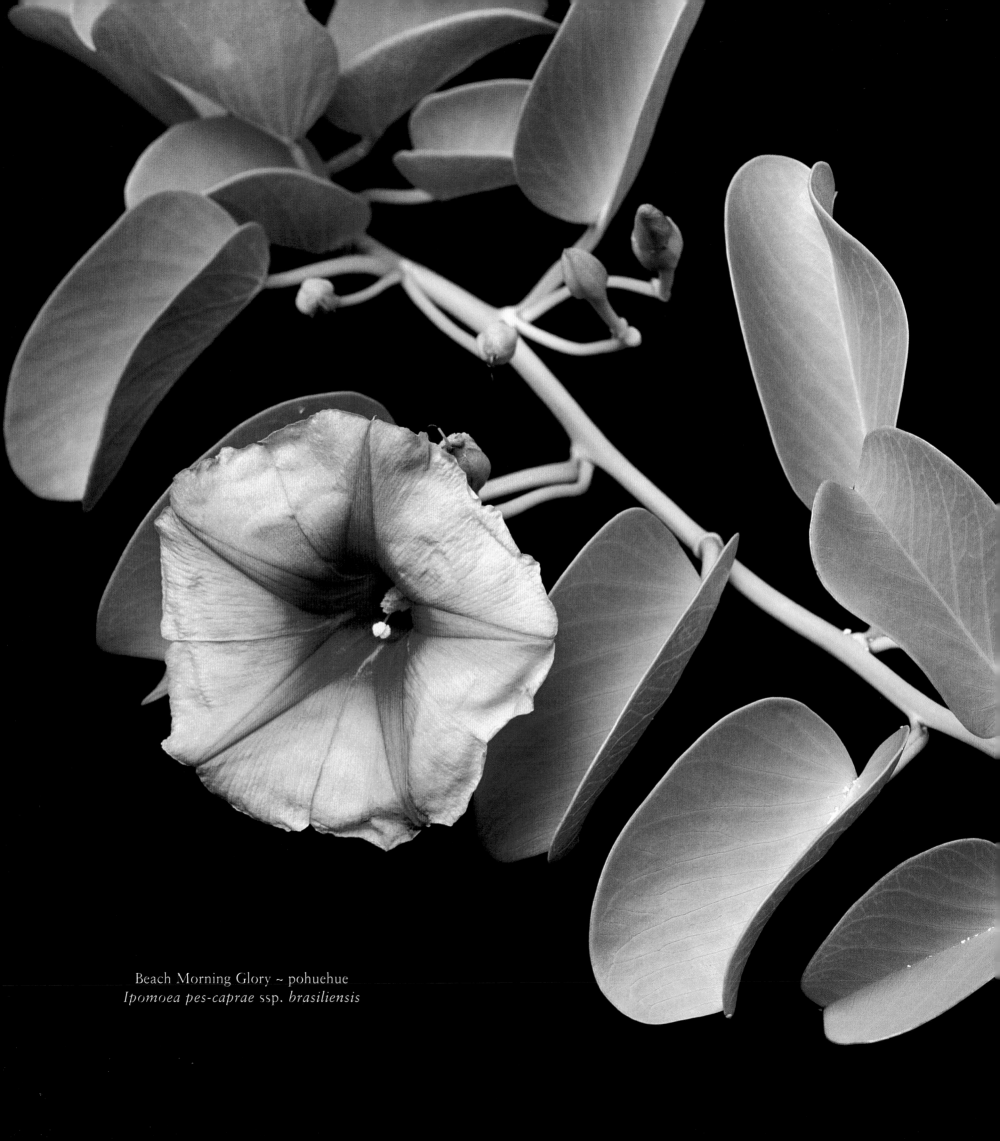

Beach Morning Glory ~ pohuehue
Ipomoea pes-caprae ssp. *brasiliensis*

Pōpolo
Solanum nelsonii

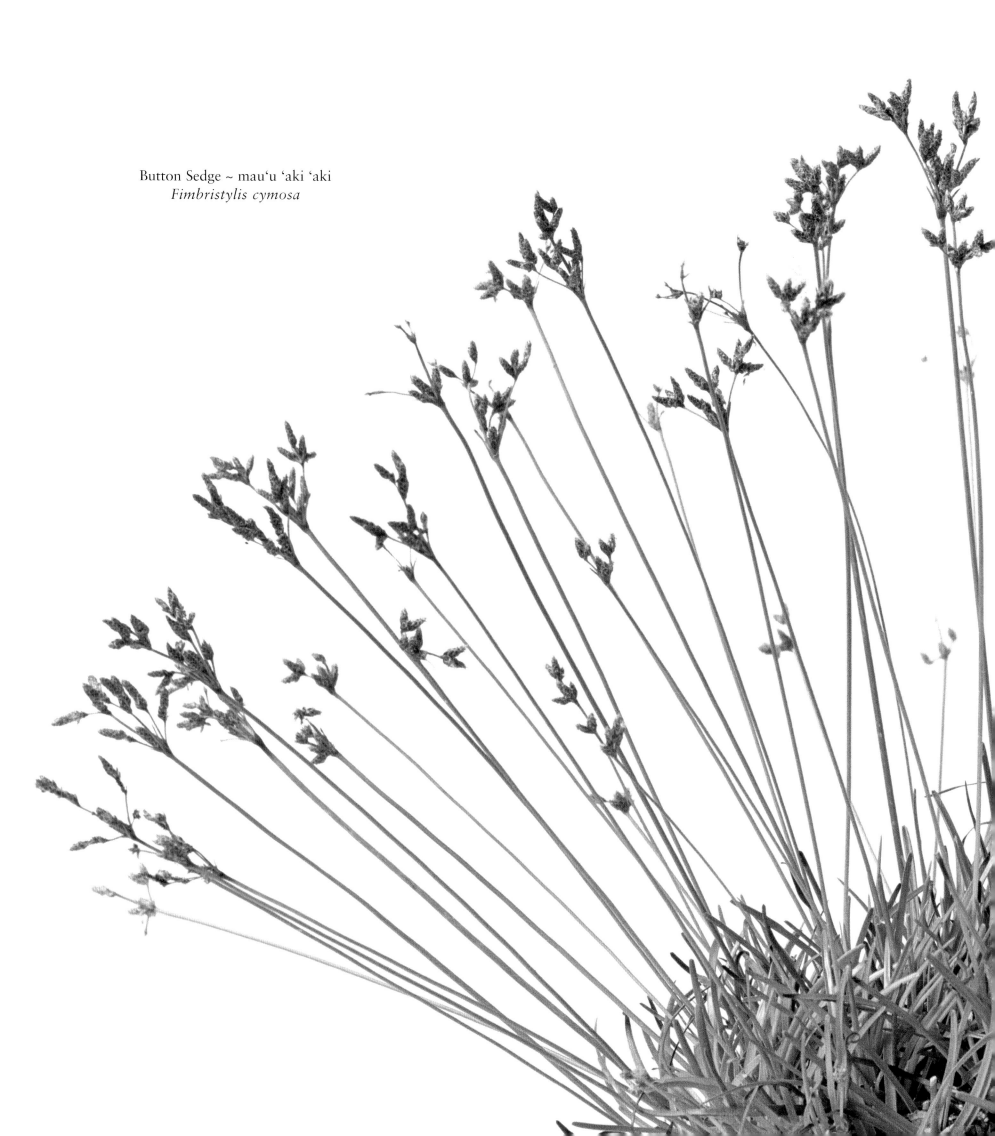

Button Sedge ~ mau'u 'aki 'aki
Fimbristylis cymosa

Midway Atoll ~ Pihemanu

28°15'N, 177°20'W

by Susan Middleton

For the last hundred years, Midway has been a story about people as well as about wildlife, and in this way it differs significantly from the other Leeward Islands. Tern Island, in French Frigate Shoals, and Kure Atoll each supported Coast Guard LORAN stations, but they have nothing like the extensive and complex history of human occupation that Midway has experienced.

Midway's saga of human contact begins with shipwrecks and castaways during the last half of the 19th century, eventually leading to the formal establishment of a population whose goal was to link and maintain the first trans-Pacific cable in 1903. The handsome cable buildings still stand, though in an advanced state of disintegration. During the mid-1930s, Pan American Airways developed the Clipper seaplane operation on Midway, which was soon followed by the U.S. Navy and the construction of a Naval air station. All this activity brought over ten thousand people to the island, and a rush of civilization.

Military operations here changed after World War II. Although Midway remained an important base during the Korean and Vietnam Wars, the population declined to around 3,000 servicemen and their dependents. Final withdrawal of military personnel occurred in 1997, when Midway was officially designated a National Wildlife Refuge and National Historic Site, and authority for the island was transferred to the U.S. Fish and Wildlife Service (USFWS). Midway's current population fluctuates between thirty and fifty people, depending upon seasonal activities. Three full-time USFWS personnel live here, in addition to volunteers; Chugach McKinley employees, primarily from Thailand, make up the rest of the population. The USFWS has contracted Chugach McKinley to maintain infrastructure, including the airport, buildings, roadways, and grounds. Even though Midway's heyday of human occupation has passed, it remains a vibrant small community, largely defined by the rich culture of the resident Thai population. They create elaborate floral wreaths to commemorate Memorial Day, Veterans Day, and the Battle of Midway, and invite everyone on the island to participate in colorful celebrations of their own holidays.

Laysan Albatross ~ moli
Phoebastria immutabilis

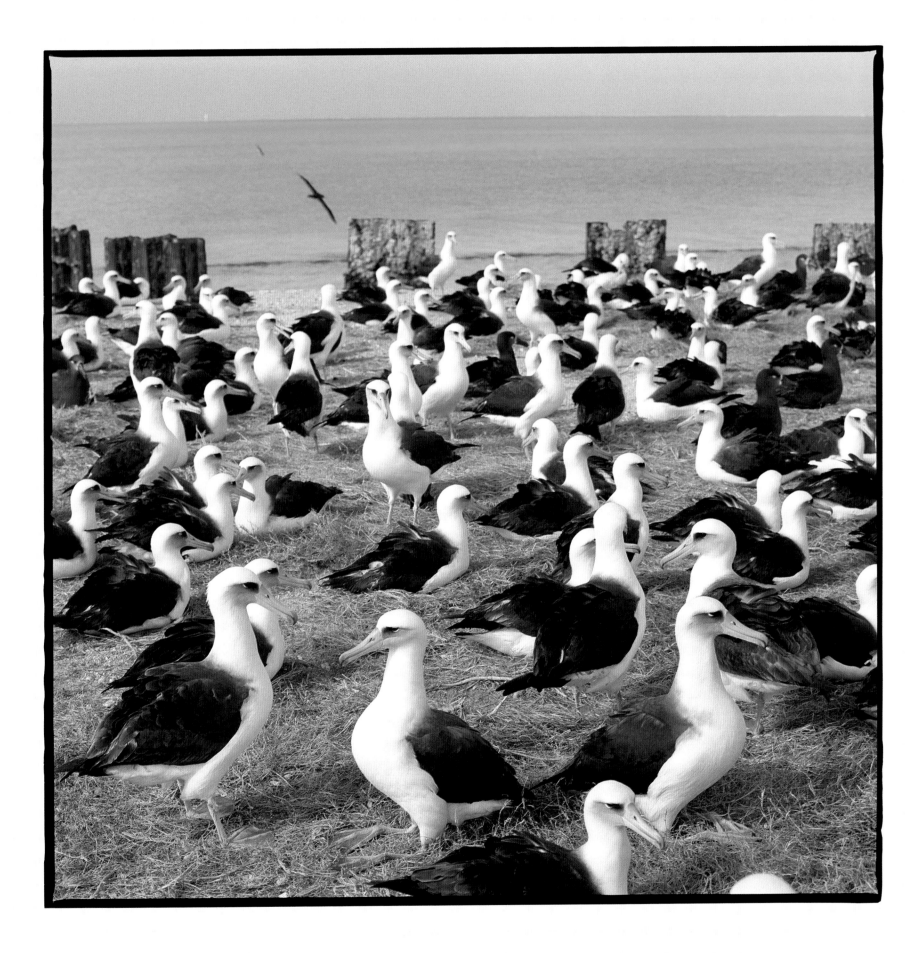

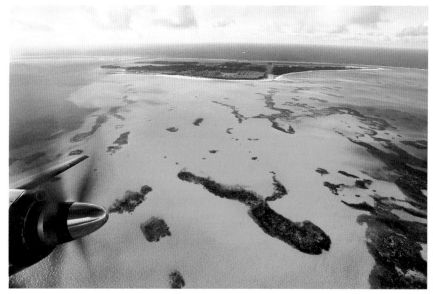

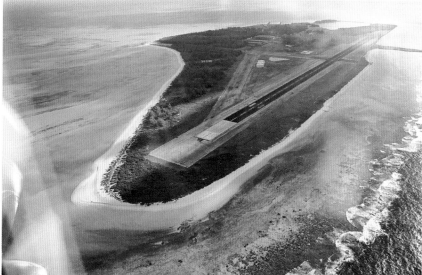

ABOVE, top left: Sand Island, Midway Atoll, and the surrounding lagoon, from the chartered G-1 airplane that re-supplies Midway with provisions and personnel. The dark patches in the lagoon are coral reefs. Top right: preparing for landing on the runway at Sand Island, Midway Atoll, showing the runway and the fringing reef. Middle left: World War II Memorial commemorating the Battle of Midway on Eastern Island. Middle right: Island residents celebrate the anniversary of the Battle of Midway. Right: Chavensak Phosri, who has lived on Midway for over 20 years, is station engineer for water operations. Water is collected off the runway and held in these massive tanks (each capable of holding over four million gallons), then processed, purified, and tested.

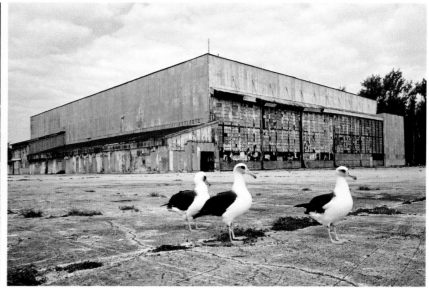
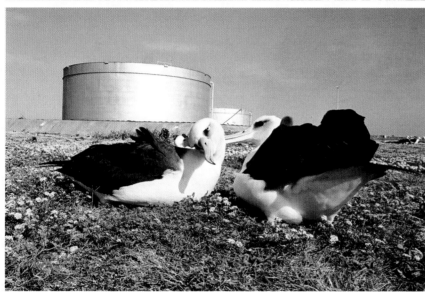
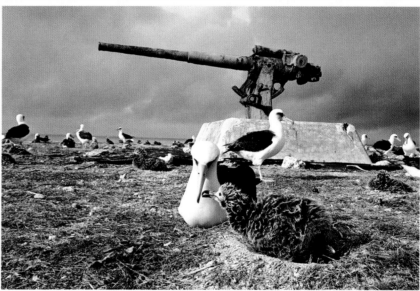

It was dark when we first arrived on Midway in early February 2003, but outside the airplane windows we were astonished to see countless white dots alongside the runway. Mike Johnson, Assistant Refuge Manager, explained: "Those are the famous gooneys sitting on eggs in their nests!" Laysan albatrosses have long been affectionately known as gooneybirds on Midway. After helping us round up our gear in a golf cart, Mike escorted us to our accommodations: a one-story cinderblock duplex built in the 50s. The front yard was crowded with gooneys sitting in nest bowls made of sand and grass. As we carried gear up the cement walkway to our front door, Mike aimed his flashlight at the white breast of a gooney next to our feet. He coaxed it to stand up, revealing a large white egg. "So your chick hasn't hatched yet; how about you?" He shone the light under another gooney across the walk, revealing a fluffy, little brown chick surrounded by pieces of eggshell. I was mesmerized; I had never been around wild birds that did not flee at the sight of me, unless I had a bribe of food. And these birds were everywhere! Nest building is discouraged only on roadways (and of course on the runway), but it's sometimes tolerated even there if an egg has been laid and vehicles can move safely around it. I was excited

ABOVE, top left: Laysan albatross chick sits in front of officers quarters designed by Albert Kahn and built during the early 1940s, currently occupied by USFWS personnel. Top right: Laysan albatrosses stand in front of the historic WWII seaplane hangar on Sand Island. Bottom left, Laysan albatrosses preen next to jet fuel tanks, and a Laysan albatross chick, bottom right, begs for food by a memorial gun emplacement on Eastern Island.

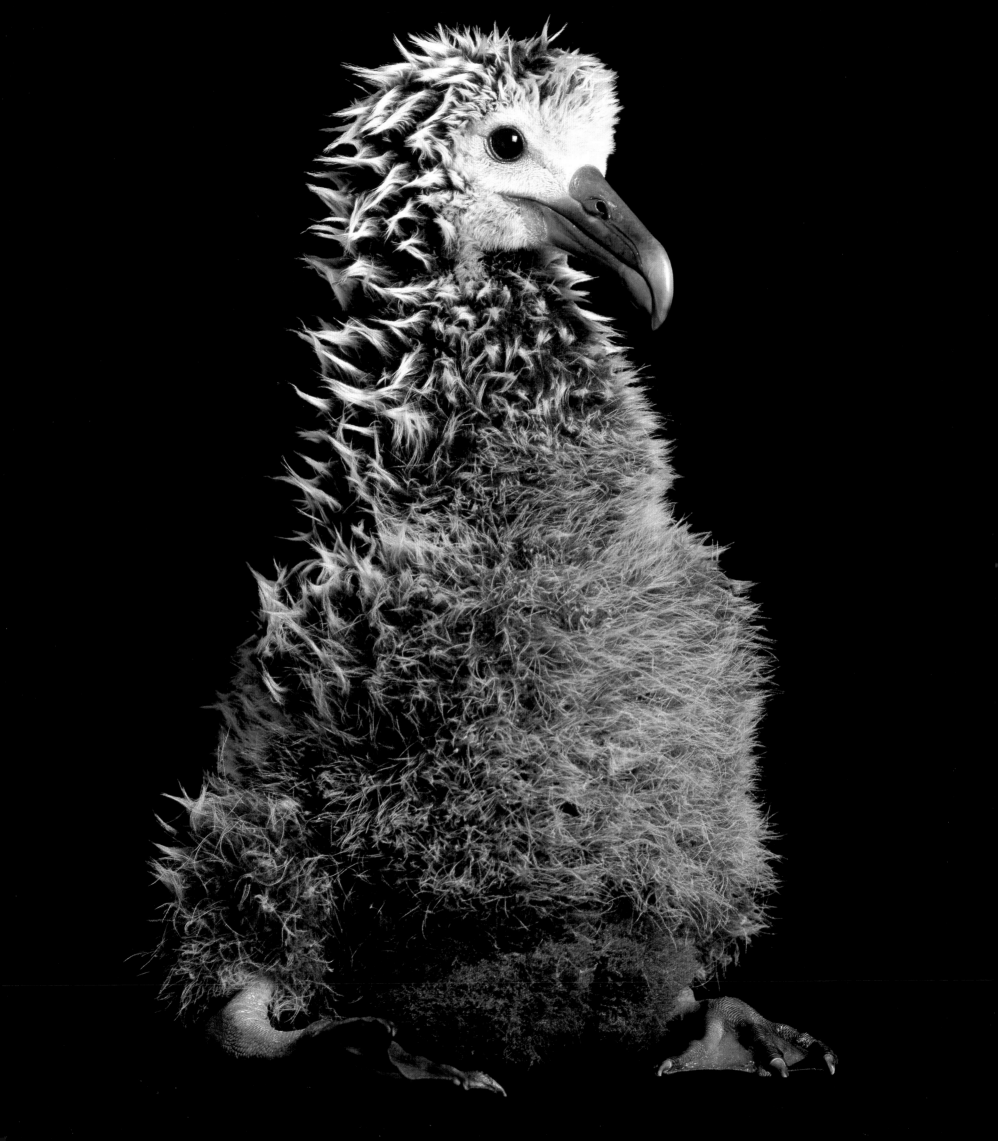

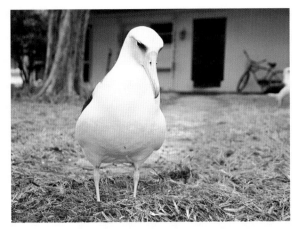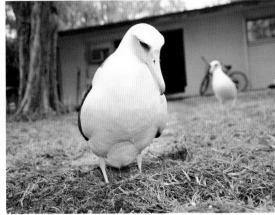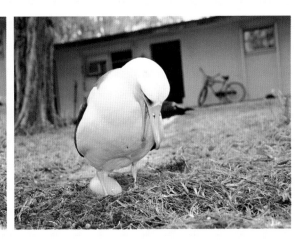

to meet our new neighbors and to see them up close. Our five-week stay would allow us to get to know them, to watch their chicks hatch and grow.

Almost like a ghost town, Midway has a general air of dilapidation. Once a thriving one-company town, it's now a skeleton operation with two primary goals: to manage Midway for the benefit of the wildlife, and to keep the airport open for emergency landings. In effect, this airport functions as the only gas station in the middle of the Pacific. Much of the infrastructure departed along with the Navy, but many buildings remain: barracks, officers quarters, airport facilities, power plant, movie theater, gym, infirmary, library, and the All Hands Club—a bar and pool hall. Some buildings are used and maintained; others are abandoned. Some have historical significance, including the cable station buildings, seaplane hangar, and gun emplacements. Several memorials commemorate the Battle of Midway and pay tribute to those who lost their lives during World War II.

During our visit, it struck me that the gooneybirds have reclaimed the island, and have truly won the battle for Midway. Roughly one million albatrosses arrive in the fall to dance, breed, build nests, lay eggs, and raise their young, a process that culminates in successful fledglings leaving the atoll the following July. Between July and October, the island seems quiet and lonely—some think calm—and it's a good time, in fact the only time, to work on the grounds before the next wave of albatross nesting.

Midway hosts the world's largest colony of black-footed albatrosses. Two individuals from the short-tailed albatross species, known as "golden goonies" for their silky golden heads, have returned to Midway each season for many years. Unfortunately they are not a breeding pair, and in fact, last year only one returned. Biologists hope to see the establishment of a local population of short-tailed albatrosses, since this magnificent bird has declined from being the most abundant albatross in the North Pacific to a current population of less than 2,000 birds. We visited the place on Midway where the golden gooney returns every year; how sad to see this spectacular bird searching in vain for a dance partner, repeatedly rejected by the Laysan and black-footed albatrosses, who will only dance with their own kind.

In addition to the albatrosses, a dozen more species of seabirds nest on Midway Atoll each year—altogether nearly two million birds. Within the Hawaiian Islands, Midway has the largest nesting colonies of white terns, black noddies, and red-tailed tropicbirds. Accordingly, most of our photographic work here focused on seabirds, and especially the chicks. Throughout the

OPPOSITE: Laysan albatross chick rescued from drowning in a flooded nest; we dried it off, warmed it up, and then returned it to the nest after the flood. It became known as "Soggy."

ABOVE: Laysan albatross lays an egg in our front yard on Midway. Below: A giant plaster albatross stands as proof that gooneybirds hold dominion over Midway.

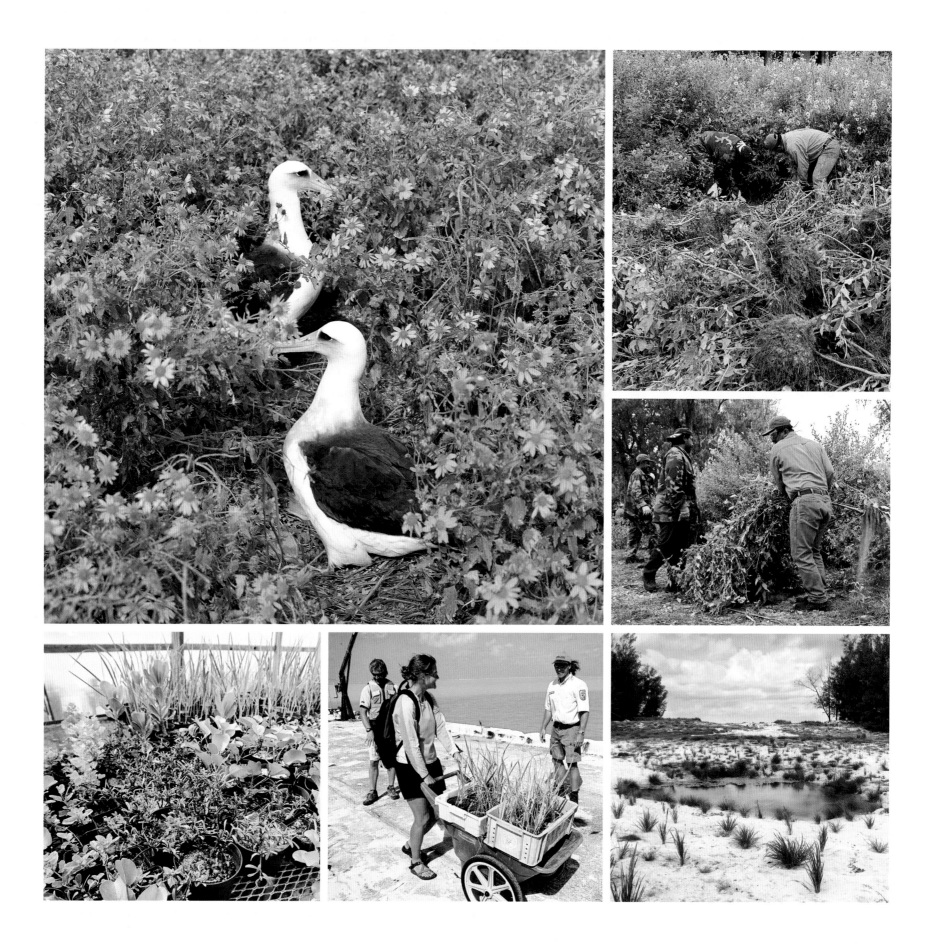

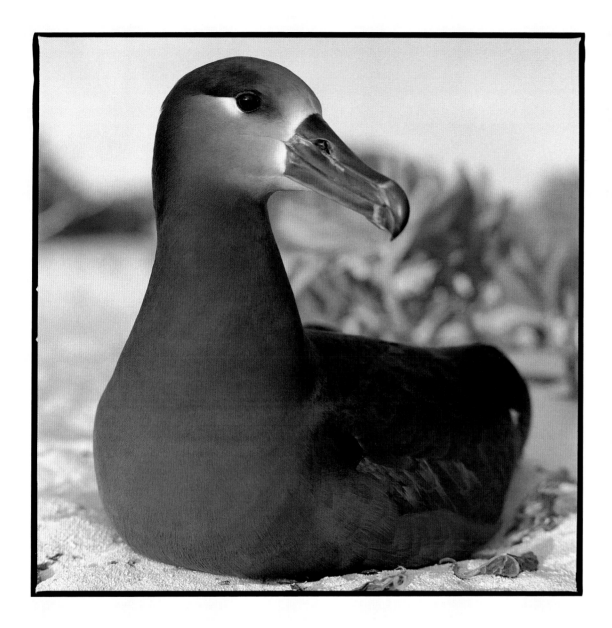

process we followed refuge biologist John Klavitter's advice, handling the chicks for only short periods of time while their parents were off fishing, and keeping them close to the safety of their nests.

Over the past century, the human inclination to alter places to our liking has eroded Midway's native terrestrial ecosystem. With no quarantine protocols in place, planes, boats, and people come and go. The native species that survive are hopelessly mixed with numerous exotics, including canaries, myna birds, and a plethora of alien plants and insects. Since our work's focus was on native flora, fauna, and habitat, we had not expected Midway to be fruitful for us, and we were surprised to discover quite the opposite. Thanks to the eradication of rats, which had been introduced during World War II, ground-nesting birds have returned to Midway, especially Bonin petrels. The USFWS has made significant progress in making Midway once again hospitable to native wildlife by creating good seabird nesting habitat; working on the removal of destructive alien species like verbesina, or golden crownbeard, which crowds out the native vegetation; and cultivating indigenous plants in key areas.

OPPOSITE, top left: Laysan albatrosses are engulfed by the invasive alien plant verbesina, which overtakes critical nesting habitat. Top right and center right: everyone on Midway participates in weed pulls, removing verbesina by hand to clear areas for seabird nesting. Bottom left: Indigenous plants are cultivated in a native-plant greenhouse. Bottom center: Native bunchgrass (*eragrostis variabilis*) is being transplanted from the greenhouse to restore native habitat for the Laysan ducks. Bottom right: The duck seep, excavated by USFWS personnel and volunteers, was planted with native bunchgrass.

ABOVE, top left: Lit by the setting sun, a black-footed albatross sits on an egg at Frigate Point on Sand Island. Top right: Now known as the Ave Maria shrine, this remnant of the military chapel hosts congregations of white terns. Bottom right: Susan reviews polaroids during a white tern photo shoot.

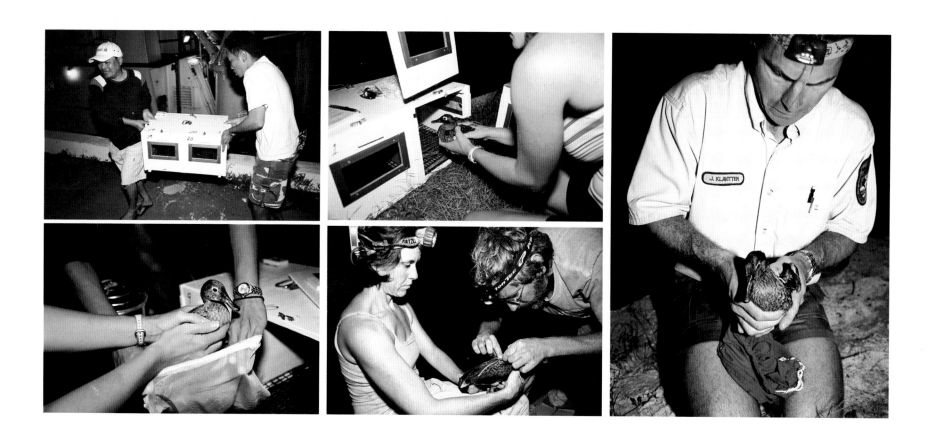

I was fortunate to witness the arrival of 20 Laysan ducks that were translocated from Laysan Island, part of a project to create another population of these extremely rare birds as a hedge against any calamity that might befall them on Laysan. During the previous year, duck seeps had been excavated on Midway and native vegetation planted around the seeps, including makaloa plants brought from Laysan to make the ducks feel at home. Aviaries were constructed to house the new arrivals until they were ready for release. The ducks arrived on the chartered vessel *Island Fury* late on an October night. A team of experts accompanied the ducks, and a Midway team joined in to get the ducks settled in their new homes, a process that continued until morning. The ducks were handled with tender loving care, up until the moment when John Klavitter gently removed each one from its bag, carefully holding it in cupped hands while he lowered it into a large dish of water in the aviary, and then let it go. Nearly a year later there has been only one fatality and the ducks are thriving; they are nesting and producing healthy ducklings.

Midway affords certain human creature comforts—a roof over your head, electricity, hot and cold running water, telephone and Internet service, and, of course, convenient access provided by the airport. All of this helped facilitate our work since less time had to be devoted to survival tasks. We decided to use Midway as a base for most of our seabird work, some of the plant work and a good deal of marine work—as much as we could do that would remain representative of the Northwestern Hawaiian Islands. We set up a marine photo studio in the boathouse and ran six aquariums at once, in different sizes to accommodate different creatures and algae. Due to stormy weather, we focused on specimens from the harbor, just outside the

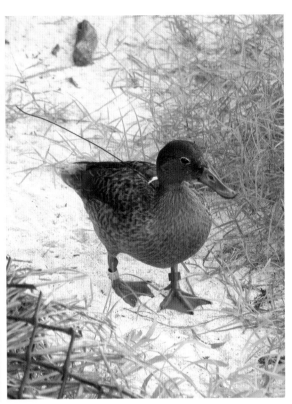

door to the boathouse. We spent more time on Midway than any other place, observing and photographing the life cycles of many of the seabirds, and reaching a greater understanding of how they live.

Successive waves of human occupation and an existing infrastructure make Midway the only place in the Northwestern Hawaiian Islands capable of extending hospitality to people. Wildlife comes first here—the gooneys reign supreme—but we humans have established a place for ourselves and have forever altered the natural environment, probably beyond any hope of complete reclamation. This haven for native wildlife, particularly seabirds, monk seals, sea turtles, and certain plants, is still the only place in the Northwestern Hawaiian Islands that can or should accommodate people, though in limited numbers and with a heightened sensibility toward the nonhuman residents.

The USFWS is exploring ways to provide public access to Midway, but the situation is a complicated one, and their primary mission remains the support of native flora and fauna. Though Midway has an airport, flights must be chartered from Honolulu, more than 1,200 miles away. Food and other goods must be brought in, and the existing staff serves the needs of the airport and the wildlife, not tourism. The logistics involved in establishing a visitor program are problematic, and in the end, Midway is a place for wildlife. Still, I would hope that it can also someday serve as a refuge for people, a few at a time, who wish to experience wildlife not as a novelty, but as the prevailing mode of life.

ABOVE: After carefully placing a duck in a dish of water, to encourage drinking, left, refuge biologist John Klavitter checks and records data. Top center: A duck receives a nutritional supplement after the long boat trip from Laysan. Bottom center: An aviary provides temporary housing for the ducks until they are ready for release. Right: A duck, bearing all its translocation regalia, takes its first walk on Midway.

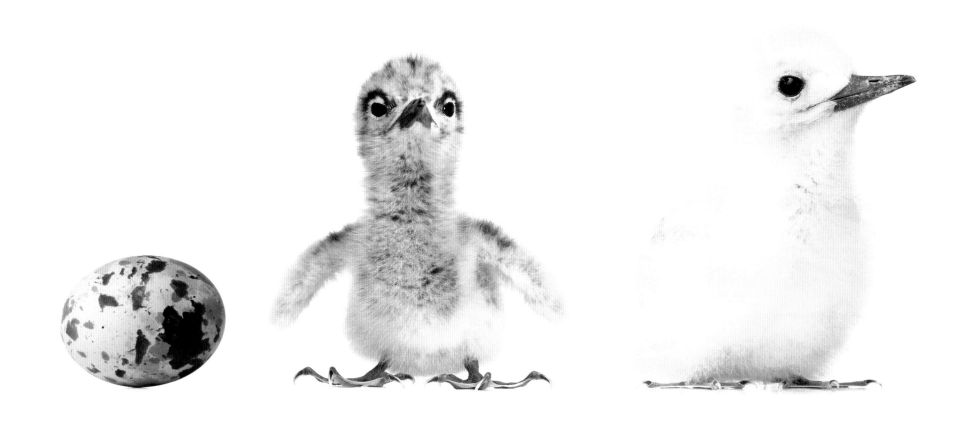

White Tern ~ manu-o-ku
Gygis alba rothschildi
(egg, two days, two weeks, two months)

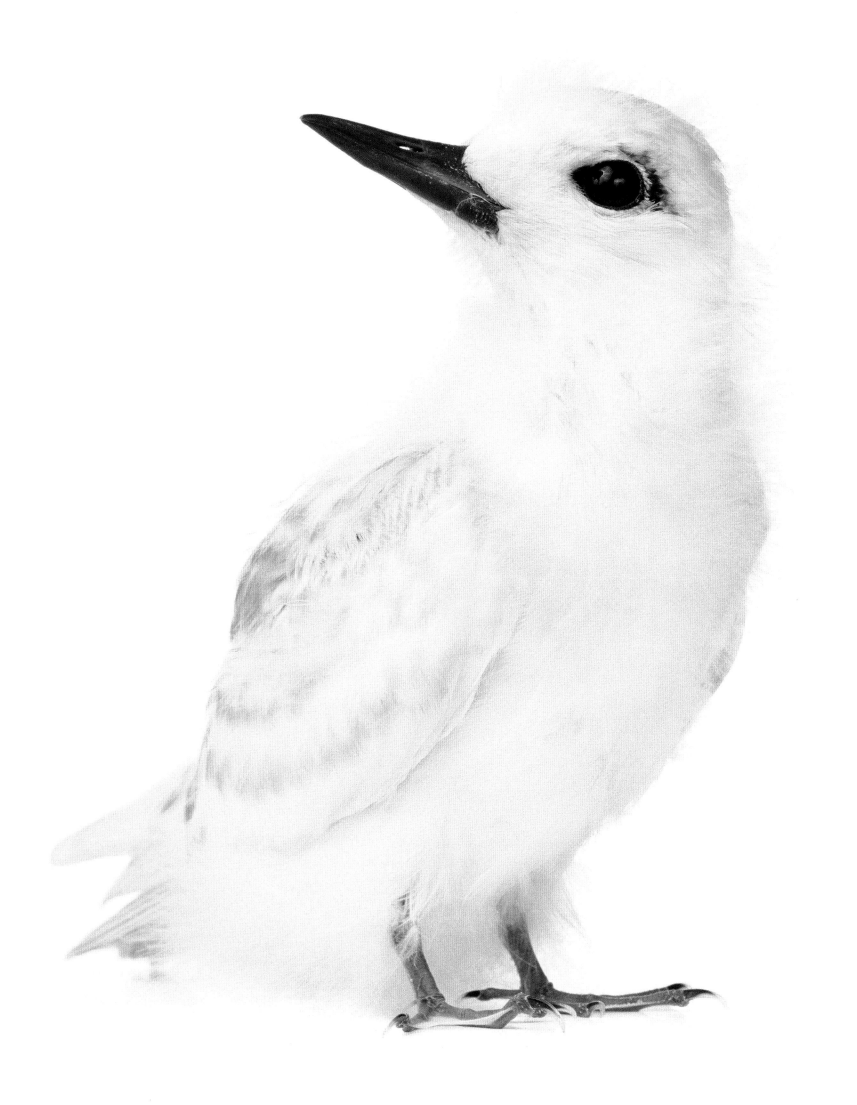

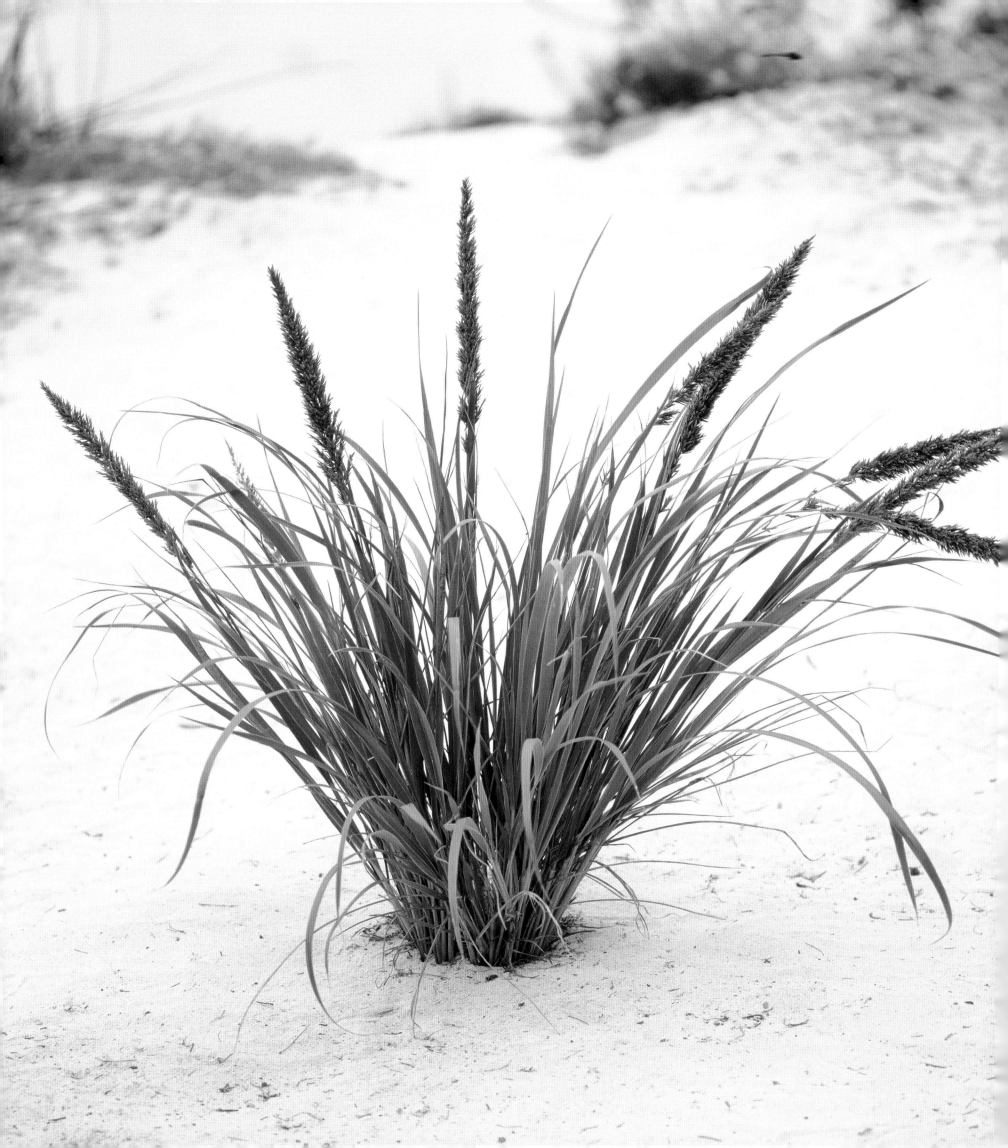

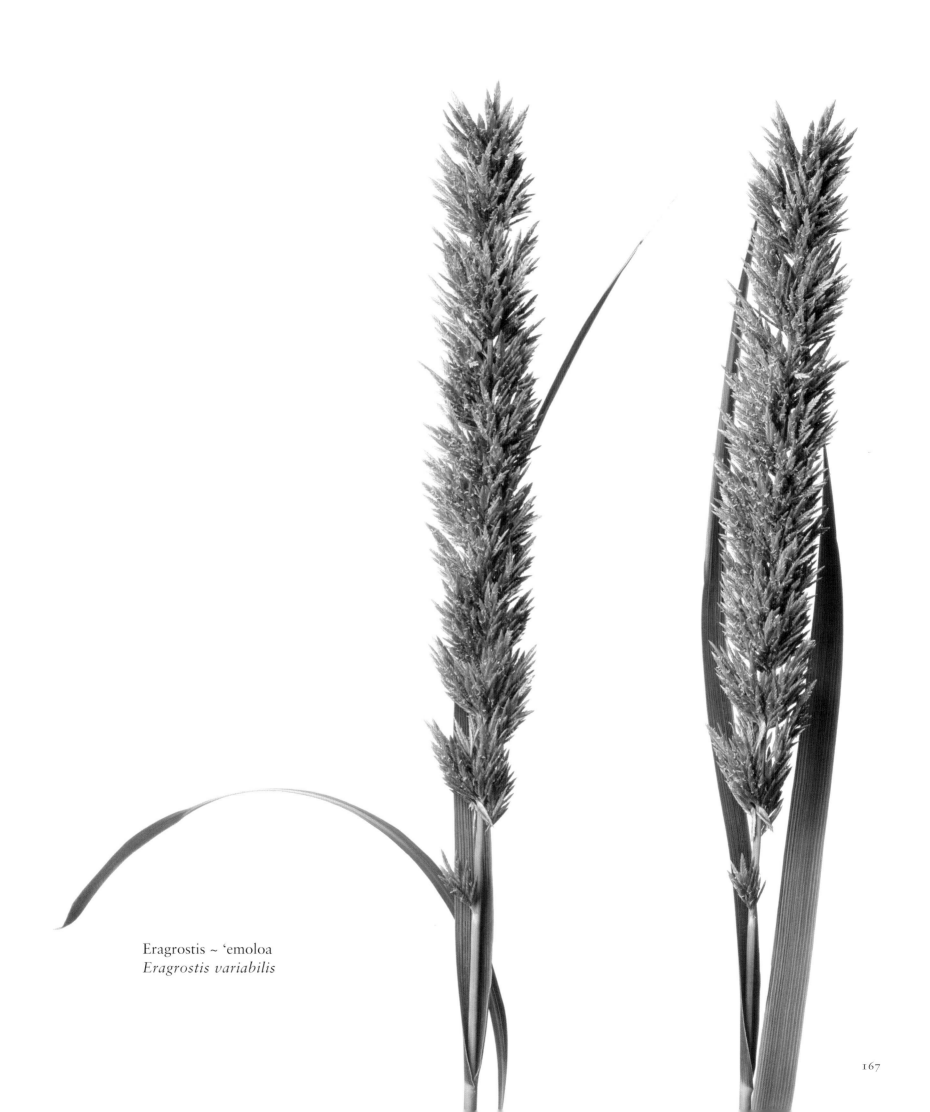

Eragrostis ~ 'emoloa
Eragrostis variabilis

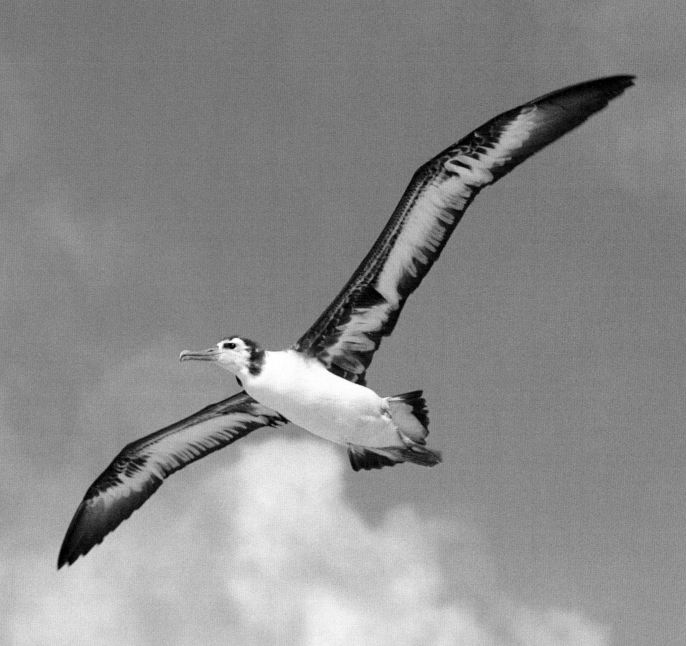

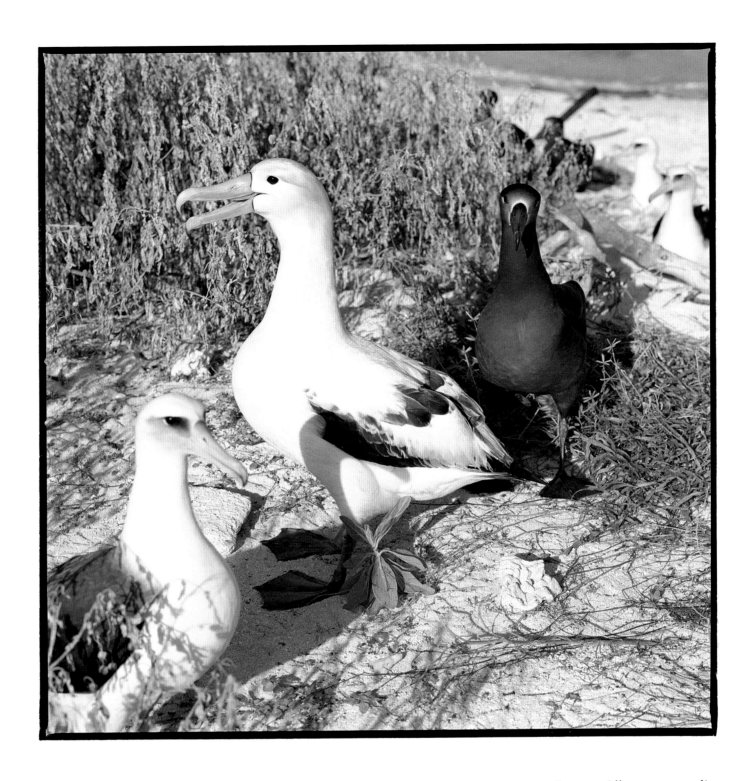

Laysan Albatross ~ moli
Phoebastria immutabilis
(opposite, fledging; above left)

Short-tailed Albatross
Diomedia albatrus
(above middle)

Blackfooted Albatross
Phoebastria nigripes
(above right)

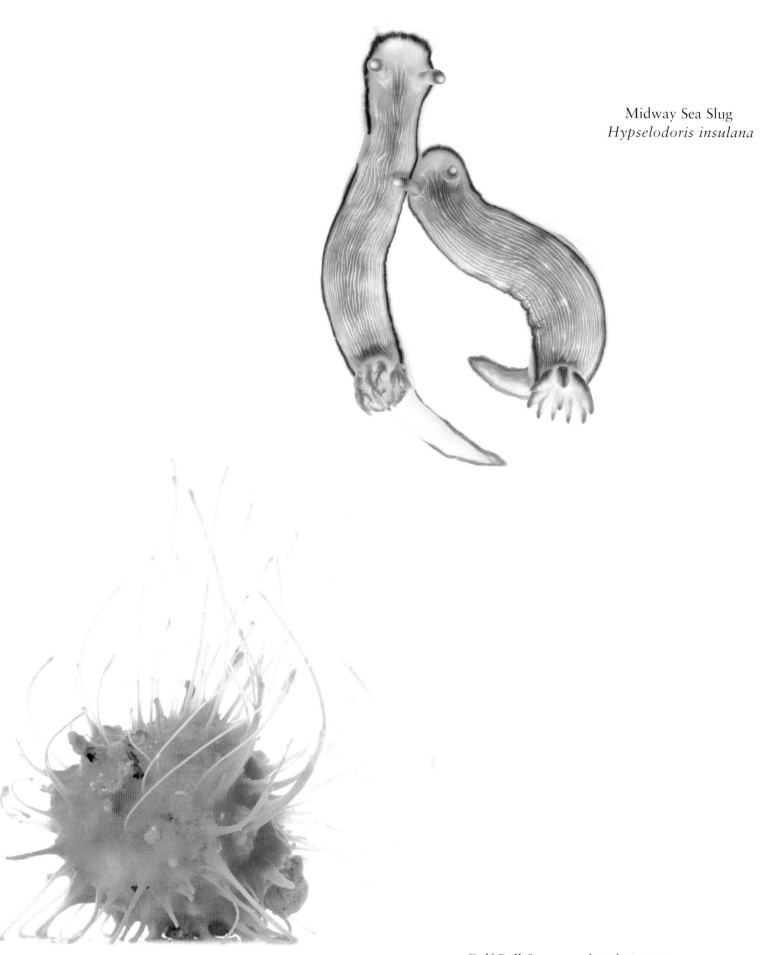

Midway Sea Slug
Hypselodoris insulana

Golf Ball Sponge ~ hu'akai, 'ūpī
Family Tetillidae

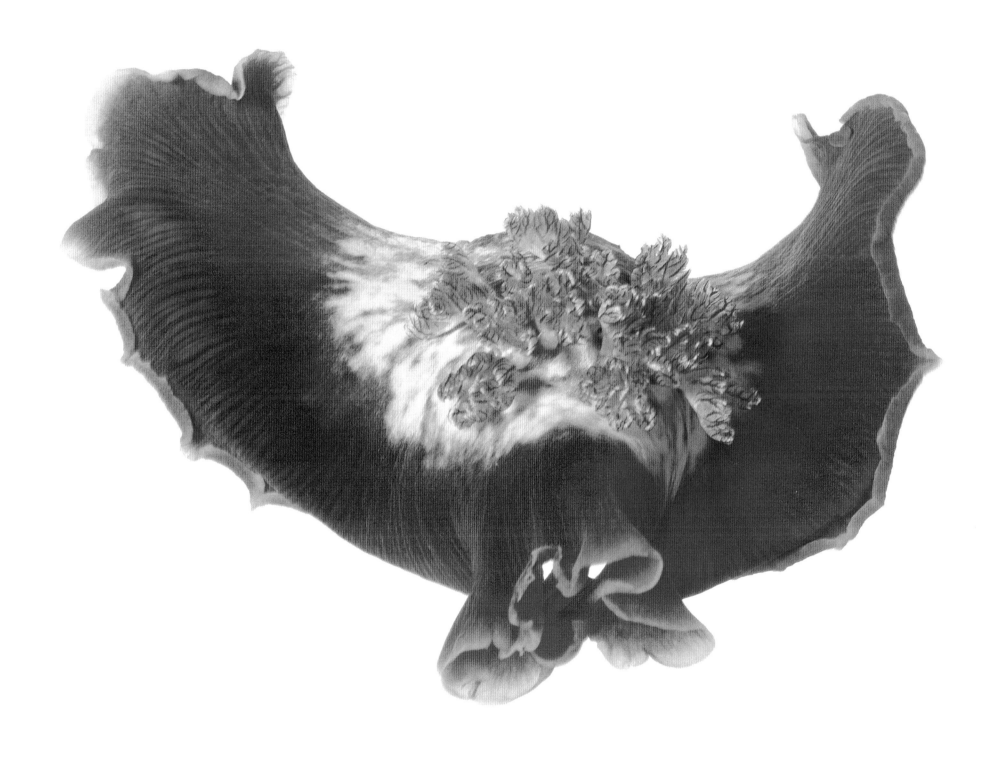

Spanish Dancer
Hexabranchus sanguincus

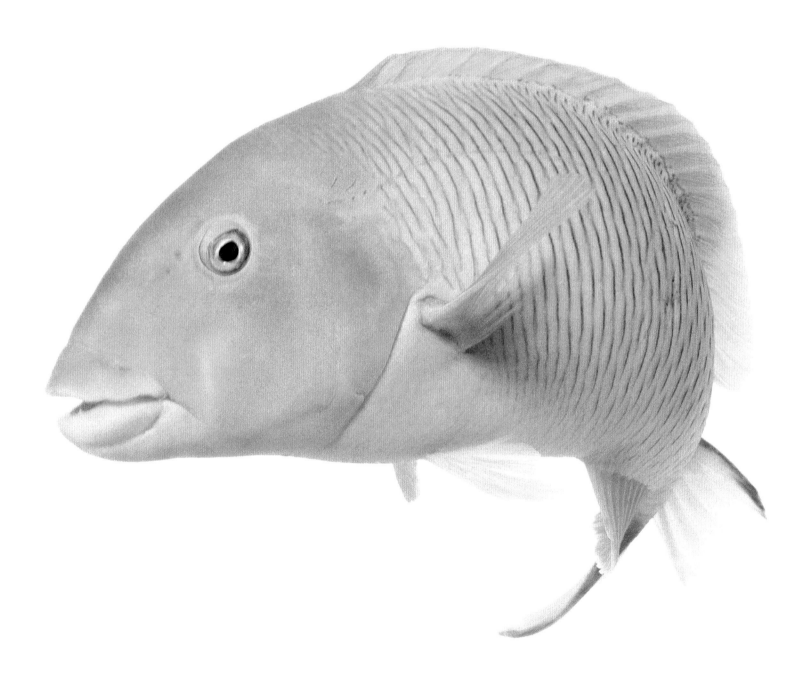

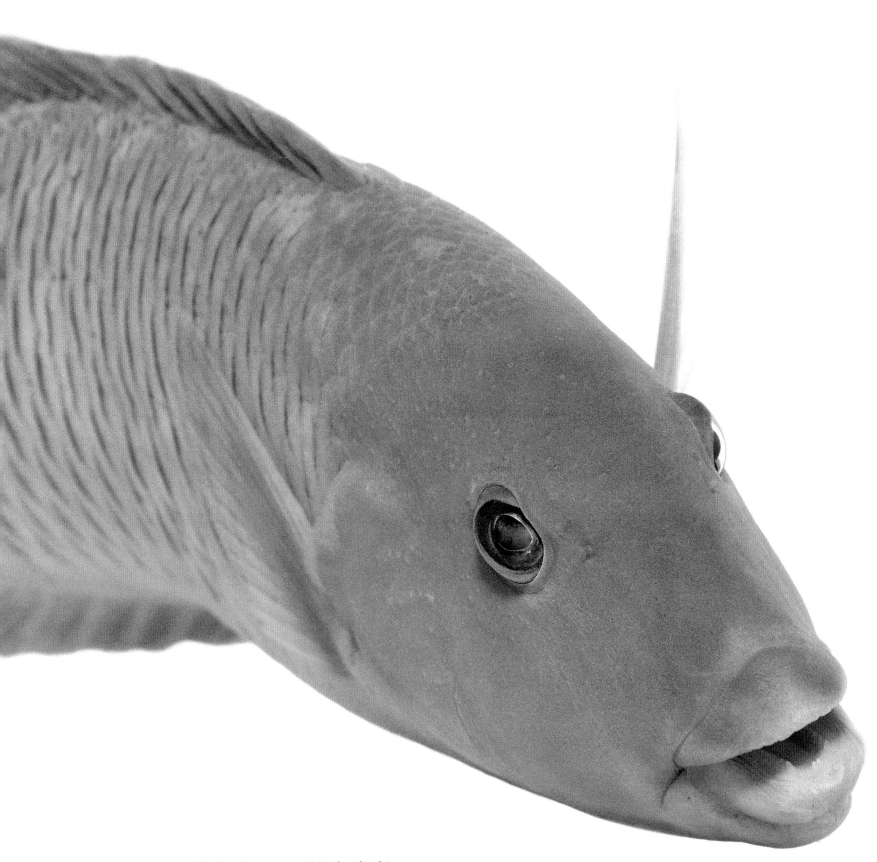

Blacktail Wrasse ~ hinālea lauhine
Thalassoma ballieui

Saddle Wrasse ~ hinālea lauwili
Thalassoma duperreyi

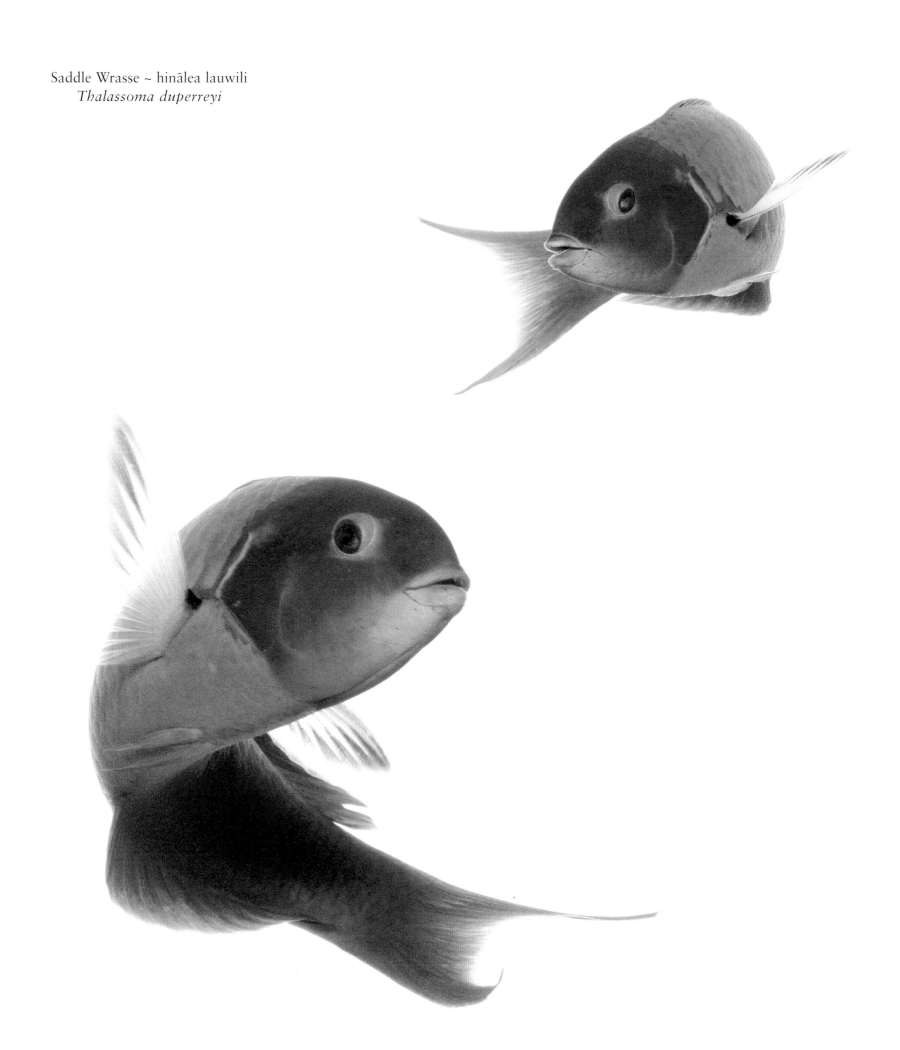

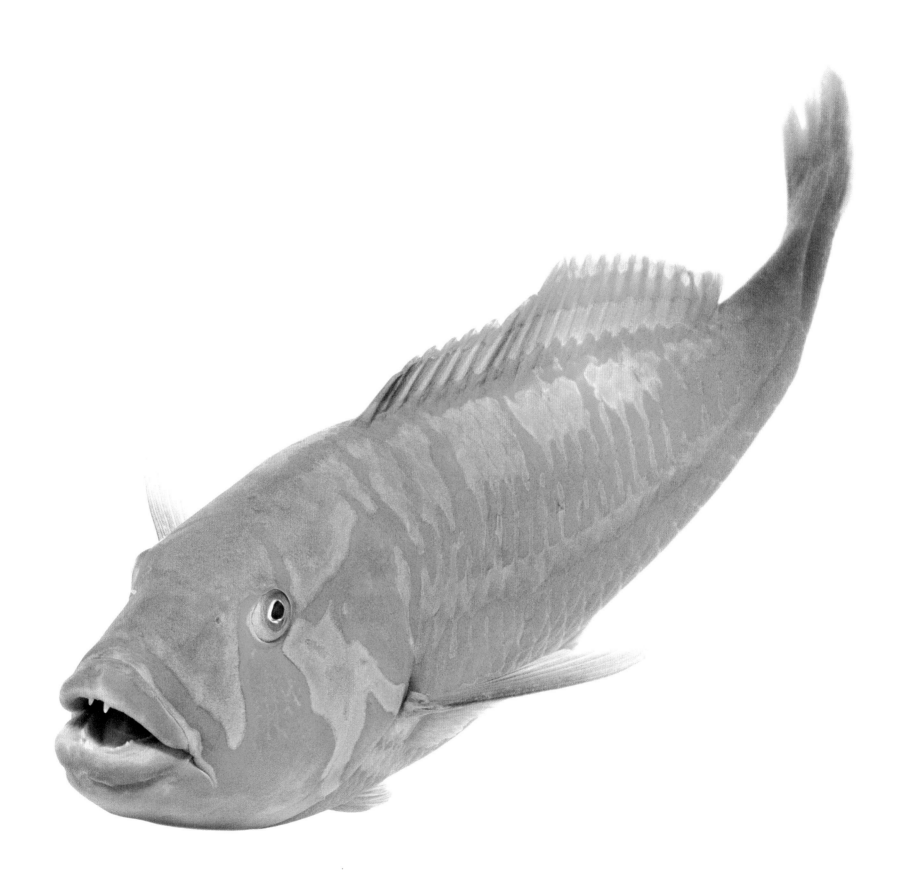

Surge Wrasse ~ hou
Thalassoma purpureum

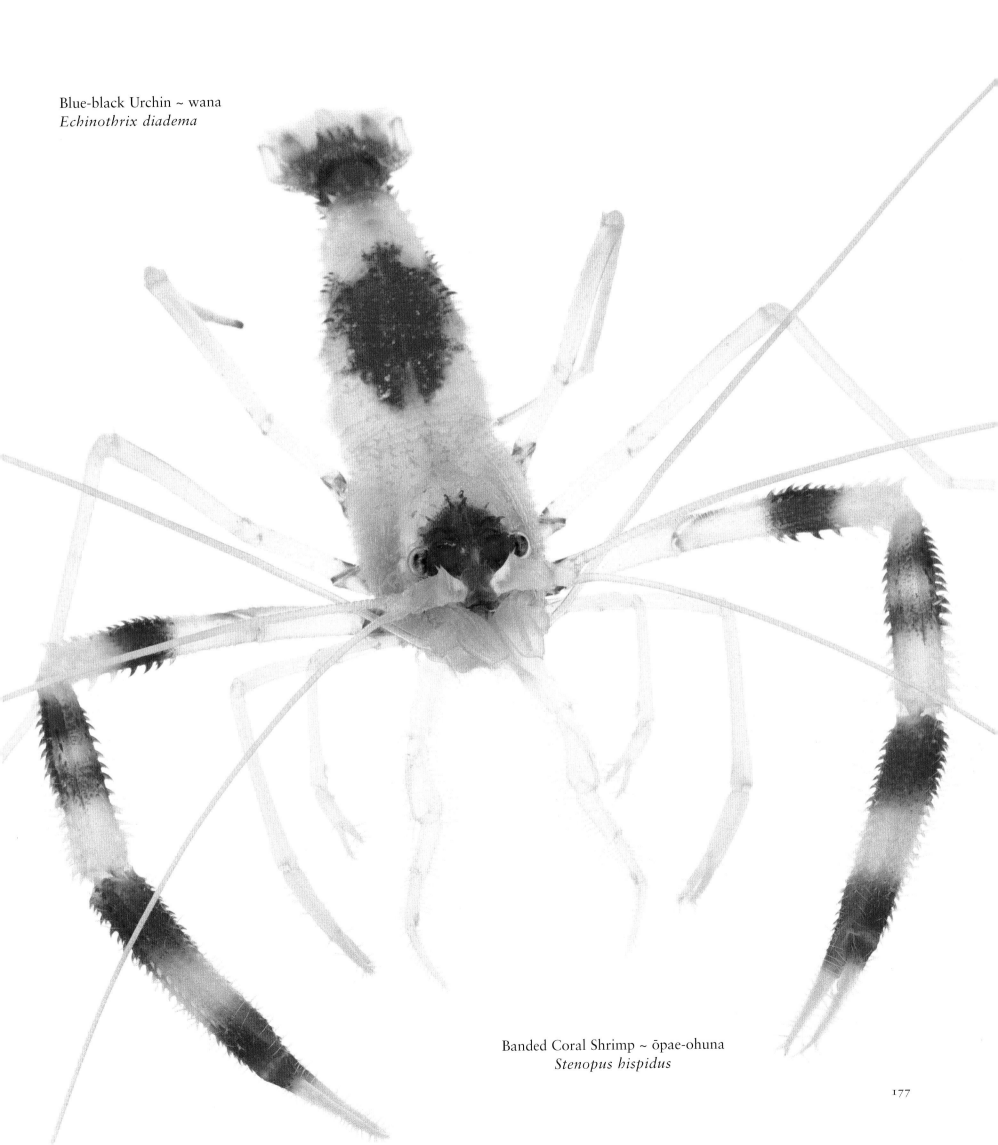

Blue-black Urchin ~ wana
Echinothrix diadema

Banded Coral Shrimp ~ ōpae-ohuna
Stenopus hispidus

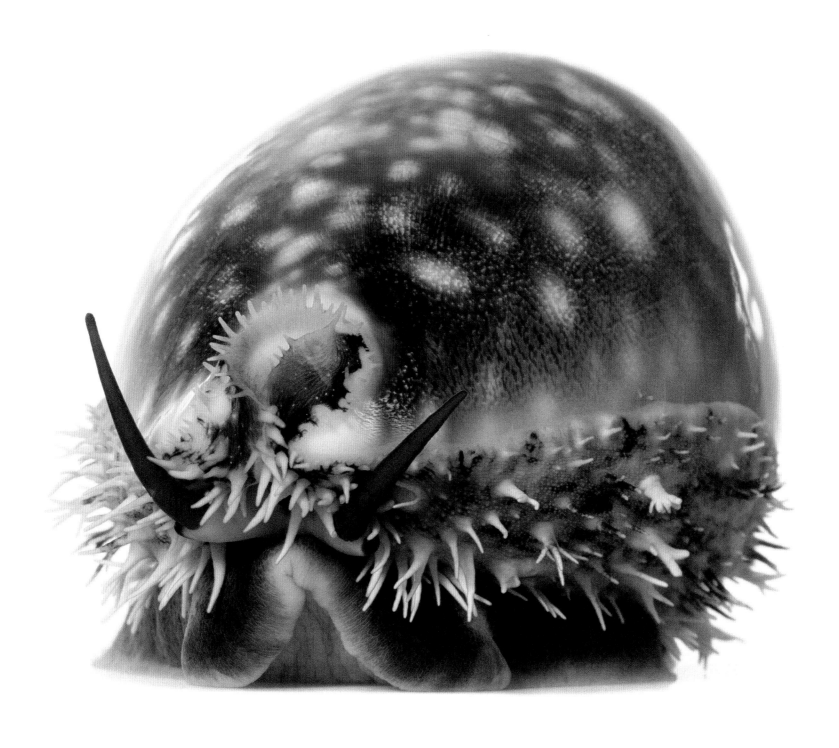

Calf Cowry ~ leho
Cypraea vitellus

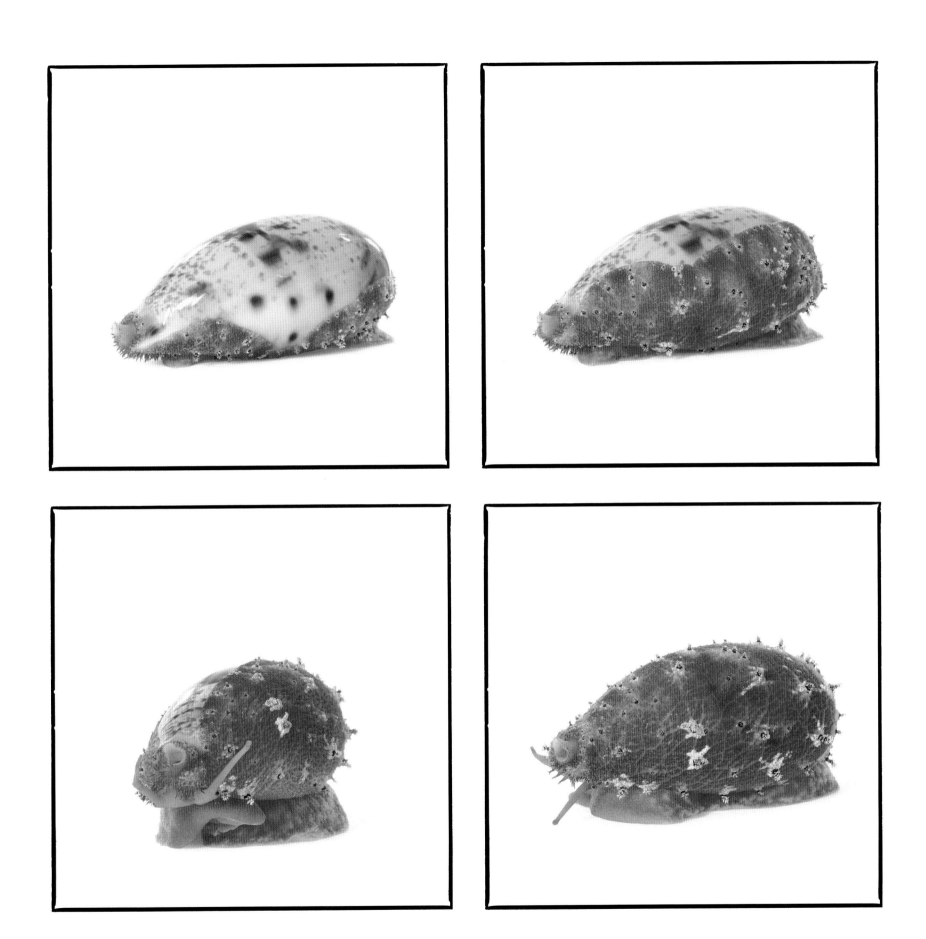

Alison's Cowry ~ leho
Cypraea alisonae

Bubble Algae (with a red alga) ~ limu
Ventricaria ventricosa
(with *Centroceras clavulatum*)

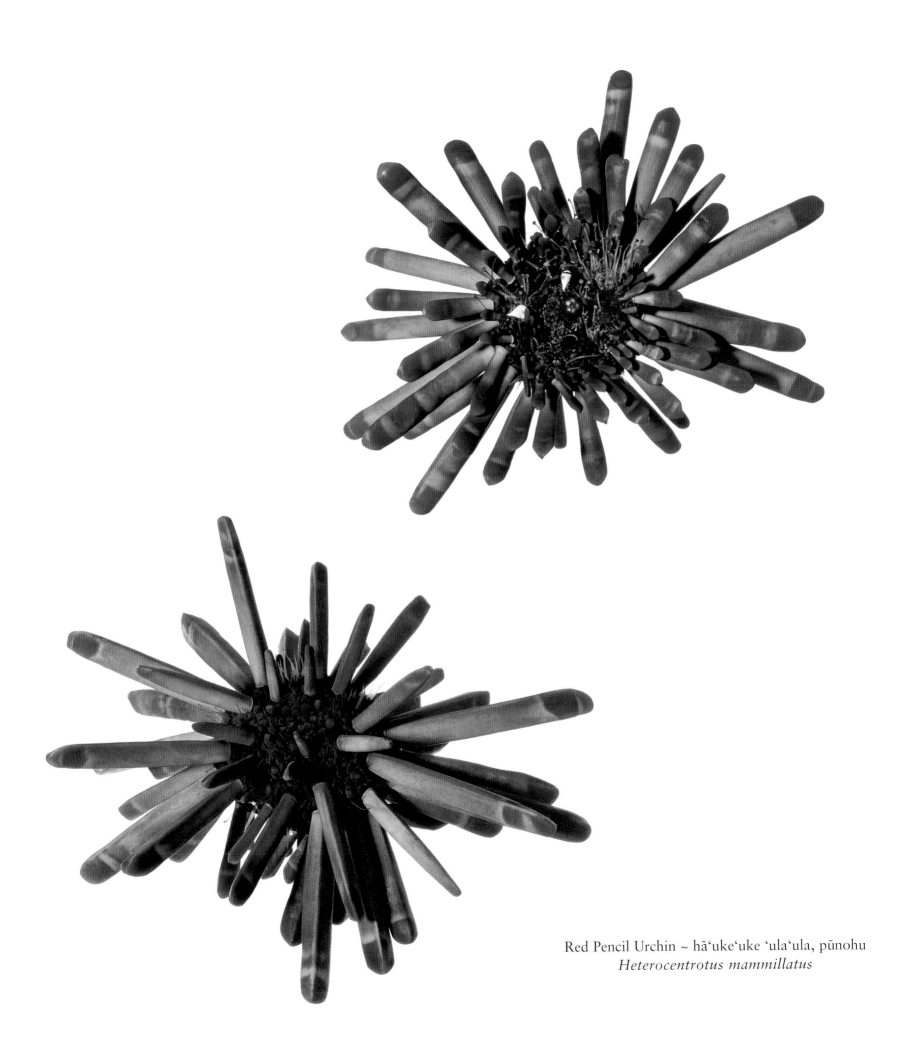

Red Pencil Urchin ~ hāʻukeʻuke ʻulaʻula, pūnohu
Heterocentrotus mammillatus

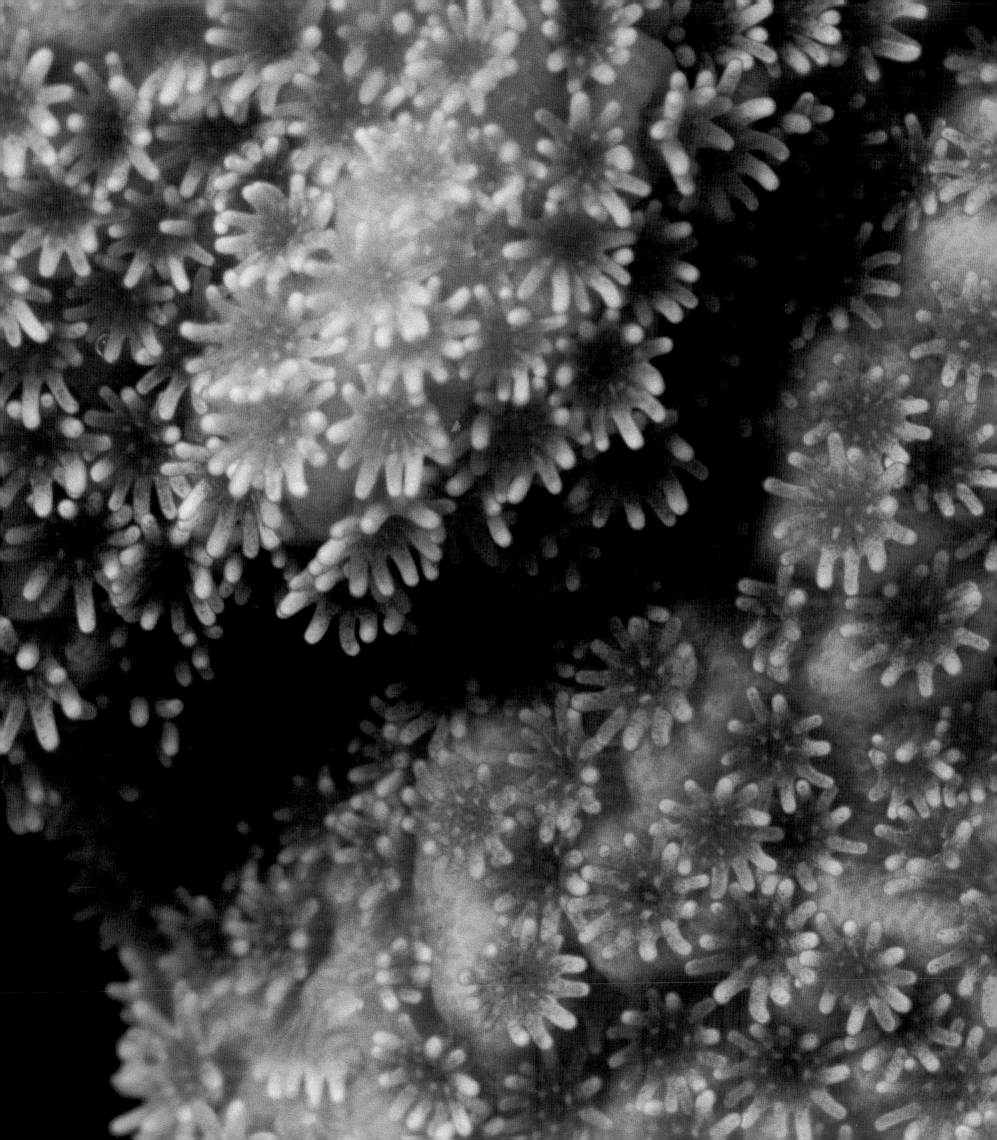

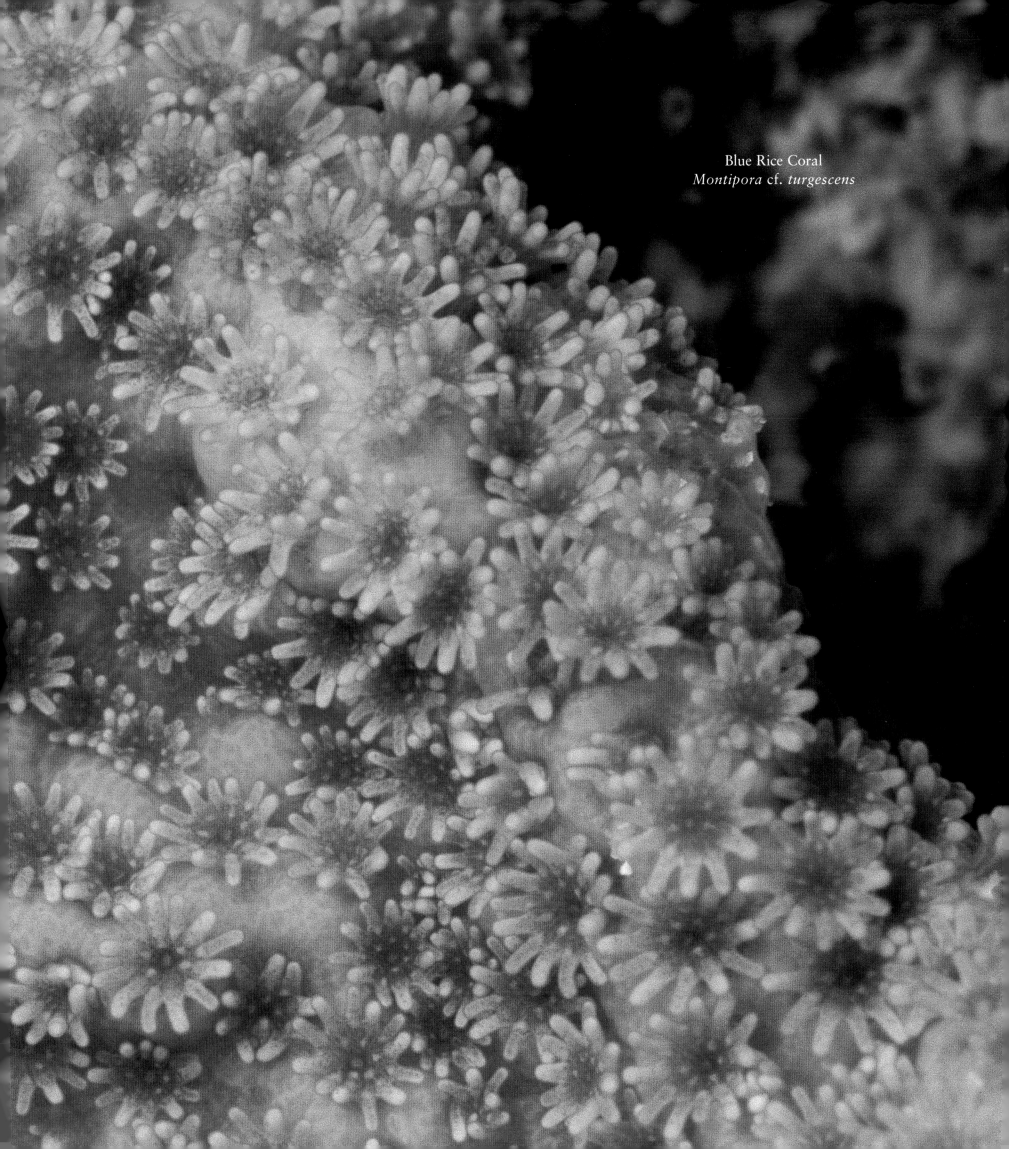

Blue Rice Coral
Montipora cf. *turgescens*

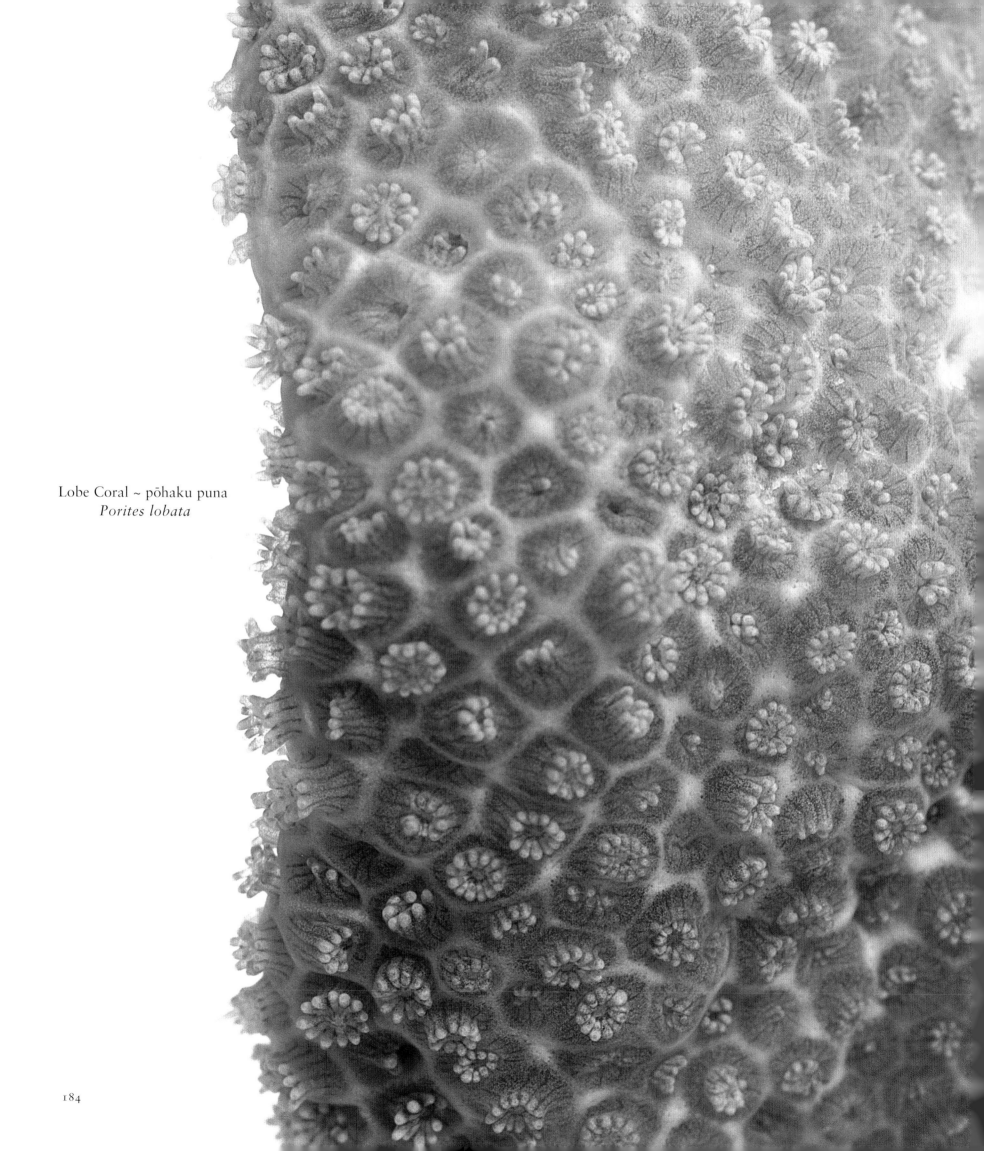

Lobe Coral ~ pōhaku puna
Porites lobata

Nicobar Triton ~ naunau
Cymatium nicobarium

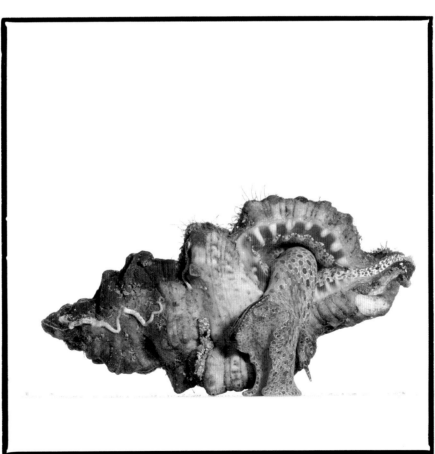

Simple Collector Crab ~ kumulīpoa, pāpaʻi limu
Simocarcinus simplex

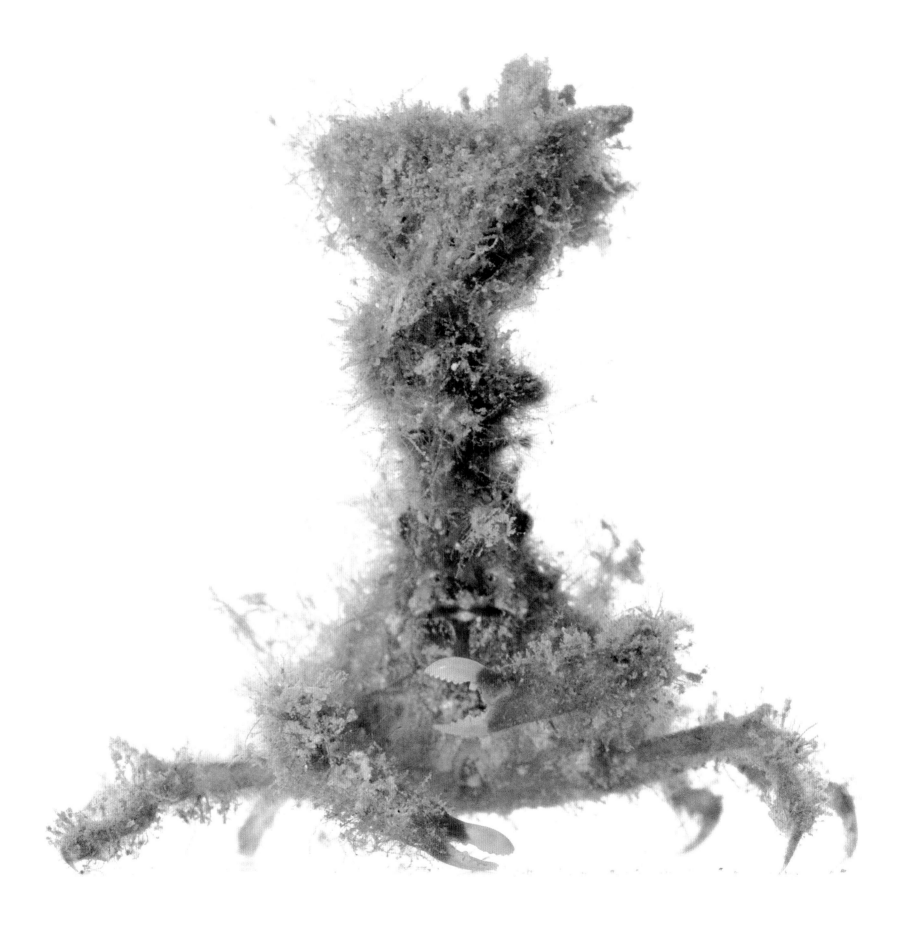

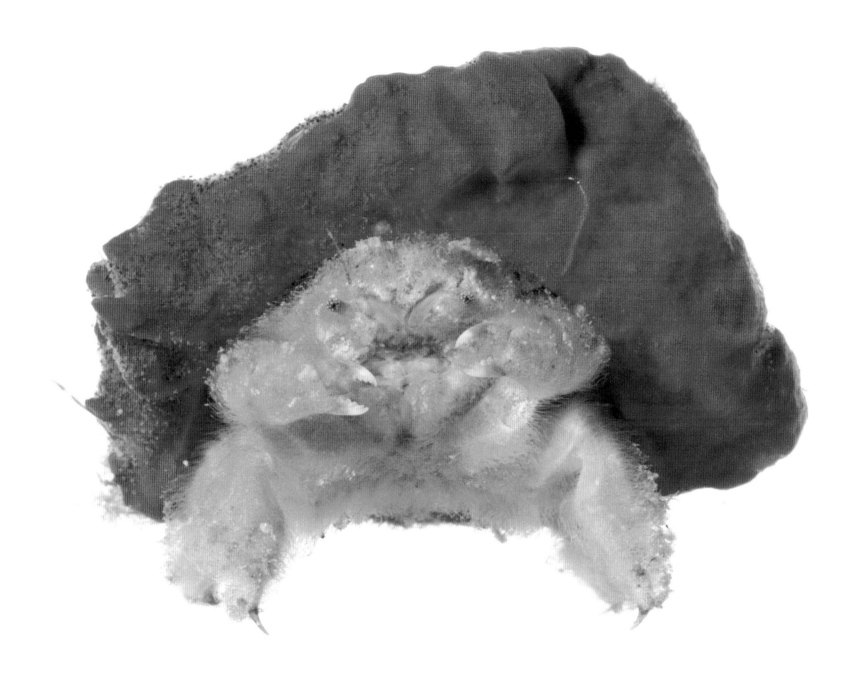

Shaggy Sponge Crab
Cryptodromiopsis plumosa

Turbinaria ~ limu
Turbinaria ornata

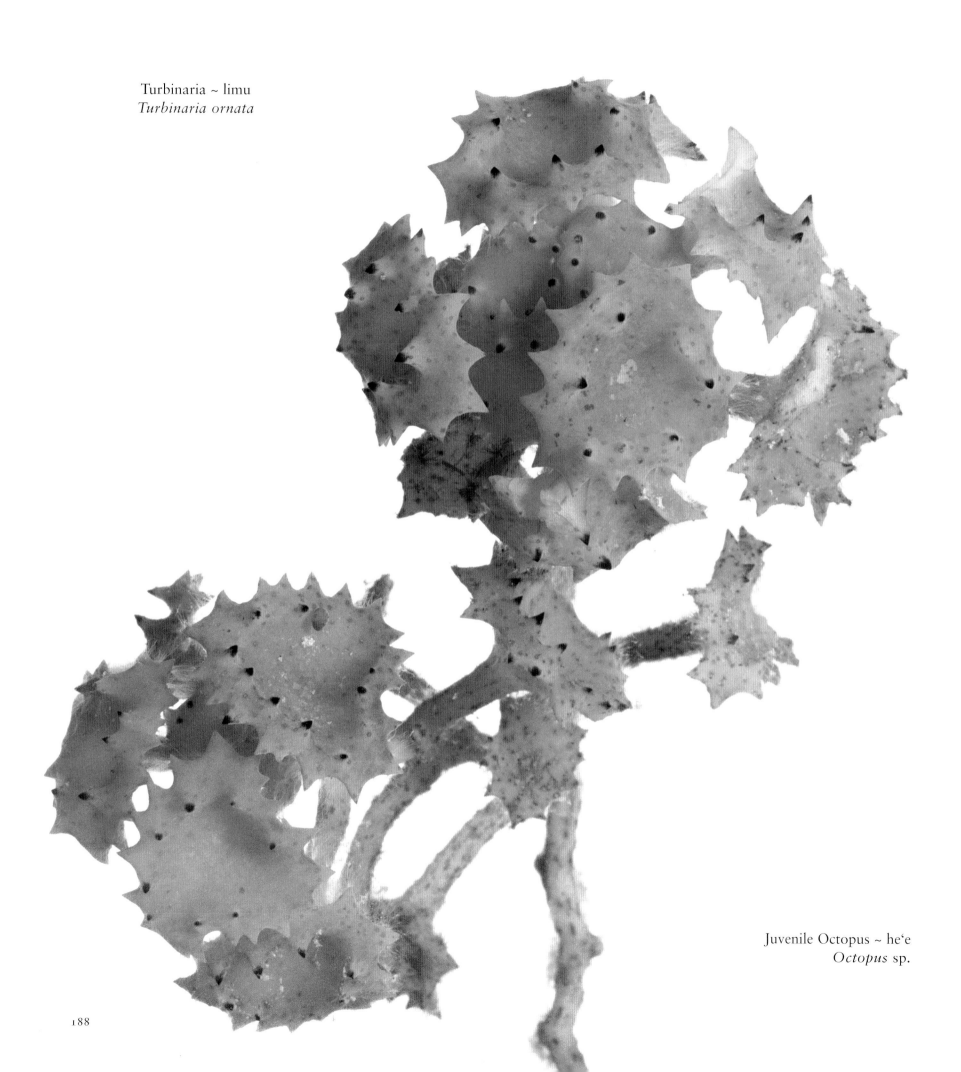

Juvenile Octopus ~ heʻe
Octopus sp.

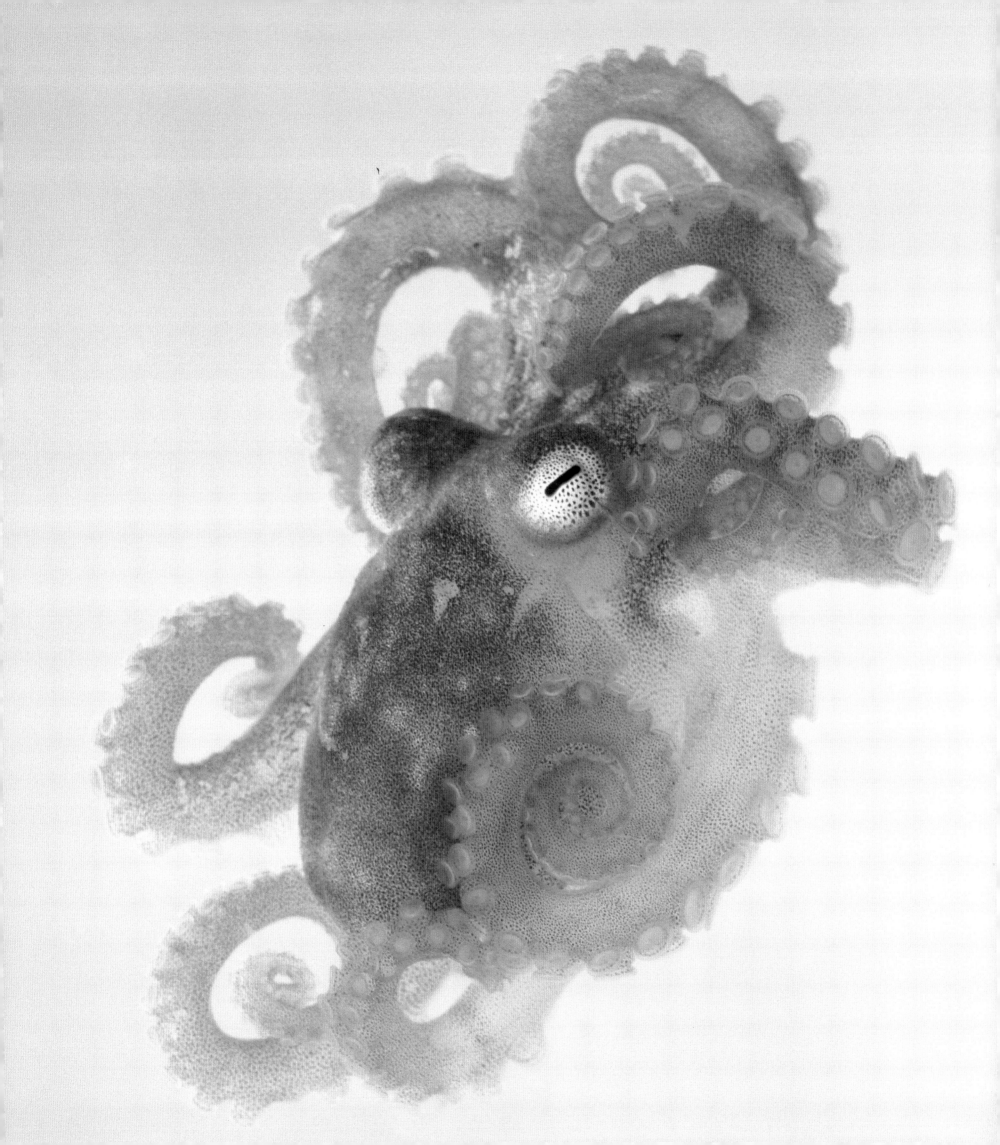

Stocky Hawkfish ~ poʻopaʻa
Cirrhitus pinnulatus

Christmas Wrasse ~ ʻawela
Thalassoma trilobatum

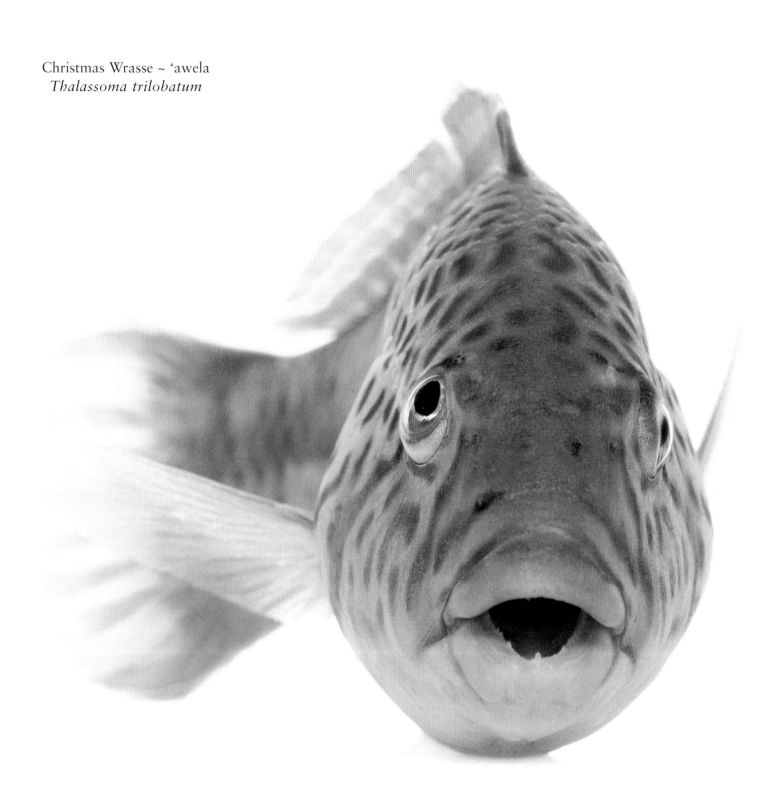

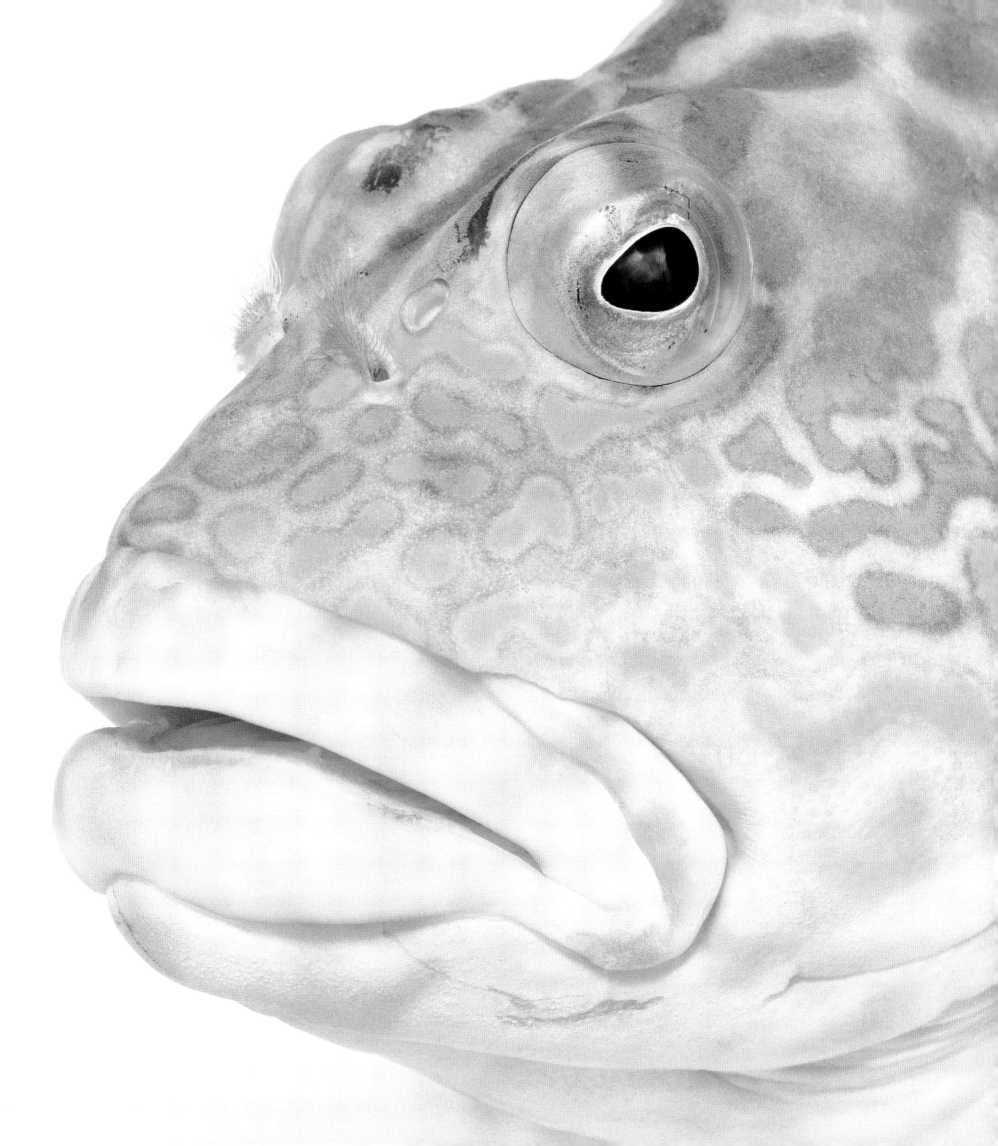

Threadfin Butterfly Fish ~ kikākapu
Chaetodon auriga

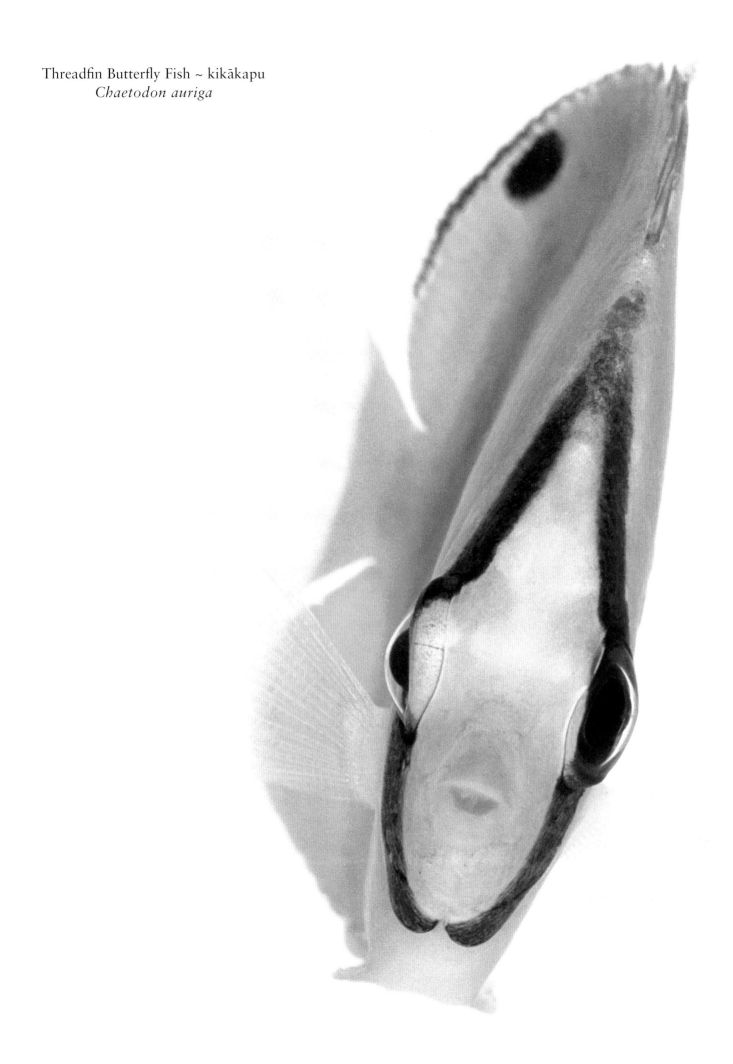

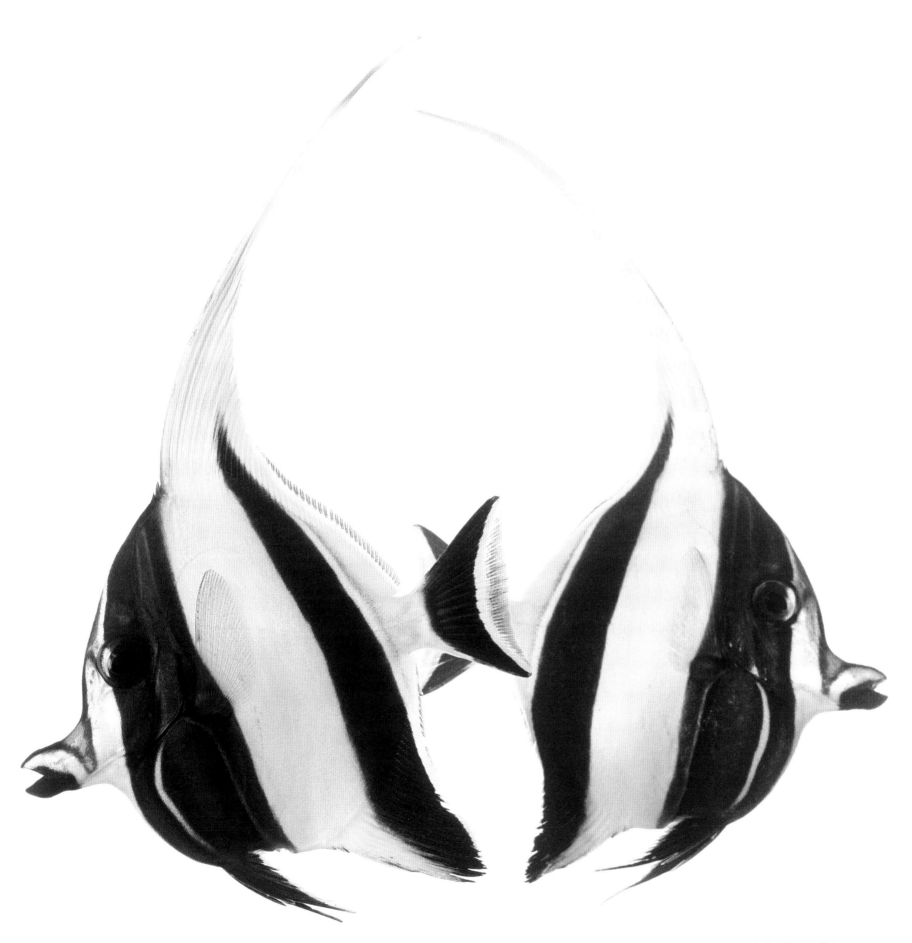

Moorish Idol ~ kihikihi
Zanclus cornutus

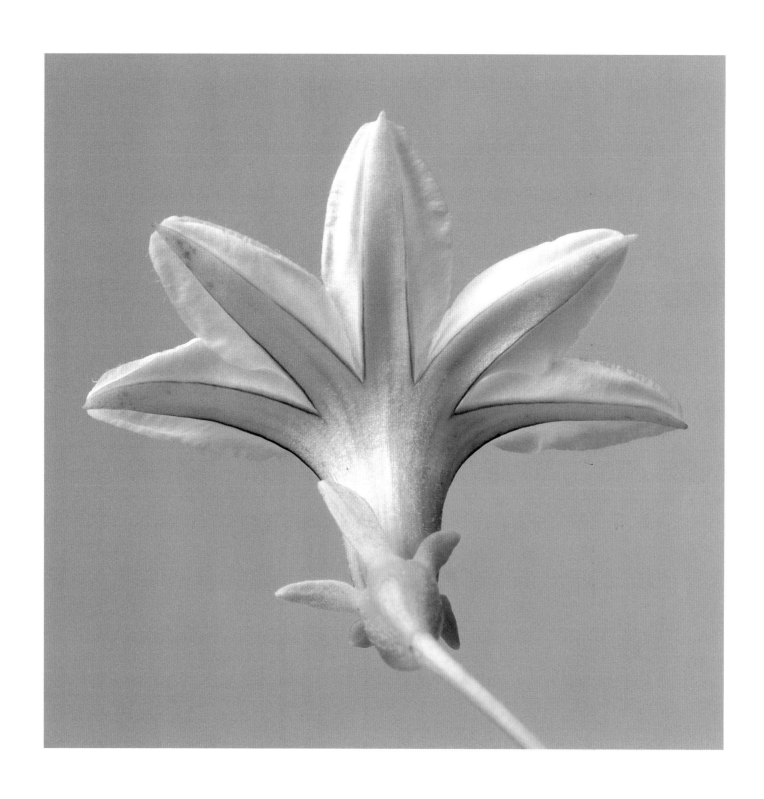

Naupaka kauhakai
Scaevola sericea

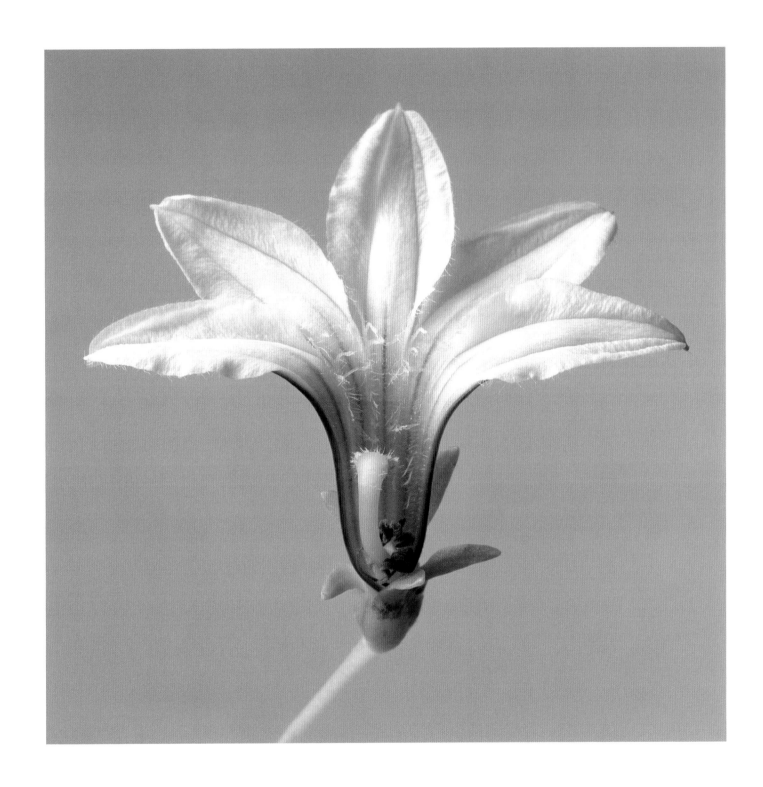

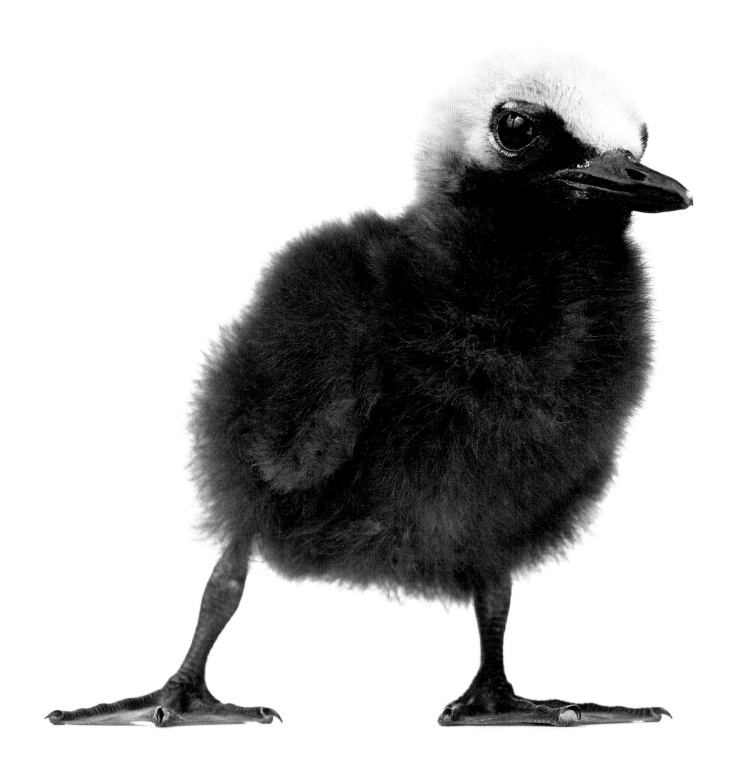

Black Noddy ~ noio
Anous minutus melangogenys

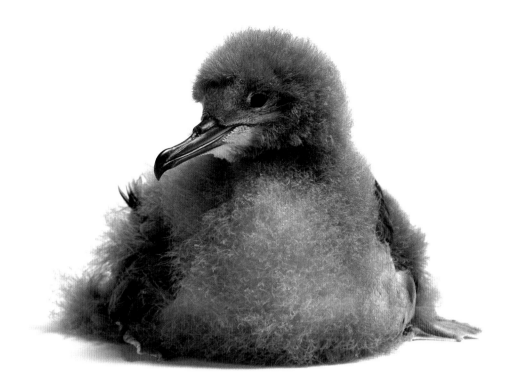

Wedge-tailed Shearwater ~ 'ua'u kani
Puffinus pacificus chlororhynchus

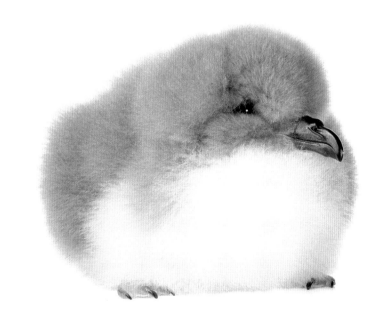

Bonin Petrel
Pterodroma hypoleuca

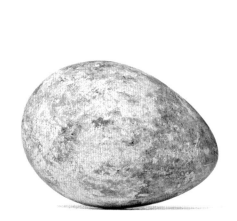
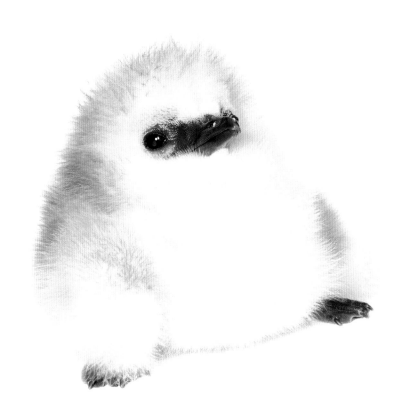

Red-tailed Tropicbird ~ koaʻe ula
Phaethon rubricauda rothschildi

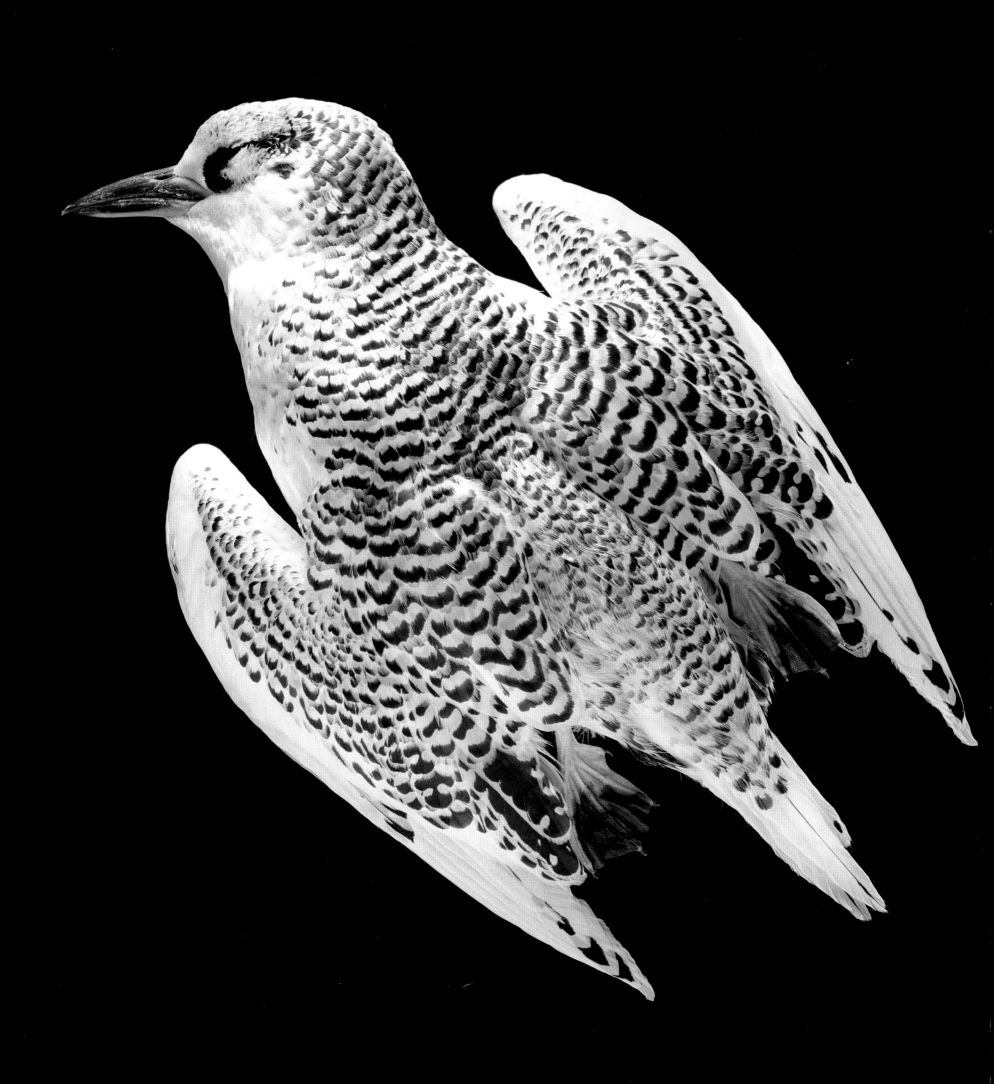

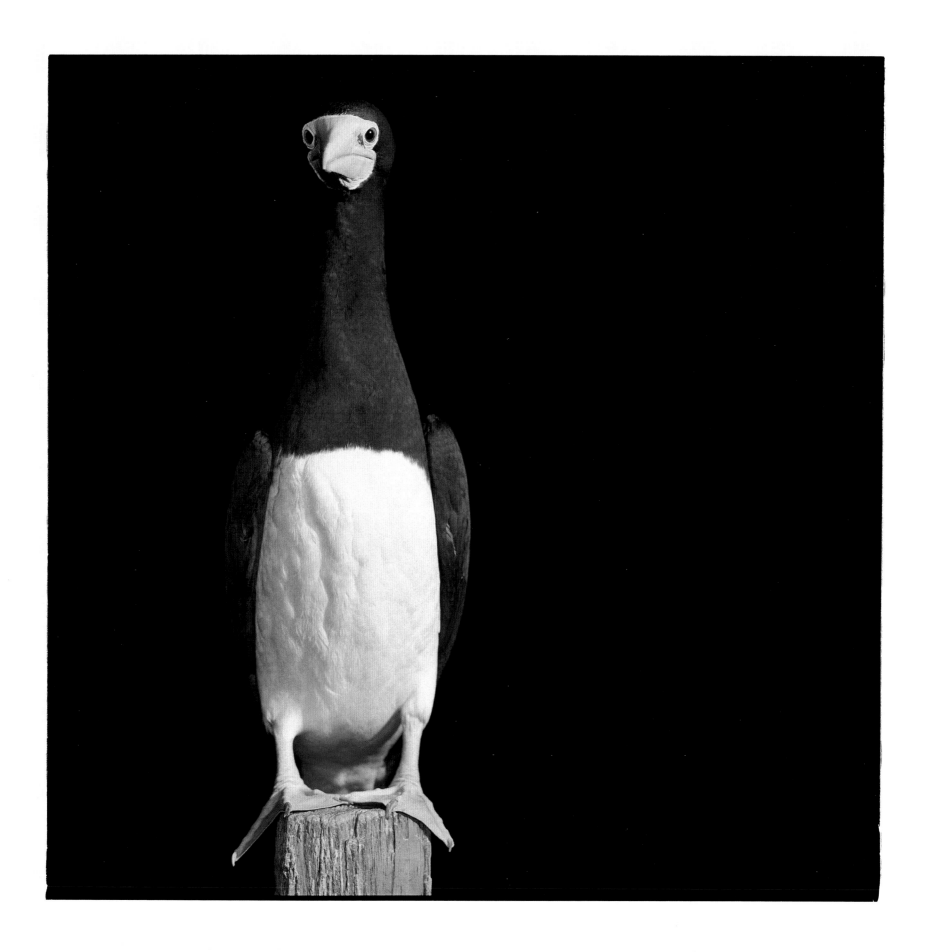

Kure Atoll ~ Moku Papapa

23°03′N, 161°56′W

by Susan Middleton and David Liittschwager

Early in the planning stages of this project, I visited Dave Smith, who oversees Kure Atoll for the Department of Land and Natural Resources for the State of Hawai'i. After I explained what we wanted to do, Dave responded, "You won't find wildlife on Kure that you can't see on other atolls, but there is something about Kure that is unique. It's the oldest island in the chain, over 28 million years old, and the farthest from Honolulu. It's special, and I'd advise you to go there." He put us in touch with Cynthia Vanderlip, who manages the Kure Wildlife Sanctuary.

Cynthia urged us to come. Getting there is not easy, since the old Coast Guard airstrip is no longer functional. That leaves boat transport, and as Kure is situated at the end of the chain, a boat must be destined for it, not just "passing by." We were working on Midway during fall 2003, and had the remarkable opportunity to go to Kure aboard the NOAA vessel *Manacat,* which was taking a group of researchers and biologists. David and I packed a large cooler full of photographic equipment and another full of food, and a small personal backpack each. It was a rough nine-hour ride over big swells; several of us felt queasy, and I recalled co-captain Tony Sarabia's warning of the night before: "Enjoy your breakfast, because you might be seeing it a second time!"

As we approached Kure, we began to make out a tiny turquoise line of blue water in the distance with a bright-white line resting above it, and, eventually, some green on the white. The *Manacat* can negotiate shallow water so we motored through a break in the nearly perfect circle of fringing reef that surrounds the lagoon. Suddenly we were in what appeared to be the world's largest swimming pool—luminous, pale blue-green water with a white sand bottom and occasional patch reefs, which Don Moses, *Manacat* captain, deftly avoided. We pulled up on the white sand shoreline, enthusiastically welcomed by Cynthia, and proceeded to haul our gear in wheelbarrows up to camp.

Brown Booby ~ 'a
Sula leucogaster

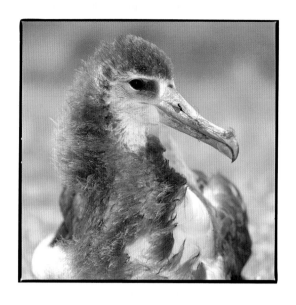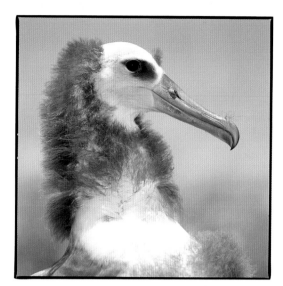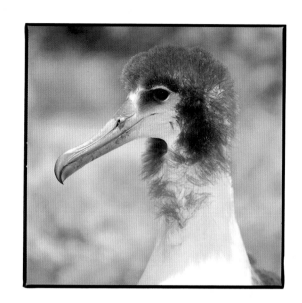
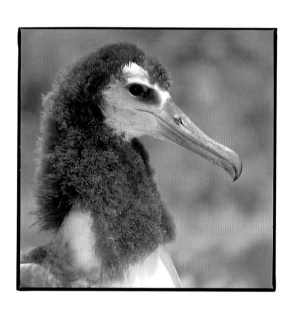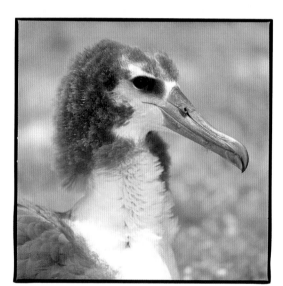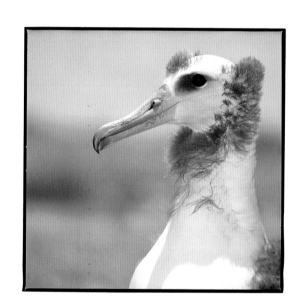
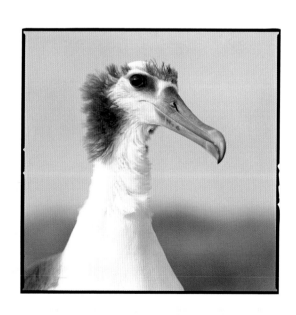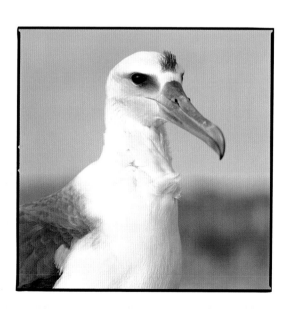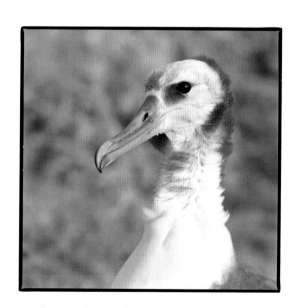

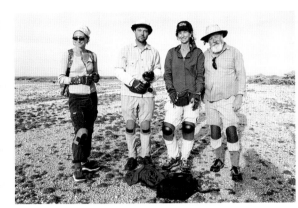 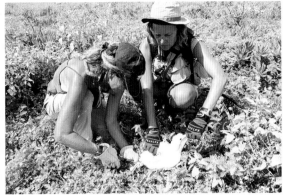 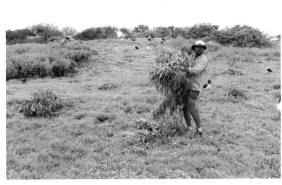

We immediately dove into work, setting up aquariums for marine photography in a toolshed which provided shade and shelter from the rain. Cynthia guided us into the atoll to the pristine patch reefs, where we snorkeled and collected marine creatures and algae for portraits, placing our specimens in white plastic buckets full of fresh seawater. Solar panels provided enough power to clean and aerate our aquariums and the "holding" buckets containing the subjects of our portraits, all of which were later returned to their reef homes. The marine work was progressing well, and we began exploring the island with Cynthia, who took us into the interior where the masked and brown boobies prefer to nest. Much of the island is covered with the invasive yellow-flowered verbesina, a member of the sunflower family—beautiful, until you understand how much damage this plant does and how difficult it is to eradicate. It chokes out native vegetation, even the hardy naupaka, and overtakes bird nesting areas. Ants are another plague on Kure; the ground is literally alive with them. These non-native pests often attack newly hatched chicks, biting their tender skin.

At the end of our second day, Cynthia invited us to stay longer and continue working, which would mean extending our visit from three and a half days to three and a half weeks, when the *Manacat* would return with a group of marine archaeologists. She assured us there were adequate provisions, so we decided to stay; I relished the opportunity even as I wondered if the time might seem too long. Still, I hoped I would get to know the atoll well enough to develop the affection for it that I heard in Dave Smith's voice when he urged us to come, and that I saw in Cynthia every day we were there. In fact, our time on Kure deepened our understanding of the Northwestern Hawaiian Islands, and we got a lot of work accomplished.

The following spring we returned for two months, to work on our project and help out at the sanctuary. There were seven of us: Cynthia and her daughter, Amarisa Marie, as well as Michael Holland, Rob Marshall, Tracey Wurth, David, and myself. Rob and Tracey were researching and monitoring monk seals, and the rest of us helped with wildlife sanctuary work: banding birds, pulling out alien plants, removing marine debris, and assisting with spinner dolphin surveys. All of us contributed to chores such as cooking, collecting and hauling water, washing dishes, and general camp upkeep. We lived in tents and shared kitchen space, complete with propane burners, located in a cinder-block structure dating from the Coast Guard LORAN station which closed in 1993. Cooking tested our ingenuity, especially when the fresh food ran out and we found ourselves staring at shelves of canned goods. Our solar-powered freezer was a real luxury; it contained cheese, tortillas, meat, and other delicacies, which we doled out sparingly. Our small supply of garlic was as good as gold.

OPPOSITE: As Laysan albatross chicks approach fledging time, baby down falls out and adult plumage grows in—an awkward but thoroughly amusing adolescent stage.

ABOVE, left to right: Amarisa Marie, David, Cynthia Vanderlip, and Michael Holland wear protective gear for chick banding including gloves, forearm covers, and kneepads. Cynthia bands a brown booby chick while Susan holds it still. David weeds invasive verbesina from an area cleared for nesting.

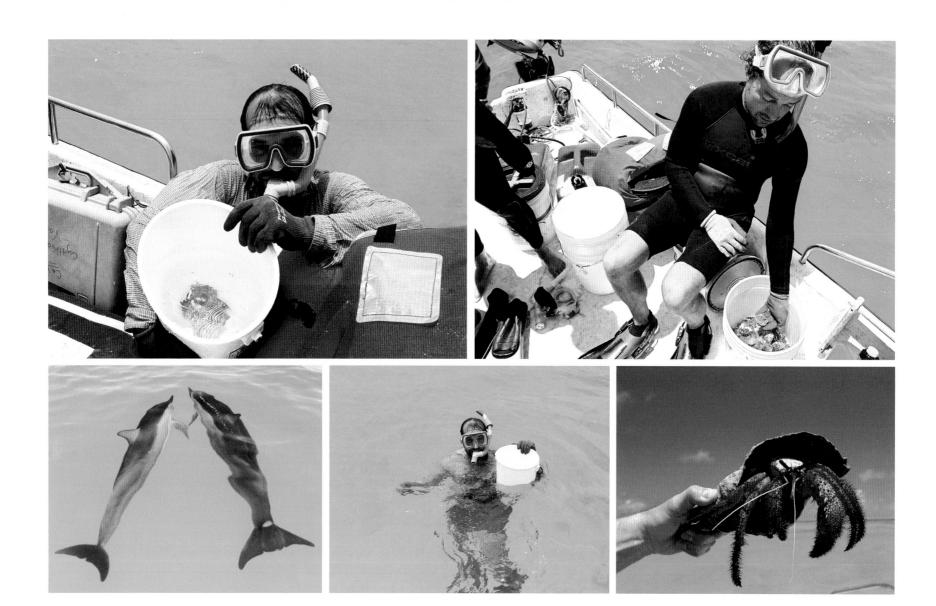

After setting up camp, we began the task of banding the nearly 1,200 young black-footed albatrosses on the island. Close to fledging time, these beautiful birds are big, strong, and ornery. We outfitted ourselves with gloves and protective gear. Working in teams of two, one of us restrained the bird, holding the beak closed and firmly gripping the tail, while the other person positioned the metal band around the bird's ankle, closing it precisely so there was no space between the ends of the band to snag a fishing line. Cynthia had told us, "If we're going to put the birds through this, we must do it right and not endanger them." She advised us to photograph the exquisite fledglings before we banded them, rather than after, when they would run away at the sight of us.

The infestation of noxious verbesina is so pervasive on Kure that our attempts to control it were futile. Cynthia decided to focus on key seabird nesting areas, and we all put in time pulling weeds, then burning the uprooted plants to inhibit reseeding. I concentrated on an area around a large, dying beach heliotrope tree where the native naupaka was being crowded out. Only a handful of full-sized trees grow on the island, and this one, which I called the "Mother Tree," provided shade and superb nesting and roosting places for black noddies, white terns, and

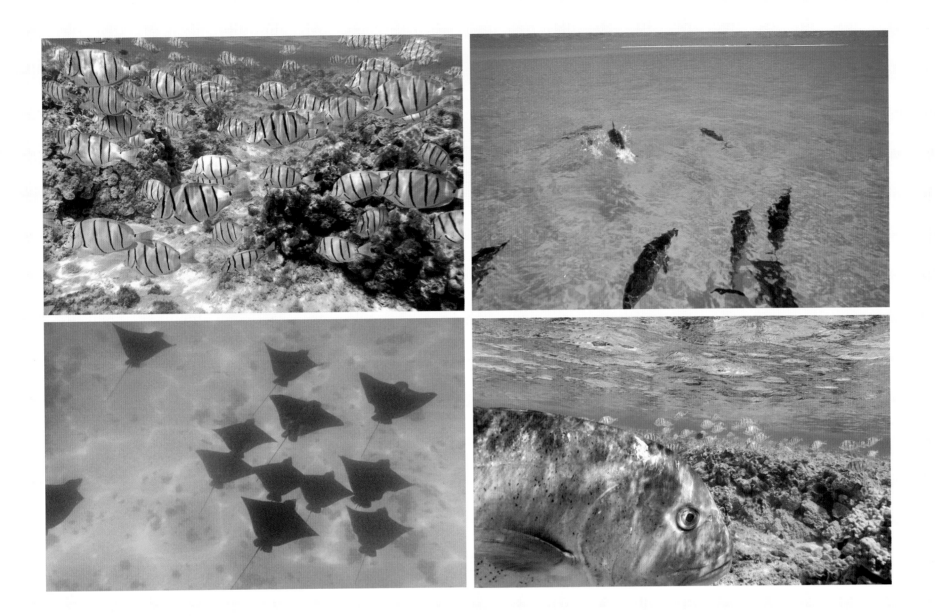

red-footed boobies. Albatrosses sought shade here too, just as I did. I returned often during my two months on Kure, to pull out the tenacious seedlings, and to observe and photograph the birds in the tree.

Camp life was embellished by our entertaining camp mates, the albatross chicks. We watched them grow, and found them endlessly engaging. Fed by their parents—who fly thousands of miles to find prey in mid-ocean gyres created by currents, which they later regurgitate into their chicks' mouths—these youngsters soon become fat and begin to lose their baby down, often appearing hilariously awkward in their adolescent phase. When adult plumage grows in, they start to appear sleek; they still can't fly, however, and they are just beginning to feel the power of their wings as they stretch them out and balance in the wind. Next to our tents we each had albatross chick neighbors, and we came to know them as individuals. They behaved like toddlers, putting everything in their mouths, yanking on tent lines, pulling on tent flaps, biting shoes and socks left outside the tents and sometimes moving them to new locations. Cynthia discovered her red bikini top missing one day, later to find it had been snatched off the laundry line by an albatross. All of this endeared the birds to us all the more.

ABOVE: Wild and watery world of the NWHI—clockwise from bottom left, manta rays, convict tangs, spinner dolphins, and a big ulua, one of the NWHI coral reefs' largest predators.

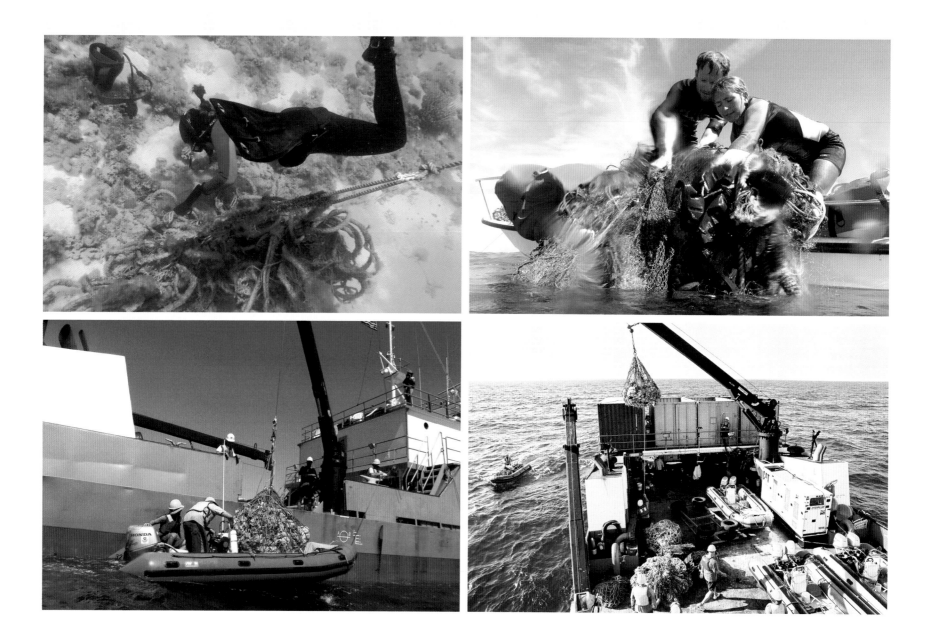

ABOVE, clockwise from top left: Derelict lines and nets are carefully removed from the coral reefs, where they pose an entanglement hazard to seals and turtles. Marine debris is hauled up into small boats. Cranes on *Casitas* lift loads of debris into containers for transport back to Honolulu. The marine debris team transports nets and lines to the chartered vessel, *Casitas*.

OPPOSITE: Christmas shearwater.

Weather could be fierce on Kure, and a particularly thrilling thunderstorm nearly blinded me with lightning—the flash actually penetrated the skin of my tent, and my eyelids; I could feel the earth shake beneath me, followed by a heavy downpour of rain. Storms were always welcomed on the island; they not only dazzled us with fireworks, but also provided a fresh supply of water. We would hurriedly mobilize during every rainstorm, positioning open buckets and barrels in strategic places. Though we brought sufficient drinking water with us in five-gallon jugs, we used rainwater for laundry, doing dishes, and taking luxurious solar-heated showers; no rainwater meant we had to make do with sticky seawater—a poor substitute.

David and I set up a marine studio in the toolshed as we had done the previous fall. We appreciated the shelter it provided, even though it was often unbearably hot and muggy inside. We measured 92 degrees with no breeze, and I took to wearing bandanas around my head and neck to keep sweat from dripping onto the equipment and specimens. Cynthia offered us a fan, which helped cool us down; it also dispelled the fumes from the stored fuel barrels, and discouraged the wasps who built nests in our strobe lights. For several weeks our existence

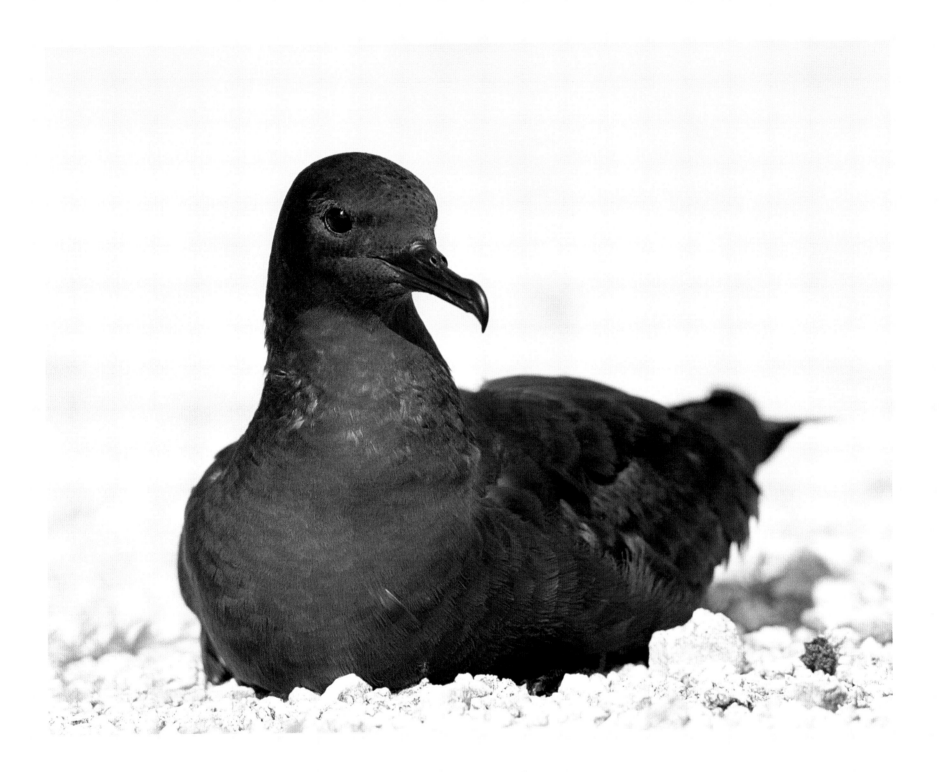

was divided between the shed and the relief of the reefs. We swam on our stomachs, skimming over the intricate corals where a vibrant community flourishes: fishes, invertebrates, algae, even the occasional curious monk seal. Here we would look for subjects to collect, bringing them to the shed for their portraits and then returning them to the coral reefs. I developed a great respect for these reefs, the largest biogenic structures made by any organism (including man) on Earth, constructed through the combined efforts of countless individual coral polyps— tiny translucent bodies—over time. Impressive and often immense, the reefs are as delicate as porcelain and particularly vulnerable to human clumsiness. We quickly learned how to move gracefully around the corals.

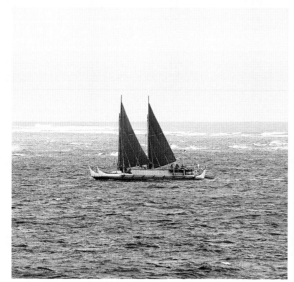

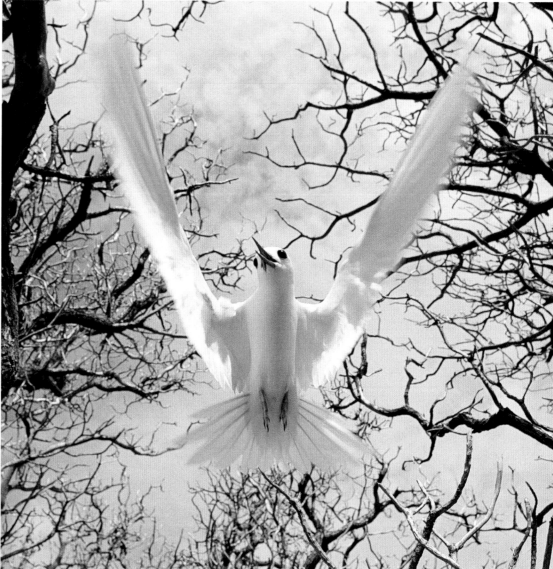

ABOVE, clockwise from left: The Polynesian voyaging canoe *Hokulea* arrives at Kure Atoll; a white tern hovers under the boughs of a beach heliotrope tree; a fluttering red-tailed tropicbird seems to anoint the offerings left by the *Hokulea* crew at the site of their traditional blessing.

One day I walked out to the shed and saw David sitting in a shady spot with an albatross I recognized. It was "Shed Bird," a chick we had watched since our arrival almost six weeks before. It had hatched near the shed, and, as albatrosses do, stayed close by to be fed by its parents, to grow, and eventually to fledge. It had become our companion and we were fond of it. David looked concerned. He explained that he had noticed Shed Bird having a hard time, panting in the hot sun; when the bird tripped over one of our plastic shower bags bulging with water, it didn't have the strength to pick itself up. David moved the bird into the shade, sprinkled water on it, and cooled it with our fan. Finally, Shed Bird seemed to revive. Relieved, we went back to work in the shed, occasionally checking on the bird, who seemed to be doing fine.

The next day we found Shed Bird dead. Cynthia decided to do a necropsy, and we watched and photographed. As she opened the bird we could see a bulging stomach with the skin stretched tight, revealing protrusions from hard, sharp bits inside, and two ulcer-like perforations. She pressed the blade through the taut skin and it split open, exposing brightly-colored plastic—

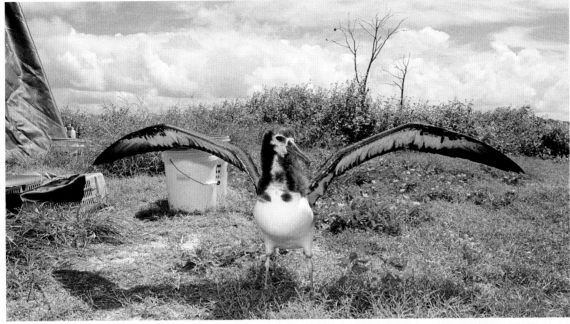

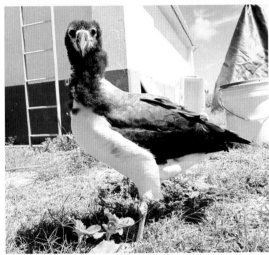

a sharp rectangular piece causing one of the perforations, two disposable cigarette lighters, several bottle caps, an aerosol pump top, shotgun shells, broken clothespins, toys—hundreds of plastic bits. "It's like opening a piñata," Cynthia said, "but so depressing...."

We were all emotional, and I had a difficult time holding back tears. Shed Bird was stuffed with plastic, which had led to dehydration, malnutrition, and ultimately starvation. The bird couldn't pass its stomach contents; it was severely impacted, and could not accept food. What a horrific experience for Shed Bird to have endured, and how sturdy it was to survive as long as it did. David photographed the bird with an open stomach, and then I spent several hours removing every item from the gut of the dead chick. I used gloved hands at first, then tweezers for the small pieces, and in the end I arranged it all on a sheet of white plastic, four feet wide by eight feet long. An exciting event for the island flies, who swarmed the putrid innards. I was nearly overcome by the powerful stench, and by my sorrow for Shed Bird, whom we had seen just a few days earlier, standing with outstretched wings, testing the wind. —S.M.

ABOVE, top: Close to fledging time, Shed Bird tests his wings. Bottom left: Shed Bird stands in front of the tool shed that served as his nest site and gave him his name. A necropsy, bottom right, reveals the plastic that killed him.

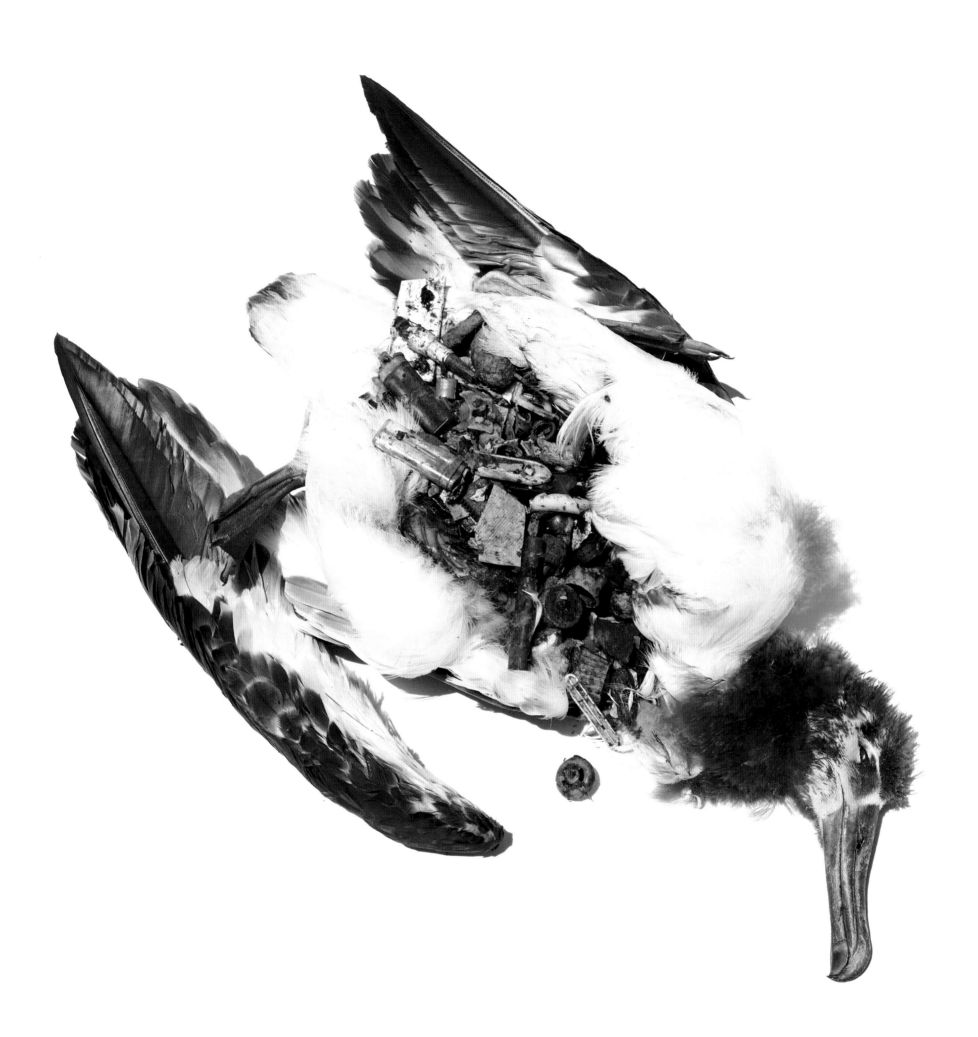

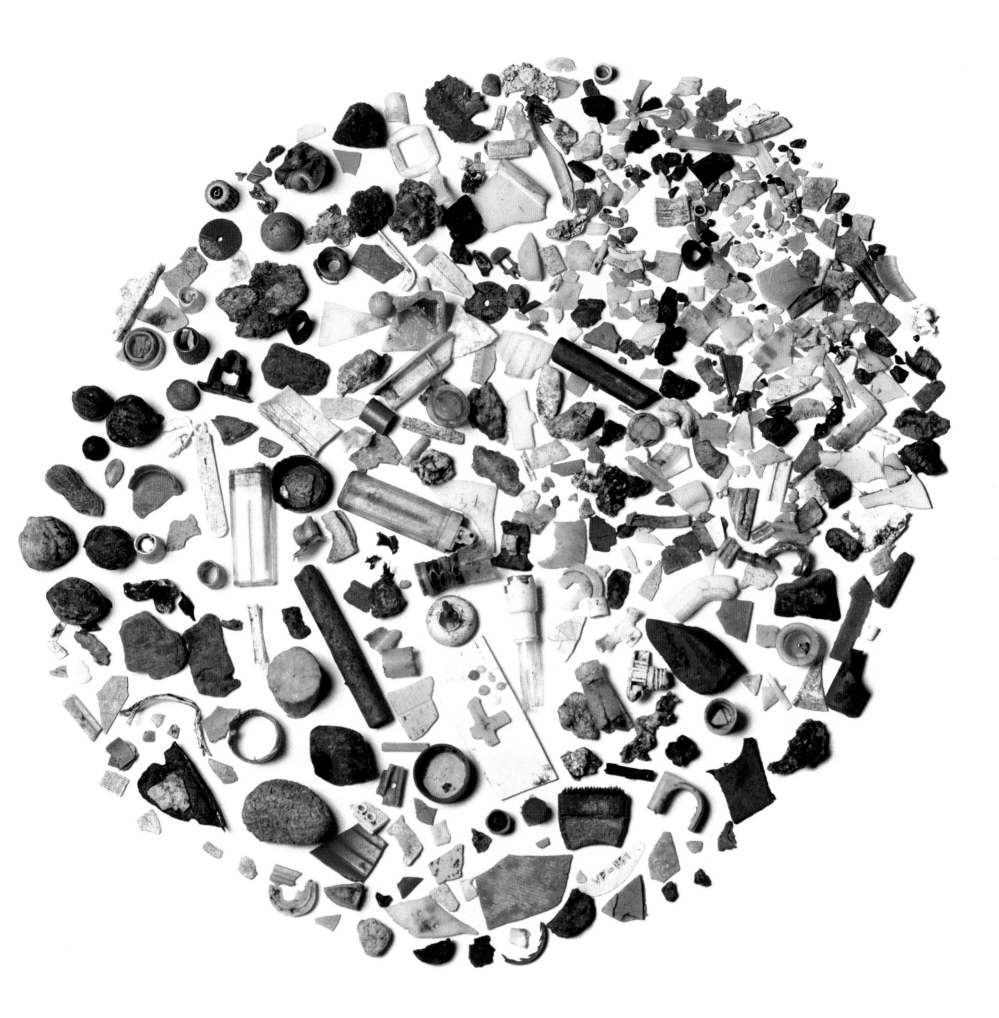

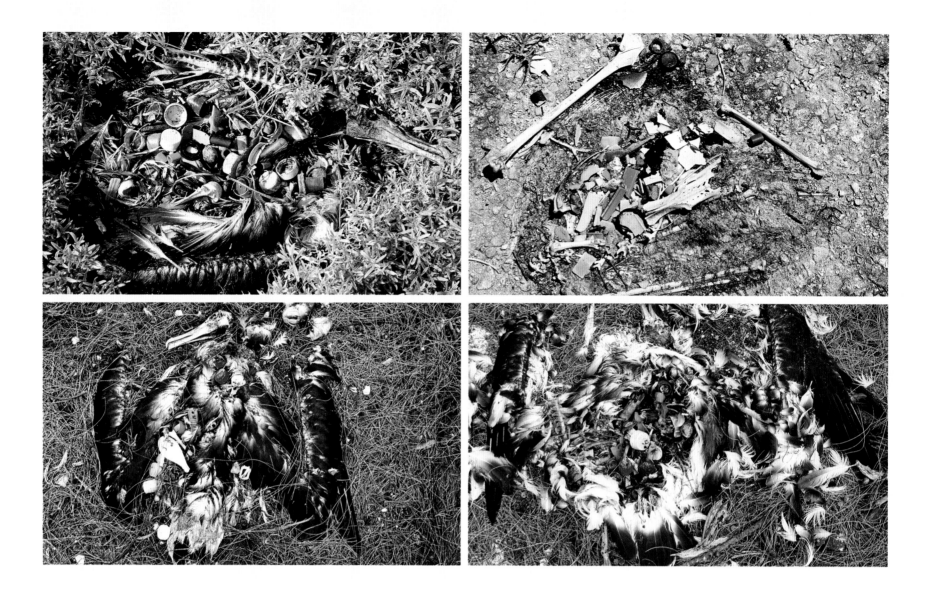

A study at Midway Atoll in the mid-1990s attempted to determine the effect of plastics ingestion on Laysan albatross chick mortality. Research showed that approximately 75 percent of the chicks examined had up to ten grams of plastic in their proventriculi—part of the birds' complicated stomach system. One chick had ingested 140 grams. Still, the study concluded that "ingested plastic probably does not cause significant direct mortality in Laysan albatross chicks."

What we observed a decade later on Kure, Midway's closest neighbor, suggests another story. The contents of Shed Bird's proventriculus weighed 340 grams; more than 80 percent of this was plastic. Imagine: Three plastic bottle caps weigh approximately 5 grams, and a regulation baseball weighs about 140 grams—two baseballs' worth of plastic in Shed Bird's stomach!

An albatross chick's proventriculus is designed to hold huge amounts of food, as there may be many days between meals while the parents are out foraging. Chicks eat whatever their parents feed them, plastic included; if these items accumulate in their proventriculi, they will feel full and may not beg properly. Albatrosses eat indigestible items that exist in nature, like squid beaks, and a well-fed chick will have a proventriculus full of these items, which it eventually throws up as a bolus at about the time it's ready to fledge. A normal bolus is about five inches long and two inches

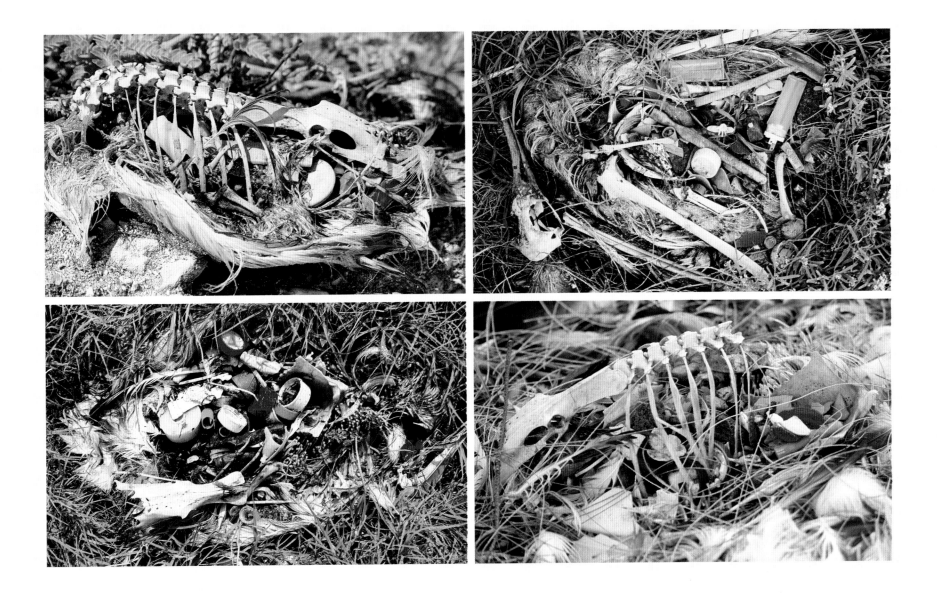

wide. Shed Bird had six times that amount of material, most of it plastic, in his proventriculus.

After the death of Shed Bird, I found and examined 60 Laysan albatross chick carcasses on Kure Atoll. Most of them contained more than 200 grams of plastic, with only five chicks registering ten grams or less. These chicks appeared to have succeeded in throwing up their boluses, as nothing—not even squid beaks—was present in their proventriculi. I observed this same phenomenon on Pearl and Hermes Atoll and Laysan Island. Plastic is invading the habitats where parent albatrosses forage. Albatrosses feed where currents come together, and the currents that concentrate food at the surface simultaneously bring in plastic as well.

Inside dead chicks, I found, to my disgust, a printer cartridge, shotgun shell casings, paintbrushes, pump spray nozzles, toothpaste tube caps, clothespins, buckles, toys, and shards from larger plastic items such as laundry baskets and buckets. If a bucket ends up on a beach, or a bottle ends up in a river, or a lighter is discarded into a lake, it may eventually wash out to sea, joining the plastic dumped from ships. Over time plastic becomes brittle in sunlight and breaks into smaller and smaller shards. For every pound of naturally occurring zooplankton in the North Pacific's subtropical gyre, there are six pounds of plastic. This debris affects not only the health of Laysan albatrosses but the well-being of the entire world. —D.L.

Calf Cone Snail ~ pupu 'alā
Conus vitulinus

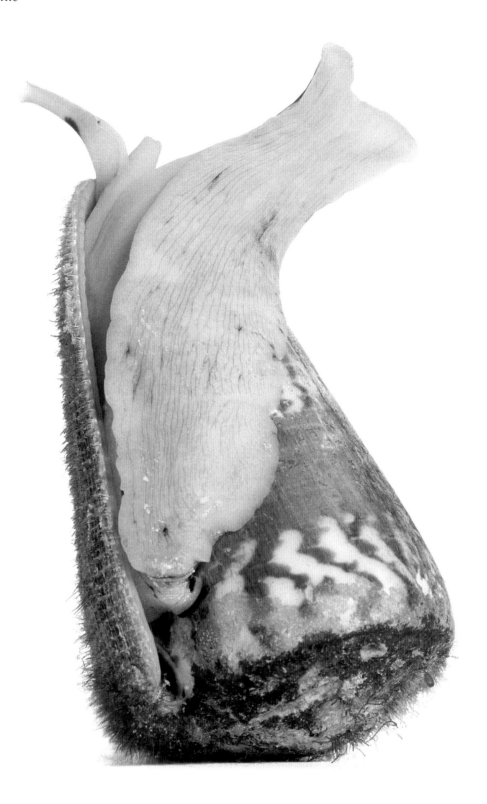

Microdictyon ~ limu
Microdictyon setchellianum

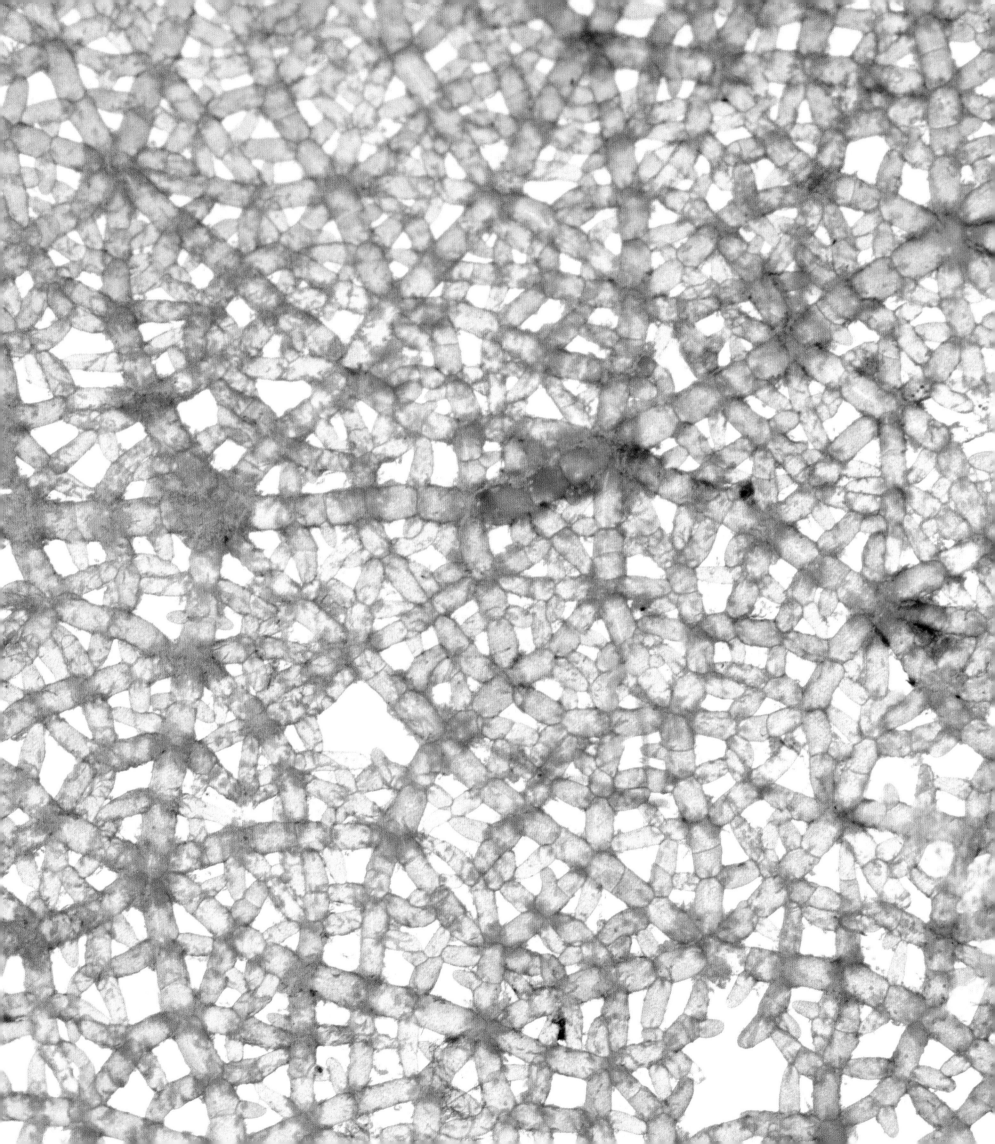

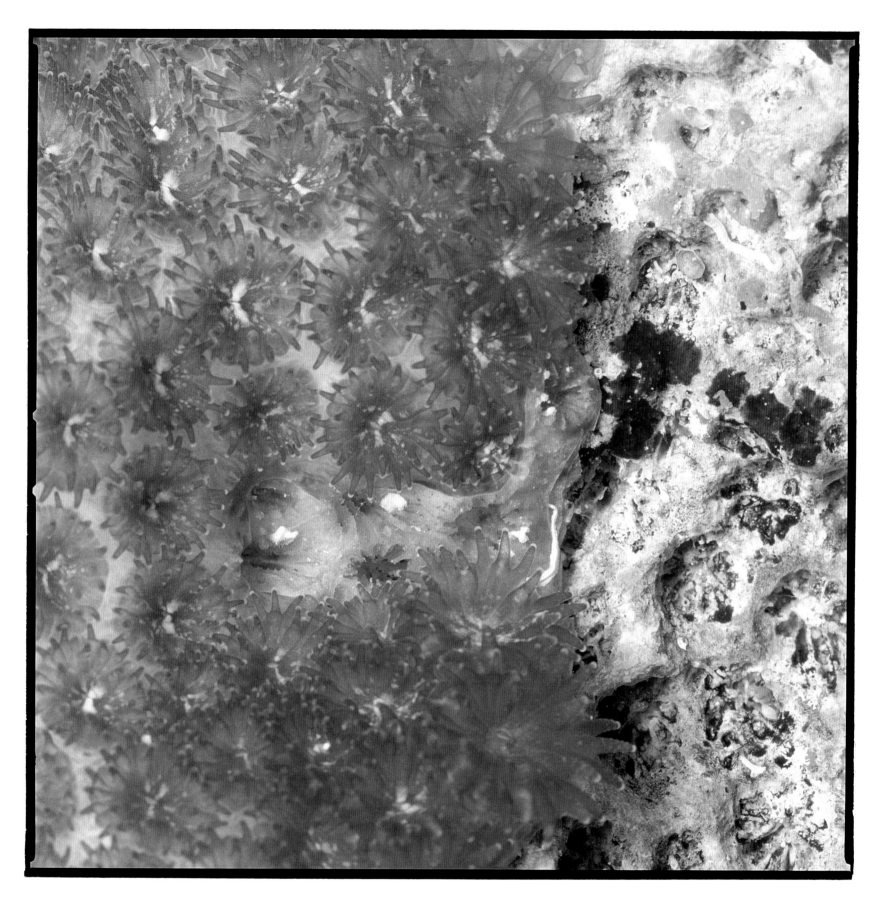

Coral close-up
Leptastrea sp.

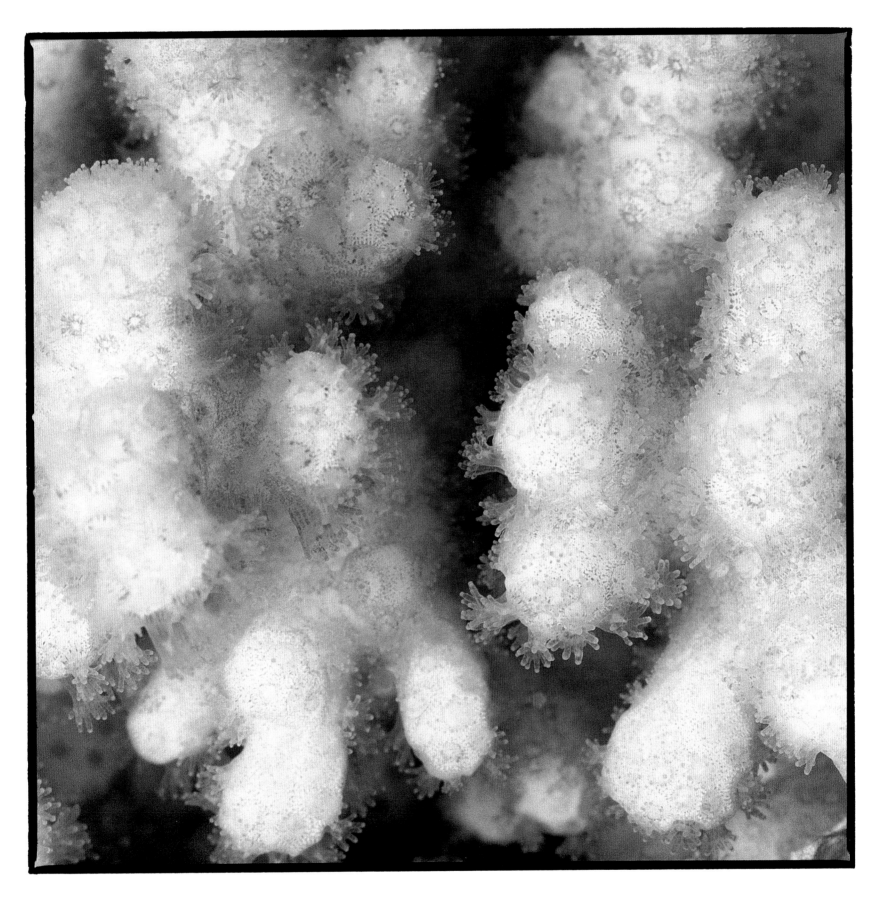

Lace Coral ~ ʻakoʻakoʻa, koʻa, puna kea
Pocillopora damicornis

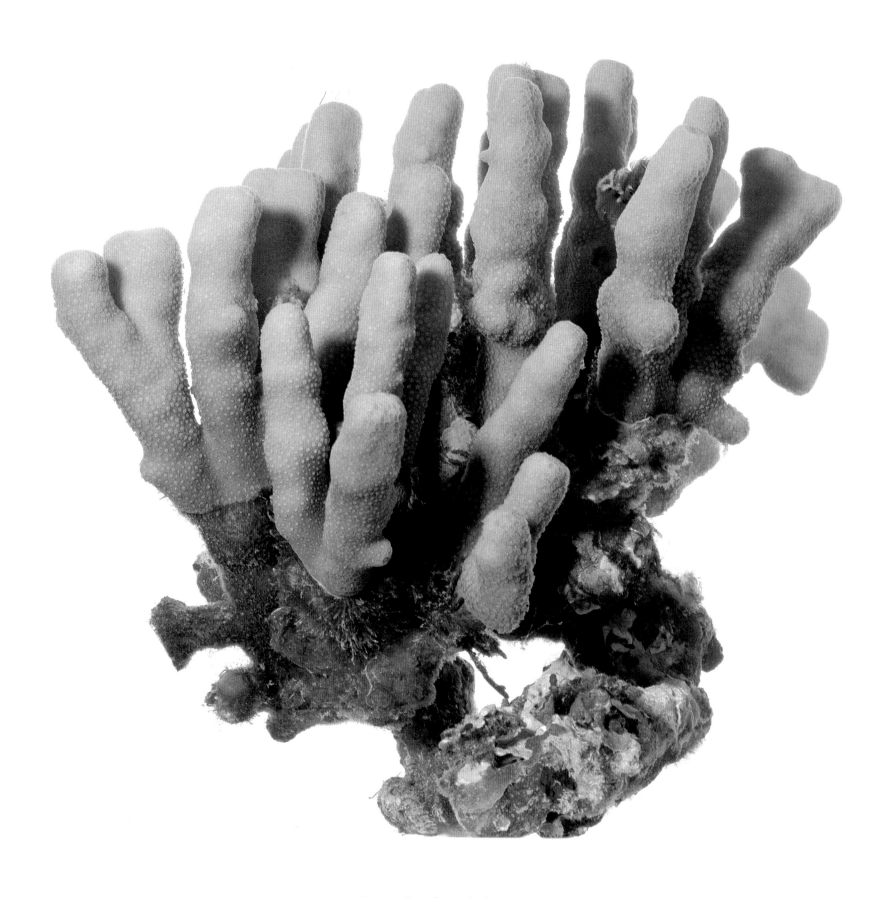

Finger Coral ~ pōhaku puna
Porites compressa

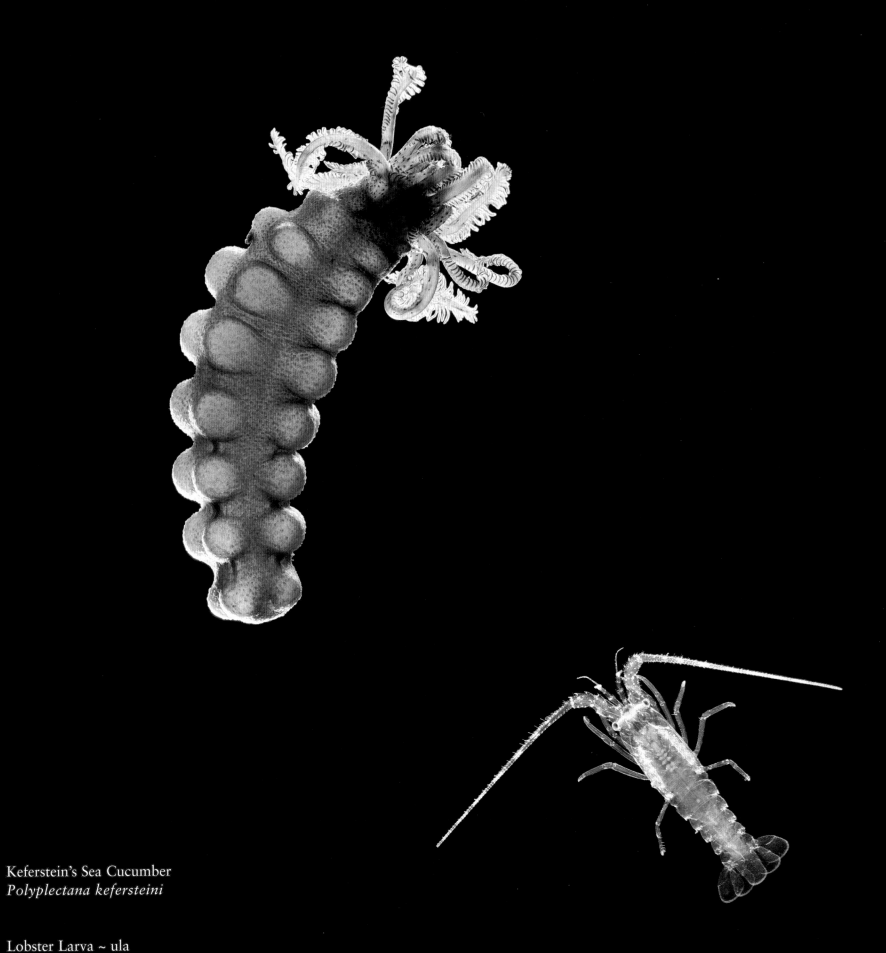

Keferstein's Sea Cucumber
Polyplectana kefersteini

Lobster Larva ~ ula
Panulirus sp.

Laurencia ~ limu
Laurencia galtsoffii

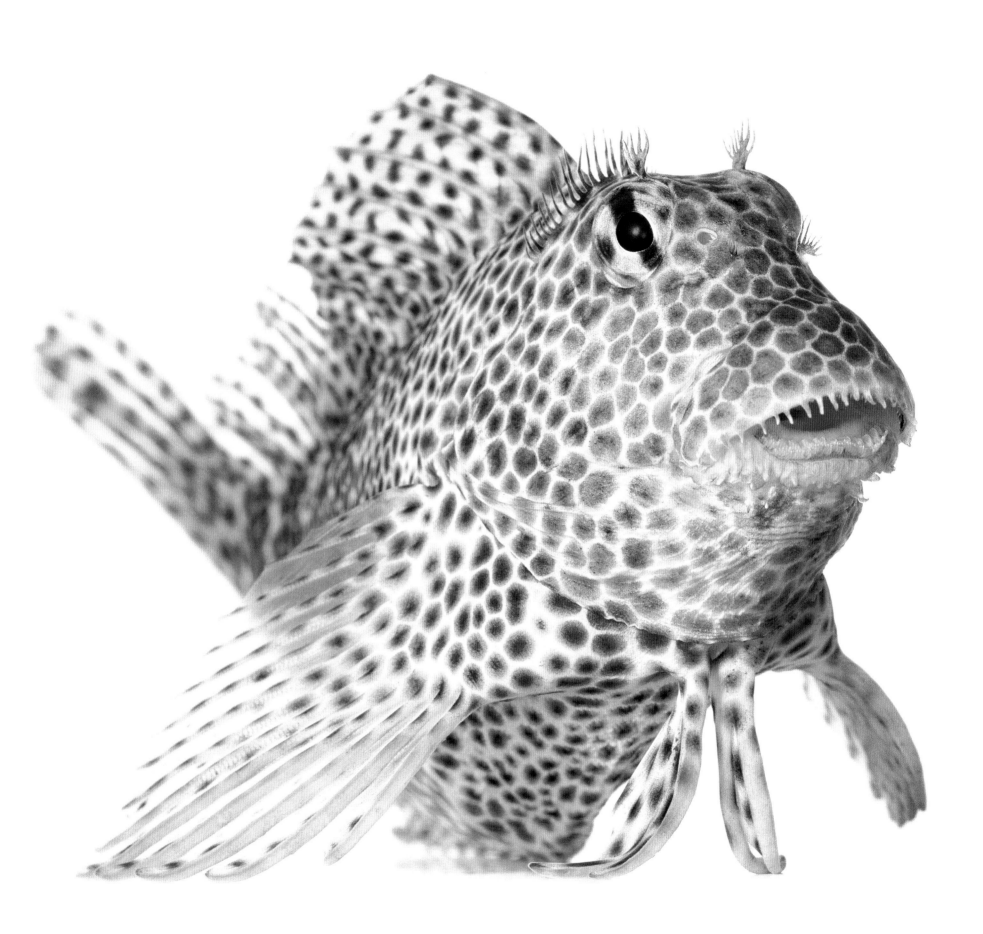

Leopard Blenny ~ pōʻo kauila
Exallias brevis

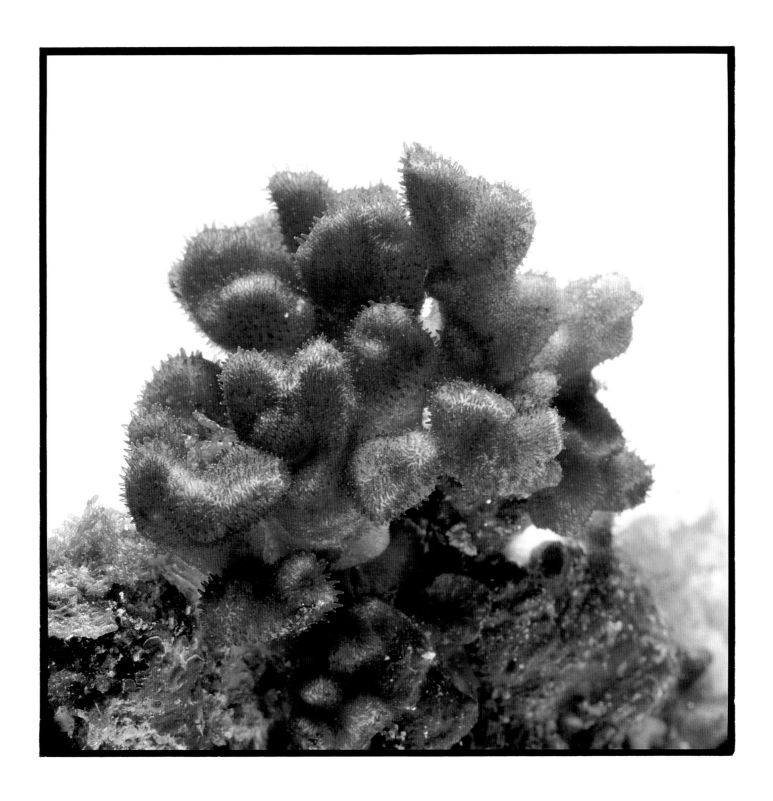

Psammacora ~ ʻako ʻako ʻa
Psammacora stellata

Goose barnacles and small crabs ~ pīʻoeʻoe
Lepas anserifera and *Planes* sp.

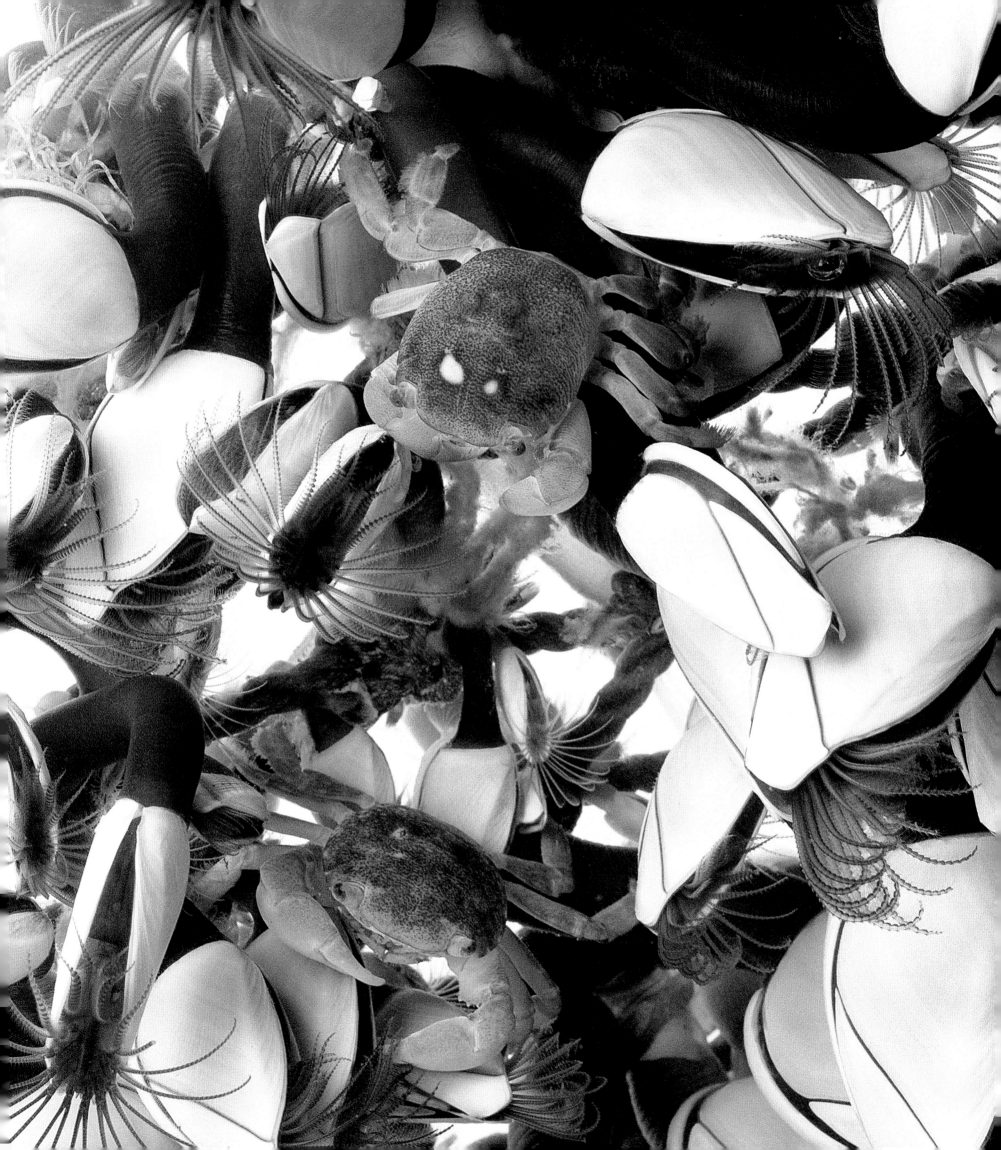

Imperial Nudibranch
Risbeca imperialis

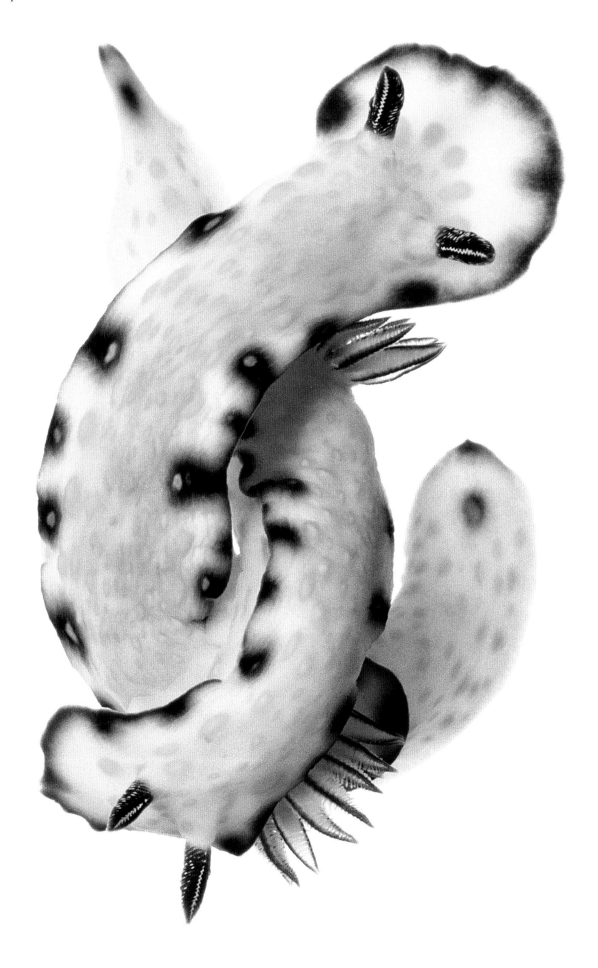

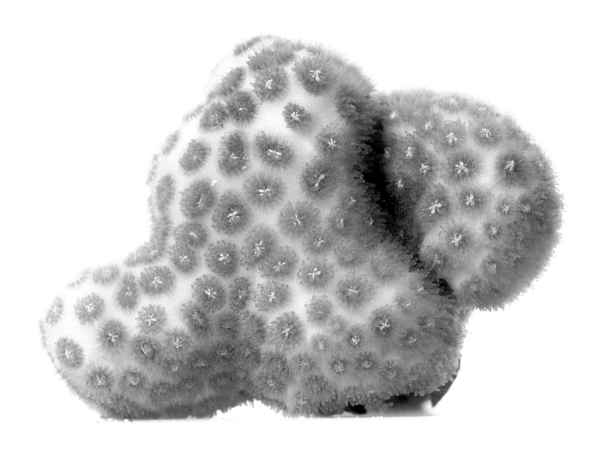

Crust Coral
Leptastrea cf. *Favia hawaiiensis*
(polyps emerging, polyps fully
emerged)

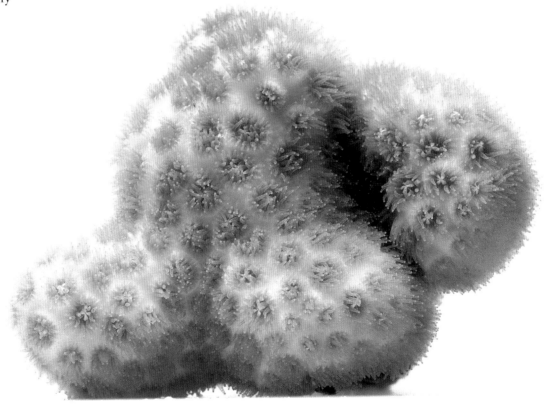

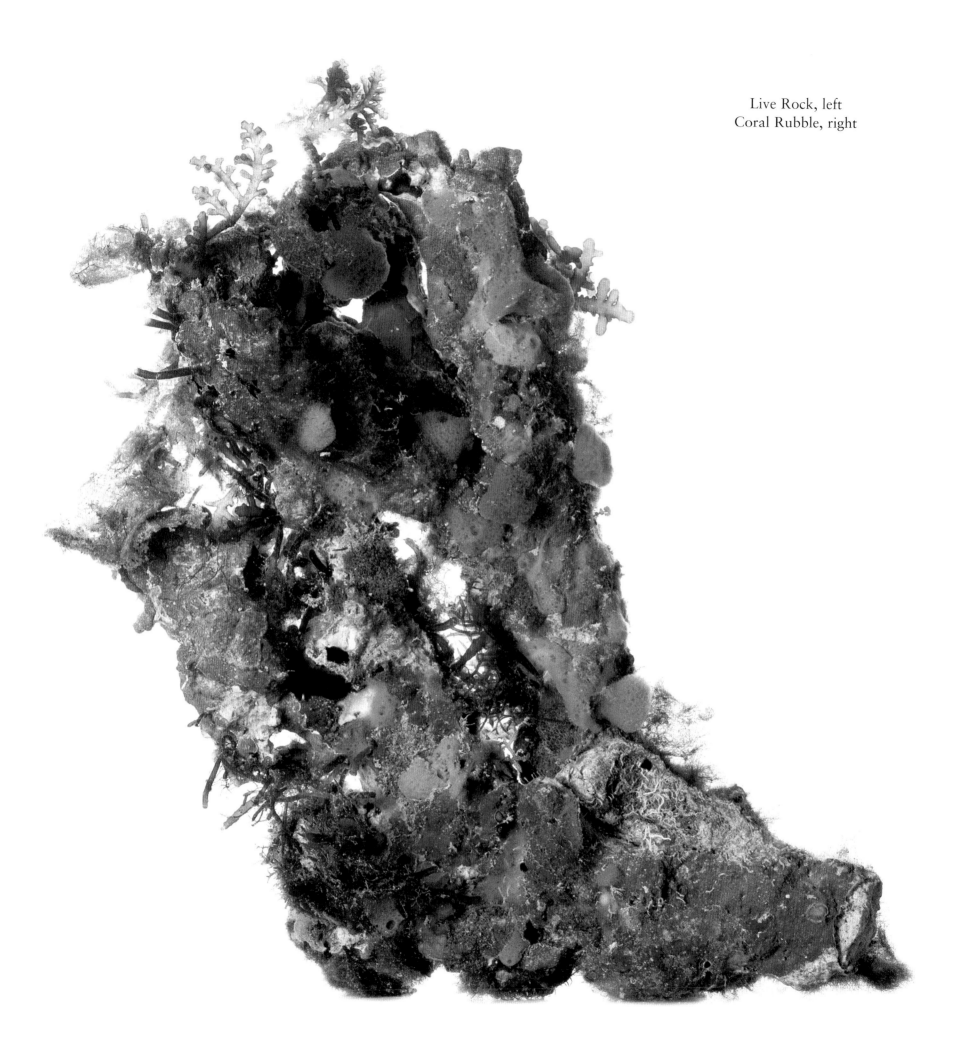

Live Rock, left
Coral Rubble, right

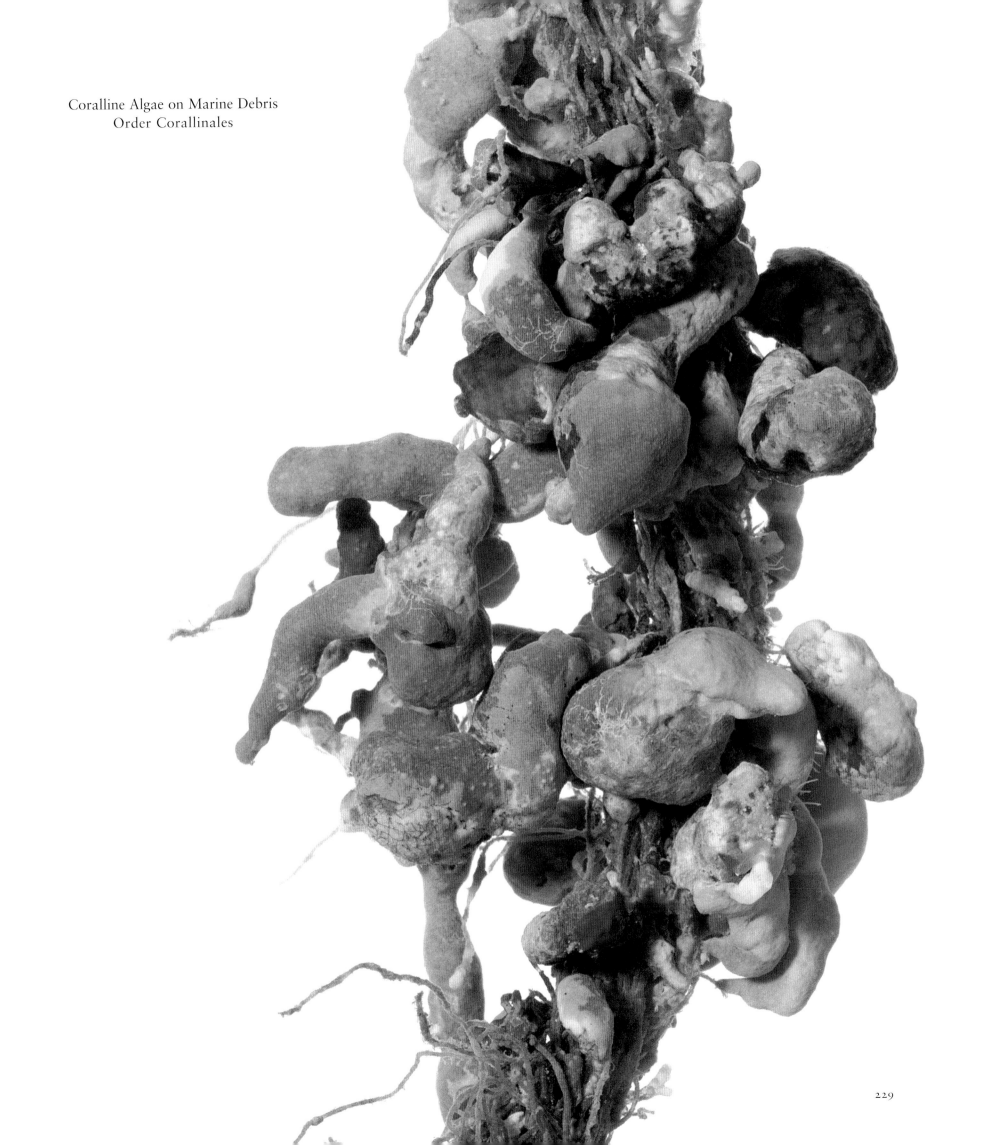

Coralline Algae on Marine Debris
Order Corallinales

Stypopodium ~ limu
Stypopodium flabelliforme

Hydroclathrus ~ limu
Hydroclathrus clathratus

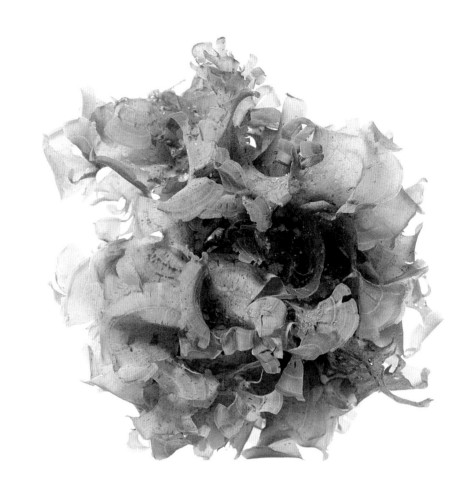

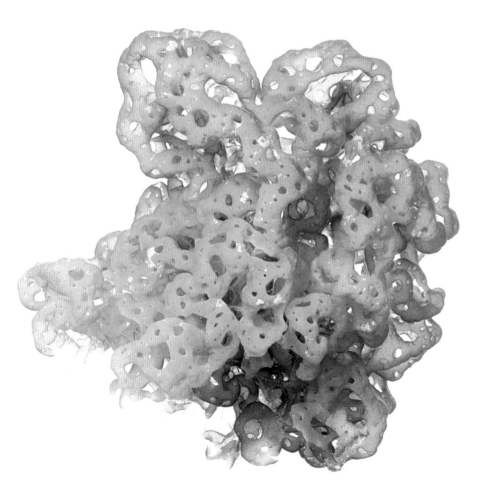

Pied Brittle Star ~ peʻa
Ophiocoma pica
on coral rubble, *Porites compressa*

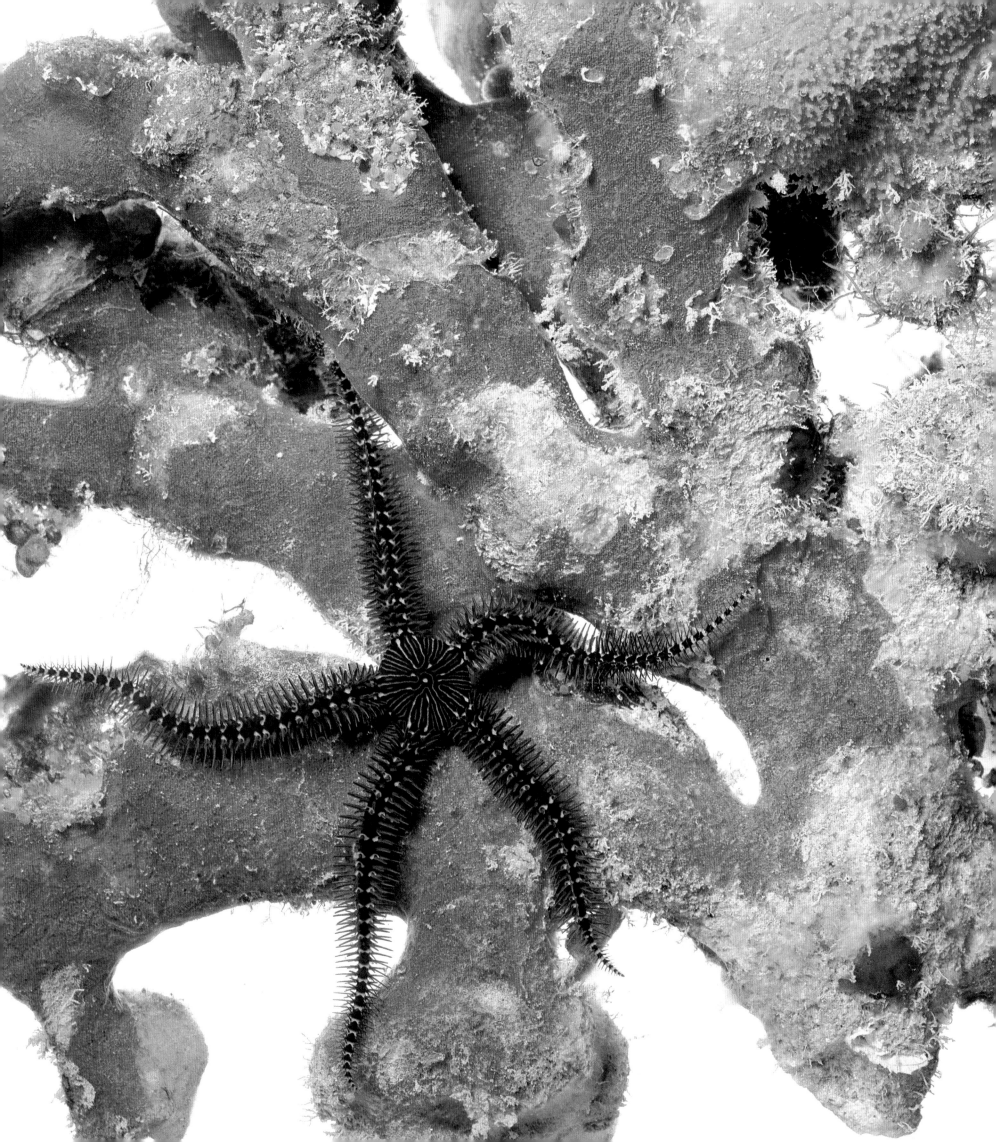

Spotted Linckia ~ opuʻapeʻa, peʻapeʻa, hōkū-kai, peʻa
Linckia multifora (on *Turbinaria ornata*)

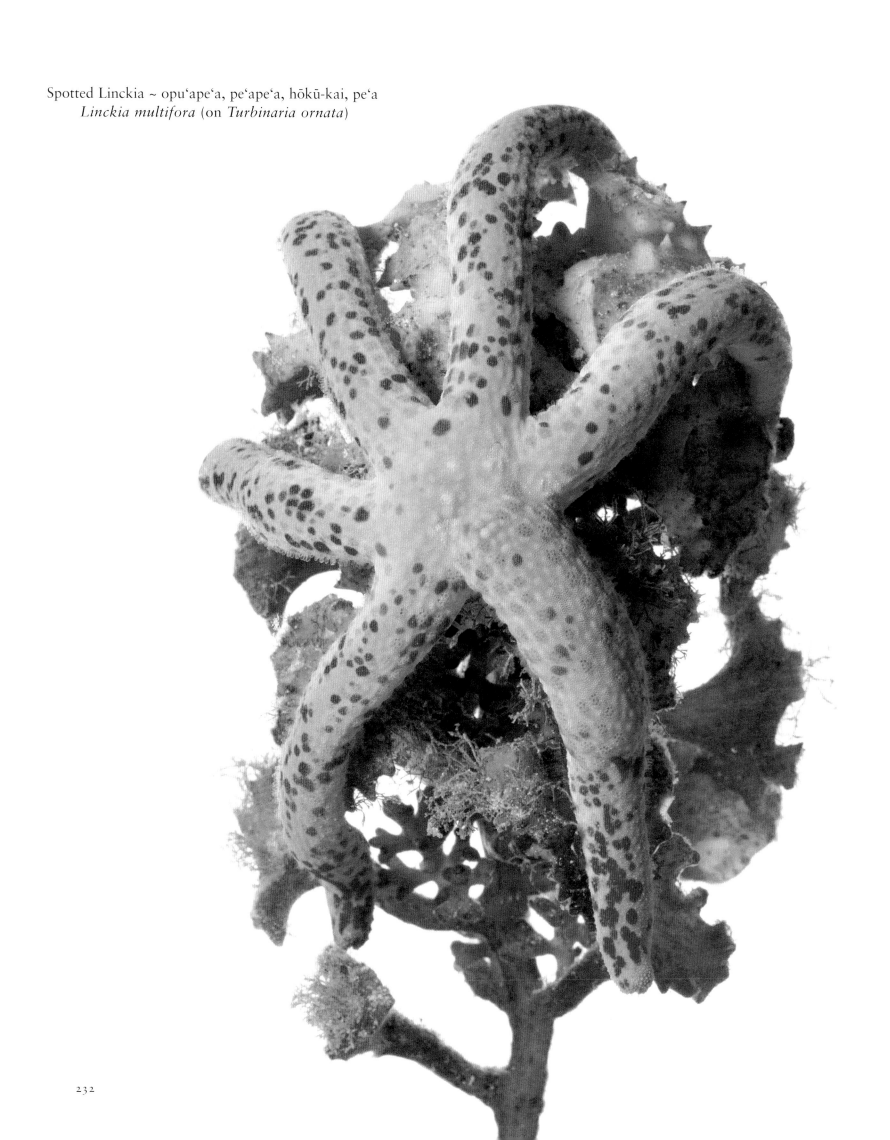

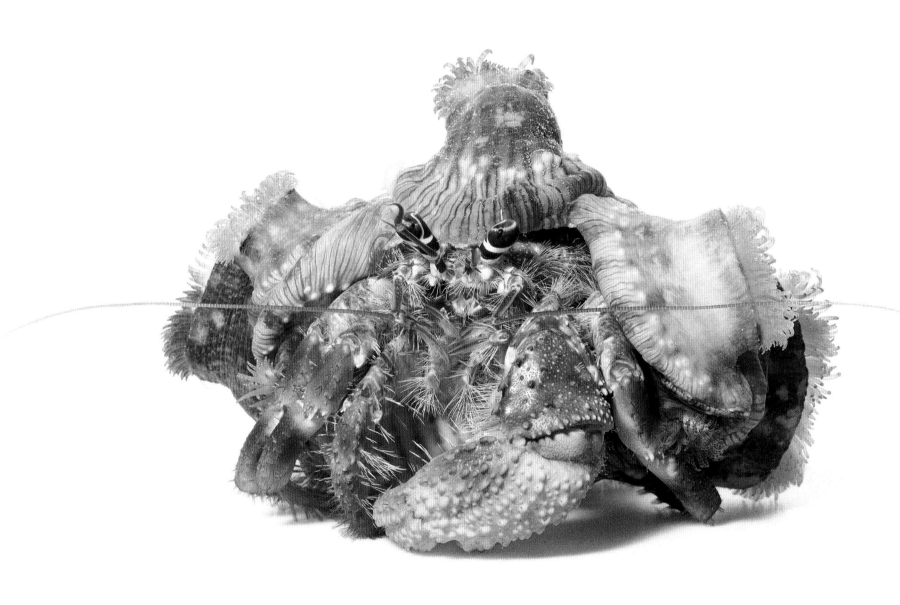

Jeweled Anemone Crab and Anemones ~ unauna and ʻōkole emiemi
Dardanus gemmatus and *Calliactis polypus* and *Anthothoe* sp.

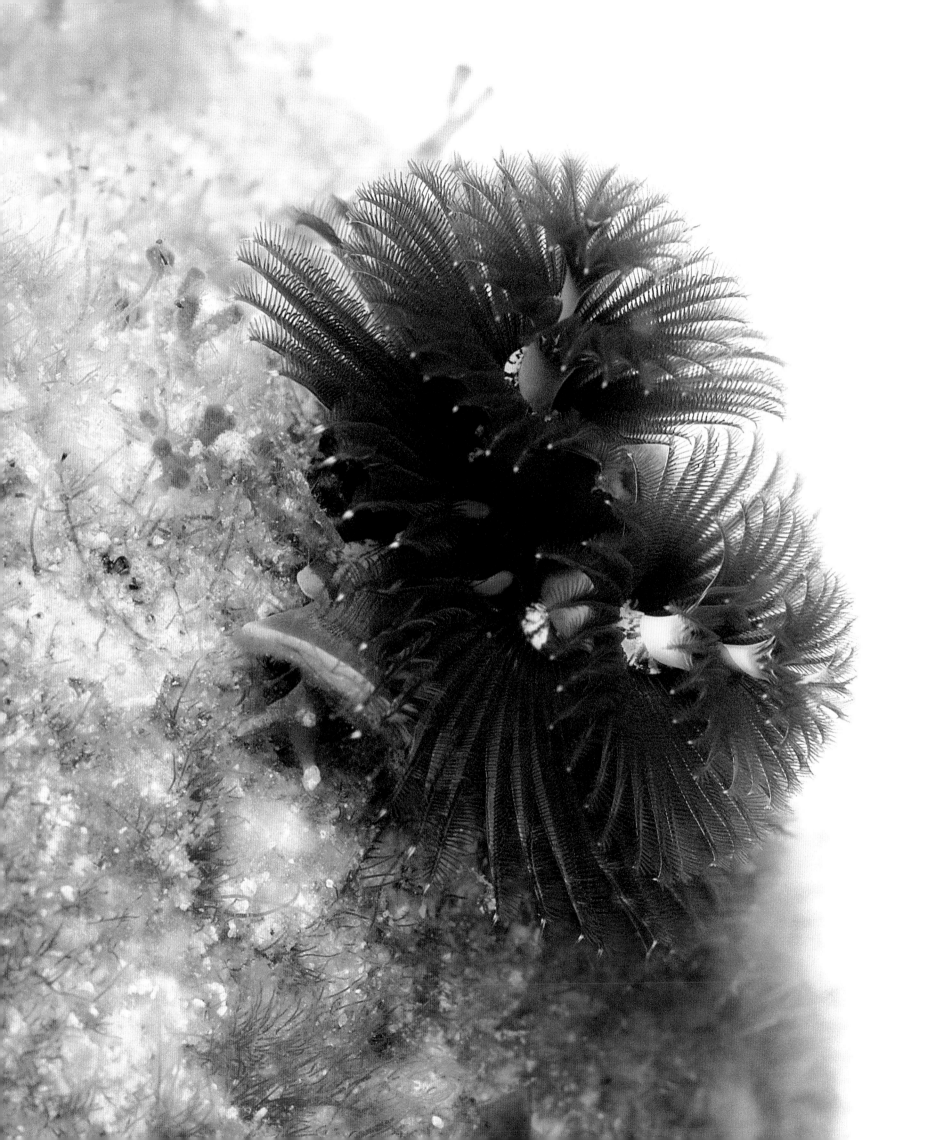

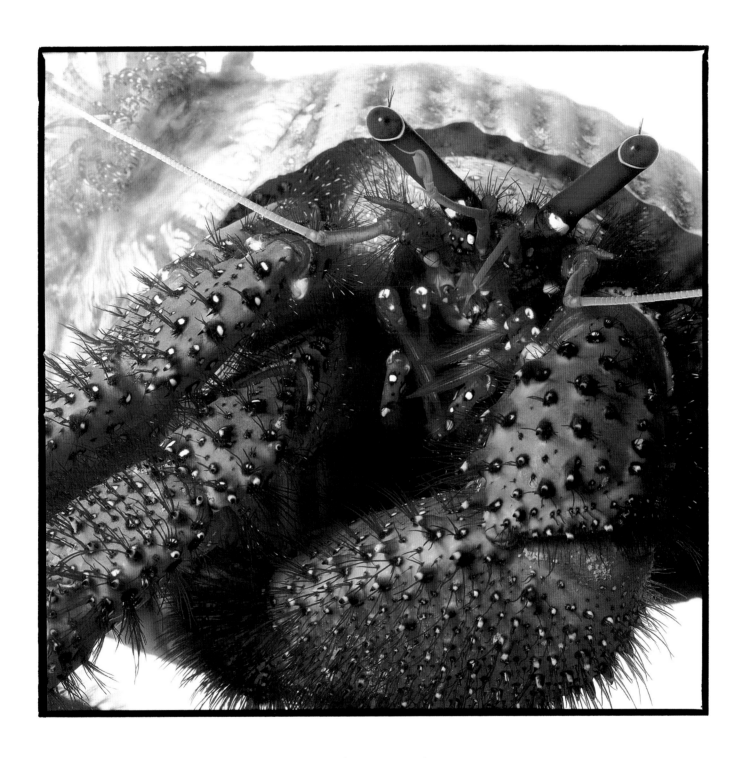

White Spotted Hermit Crab ~ unauna
Dardanus megistos

Christmas Tree Worm ~ kio
Spirobranchus giganteus

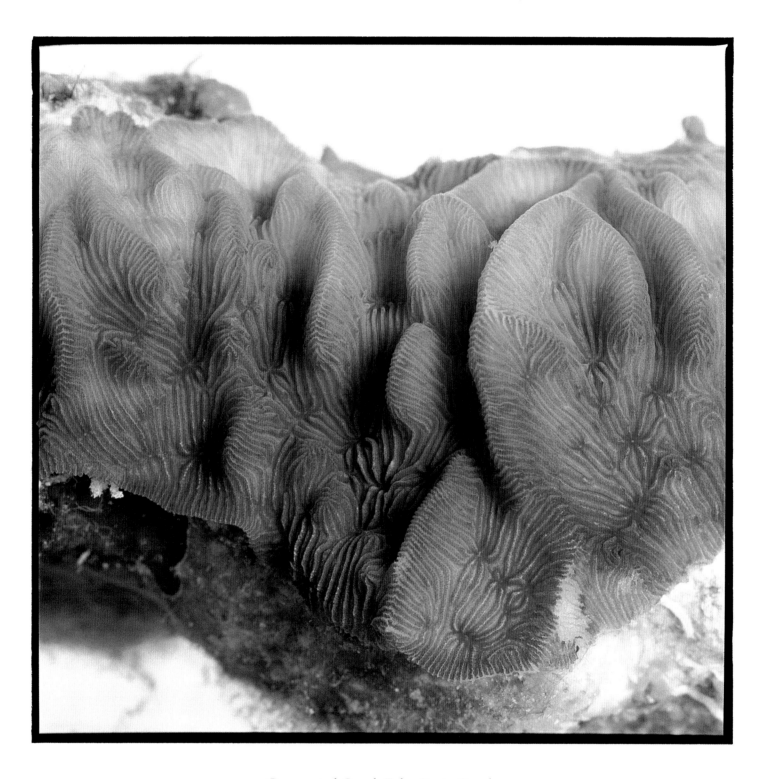

Corrugated Coral, False Brain Coral
Pavona varians

Juliana's Sea Hare and Black-Lipped Pearl Oyster ~ pā and kualakai
Aplysia juliana and *Pinctada margaritifera*

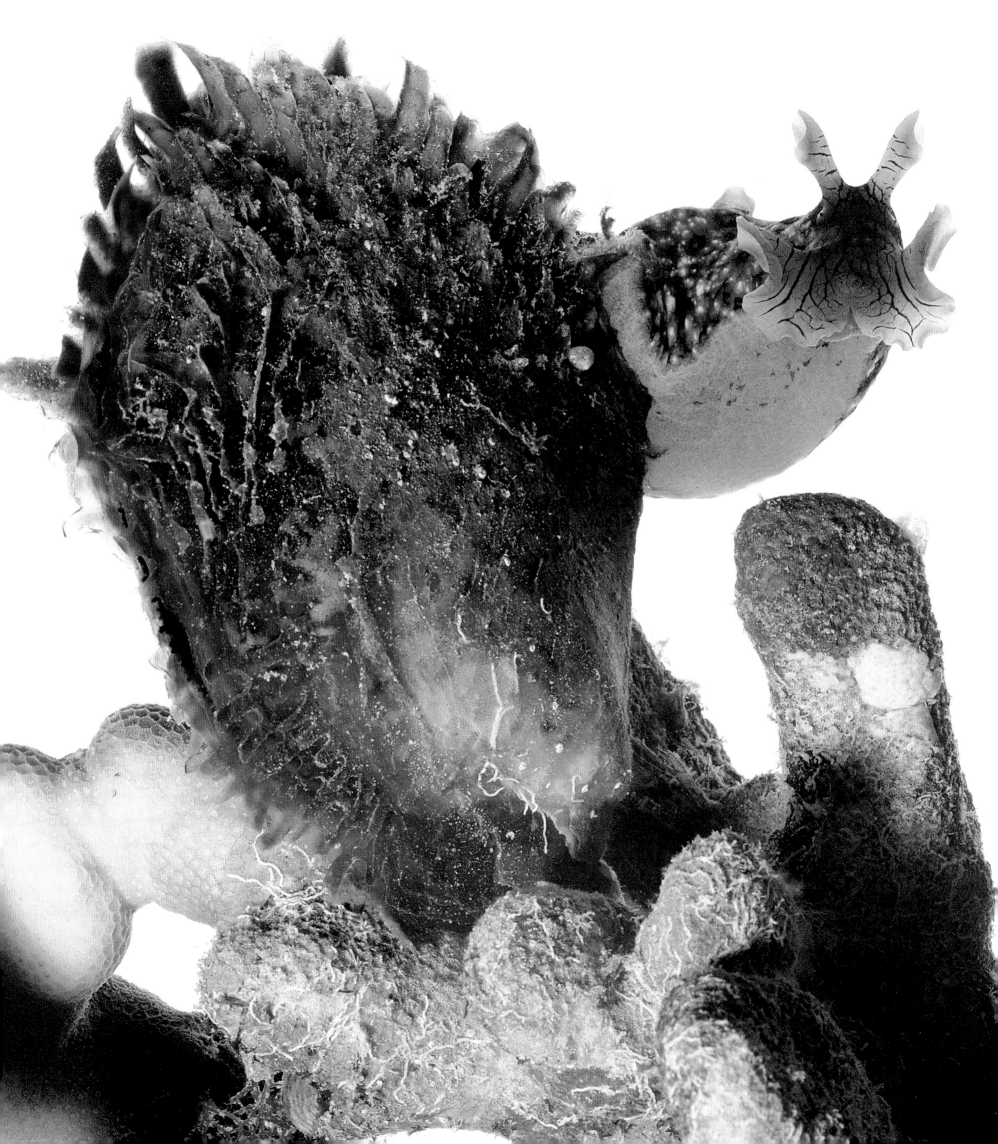

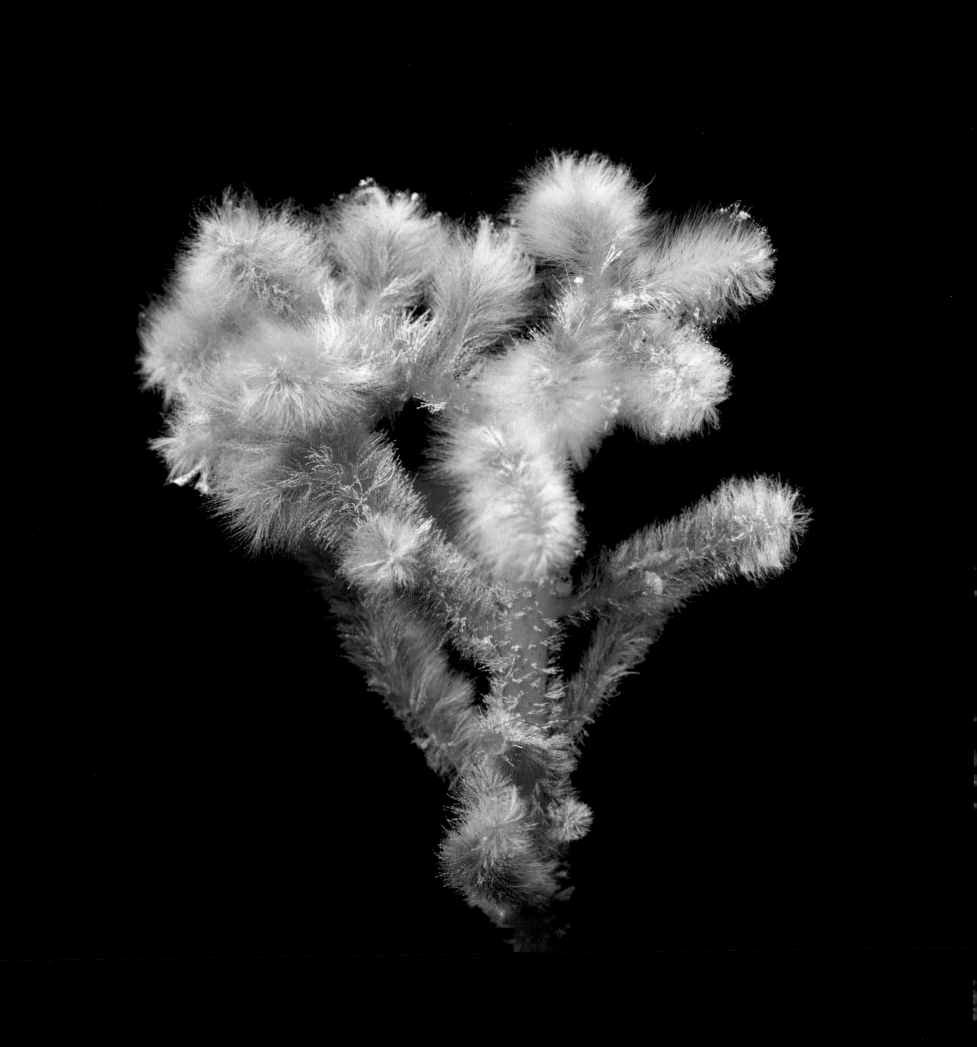

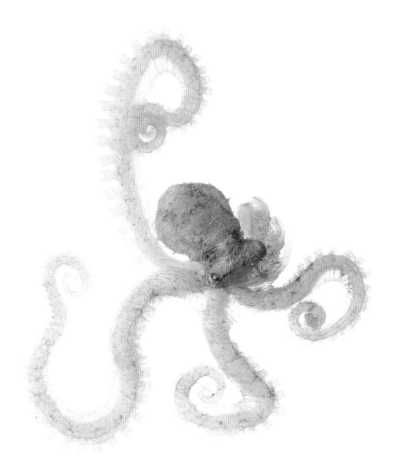

Juvenile Octopus ~ heʻe
Octopus sp.
(top, at rest; bottom, after being
offered a shrimp)

Dasya ~ limu
Dasya iridescens

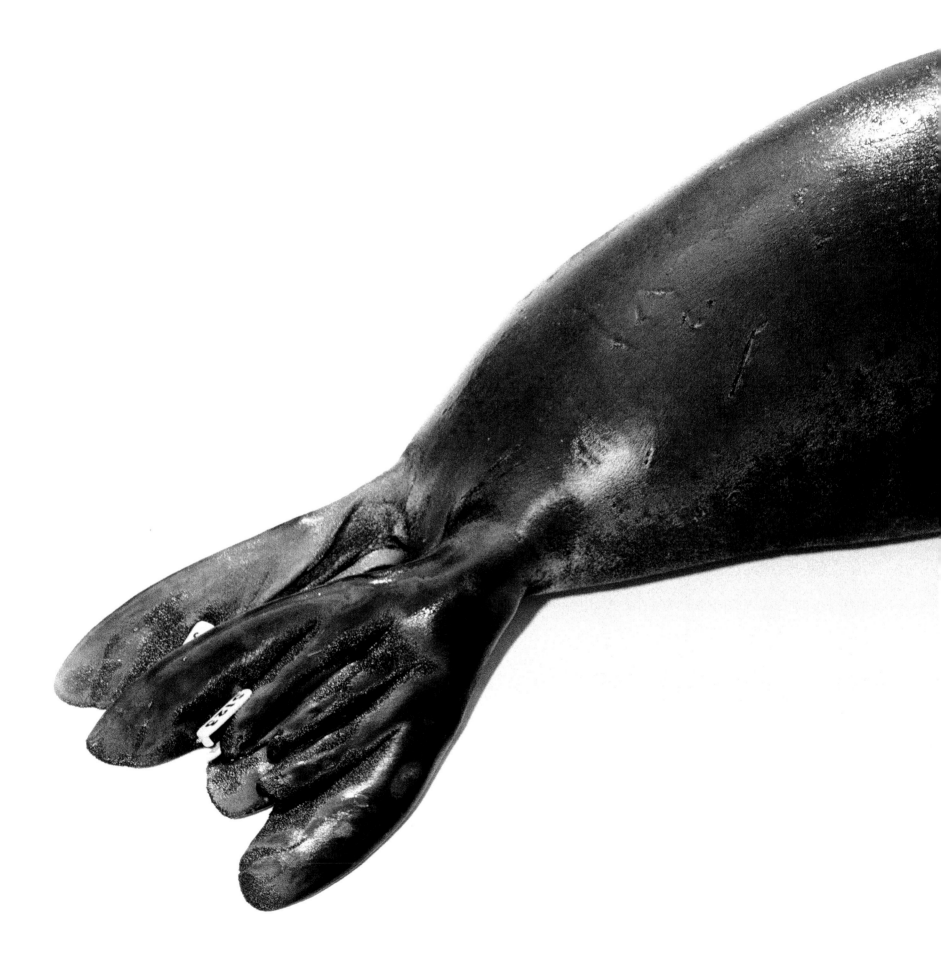

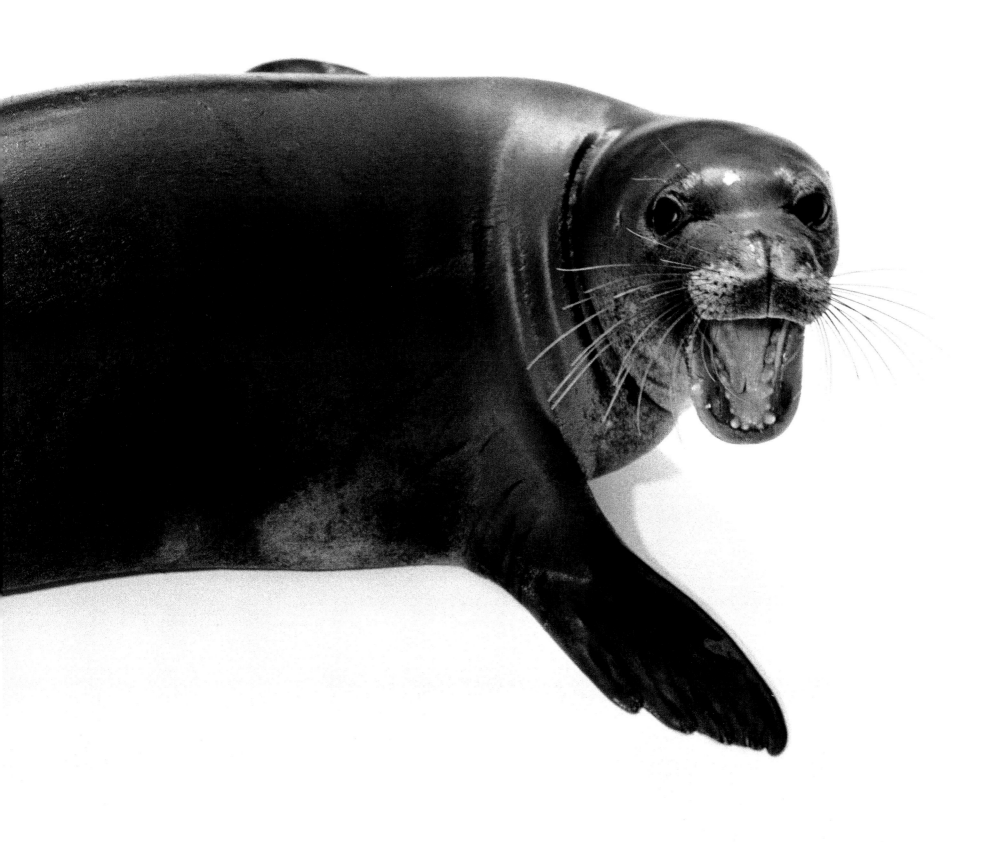

Monk Seal ~ ʻīlioholoikauaua
Monachus schauinslandi

Species Profiles

Marine profiles by Stephani Holzwarth.

Terrestrial plants and birds by Alex Wegmann.

Terrestrial invertebrates by Anita Manning and Steve Lee Montgomery.

with assistance from the following people who generously reviewed the profiles

FISHES: *Randall Kosaki*, Ph.D. Research Coordinator, NOAA/NOS National Marine Sanctuary Program, Northwestern Hawaiian Islands Coral Reef Ecosystem Reserve; *Bruce Mundy*, Fisheries Biologist, NOAA Pacific Islands Fisheries Science Center; *John E. Randall*, Ph.D., Senior Ichthyologist, Bishop Museum Honolulu, Hawai'i; *Arnold Suzumoto*, Ph.D., Collections Manager, Ichthyology, Bishop Museum

MARINE INVERTEBRATES: *Scott Godwin*, Marine Biologist, Hawai'i Biological Survey, Bishop Museum; *Daphne Fautin*, Ph.D., Curator (Natural History Museum) and Professor, University of Kansas; *Dwayne Minton*, Ph.D., Natural Resource Manager, War in the Pacific National Historical Park, Guam

MARINE ALGAE: *Peter Vroom*, Ph.D., Algal Biologist, Joint Institute for Marine and Atmospheric Research, contracted to NOAA Fisheries Coral Reef Ecosystem Division, Affiliate faculty, Department of Botany, University of Hawai'i

CORALS: *Jim Maragos*, Ph.D., Coral Reef Biologist & Field Dive Officer, Pacific Remote Islands National Wildlife Refuge Complex, U.S. Fish and Wildlife Service

BIRDS: *Beth Flint*, Supervisory Wildlife Biologist, U.S. Fish and Wildlife Service, Pacific Remote Islands National Wildlife Refuge Complex

TERRESTRIAL INVERTEBRATES: *Carl C. Christensen*, Associate in Science, Bishop Museum; *Daniel Chung*, Lecturer, Kapiolani Community College; *Sheila Conant*, Professor and Chair, Department of Zoology, University of Hawai'i at Mānoa; *Robert H. Cowie*, Center for Conservation Research and Training, University of Hawai'i, Mānoa; *Mike Richardson*, Entomologist, U.S. Fish and Wildlife Service, Pacific Islands Office; *Daniel Rubinoff*, Department of Plant and Environmental Protection Sciences, University of Hawai'i

GREEN SEA TURTLE: *Irene Kinan*, Turtle Program Coordinator, Western Pacific Fishery Management Council

MONK SEAL: *Jason Baker*, Ph.D., Team Leader, Monk Seal Assessment Program, Protected Species Division, NOAA Pacific Islands Fisheries Science Center

HAWAIIAN CULTURAL AND LINGUISTIC ASSISTANCE: *Isabella Aiona Abbott*, Ph.D., G.P. Wilder Professor of Botany, University of Hawai'i; *Larry Kimura*, Chair of the Hawaiian Lexicon Committee

Hawaiian Green Sea Turtle hatchling ~ honu, *Chelonia mydas*

p. 4–5, p. 118–119

PHOTOGRAPH: Tern Island field studio, French Frigate Shoals, 17 September 2004
RANGE: pan-tropical
HABITAT: pelagic (juveniles); coastal (adults)
SCALE: hatchlings, carapace 4 cm across; adults to 200 kg

We went looking for them just before dawn—the lost ones, the ones that took a wrong turn in their first hour above ground. It was nesting season on Tern Island, and Hawaiian green sea turtle hatchlings were popping out of the sand in the dark of night and heading straight for the water, discerning it as a dull glow. Vegetation absorbs light, while water reflects it, so even at night the turtles can tell what direction to go—except for the few who invariably get lost. Along brightly lit coastlines, turtle hatchlings often get confused and end up in parking lots instead of the ocean. Even on Tern Island, with no lights to make things harder, a few hatchlings still manage to head the wrong way. Ghost crabs cart off a few of them, frigatebirds pluck them from the sand, and large ulua swallow some of them whole.

But on this night, the predators were out of luck. We scooped up the stragglers and took them to a makeshift studio in the field station's tool shed, a roomy concrete-block structure with barn doors. David and Susan had outfitted it with portable lights, backdrop, tripod, and medium-format camera with bellows. The sky was just beginning to lighten when I pedaled back on my beach-cruiser bike with a bucket holding five baby turtles, resting on a towel.

"Put one in!" David told me, and I slipped the liveliest one into the waiting aquarium as the photographers snapped away. After a brief turn, I put each subject back into the bucket, to avoid tiring it out before its epic journey had even begun. At the session's end, I carried the hatchlings out to the beach and walked into knee-deep water, away from the ghost crabs. One by one, I cradled the hatchlings in my hands until they seemed somewhat oriented, and then watched as they paddled enthusiastically out to sea.

A long journey lies before these babies, each about as long as a stick of gum. If they make it out of the atoll into the deeper water of the big blue ocean, they'll disappear for the first five to ten years of their lives. When they've grown to the size of a dinner plate, the turtles start to come back to shallow reef areas, where they feed on fleshy algae. Most will be about 25 years old and weigh 200 pounds or more by the time they are ready to mate, though only one or two hatchlings from about 1,000 eggs will make it to this stage.

Sea turtle populations have plummeted all over the world in the past century. Hawai'i's green sea turtles, locally called honu, are among the few that have pulled out of this nosedive. As recently as the 1970s, honu were being harvested in large numbers by suppliers of main-island restaurants, and by fishing boats in the NWHI. In 1978 legal harvests ceased when honu were listed as threatened under the Endangered Species Act, and their numbers have slowly rebounded. Today, an estimated 500 mature females per year lay their eggs in Hawaiian sand.

Unfortunately, many of the young turtles that congregate in the coastal waters of the main Hawaiian Islands have been developing grotesque tumors, caused by a contagious virus called fibropapilloma, the cause of which is still unknown. The tumors grow internally on the organs and externally on the skin; lumps on the face, neck, and throat eventually can blind the turtle or render it unable to swallow food. It takes over a year for a turtle to starve to death: a slow, painful way to die. Scientists are currently working to understand what causes the virus, and how to prevent its spread.

Even with the virus, sea turtles in Hawai'i are better off than turtles in much of the world, thanks to the intact nesting beaches of the NWHI and reduced harvest pressure. An estimated 90 percent of the region's honu breed at French Frigate Shoals, whose beaches remain free of introduced predators, human harvesting, beach development, and light pollution, all of which exact staggering tolls on turtles elsewhere. Plastic and marine debris pose other hazards, and interactions with fisheries can result in turtles drowning in gillnets or biting baited hooks.

Honu were revered by the ancient Hawaiians, who not only ate their meat but also carved their shells and bones into fish hooks, combs, headdresses, and weapons. Some families considered the sea turtle their 'aumakua—guardian spirit—and wove the animal into many stories and legends. At Panalu'u, on the Big Island, the legend of Kauila tells of a sea turtle that turns into a girl and protects the children as they play; other stories give turtles spiritual or familial significance.

Possessing a superb design for a life lived at sea, turtle hatchlings have loose joints for swimming, puppy-dog-style foreflippers for endless paddling, and agile back flippers for steering. All help increase the odds for survival, as does a custom-fitted shell with smoky black top and creamy white belly, providing camouflage from above and below. The turtle's large black eyes even contain special glands that cry big, salty tears to balance water and mineral levels. These photographs reveal a remarkable moment in the life of a sea turtle, which can extend for 70 or 80 years: the moment when a hatchling experiences water, its natural element, for the very first time.—S.H.

Morning Glory ~ koali ʻawa, *Ipomoea indica*

p. 8

PHOTOGRAPH: Green Island, Kure Atoll, 16 August 2003
RANGE: pantropical
HABITAT: low elevation, often in disturbed areas
SCALE: flower 8.5 cm in diameter; vines are often more than 5 meters long

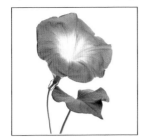

A morphologically diverse group of plants, the morning glory family (Convulvulaceae) contains herbs, vines, lianas, and shrubs or small trees. Despite differences in form, members of this family share the following traits: blooms that wilt quickly after opening, and flowers with 5 sepals and 5 stamens. Convulvulaceae enjoys worldwide representation with 50 genera and 1,200 species. The *Ipomoea* genus comprises approximately 500 species of vines and shrubs spread globally within tropical and subtropical latitudes. Nineteen known *Ipomoea* species grow in Hawaiʻi, fourteen of which are considered native or naturalized. Koali ʻawa, or *Ipomoea indica*, occurs on all the main Hawaiian Islands, as well as on Kure Atoll, Midway Atoll, Laysan Island, and Nihoa Island in the northwestern chain. The large, funnel-shaped, light blue to lavender koali ʻawa flowers are pollinated by sphinx moths (*Sphingidae*), among other flying insects. A white-flowered form of *Ipomoea indica* grows on Lisianski Island, Kauaʻi, Oʻahu, and Maui; plants with intermediate flower colors—between blue and white—occur in association with this form. *Ipomoea indica* sends prostrate vines over the floor of its habitat, often covering other ground-cover plant species or patches of bare sand or soil. Round, velvety seeds, between one to four in number, can withstand prolonged exposure to salt water—a necessary trait for plant species that disperse seeds via ocean currents. Traditional Hawaiian use of koali ʻawa included processing the plant's roots and leaves into poultices for treating wounds, sores, and broken bones.—A.W.

Boerhavia ~ ʻalena, *Boerhavia repens*

p. 9

PHOTOGRAPH: Green Island, Kure Atoll, 16 August 2003
RANGE: pantropical throughout the Indian and Pacific Oceans
HABITAT: coastal strand
SCALE: flower head 1.5 cm across; plant up to 30 cm tall

Found throughout the main Hawaiian Islands and all of the low, sandy islands and atolls in the Northwestern Hawaiian Islands, *Boerhavia repens* is a common member of the coastal plant community. Boerhavia, or ʻalena in Hawaiian, grows well in nutrient-poor, sandy soil, and can withstand temporary immersion in salt water—both important traits for a plant living at the land-sea interface. On Laysan Island and the small islets of Pearl and Hermes Atoll, Laysan finches (*Telespiza cantans*) readily forage on the small, green ʻalena fruit. These fruit have a sticky coating which facilitates seed dispersal; while walking around breeding colonies, Laysan and black-footed albatrosses (*Phoebastria* sp.) frequently transport ʻalena fruit stuck to their breast feathers. During vegetation surveys on Southeast Island at Pearl and Hermes Atoll, I regularly walked through large patches of fruiting ʻalena, emerging with hundreds of sticky, 4mm-long fruit stuck to my leg hairs. Removing the fruit was rather painful, though I learned that if I stood still for a few minutes, several opportunistic Laysan finches would spot the smorgasbord and make quick work of the ʻalena fruit stuck to my legs. The edible ʻalena roots, leaves, and seeds are eaten by people living within the plant's broad range. The roots also have medicinal importance and were used traditionally to treat such ailments as asthma, anemia, and intestinal inflammation.—A.W.

Convict tang ~ manini, *Acanthurus triostegus*

p. 11

PHOTOGRAPH: *Hiʻialakai* shipboard studio, Midway Atoll, 3 October 2004
RANGE: Indo-Pacific
HABITAT: reef habitats with algal cover
SCALE: largest pictured 10 cm total length; adults to 25 cm

Convict tangs, or manini, contribute to reef health by heavily grazing algae, like herds of underwater sheep, which in turn clears space for slow-growing corals and macro-algae. Schools of several hundred to over a thousand manini roam across the reef in a fluid hoard, behaving like one large, dynamic super-herbivore. Their sheer numbers overwhelm pugnacious territorial fish such as damsels, which tend gardens of edible algae. The ever moving school visually confuses predators with a constant flux of stripes. Otherwise, convict tangs are relatively defenseless, since the spines at the base of their tails are poorly developed compared to other surgeonfishes (Family Acanthuridae). Hawaiians historically valued manini as food fish. Tiny manini that settled in the tide pools were transparent; Hawaiians called them ʻohua-liko, which describes them as larval fish (ʻohua) like a leaf bud (liko). After their stripes appeared, they were called ʻohua-kaniʻo—larval fish with stripes. Manini, the name for adult fish, means "no big thing" in modern Hawaiian slang, referring to its puny size compared to other locally speared fish. The convict tang has round dark spots on its face, like freckles, that darken or disappear depending on the level of excitement in the fish. Their eyes are set high on their heads, and they have petite downturned mouths with flexible, comblike teeth for raking and clipping algae.—S.H.

Masked Booby ~ ʻa, *Sula dactylatra*

p. 12

PHOTOGRAPH: Southeast Island, Pearl & Hermes Atoll, 21 May 2003
RANGE: pantropical
HABITAT: pelagic; breeds on remote islands
SCALE: wingspan 70-87 cm; mass 1.2—2.4 kg

Grandest member of the family *Sulidae*, masked boobies are dimorphic in mass, with females weighing 200g more than males. Nonetheless, sex determination requires voice to provide the key discriminator: Males whistle, females honk. On remote islands, monogamous breeding pairs clear small, circular nest-scrapes in nonvegetated habitats of sand, gravel, smooth lava, or loose soil. Clutches contain two eggs, with the first, and usually slightly larger, egg appearing several days before the second. Lacking an incubation patch on their breast, masked boobies incubate by covering the eggs with their broad webbed feet. Raw, helpless, and utterly altricial when newly hatched, masked booby chicks bend the ugliness curve back to cute. The first-laid egg hatches several days prior to the second. In a deadly version of sibling rivalry, the older, larger chick muscles the new hatchling outside the guano ring that defines the nest area. Since parents only attend to chicks within the nest boundary, the ejected sibling will die from exposure or starvation, or fall prey to frigatebirds (*Fregata* sp.) or land predators. This practice of fratricide may be an adaptation to a habitat of limited food resources; laying two eggs, yet raising only one chick, enables the species to conserve resources while hedging its bet against infertile eggs and mortality of young chicks. Alone and in flocks, masked boobies plunge-dive from heights of 40 meters to seize shallow-swimming fish and squid, which they swallow at the surface, feeding nestlings later by regurgitation.—A.W.

Sooty Terns ~ ʻewa ʻewa, *Sterna fuscata*

p. 16–17

PHOTOGRAPH: Eastern Island, Midway Atoll, 17 April 2003
RANGE: pantropical
HABITAT: pelagic; breeds on remote or offshore islands throughout range
SCALE: wingspan 82–94 cm; mass 200 g

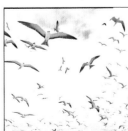

Their seemingly endless vocalizations have earned sooty terns an onomatopoeic moniker: While on the wing, the tern frequently utters a call like a little voice from above—"Wide awake, wide awake!" Sooty terns inhabit tropical and subtropical oceans around the world, fishing the wide-open expanses and nesting on remote islands. Their breeding colonies are some of the largest single-species bird colonies in the world, with some containing over one million individuals. Needless to say, the pandemonium and din generated by a large sooty tern colony is overwhelming. At one time, nearly every tropical island group hosted a sooty tern breeding colony. Alteration of nesting habitat, hazing and egg harvesting by humans, and the introduction of terrestrial predators have all led to the eradication of this species from many islands; current estimates put the worldwide population at 60 million to 80 million birds. Sooty terns live the majority of their life on the wing. Between nesting cycles, breeding adults will spend six to seven months away from the colony, all the while not touching land or resting on the ocean. A freshly fledged juvenile may spend years at sea, always flying, before it returns to land in search of a mate. While away from the colony, sooty terns scour the ocean's surface for small fish and squid, often snatching up prey as it escapes from large, predatory fish—usually tuna. Due to the bird's tight, foraging-based affiliation with tuna, unchecked tuna fisheries in tropical waters could indirectly threaten sooty tern populations.—A.W.

Spiny Brittle Star ~ peʻa, *Ophicoma erinaceus*

p. 18

PHOTOGRAPH: Sand Island field studio, Midway Atoll, 18 March 2004
RANGE: Indo-Pacific
HABITAT: under rocks and in crevices
SCALE: 14 cm arm span

During the day this spiny brittle star appears in basic black, sometimes with a little brown. At night however, it decorates its arms with gray stripes. While not as showy as many of their colorful sea-star cousins, brittle stars make the most of their low-profile lifestyle and are considered a very successful group. With flexible snake-like arms, they're quicker and more mobile than sea stars. In Greek, *ophis* means "snake," leading to the name Ophiuroidea for the class that includes brittle stars. Extremely adept at hiding in small places, brittle stars usually manage to keep out of sight and harm's way, a necessary precaution since their flexible legs are easily ripped off by a hungry fish. Wrasses especially will devour any brittle star unlucky enough to be exposed to the light of day. If its rock is flipped over or its hiding place compromised, a brittle star will rapidly retreat toward the nearest dark corner it can find, rowing across the bottom with gyrating legs. Along with sea stars and urchins, brittle stars belong to the Phylum *Echinodermata*, which means "spiny skinned." The spines on the arms of a brittle star are not actually sharp or brittle, like those of an urchin. Rather than deterring potential predators with a painful poke, the brittle star uses its blunt spines to scoot itself along the bottom and wedge itself under rocks. Peʻa, the Hawaiian word for brittle star, means "to cross," as in the shape of an X.—S.H.

Portuguese Man-of-War ~ paʻimalau, *Physalia physalis*

p. 19–20

PHOTOGRAPH: Green Island field studio, Kure Atoll, 26 July 2005
RANGE: worldwide
HABITAT: open ocean
SCALE: 5 cm across

Rather than one individual animal, a Portuguese man-of-war is actually a complicated colony of polyps and medusa that live together in the form of a small but fearsome battleship. While *Physalia* claims kinship to jellyfish and packs a similarly painful sting, it is a hydroid (Class Hydrozoa) rather than true jellyfish (Class Scyphozoa). A man-of-war begins life as an egg that hatches into a polyp, a tube-shaped body form with one open end ringed by tentacles—similar to coral. The polyp first grows a float and then buds off more polyps as well as medusae, bell-shaped body forms that also have one open end ringed by tentacles—similar to jellyfish. The polyps have special tasks: Some form long, stinger-laden tentacles used to stun and kill small fish and other prey, and some form shorter tentacles that digest the prey. Specialized medusae produce eggs and sperm for sexual reproduction, and also generate a small amount of propulsion. The man-of-war's travel mostly consists of sailing, with the float's crimped top providing a flat surface that catches the wind. This is passive sailing, however, and often entire man-of-war fleets will be driven ashore by the wind, where they die on the beach. Filled with carbon monoxide, the float provides buoyancy in addition to serving as a sail. The man-of-war spends its life at the surface, though other siphonophores travel up and down in the water column by changing the amount of gas in their float, and/or by swimming.—S.H.

Sporochnus ~ limu, *Sporochnus dotyi*

p. 22

PHOTOGRAPH: Hiʻialakai shipboard studio, Maro Reef, 21 September 2004
RANGE: endemic
HABITAT: moderately deep water on reefs and banks
SCALE: to 30 cm tall

Algae in the genus *Sporochnus* have caused some grief for biologists, who often rely on physical characteristics to distinguish between species, such as the length of pedicels (small side branches) and the shape of receptacles (special structures at the tip of the pedicel). The difficulty with *Sporochnus* is that these characteristics vary depending on the age of the plant, and the depth and turbulence of the water in which it is found. Pictured in the portrait, *Sporochnus dotyi* has conspicuous tufts, shaped like pom-poms and made up of tiny hairs which hold pigments for photosynthesis, allowing the plant to use sunlight to make its own food. *Sporochnus* is classified as a member of the Division Phaeophyta (brown algae) because its pigments include fucoxanthin and chlorophyll c, which give the plant a brownish-green color. Known only in Hawaiʻi, *Sporochnus dotyi* is rare even here. William Brostoff, the scientist who first described this alga, had only a few specimens: One plant came up with a fish trap that had been cast in the relatively shallow waters of French Frigate Shoals, and three more were brought up with an anchor from deeper water (about 40 m) at the mouth of Kaneohe Bay, Oʻahu. While this alga is uncommon on most reefs, scientific divers have come across fields of it at Maro Reef—although it's unclear why this particular location allows *Sporochnus* to flourish.—S.H.

Bonin Petrel, *Pterodroma hypoleuca*

p. 23

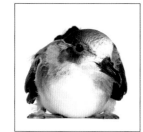

PHOTOGRAPH: Sand Island, Midway Atoll, 5 June 2003
RANGE: Pacific Ocean; breeding range limited to the NWHI and two small Japanese islands
HABITAT: pelagic; breeds on remote islands
SCALE: wingspan 63–71 cm; mass 205 g

An estimated 315,000 breeding pairs of Bonin petrels nest on the Northwestern Hawaiian Islands. Lisianski Island hosts the world's largest Bonin petrel colony of nearly 250,000 nesting pairs. Bonin petrels also breed on two islands near Japan, volcanic Kazan Retto and namesake Bonin Island, but little is known about these colonies. Fossil remains suggest that prior to human arrival in the Hawaiian Islands, Bonin petrels nested on Molokaʻi, Oʻahu, and Kauaʻi. The bird was likely extirpated from these islands shortly after Polynesian colonization. Indeed, the Hawaiian language does not contain a word for Bonin petrel. These birds are agile, efficient fliers who mostly forage at night for shallow-swimming fish, squid, and crustaceans. In a necessary adaptation to nocturnal foraging, Bonins possess high levels of rhodopsin, an ocular pigment that augments night vision. Nesting Bonin petrels dig substantial burrows, up to three meters long and one meter deep, in sandy soil; they enlarge the tunnel's end to form a nest chamber, which they line with dry grass and feathers. Both members of a breeding pair participate in burrow construction, using their bills to loosen soil and their webbed feet to send it flying—at a rate of 3.3 kicks per second. Females lay only one egg per year, and do not re-lay if the egg fails. Male and female birds take turns incubating during the 49-day incubation period, and each participates in chick-rearing activities: One mate tends to the egg or chick while the other scours the ocean for food.—A.W.

Stout Moray Eel ~ puhi, *Gymnothorax eurostus*

p 24

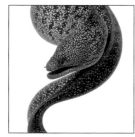

PHOTOGRAPH: Sand Island field studio, Midway Atoll, 27 March 2004
RANGE: Indo-Pacific and eastern Pacific, antitropical
HABITAT: seaward reefs and rocky areas of reef flats
SCALE: to 60 cm total length

With a large mouth, needle-sharp teeth, and long supple body, the moray eel is superbly outfitted for hunting. Morays cruise along reef flats at night, searching for sleeping fish and night-feeding crustaceans that have ventured out of their holes. During the day, the nocturnal moray retreats into a favorite cave or crevice, though its head will appear almost instantaneously when an injured fish is nearby. The promptness and predictability of this response leads marine biologists to suspect that certain species of moray eels can detect chemical or electrical signals emitted by stressed or injured fish. The Hawaiian word for moray eel is puhi; puhi paka denotes the yellow-margined moray (*Gymnothorax flavimarginatus*), which was historically renowned for its ferociousness. Puhi kapa—the snowflake moray (*Echidna delicatula*)—was also respected as a "fierce eel" because of its strong bite. The snowflake's molar-shaped teeth enable it to crush crabs and other crustaceans, as opposed to the pointed teeth of the moray, designed for feeding on fish. Puhi were once a highly prized food item, and Hawaiian royalty (aliʻi) served this delicacy only to honored guests. In recent years, morays have become ciguatoxic, rendering them inedible. The young eel in the portrait may have started its life far from Hawaiʻi. Morays have a long larval stage in which the baby eel floats in the open ocean, hunting tiny zooplankton and trying to avoid being eaten itself. Able to last a long time as larvae, most moray species enjoy a wide distribution.—S.H.

244

Padina ~ limu, *Padina sanctae-crucis*

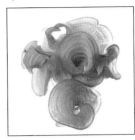

PHOTOGRAPH: Green Island field studio, Kure Atoll, 29 July 2003
RANGE: worldwide (Pacific, Atlantic, and Indian Oceans, and Caribbean Sea)
HABITAT: tide pools, intertidal benches, and shallow reef flats
SCALE: 6 cm tall

Relatively common on coral reefs, padina are found throughout the world's warm oceans. Hawai'i has seven species of padina, two of which are endemic. The portrait shows a specimen of *Padina sanctae-crucis,* found attached to rubble on a shallow reef at Kure Atoll. The whitish concentric lines on the surface of the fronds are calcium carbonate, the same substance snails and clams use to build their shells. This calcification gives the algae a structural integrity, allowing it to hold its shape while still remaining sufficiently flexible to bend with strong currents and wave action. Calcium carbonate may also act as a physical sunblock, protecting plant tissues from the burning rays of the sun. The white, chalky substance has the added benefit of making the algae less palatable to herbivorous fish and reef invertebrates. In spite of this feature, the edges of padina fronds often show signs of nipping by hungry fish. To minimize potential damage, the frond is equipped with an in-rolled edge, offering protection to new growth by coiling it inside layers of less vulnerable plant material. Calcification occurs most commonly in red (Division Rhodophyta) and green (Division Chlorophyta) reef algae, but researchers recently discovered a second genus of tropical brown algae related to padina, called *Newhousia,* that also incorporates calcium carbonate into its tissues.—S.H.

Laysan Albatross ~ moli, *Phoebastria immutabilis*

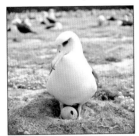

PHOTOGRAPH: Sand Island, Midway Atoll, 18 February 2003
RANGE: North Pacific
HABITAT: pelagic; breeds on Northwestern Hawaiian Islands and small islands offshore from Mexico and Japan
SCALE: wingspan 208 cm; mass 2.5—3.3 kg

Mention the Northwestern Hawaiian Islands, and I see albatrosses, agile and stoic, traversing the ocean wilderness; albatrosses, clumsy yet focused, on foot in their remote island breeding grounds. In November, approximately 1.2 million Laysan albatrosses return from pelagic wanderings to breed on the Northwestern Hawaiian Islands; nearly three-fourths of the world's population nests on Midway alone. The Laysan albatross does not breed until its eighth or ninth year, and spends its first two to four years at sea with only brief visits to the colony. These monogamous birds will seek out a new partner should a mate die.

Nests are shallow cups either scraped in the sand or soil, or formed by piling and shaping loose dirt and vegetation. Prior to egg laying, breeding pairs line their nests with stems and leaves from surrounding plants; egg laying begins in mid-November. Over a 65-day period, the male and female each take turns—for several days to several weeks at a time—incubating a single, large egg. Incubating adults sleep, preen, pick at nearby vegetation, and occasionally stand to ventilate the egg. During the month of December, right after most pairs lay their egg, incubating males outnumber incubating females fifteen to one. The female usually incubates first, and then only for two days before she's relieved by her mate. When the male takes over, he may sit on the nest for as long as three weeks before the female returns; her extended foraging trip is to compensate for loss of body mass due to egg production.

If the egg is infertile or breaks during incubation, the breeding pair will not re-lay that year. As hatching nears, incubating birds increasingly "talk" to their eggs, uttering a soft eh-eh-eh to acquaint the chick with its parents' voices. From day one, chicks are fed seafood and rich stomach oil filled with fatty acids and other essential nutrients. This high-energy diet allows the chick to survive when several days separate feeding events. Fledging occurs five to six months after hatching (mid-June through late July). Parents usually leave before the chicks attain their full juvenile plumage and make their first trial flights.

Young Laysan albatrosses, or subadults, spend their first three to five years searching the wide North Pacific for food. Laysans rarely breed before their sixth year; the time between their return to the colony and their first successful reproduction is spent practicing—dancing, making practice nest cups, even incubating abandoned eggs and preening unattended chicks. In all likelihood, first-time nesters are within squawking distance of their parents, as albatrosses have high nest-site fidelity. Young breeders engage in elaborate courtship displays that involve several body parts: wings, feet, bill, and neck. The dancing facilitates mate selection and the formation of a pair bond that often lasts until one mate dies, which could be 30 or more years after the initial coupling. Mature breeding pairs are less enthusiastic in their courtship dances, and may not dance at all.

Laysan albatrosses nesting on Tern Island in French Frigate Shoals were recently fitted with satellite positioning tags as part of a foraging behavior study. The resulting data showed that these birds often fly several thousand kilometers during a single foraging bout. In July, at the end of the breeding season, most birds head northwest toward Japan, and then northeast toward the Aleutian Islands off continental Alaska. Laysan albatrosses sit on the ocean's surface to feed, snapping up squid, fish, fish eggs—and, all too often, the pieces of plastic to which those fish eggs are attached. A foraging albatross views anything that floats as food, and the ocean is afloat with the spoils of humanity's progress: plastic lighters, bottle caps, toy soldiers, fishing line, and syringes with hypodermic needles still attached. Although adults can pass most nonfood items without serious consequence by frequently regurgitating a dense bolus of undigested stomach contents, breeding birds inadvertently pass plastic offal to their chicks during feeding events. Since chicks cannot regurgitate until they near fledgling age, the ubiquitous plastic items compete for their stomach space with much-needed food. The sheer volume of plastic and other marine trash brought back to land by Laysan and black-footed albatrosses makes me wonder if perhaps they have undertaken a silent, persistent mission to remind us how disrespectful humankind has become to the ocean and its native inhabitants.

Feather hunters extirpated Laysan albatrosses in the late 1800s and early 1900s at Johnston Atoll, Wake Island, and Marcus Island; in 1909, more than 300,000 birds were killed on Laysan Island alone. Under the protection of the Hawaiian Islands National Wildlife Refuge, designated in 1909 by President Theodore Roosevelt, albatrosses and other seabirds now find asylum in the remote Northwestern Hawaiian Islands. In 1991, in order to protect the critically endangered Hawaiian monk seal, a 50-nautical-mile Protected Species Zone, excluding longline fishing, was established around the Northwestern Hawaiian Islands. Laysan and black-footed albatrosses have also benefited from this protection, as the 50-mile buffer reduces the chance that albatrosses foraging close to their breeding sites will become a longline fisheries by-catch statistic; estimates indicate that longline fisheries and illegal driftnet operations killed 17,500 Laysan albatrosses in 1990, a figure that represents one percent of the total population.—A.W.

Lipspot Moray Eel ~ puhi, *Gymnothorax* cf. *chilospilus* (juvenile)

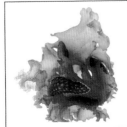

PHOTOGRAPH: *Hi'ialakai* shipboard studio, French Frigate Shoals, 19 September 2004
RANGE: Indo-Pacific
HABITAT: reef habitats with holes and crevices
SCALE: 7 cm across

This juvenile lipspot moray eel entwined itself in a blade of red algae during a photo shoot on the NOAA ship *Hi'ialakai.* Both had been collected during research dives at French Frigate Shoals earlier that day, and were awaiting their turn before the camera in a five-gallon bucket, along with an assortment of other small reef creatures and algae. The eel hid itself in the fronds of the red, gelatinous algae and the two got scooped up together. Once in the small portrait aquarium, the eel swam in and out of the slippery red blade of algae, poking its head out of various holes. In this same exploratory manner, an eel navigates its natural habitat on the reef, searching for carrion or live prey while trying to avoid being seen. Moray eels are covert in general, and juveniles have even more reason to stay hidden since they can be preyed on more easily than a large, toothy adult stationed in its home cave. Juvenile morays often hide in rubble or other small-scale complex habitats, including large tangled masses of derelict fishing nets that have drifted on the reef. When fishers haul nets into small boats for removal from the reef, it's not unusual for a dozen tiny, wriggling eels to fall out of the debris and escape back into the water through the boat's scuppers. The alga pictured is a specimen of *Kallymenia sessilis,* in the Division Rhodphyta.—S.H.

Kallymenia ~ limu, *Kallymenia sessilis*

p. 36

PHOTOGRAPH: *Hi'ialakai* shipboard studio, French Frigate Shoals, 19 September 2004
RANGE: Hawai'i, Japan, and the Philippines
HABITAT: shallow to moderately deep reef habitats
SCALE: to 18 cm tall

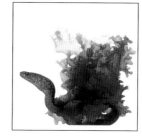

The alga in this portrait has a luminous quality that comes from a glossy layer of mucus on the translucent pink blade. This alga is a specimen of *Kallymenia sessilis*, a gelatinous red alga in the division Rhodophyta. Although the function of the mucus remains a bit of a mystery, it probably has a protective capacity. The mucus may contain chemicals that act as sunscreen, shielding the plant's tissues from overexposure to ultra-violet radiation. The slippery coating may also discourage epiphytes (plants that grow on other plants), or help the plant slough off potential invertebrate settlers and parasites. Not just for looks, the ruffled edges of the alga serve to increase the turbulence of water flowing over the smooth blade, creating microscopic eddies that disrupt the boundary layer – a thin layer of stagnant water around the alga that grows devoid of minerals and nutrients as the plant absorbs them. Ruffled edges, holes, and other strange configurations are often employed by algae to encourage small amounts of turbulence that will flush fresh minerals and nutrients past the troublesome boundary layer.—S.H.

Day Octopus ~ he'e maul, *Octopus cyanea*

p. 46

PHOTOGRAPH: *Hi'ialakai* shipboard studio, Pearl & Hermes Atoll, 28 September 2004
RANGE: Indo-Pacific
HABITAT: from shallow tide-pools to deep (50 m) reef, especially habitats with pukas (holes)
SCALE: 17 cm across; adults to 90 cm arm span

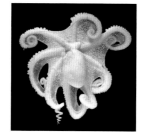

The day octopus is dexterous and intelligent, a reef creature with an amazing bag of tricks and tools for survival. With eight arms, a boneless body, and excellent vision, the octopus crawls across the reef, squeezes through tiny crevices, and interacts with other reef residents in ways that intrigue biologists, divers, tide-pool explorers, and fishermen. When hunting, the octopus scouts the reef, investigating small holes with the sensitive tips of its arms. When it finds a small shrimp or crab, the octopus unfurls a skin web to trap the crustacean as it flees; for larger prey, the octopus administers a bite to inject saliva that contains paralyzing agents and meat tenderizer. An octopus also has a radula that can drill holes into its slower, smaller-brained cousins, cowries and snails. Discarded broken shells often lie scattered near the mouth of an octopus's lair, giving away its hiding spot. In the days of old Hawai'i, he'e (octopus) was plentiful on the reef flat as well as the dinner table, thanks to seasonal fishing regulated by the kapu system, which used the death penalty as a deterrent. During fishing season, young boys, old aunties, and men alike would spear he'e; a special cowry-shell lure was used by those who knew how to dangle it in just the right, alluring way. Apparently, the he'e finds certain cowries irresistible; it latches onto the shell with suckered arms, holding on greedily while being pulled to its doom.—S.H.

Bluefin Trevally ~ papio (juvenile), 'ōmilu (adult), *Caranx melampygus*

p. 47

PHOTOGRAPH: *Hi'ialakai* shipboard studio, Lisianksi-Neva Shoals, 10 October 2004
RANGE: Indo–Pan-Pacific
HABITAT: reefs and other coastal habitats
SCALE: 20 cm total length; adults to 100 cm total length

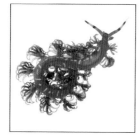

Papio, as these young jacks are called in Hawai'i, do not yet have the brilliant blue speckling of 'ōmilu, adult bluefin trevally. This young jack has a pearly cast to its skin and is generally pale, the better to blend in with brightly lit sand and water in the surf zone. Juvenile jacks need a safe place to hide, having not yet achieved the size or status of an apex predator, like their impressive parents who can weigh up to 44 kg (96 pounds). The NWHI is remarkable for its generous abundance of apex predators. While the NWHI is not the only remaining place with high predator densities, it is still one of the few. The vast majority of reefs in our modern world have significantly depressed populations of large, mobile predators. Jacks and sharks are noticeably scarce at all but a few reefs in the main Hawaiian Islands. Large predators typically respond poorly to fishing pressure because they do not reproduce until they are relatively large, and they often have fewer offspring than other fishes. Reef sharks, for example, usually begin mating at about five years of age and even then bear only one to six shark pups per year. One of the most valuable assets of the NWHI is its quality of being intact—the fact that it still has all the layers of its food web, including impressive, bad-ass hunters, like the one this small jack hopes to be some day.—S.H.

Blue Dragon Nudibranch, *Pteraeolidia ianthina*

p. 48

PHOTOGRAPH: *Hi'ialakai* shipboard studio, French Frigate Shoals, 10 October 2004
RANGE: Indo-Pacific
HABITAT: reef areas with boulders, rubble, or other hard surface
SCALE: to 15 cm

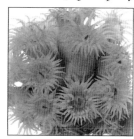

The blue dragon nudibranch represents a typical aeolid nudibranch—long, skinny, and frilly. The frills are not gills, as in other nudibranches, but rather skin projections called cerata. The color and shape of the cerata vary widely in this species, which can be purple, green, blue, or tan, with long or short cerata, whose length it may be able to change at will. The color and possibly the shape of the cerata relate to the nudibranch's internal solar-energy farm. Like corals, the blue dragon nudibranch has symbiotic algae in its tissue. The algae (zooxanthellae) are acquired when a nudibranch is young. Juveniles appear translucent white but later develop a golden brown tint to their tissue, evidence of the algae. The plants thrive in the living, moving greenhouse of the nudibranch; they share energy in the form of sugar with their host, which in turn makes the most of its farm and tries to maximize the solar-energy output. Nudibranchs do not rely solely on the algae for energy but also eat hydroids, small stinging animals related to corals. The nudibranch can swallow the polyp without triggering its stinging cells (nematocysts), which are then incorporated into the tips of the cerata. In this way, the nudibranch co-opts the defense mechanism of its prey. The boulders at the base of La Pérouse Pinnacle of French Frigate Shoals are often covered in blue dragon nudibranchs, which are locally abundant in parts of the main Hawaiian Islands as well.—S.H.

Colonial Tube Coral (open polyps), *Tubastraea coccinea*

p. 47

PHOTOGRAPH: *Hi'ialakai* shipboard studio, Maro Reef, 22 September 2004
RANGE: Indo-Pacific
HABITAT: shaded areas, especially in caves and under ledges
SCALE: colony 8 cm across

This coral can grow in the near-dark. One of the few "azooxanthellate" stony corals, colonial tube coral can tolerate far lower light levels than most other species. Reef-building corals host symbiotic algae (zooxanthellae). While corals with zooxanthellae require sunlight to feed the algae, tube corals are able to grow where other corals and macro algae cannot. They specialize in occupying the shady side of the reef—roofs of caves, undersides of arches, under ledges, even dock pilings shaded by a pier. Tube coral forms only small porous lumps of stony mass rather than contributing large sheets or mounds to the reef. The zooxanthellae in reef builders provide extra energy and somehow increase the amount of calcium carbonate a coral can fix. While not contributing massive amounts of structure to the reef, tube coral does quite well for itself. Small colonies of this and related species of bright orange coral are found throughout the world's tropical oceans. Cushion stars (*Culcita novaeguineae*) are one of the few animals that prey on tube coral. The coral-eating sea stars crawl into caves, and, upon finding a cluster of tube corals, extrude their stomachs onto the coral to digest it. After the fleshy part of the coral has been liquefied, the cushion star sucks up the coral slurry and continues on its way. The colorful sponges and dark lace-like bryozoan on this chunk of reef share the tube coral's preference for shaded, out-of-the-way habitats.—S.H.

Banded Spiny Lobster ~ ula, ula poni, ula hiwa, *Panulirus marginatus*

p. 48–49

PHOTOGRAPH: *Hiʻialakai* shipboard studio, Maro Reef, 10 October 2004
RANGE: endemic
HABITAT: shallow to deep reef and associated sandy areas (1 to 200 m)
SCALE: view 11 cm

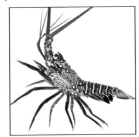

The banded spiny lobster is the original Swiss Army knife—it has a pair of specially shaped legs for almost everything. It has appendages for finding food, tasting food, grasping and grinding food, and walking sideways on cave walls. It uses different body parts to jet backwards, poke fish in the eyes, fan eggs with oxygenated water, mate, fight, and make aggressive sounds. Male spiny lobsters use one of their utilitarian legs to attach a sticky packet of sperm to the female's abdomen. As the eggs emerge and are fertilized, the female uses a special small claw on her last walking leg to carefully tuck the eggs under her swimmerets. The banded spiny lobster in the photograph was found on a crowded cave ledge with twenty other lobsters, some small like this one and others over a foot long. A waving thicket of antennae provided the only outward sign of the lobster-packed cave. A spiny lobster spends the day holed up in a cave or under a ledge, warding off potential predators and intruders with long, impressively spiked antennae. At night, the lobster ventures out onto sandy areas of the reef to scavenge for carrion and prey on small reef invertebrates. Many predators that hunt on the reef, humans included, consider spiny lobsters extremely tasty. Monk seals, large grouper, snapper, barracuda, and sharks all dine on lobster at least occasionally. This endemic lobster co-occurs with the tufted spiny lobster (*P. pencillatus*), an Indo-Pacific species with striped legs.—S.H.

Chocolate Chip Sea Cucumber ~ loli, *Holothuria* sp.

p. 50

PHOTOGRAPH: *Hiʻialakai* shipboard studio, Pearl & Hermes Atoll, 30 September 2004
RANGE: endemic
HABITAT: coral reef areas with sand
SCALE: to 15 cm

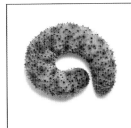

Whimsically dubbed the chocolate chip sea cucumber for its uncanny resemblance to a roll of cookie dough, this species was first discovered in the NWHI but is also found uncommonly in the main Hawaiian Islands. The invertebrate biologist who first collected the unusual species, Scott Godwin of the Bishop Museum in Honolulu, is working with other researchers on the species description that will endow the animal in this portrait with a formal scientific name. Sea cucumbers are called loli by Hawaiians, and were harvested for food and medicinal value. On many Pacific islands, women harvest the intestines from certain species of sea cucumbers. The sea cucumber is returned to the ocean after its innards are squeezed into a glass bottle or eaten on the spot, and the creature may be able to regenerate its organs. The substance tastes rich and slightly metallic, with a strong but pleasant aftertaste, according to reports. Some species of sea cucumber have a strange but effective defense mechanism. If disturbed, the animal relaxes its connective tissues to the point of becoming limp like a wet sock, eventually melting into unmanageable slime if the disturbance continues. This handy trait saves these sea cucumbers from reef predators (who wants to eat a wet sock?) and from the commercial beche-de-mer trade, since the body dissolves after harvest. Other sea cucumbers are not so lucky, and many coral reef habitats have been stripped of their sea cucumber populations because they command such a high price.—S.H.

Halimeda ~ limu, *Halimeda velasquezii* (non-reproductive & reproductive)

p. 51

PHOTOGRAPH: *Hiʻialakai* shipboard studio, Maro Reef, 25 Sept 2004
RANGE: Indo-Pacific (Hawaiʻi, Philippines, Guam, China, Japan, and New Caledonia)
HABITAT: intertidal to 100 m in shallow pools, channels, reef flats, sand flats, rubble zones
SCALE: 3.5 cm long

Unencumbered by internal cell walls, Halimeda transports its internal components from one end of its body to the other, as the situation requires. The green beads at the tips of the segments are reproductive capsules poised for release into the ocean. After reproduction, the parent plant's calcium carbonate skeleton disintegrates into oatmeal-sized sand. This once-in-a-lifetime style of plant sex is called holocarpic (whole body) reproduction, and while it sounds like a dramatic way to go, it is not uncommon. Wild salmon do it, octopus do it, agave and century plants do it, and annual plants are so named because they grow for a season, seed once, and then die. In spite of concerted efforts to decipher the reproductive timing of this ecologically important algae, biologists remain stumped. The plants all seem to know the chosen night for the big gamete release party, which varies by species and region. A substantial proportion of the adult algae of given species will spawn on the same night at a reef. One day they are all a nice even shade of pale green (females tend to be slightly darker), and the next morning the reef is littered with ghost-white skeletons. Usually the algae begin concentrating the green vital fluid into the capsules in the early evening, and release them about half an hour before sunrise. Neither moon nor tides predicts mass spawning events, but some unknown environmental signal could be synchronizing the algae—it is as if they all know a secret password.—S.H.

Mushroom Coral ~ ʻākoʻakoʻa kohe, *Fungia scutaria*

p. 52–53

PHOTOGRAPH: *Hiʻialakai* shipboard studio, Maro Reef, 21 September 2004
RANGE: Indo-Pacific
HABITAT: lagoon and seaward reef habitats
SCALE: 3.5 cm view

This strange, beautiful mouth belongs to a mushroom coral, an oval, saucer-shaped stony coral. The soft animal is a single large polyp and lives unattached to the reef. Its translucent flesh forms short tentacles, a sensual mouth, and a simple gut. When the coral is disturbed or inactive, the tentacles retreat into the spaces between the grooves. The luminous green color of the tentacles and brown hue of the remaining coral come from tiny specks of pigmented algae (zooxanthellae) living in the coral's tissue. The zooxanthellae produce sugar from the energy of sunlight and share it with the coral host, which provides shelter and raw materials for the algae. The magenta-striped mouth is more likely a result of pigments produced by the coral itself, possibly as a sunscreen to protect the exposed lips from being harmed by ultraviolet rays. In addition to functioning as miniature greenhouses, the tentacles are equipped with stinging cells (nematocysts) that zap tiny critters and collect organic nutrients suspended in the water column. The food items are transferred from the tentacles to the mouth and are digested in the gut. Corals are simple animals with a sack-shaped gut, so waste is ejected back out the same orifice. Less prudish than most cultures, Hawaiians call this coral ʻākoʻakoʻa kohe—coral that is like a kohe (vagina). They used the beach-cast ribbed skeleton as sandpaper on their canoes and as a scraper for pig skins.—S.H.

Potter's Angelfish, *Centropyge potteri*

p. 54

PHOTOGRAPH: *Hiʻialakai* shipboard studio, Kure Atoll, 6 October 2004
RANGE: endemic to Hawaiʻi and Johnston Atoll
HABITAT: reef face and forereef slopes
SCALE: 8 cm total length

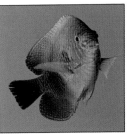

The ember-colored Potter's angelfish spends most of its time darting in and out of a refuge, grabbing bites of filamentous algae, golden diatoms, sponges, and detritus. This cheeky angelfish even snatches bites of mucus from coral and anemones. Potter's angels form harems in which a number of females mate with a single male at a prominent coral head or outcrop, just before dusk. The male spawns with the alpha female of the territory first, who is aggressive toward other females until after she has mated. Both fish blanch so their blue bars are lighter, and the male circles the female, grunting audibly and making short soaring forays up into the water column to encourage her to mate with him. The pair dashes up into the water column, squirting out eggs and sperm, and then returns to the safety of the reef. The male spawns with as many as seven or eight females in rapid succession during the last few minutes of daylight, though the ritual is delayed or aborted if a voyeuristic barracuda or other large, toothy predators show up. The long, sharp spine decorating the gill cover is characteristic of angelfishes and provides some effectiveness as a predator deterrent. The fish relies mostly on being close to a safe hole or other refuge. Potter's angelfish are pygmy angels, which are small and brightly colored. Other pygmy angelfishes found in Hawaiʻi include the pretty and somewhat common flame angel (*C. loriculus*), the exquisite and rare Japanese angelfish (*C. interruptus*), and the endemic Fisher's angelfish (*C. fisheri*).—S.H.

Sponges ~ ʻupi, huʻe huʻekai, Phylum *Porifera*

p.55

PHOTOGRAPH: *Hiʻialakai* shipboard studio, Lisianski-Neva Shoals, 9 October 2004 (orange tube sponge); Pearl & Hermes Atoll, 6 October 2004 (purple, black, and fire sponges)
HABITAT: coral pavement and rubble

Sponges belong to one of the oldest, simplest animal groups—Phylum *Porifera*, the pore-bearers. Only single-celled animals are considered more rudimentary. Sponges are more or less a cooperative of cells that collectively form a loosely organized filtering station. The filtering stations come in a variety of sizes, shapes, and colors. Visible orifices, called oscullums, are not mouths but allow for the outflow of water pumped into the sponge. Each cell has a hair called a cilium that it waves back and forth to pump water, and also to clear off sediment or debris that could block the flow. Even a small sponge filters gallons of water over the course of a day, absorbing nutrients and minerals for its sustenance. In some places sponges grow as tall as people, and are highly visible on the reef. In Hawaiʻi, sponges are usually cryptic or hidden. They grow mostly on the undersides of rubble, ledges, and overhangs, and other shaded habitats where there is less competition from corals or algae. The dark-red sponge is a fire sponge that has tiny slivers of glass in its body that burn, itch, and sting if touched. The orange tube sponge has an inner hollow space, while the grape-colored and the blackish-purple round sponges are made of solid sponge material throughout. Hawaiians paid little attention to the inedible sponges. ʻUpi is from the Hawaiian verb "to squeeze," and huʻe huʻekai means "foam of the sea."—S.H.

Harlequin Crab, Sea Cucumber Crab, *Lissocarcinus orbicularis*

p.56

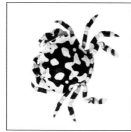

PHOTOGRAPH: *Hiʻialakai* shipboard studio, Pearl & Hermes Atoll, 29 September 2004
RANGE: Indo-Pacific
HABITAT: sea cucumbers (usually on sandy areas near reefs)
SCALE: carapace 1.5 cm wide

The harlequin or sea cucumber crab has an unusual lifestyle for a portunid, or swimming, crab: It lives on a sea cucumber. It apparently neither hurts nor helps its slow-moving, eyeless host and home, which frequently accommodates two of these small crabs. The dark color of the crab varies from reddish brown to purple to almost black. A crab can have dark ink-blot spots on a white background, like the crab in the portrait, or the reverse. Often just one of several animals living on the same sea cucumber, this crab shares its home with pearlfish, shrimp, and worms. Pearlfish live inside the sea cucumber, while the shrimp and marine worms stay on the surface. The crabs are most often found in the mouth tentacles or near the anus, where they scavenge for food on its way in or out of the sea cucumber's digestive system. In general, the various residents of this mobile apartment seem to share the sea cucumber peaceably, with one exception. The parasitic worms, which feed on the tissue of the sea cucumber, sometimes try to eat the crabs and shrimp. Crabs also live commensally with feather-stars, urchins, and anemones, though most of these are bottom-dwellers rather than swimmers.—S.H.

Fine-spined Urchin, *Leptodiadema purpureum*

p. 57

PHOTOGRAPH: *Hiʻialakai* shipboard studio, Pearl & Hermes Atoll, 28 September 2004
RANGE: endemic
HABITAT: caves and crevices
SCALE: body 2 cm diameter

With a red-velvet body and gold-spun spines, the fine-spined urchin is one of the stunning creatures tucked into the small spaces of a coral reef. The impossibly thin spines of this golden creature are surprisingly flexible and will bend before they break. Brittle is the general rule for thin urchin spines, specifically designed to snap at the slightest provocation, lodging into the flesh of a potential predator and causing pain. The fine-spined urchin does protect itself in this manner, but the flexibility of its spines enables it to wedge itself into smaller cracks and crevices. Red flesh covers a globe-shaped test (internal skeleton) encasing the internal organs, the bulk of which are digestive and reproductive glands. Pinprick holes in the skeleton allow hydraulically operated tube feet to protrude, visible in the portrait as rubbery extensions between the spines. The tube feet are tipped with suction cups, which the sea urchin uses to pull itself forward or to manipulate and transport food toward its mouth. The mouth faces downward in order to scrape algae from the reef floor, and is outfitted with five triangular teeth operated by an elaborate apparatus called Aristotle's lantern. Surrounding the mouth are short spines that the urchin uses to push itself along. The anus faces upward and frequently has a bubble shape, sometimes with a tiny crab living inside. The crab takes advantage of the protection of the urchin spines and the constant supply of nutrients, albeit recycled.—S.H.

Dasya ~ limu, *Dasya atropurpurea*

p. 58

PHOTOGRAPH: *Hiʻialakai* shipboard studio, Pearl & Hermes Atoll, 29 September 2004
RANGE: endemic
HABITAT: deep areas near coral reefs (20 to 170+ m)
SCALE: 5.5 cm section

On a research cruise in 2003, diver Molly Timmers found a specimen of this beautiful, nebula-like red algae in the moderately deep waters (65 to 70 feet) of the reef slope near Southeast Island at Pearl and Hermes Atoll. She was collecting data about algae and coral percentages when she noticed a number of uprooted algae drifting past, like underwater tumbleweeds; she pocketed one of the pinkish-red plants and later gave it to algal biologist Dr. Peter Vroom. He identified it as a new species of red algae (Division Rhodophyta) in the genus *Dasya*. That specimen now resides in the Bishop Museum herbarium as the holotype, or original example of the species. Hawaiʻi has five other species of *Dasya*, three endemic like this one. *Dasya atropurpurea* possesses several unique characteristics, most obviously its tall stature, especially compared to other Hawaiian species of *Dasya*, and the thick axis in the middle of the plant, which appears in the portrait as a translucent pink stem, providing vertical structure for the smaller branches and fine hairs, and maximizing photosynthesis and nutrient uptake. Dr. Vroom chose the name *"atropurpurea"* for this algae in admiration of its subtle, reddish-blue iridescence. Another Hawaiian species, the smaller, pinkish gold *Dasya iridescens*, is also covered in fine iridescent hairs (see portrait, page 273).—S.H.

Red Algae ~ limu, *Plocamium sandvicense* or *Portieria hornemannii*

p. 59

PHOTOGRAPH: *Hiʻialakai* shipboard studio, Gardner Pinnacles, 20 September 2004 (specimen from FFS)
RANGE: endemic (if *Plocamium*) or Indo-Pacific and Red Sea (if *Portieria*)
HABITAT: shallow habitats to deeper water (30 m)
SCALE: 2 cm tall

This small, neatly branched red alga is a puzzle. Algal biologists usually have no trouble identifying the genus of an alga, even if it takes a microscope to figure out the exact species. The alga in this portrait could be in the genus *Plocamium*, which has one known species in Hawaiʻi (*P. sandvicense*). Alternatively, it could be a species of the genus *Portieria*, which occurs in Hawaiʻi as *P. hornemannii*. While *Plocamium* and *Portieria* are not in the same family, they happen to have extremely similar branching patterns. The very tips of the smallest branchlets are slightly curled over in *Portieria*. Oddly enough, another useful characteristic for identifying *Portieria* is the way it smells—highlighting the difficulty of making identifications from pictures alone. Some biologists find the odor sulfurous, and others claim it resembles crushed carrots, but all agree on its pungency. In either genus, the plant is a fleshy red alga with lacey fern-like branchlets that extend off central stem-like structures. These thicker portions do not actually function as stems do in a land plant. Living underwater, algae experience what is effectively a low-gravity environment, eliminating the need for the rigid vertical support of terrestrial-style stems. Nutrients and minerals are absorbed from the surrounding water, making roots unnecessary as well, although algae usually have a holdfast to attach to the sea floor. The holdfast grips rock, sand, or a piece of coral in an anchoring attempt, but, unlike a root, it has no uptake capabilities.—S.H.

Kallymenia ~ limu, *Kallymenia thompsonii* *p.59*

PHOTOGRAPH: *Hiʻialakai* shipboard studio, Maro Reef, 21 September 2004
RANGE: endemic
HABITAT: shallow water to 20 m, reef crevices, reef slope, rubble
SCALE: 5 cm section

What looks like a piece of wine-colored Swiss cheese is actually the leafy blade of a rare species of foliose red algae, recently discovered at Midway Atoll by Dr. Karla McDermid, from the University of Hawaiʻi. She and Dr. Isabella Abbott subsequently described and named the alga in a scientific publication in 2002. So far the alga has only been seen at a few reefs in the NWHI, including Midway Atoll where the holotype (original specimen) was collected, and Maro Reef where the pictured piece was found. One other tropical *Kallymenia* exists on reefs off central Japan and Hawaiʻi, but it lacks the numerous small, irregularly scattered perforations that are characteristic of *K. thompsonii*. The specimen in the photograph was a loose scrap of alga drifting over a deep sand patch, probably a casualty of storm waves or other rough weather. The alga typically attaches to reefs by means of a fibrous holdfast, and has several leaf-like blades arranged in a rosette shape. The holes probably help the plant absorb more nutrients by increasing small-scale water turbulence. A thin layer of unmoving water, called the boundary layer, surrounds the alga and needs to be disrupted for efficient nutrient absorption. The holes cause water to swirl as it passes through the blade, creating turbulence and flushing the blade's surface with essential trace minerals and nutrients.—S.H.

Brainard's Red ~ limu, *Acrosymphyton brainardii* *p.59*

PHOTOGRAPH: *Hiʻialakai* shipboard studio, French Frigate Shoals, 16 September 2004
RANGE: endemic to French Frigate Shoals, NWHI
HABITAT: subtidal rubble habitats from 3 to 10 m
SCALE: 5.5 cm view

Systematic sampling along with a dose of good luck contributed to the recent discovery of this species of algae. In 2000, biologists first laid eyes on *Acrosymphyton brainardii* (Division Rhodophyta) during the first coral reef assessment cruise conducted by the newly formed Coral Reef Ecosystem Division of NOAA-Fisheries, Honolulu Lab. The cruise took place in September, a time of year when the visible part of the alga has usually disintegrated. The plant has a frilly, red, gelatinous body throughout the spring and summer. In fall and winter, the alga converts into its alternate, microscopic phase. In this tiny form, the alga hides out in the rubble, waiting for better weather. "The alga is robust but delicate," says Dr. Peter Vroom, who described the species along with Dr. Isabella Abbott. "It would disintegrate with heavy water motion," he surmises, which explains why the alga abandons its summer form during the heavy weather that rolls through the NWHI in fall and winter. This species of algae has separate sexes, and the plant's tall, fleshy body can be male or female. The holotype, or original specimen, was a reproductive female. No males have been found yet, although they are assumed to exist. So far the alga has only been found at French Frigate Shoals, specifically near a knife-shaped rock called La Pérouse Pinnacle. One of six species of "gooey reds" in the genus *Acrosymphyton*, the algae was named for Dr. Rusty Brainard, chief scientist and founder of the Coral Reef Ecosystem Division.—S.H.

Gibsmithia ~ limu, *Gibsmithia hawaiiensis* *p.59*

PHOTOGRAPH: *Hiʻialakai* shipboard studio, French Frigate Shoals, 18 September 2004
RANGE: Indo-Pacific
HABITAT: subtidal coral reef habitats, often found in coral skeletons
SCALE: 2 cm tall

This fuzzy pink bunch of lollipops is an alga called *Gibsmithia hawaiiensis*—one of the "gooey reds" from the Division Rhodophtya. An advantage to having a translucent body is that sunlight passes freely through the tissues, reaching all the cells and allowing the plant's entire body to serve as a solar panel that produces energy through photosynthesis. Being gooey may make it harder for fishes or invertebrates to nibble on the plant, since there is nothing firm to bite. According to scientists who have collected it, the alga has the unappetizing consistency of snot. It often grows on dead coral skeletons, nestled between the branches and out of reach of most fish mouths. The fine fuzz on the rounded branches is made up of thousands of filament tips poking past the plant's mucous-coated skin. These long, thin filaments are part of the gelatinous matrix inside the plant. The filament tips may protrude as a way for the alga to increase the surface area available to absorb nutrients from the surrounding water. *Gibsmithia* has a woody base, indicating that the plant may be perennial. If so, the base of the plant likely grows a new set of branches every spring or summer, when the weather provides more sun and fewer storms.—S.H.

Leaf Scorpionfish, Leaf Fish, *Taenianotus triacanthus* *p.60–61*

PHOTOGRAPH: *Hiʻialakai* shipboard studio, Pearl & Hermes Atoll, 26 September 2004
HABITAT: Reef flats, outer reef slopes, current-swept channels, and, occasionally, lagoon reefs
SCALE: 4.5 cm tall; to 10 cm total length

Remarkably, a leaf scorpionfish such as the red individual can shed its skin and change into a black version of itself—or mottled green, yellow, brown, or silvery white. Color is dictated by the individual's need for camouflage. Instead of scales, the skin of a leaf scorpionfish comprises small, irregular bumps, called papillae. The fish molts, or sheds, its outer layer of skin as often as twice a month, starting with its head. The scruffy face and ragged fins of the leaf scorpionfish render it almost indistinguishable from the vegetative surface of the reef. It relies on this near-perfect disguise to ambush small fish and crustaceans traveling along the reef's surface. Adding to the realism of its charade as a piece of seaweed, the leaf scorpionfish sways from side to side, allowing the current to push against its tall, stiff dorsal fin; alternatively, it can rock back and forth on its pectoral fins. Although the leaf fish is considered a unique and quirky member of the scorpionfish family (Scorpaenidae) and is designated with its own genus, it shares the family trait of venomous spines, located in its dorsal fin, which it holds erect in the face of any predator that sees through its camouflage. As a last resort, the leaf fish will abandon its pose as a blade of algae and make a dash for cover.—S.H.

Pale Anemone Crab ~ unauna, *Dardanus deformis* *p. 62*

PHOTOGRAPH: *Hiʻialakai* shipboard studio, Kure Atoll, 8 October 2004
RANGE: Indo-Pacific
HABITAT: shallow reef flats
SCALE: 2.5 cm tall

Smaller and paler than the jeweled anemone crab, the pale anemone crab decorates its shell with a similar garden of anemones, though in this case they dwarf the small crab. The large anemone is *Calliactis polypus*, while the pure white anemones around the inner rim of the shell are *Anthothoe* sp. The small crab is more than happy to carry around the bulky anemones, whose tentacles are lined with stinging cells that discourage soft-skinned predators from bothering either the crab or the anemones. The crab somehow avoids getting stung itself, perhaps by means of its body armor, or in a manner similar to that of the anemone fish, whereby the crab, as a familiar object, does not trigger the stinging cells. The large anemone sometimes releases bright pink threads, called acontia, which also sting (visible in the portrait above the hermit crab's eyes). This species, like the other two in Hawaiʻi that carry anemones, has striped eye stalks and large oval eyes. The pale anemone crab's walking legs are lightly banded, and its large left claw is smooth compared to the tubercle-studded pincers of its large, orange cousins. While an anemone is able to crawl short distances, it is content to conserve energy by hitching a ride on the shell of the hermit crab. The anemones grab whatever food scraps come their way, and the large one is even able to catch small fish.—S.H.

Sand Anemone ~ 'okole, 'okole emiemi, *Heteractis malu*

p. 63

PHOTOGRAPH: *Hi'ialakai* shipboard studio, Maro Reef, 6 October 2004
RANGE: Hawai'i, Japan, and eastern Indian Ocean
HABITAT: sandy areas and reef flats
SCALE: 11 cm across

For a creature without a brain, the anemone is amazingly active and capable of all sorts of surprising tricks. The animal in the portrait is a sand anemone. Admiring the unusual pink color of this individual, fish biologist Dr. Randy Kosaki collected it during a dive survey and brought it back to the ship to be photographed. When it arrived at the shipboard studio, the anemone was about the size and shape of a balled-up fist, with thin wilted tentacles. By the next morning, the anemone had relaxed and become dramatically bigger. The whole animal was flush with water, radiant pink, and open like a flower. It explored the tank by creeping around on its foot, stretching its stalk, and touching things with its tentacles. We placed a small piece of fish on one of the tentacles, which the anemone promptly inserted into its mouth as if licking a finger; after a few seconds it ejected the fish chunk in an apparent objection to the flavor. Susan and David were so enchanted by the sand anemone and its ever changing moods that they asked me to take it away after a few hours, so they would not squander all of their film on this one enigmatic, charming flower animal. I moved it to a bucket and we later returned it to Maro Reef, where it used its muscular foot to dig itself back into the sand and rubble where it feels most comfortable.—S.H.

Green Lionfish ~ nohu, *Dendrochirus barberi*

p. 64

PHOTOGRAPH: *Hi'ialakai* shipboard studio, Kure Atoll, 6 October 2004
RANGE: Hawaiian Islands and Johnston Atoll
HABITAT: under ledges in lagoons and on seaward reefs
SCALE: 8 cm total length

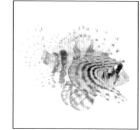

Like other members of the scorpionfish family (Scorpaenidae), green lionfish have venomous spines and mottled, camouflage-style coloration. They store venom in capsules at the base of 18 venomous spines. Manual pressure activates a type of auto-injection mechanism, which squeezes the venom out along a groove in the spine. This small, cryptic lionfish perches under a ledge or in a cave during the bright hours of the day, venturing out to forage after dusk. During its hunting hours, the green lionfish swims along the reef looking for banded coral shrimp and small crabs, which it swallows whole. Like other lionfish, this species uses its wide pectoral fins to trap prey in a confined space, grabbing it with a quick thrusting motion of its jaws. Their ability to deliver an extremely painful sting has not denied lionfish the dubious honor of popularity within the marine aquarium industry. Collectors even sell the less showy green lionfish on the international market, touting it as a hardy survivor. Worldwide, lionfish get back a little of their own by stinging an estimated 40,000 to 50,000 humans every year. Possessing the soft, sweet meat of their rockfish cousins, lionfish have earned another dubious distinction: They are considered a delicacy in many Indo-Pacific island communities. Their slow swimming makes them relatively easy to catch, and increases their risk of depletion on reefs near human populations.—S.H.

Hawaiian Lionfish ~ nohu pinao, *Pterois sphex*

p. 65

PHOTOGRAPH: *Hi'ialakai* shipboard studio, Pearl & Hermes Atoll, 28 September 2004
RANGE: endemic
HABITAT: under ledges on lagoon and seaward reefs
SCALE: 8 cm tall, to 22 cm total length

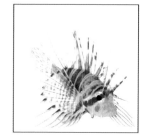

The Hawaiians called the lionfish nohu pinao (dragonfly), a fitting name for this small, yet showy, reef predator belonging to the scorpionfish family (Scorpaenidae). When threatened, the brightly colored lionfish seldom flees, choosing instead to splay out its venomous spines and point its head down like a bull, secure in its "untouchable" status. Certain predators, such as small sharks and moray eels, nonetheless manage to eat an occasional lionfish, probably by engulfing it head-on, folding back the spines. This specimen was found perched on the ceiling of a small cave. A second lionfish inhabited the cave next door, and in fact these fish are considered to be somewhat social. Lionfish spend most of the day in quiet holes or crevices, venturing out on the reef in the late afternoon to hunt. They use their wide pectoral fins to herd small fish, shrimp, and crabs into a corner, where they snap these hapless creatures up with a quick jab of their expandable mouths. Remarkably, the mouth of a lionfish can open to almost the size of its own head. Some lionfish species forage in groups, swimming side by side and using their fins and bodies as a barrier net of sorts. When they have cornered their prey, the cooperating hunters take turns nabbing the small shrimp and fish that scurry around, panicked, in the face of an imposing line of lionfish.—S.H.

Redbanded Hawkfish ~ piliko'a, *Cirrhitops fasciatus*

p. 65

PHOTOGRAPH: *Hi'ialakai* shipboard studio, Kure Atoll, 7 October 2004
RANGE: Hawai'i, Madagascar, Mauritius, Japan, and Reunion
HABITAT: seaward reefs with coral
SCALE: 5 cm tall, to 12 cm total length

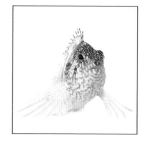

In the taciturn descriptive style that fish biologists often employ, Jack Randall writes of the redbanded hawkfish in his field guide, *Shore Fishes of Hawai'i*, "Unusual disjunct distribution." He is referring to the strange fact that redbanded hawkfish are found only in a few reef systems scattered throughout the Indo-Pacific. These reefs are widely separated by sections of ocean. Therein lies the puzzle for fish biologists and oceanographers: They understand that larvae ride ocean currents from one reef to the next, populating regions in a hopscotch manner, but how the world's population of redbanded hawkfish gets deposited at Hawai'i, Madagascar, Mauritius, Japan, and Reunion Island is harder to explain. Hawaiians call the fish piliko'a, which means "coral-clinging," a name that is used for several species of hawkfish. A native variety of sugarcane with reddish stripes is also called piliko'a, named after the hawkfish. This small hunter is dappled with red and white spots and bars, and has ten elegant white-tipped dorsal spines. It perches on a coral head or other suitable object and waits for a small fish, shrimp, or crab to swim past. If it deems the prey item small enough to swallow and close enough to catch, the redbanded hawkfish darts forward as if from a slingshot, mouth snapping shut on the hapless prey. The genus name comes from the Latin for "curl" or "fringe," referring to the tufts (cirri) at the tips of the first few dorsal spines.—S.H.

Crosshatch Triggerfish ~ humuhumu, *Xanthichthys mento*

p. 66–67

PHOTOGRAPH: *Hi'ialakai* shipboard studio, Pearl & Hermes Atoll, 28 September 2004
RANGE: eastern and western Pacific Ocean
HABITAT: seaward reefs above drop-offs
SCALE: 25 cm total length

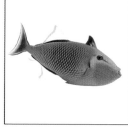

The exquisitely patterned crosshatch triggerfish lives in the clear, deep waters along drop-off features of Hawai'i's three northernmost atolls, though they also occur in the main islands in deeper waters. Triggers have tough skin made up of diamond-shaped scales, on display in this portrait of a supermale from Pearl and Hermes Atoll. As a supermale, he fertilizes and guards the nests of one or more females. The females help guard their nests and squirt streams of water across their sand-covered eggs to keep them well oxygenated. After two days, the eggs hatch and the young fish are on their own. Like other triggerfishes (Family Balistidae), the crosshatch trigger has a defensive mechanism involving three short, strong spines. When pursued, a triggerfish ducks headfirst into a hole and raises a spine on its back, which is locked in place by a smaller spine that lies flat. The fish flexes an additional spine on its belly to wedge itself in completely, rendering it virtually immovable. Triggerfish typically swim with a languid undulation of their dorsal and anal fins, pressing their tails into service when they need a burst of speed. Much to our amazement, during the photo shoot the crosshatch trigger in the portrait buzzed around the surface of his holding tank by using his tail in a propeller-like manner.—S.H.

Triton's Trumpet ~ pū, ʻolē, *Charonia tritonis*

p. 68-69

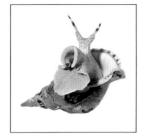

PHOTOGRAPH: *Hiʻialakai* shipboard studio, Midway Atoll, 2 October 2004
RANGE: Indo-Pacific, Red Sea, coastal Japan, and Mozambique
HABITAT: coral-rich habitats
SCALE: 45 cm

Named for the ancient Mediterranean god of the sea, Triton's trumpet is a marine snail found in most of the world's warm oceans. Hawaiians and other Polynesians traditionally blow into the shell, trumpet fashion, to announce the start of a ceremony. The living snail, a fast-moving predator, has eyes on stalks and a well-developed head. Using its muscular foot, it crawls across the reef floor in search of coral-eating sea stars, its favorite food. At the first touch of the snail's foot, the sea star attempts to beat a hasty retreat, but its foe typically responds with equal speed as it climbs atop the sea star and administers an injection of paralyzing saliva. The snail then drills through the sea star's tough skin and consumes the soft internal organs. Crown-of-thorns sea stars, protected by their mantle of venomous spines, manage to consume large quantities of living coral. As one of the few reef animals capable of preying on crown-of-thorns, this marine snail plays an important role in maintaining healthy coral reef ecosystems. Populations of Triton's trumpets have decreased due to the large spiral shell the snail builds to protect its soft body. With misplaced appreciation for the ocean, tourists who purchase these shells as souvenirs inadvertently harm the reef by subsidizing the removal of an important predator. When the snail dies of natural causes, its empty shell provides a home for large hermit crab species, such as the white-spotted hermit crab and the hairy yellow hermit crab.—S.H.

Martensia ~ limu, *Martensia flabelliformis*

p. 70

PHOTOGRAPH: *Hiʻialakai* shipboard studio, Laysan reef, 24 September 2004
RANGE: Indo-Pacific
HABITAT: rocks and coral from shallow areas to 10 m depth
SCALE: 4 cm long

Looking like an oddly shaped butterfly with iridescent pink wings and a golden body, *Martensia flabelliformis* is actually a marine plant with an unusual structural design. Young individuals consist of solid blades without any mesh. As the olive-green blade matures, the plant develops an iridescent mesh along its outer margin. The net-like architecture confers a hydrodynamic advantage to the whole plant. The holes in the mesh disrupt water flow and create tiny eddies, giving the cells access to more nutrients and preventing stagnant water from settling near the surface of the alga. Unlike terrestrial plants, which have a vascular system that transports water, nutrients, and minerals from one part of the plant to another, the cells inside an alga generally do not share with one another. Each cell is independent and makes its own sugar, absorbs its own nutrients and minerals, and maintains its own water balance. This is possible in an aqueous environment, where the plant is bathed in a soup of ocean water. Martensia has a relatively unique form, but many algae use holes, ragged edges, ruffles, or other irregular forms to disrupt the laminar flow of water across the smooth blade. The Latin name for this species describes it with elegance—mar means "sea," tens means "stretched," and flabelliform refers to its fan shape. One other species of martensia occurs in Hawaiʻi, *M. fragilis,* which has a similar appearance but with proportionally less mesh.—S.H.

Sea Lettuce ~ limu pālahalaha, *Ulva fasciata*

p. 71

PHOTOGRAPH: *Hiʻialakai* shipboard studio, Lisianksi-Neva Shoals, 10 October 2004
RANGE: worldwide
HABITAT: shallow water, often at waterline
SCALE: 8 cm tall

Attractive, bright green *Ulva* is found throughout the world. Sea lettuce, as it is commonly called, is deemed a tasty sea vegetable by many cultures. Hawaiians traditionally harvested it from the shoreline and shallow reef flats of all the main islands. They called it limu pālahalaha, which translates as "algae that is spread out." In her book, *Limu: An Ethonobotanical Study of Some Hawaiian Seaweeds,* Isabella Abbott gives instructions for the collection and preparation of *Ulva.* "Easily collected," she writes, "remove small black snails that are usually feeding on the blades. Wash well and chop into pieces less than 1 inch square. Mix with other limu (e.g., huluhuluwaena) to serve." She goes on to list various culinary possibilities, such as lightly salting and mixing it with chunks of raw aku palu (skipjack tuna), or adding it to soup made with leftover meat scraps. The blades of *Ulva fasciata* are thin, transparent sheets of plant tissue only two cell layers thick. The brilliant green color comes from chlorophyll, a pigment that is characteristic of green algae and also common in the leaves of terrestrial plants. The plant, whose blades have a silky texture, grows in the full sunlight of the shallows attached to any available hard substrate, such as coral rubble, rock, or even debris. This specimen was found near the low-tide waterline on the beach of Lisianski Island; growing on a discarded fishing net half buried in the sand, it covered every square inch of exposed net.—S.H.

Bandit Angelfish, *Apolemichthys arcuatus*

p. 72

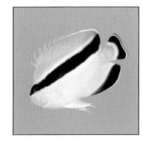

PHOTOGRAPH: *Hiʻialakai* shipboard studio, Pearl & Hermes Atoll, 26 September 2004
RANGE: endemic to Hawaiʻi and Johnston Atoll
HABITAT: coral and rocky reefs
SCALE: 9 cm total length

A deepwater sponge eater, the bandit angelfish is most abundant on reef slopes between 25 and 50 meters, and has been found as deep as 183 meters (over 600 feet) in the dusky twilight zone of coral reefs. The species is found only in Hawaiʻi and its nearest neighboring reef ecosystem, Johnston Atoll. In the carnival-colored world of reef fishes, the bandit angel has a certain simple elegance with its bold black diagonals edged in pearly white and gray. The Zorro-style eye stripe disguises the angelfish's eye, obscuring what is otherwise an easy clue for predators. The separate blocks of gray, black, and white blur the outline of the fish for the same purpose, making it harder for a predator to recognize the form as a fish. The bandit angel swims along ledges and among boulder piles, investigating caves and crevices for food. This species travels singly or in pairs. The small mouth is well shaped for taking bites of sponge, which generally grows in dark or shaded places where it is not in direct competition with algae or coral for space. A bandit angel supplements its diet by nibbling on algae and other nutritious goodies it comes across, such as hydroids and egg masses attached to the reef floor. Like other angelfishes, the bandit angel has several sharp spines in its dorsal fin and one on each cheek.—S.H.

Masked Angelfish (male), *Genicanthus personatus*

p. 73

PHOTOGRAPH: *Hiʻialakai* shipboard studio, Pearl & Hermes Atoll, 28 September 2004
RANGE: Endemic
HABITAT: Seaward reefs and ledges exposed to current
SCALE: to 21 cm total length

The masked angelfish is legendary for its stunning, subtle beauty and the high price on its head, with reported bounties of up to $5,000 per mated pair. Although endemic, the angelfish is rare in the main Hawaiian Islands, where it's found only in deep water, well beyond the reach of most divers. In the atolls of the Northwestern Hawaiian Islands, however, the masked angel is more common and occupies both shallow and deep-reef areas. Like other angelfishes (Family Pomacanthidae), masked angels can change sex. Starting life as female, with ivory-white bodies and charcoal-black masks, masked angels form harems that live with one male. If the male disappears from the group, one of the females turns into a male to replace him. In addition to internal reproductive organ changes, the female masked angel's coloration changes as well, with her face and the tips of her dorsal, anal, and pectoral fins turning gold as she becomes a he. When divers encounter masked angels in the NWHI, the angelfish usually ducks under a nearby ledge but reappears a few seconds later, too curious to stay hidden for long; soon, the angelfish relaxes enough to resume the soft, fluid darting motion that characterizes its feeding. Masked angels pluck plankton (tiny floating plants and animals) from the water above the reef rather than nipping algae and invertebrates from the reef floor like other angelfishes.—S.H.

Rounded Cockle ~ ʻōlepe kupe, pūpū kupa, *Trachycardium orbita*

p. 74

PHOTOGRAPH: *Hiʻialakai* shipboard studio, French Frigate Shoals, 19 Sept 2004
RANGE: Indo-Pacific
HABITAT: among patches of coral rubble
SCALE: 5.5 cm tall

A native Hawaiian named Kepelino wrote in an old manuscript "The ʻōlepe is entirely white; its shell is ridged. Its body is round and plump.... The ʻōlepe lives in the sand. Its flesh is delicious, eaten just as it is—raw." He may have been speaking of another clam or cockle, since ʻōlepe is the Hawaiian word for bivalves in general, but ʻōlepe kupe, which means "native clam," fits the description perfectly. The rounded cockle (*Trachycardium orbita*) is an active burrower, digging with its long foot to bury itself in the coral rubble where it lives. The foot resembles a lolling tongue, reaching out of the shell in search of something hard to push against. The cockle can actually hop around on this muscular foot, although more often it scoots deeper into the rubble pile. The animal can afford to lodge itself under a pile of rubble because it has a feeding siphon to extend up into the moving water. The cockle sucks water in through the siphon and filters out edible elements with its gills, which are tucked safely inside the shell along with the rest of the organs. A flexible hinge connects the two shells; the animal relaxes to open its shell or contracts twin muscles inside the shell to slam it shut. The cockle is wise to lock up its soft boneless meat, considered a delectable treat by octopus, large snails, fishes, and people.—S.H.

Divided Flatworm, *Psuedoceros dimidiatus*

p. 75

PHOTOGRAPH: *Hiʻialakai* shipboard studio, Lisianksi-Neva Shoals, 12 October 2004
RANGE: central and western Pacific Ocean
HABITAT: benthic substrate of coral reefs
SCALE: 5.5 cm long

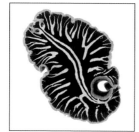

The flamboyantly colored divided flatworm lives as a micro-carnivore and scavenger of the reef, sniffing out tunicates and other stationary invertebrates. It senses its prey with specialized cells on its head called chemoreceptors, which function like external taste buds. When the flatworm finds something edible, its mouth shoots out an extendible tube with a muscular pharynx at the end that punctures and pulverizes the quarry. The flatworm then secretes digestives juices into the prey and sucks everything back into its belly. The flatworm's simple but functional digestive system allows it to eject indigestible bits back out through the mouth. Because flatworms are paper-thin, nutrients can diffuse from cell to cell. The bright yellow and orange lines on the velvety black body of the divided flatworm benefit reef fish, which have excellent color vision. The conspicuous coloration warns predators that the soft, tempting flatworm morsel tastes horrible and is probably toxic. Similar color combinations have evolved in completely unrelated animals with equally noxious traits—such as frogs, salamanders, and spiders—and offer evidence that yellow and black acts as a universal warning sign in nature. The divided flatworm acquires toxin from one of its favorite foods: tunicates. After grazing on colonial tunicates, flatworms incorporate their meal's distasteful poison into their own tissues.—S.H.

Hawaiian Morwong ~ kikākapu, *Goniistius vittatus*

p. 76

PHOTOGRAPH: *Hiʻialakai* shipboard studio, Midway Atoll, 3 October 2004
RANGE: anti-tropical (Hawaiʻi to the north, New Caledonia, Kermadec Islands and Lowe Howe Island to the south)
HABITAT: seaward reefs
SCALE: 10 cm tall

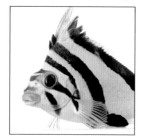

An odd-looking fish, the Hawaiian morwong perches on its pectoral fins like a hawkfish, is decorated with diagonal black bands like a butterflyfish stretched sideways, and sports a mouth only a mother could love. Considered by some the ugly duckling of reef fishes, and by others utterly endearing for its quirky, unique shape and expression, the morwong is definitely an original. Taxonomists agree that the fish is an oddball and place it in its own small family, Cheilodactylidae, which has only a handful of species worldwide. The distribution of the morwong—to the north and south of the tropics, but nowhere in between (called anti-tropical distribution)—is also a bit strange, although it occurs in other kinds of fish as well. The morwong has a small mouth, small teeth, and thick pink lips that work well for feeding on a variety of small invertebrates such as worms, heart urchins, mollusks, crabs, and shrimp. Negatively buoyant and sans swim bladder, like its closest relative the hawkfish, the morwong often rests on the bottom or swims slowly along the underside of ledges and caves. When alarmed, the fish raises its dorsal fin, which is equipped with several stiff spines. Hawaiians call this fish kikākapu, a name they also use for some species of butterflyfish. Kikā means "lowly" or "humble," and kapu means "forbidden" or "taboo."—S.H.

Hawaiian Domino Damselfish ~ ʻā or ʻaʻā (juvenile), ʻāloʻiloʻi (adult), *Dascyllus albisella*

p. 77

PHOTOGRAPH: *Hiʻialakai* shipboard studio, Laysan reef, 24 September 2004
RANGE: endemic to Hawaiʻi and Johnston Atoll
HABITAT: shallow, sheltered coral or rocky reefs
SCALE: largest individual pictured 1.6 cm total length, adult to 13 cm total length

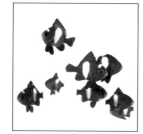

On the reef, young Hawaiian domino damselfish cluster around an object, such as a coral head, urchin, or anemone. Being small has disadvantages—you fit in the mouth of most meat eaters on the reef—but it also confers certain advantages, such as being able to fade effortlessly out of reach into small, safe spaces. A cloud of domino fish hovering around a coral head expands and contracts as if on elastic strings. These fish venture out into the water column in a halo around the coral, picking up plankton that floats past. At the slightest sign of danger, they fade back into the thick branches of coral, where they are, for all intents and purposes, inaccessible. If no coral is available, loitering near an urchin offers the same protection, as most predators are reluctant to poke their noses into a bristling set of moving urchin spines. Several different species of domino fish are found in the Indo-Pacific, some with gold fins, others with small white spots. Hawaiʻi has just one species of domino damsel, which is endemic. Juveniles are adorned with a swatch of neon blue across the forehead. Adults are monochromatic gray, black, and white, with only a thumbprint smudge of white remaining from the bold white bar on the juveniles. Adult domino fish guard their home coral head with a rough, rhythmic purring noise. Hawaiians call them ʻāloʻiloʻi, which means "humble." Hawaiians had a special name for the young damselfish: ʻā or ʻaʻā, which means "to glitter or sparkle."—S.H.

Crowned Jellyfish, *Cephea cephea*

p. 78

PHOTOGRAPH: *Hiʻialakai* shipboard studio, Lisianski Island-Neva Shoals, 10 October 2004
RANGE: Indo-Pacific
HABITAT: oceanic
SCALE: ~15 cm diameter

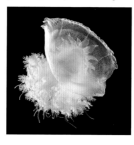

This lacey creature made of water and thin bits of tissue structure has no brain, no heart, no eyes, and no skeleton. The crowned jellyfish does, however, have a mouth, a stomach, and a nerve net, and manages quite well with these simple features. It swims by flapping its bell-shaped body, which allows it some directed movement, particularly on the vertical plane, though the jellyfish is generally along for the ride on the ocean currents. Most at home in the open ocean, crowned jellyfish occasionally find themselves close to shore, a danger zone for them as neither breaking waves nor sandy beaches are a happy place for a jellyfish. Jellies have a delicate construction, consisting of gel sandwiched between two layers of tissue. The tentacles are studded with tiny stinging cells called nematocysts, visible in the photograph as an apparent sugar-coating. Each nematocyst has a miniature harpoon, which remains coiled up in the cell until an object connects with the tentacle. The nematocyst automatically fires its harpoon on contact. The immediate effect is that small prey are immobilized, transferred to the mouth, and digested in the gut. The crowned jellyfish does not generally have a strong-enough sting to penetrate human skin. Sea turtles, with their reptilian mouths and throats, are quite fond of jellyfish and eat them without ill effect.—S.H.

Keeled Heart Urchin ~ hāwa‘e, *Brissus latecarinatus*

p. 79

PHOTOGRAPH: *Hi‘ialakai* shipboard studio, Lisianski Island-Neva Shoals, 12 October 2004
RANGE: Indo-Pacific
HABITAT: sandy areas
SCALE: 11 cm long

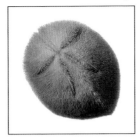

Plowing along under the sand, the keeled heart urchin maintains a low profile. Its flattened, oblong shape perfectly accommodates its job as a sand eater. At one end it has a wide crescent-shaped mouth, angled slightly forward for scooping as the heart urchin moves through the sand. At the opposite end of its digestive tract, it sports a large round hole designed to hasten the exit of sand that has been cleaned of its nutritive organic matter, thereby making room for yet more of the heart urchin's favorite food. The sand moves through the urchin as if on a conveyer belt, coming in one end and going out the other; the final product—cleaner, more finely ground sand—is the heart urchin's contribution to bio-erosion. Short, flexible spines, located on the top of the heart urchin, lie combed flat against its body, keeping it streamlined for its steady push through the sand. Heart urchins use the stubble-like spines that protrude from their belly to scoot themselves forward. Eagle rays dig in the sand searching for heart urchins to eat, as do some sea stars. Although abundant in many sandy areas, living heart urchins are seldom seen by people, given their under-sand activities. The empty white test, or body casing, appears more often, eliciting admiration for its delicate five-petal pattern of tiny holes. A live heart urchin has thin, flexible tube feet that reach up through these holes, helping the animal breath.—S.H.

Shortnose Wrasse ~ hinālea, *Macropharyngodon geoffroy*

p. 80

PHOTOGRAPH: *Hi‘ialakai* shipboard studio, Lisianksi-Neva Shoals, 10 October 2004
RANGE: Hawai‘i, south Pacific, and east Indies
HABITAT: mixed sand, rubble, and coral areas
SCALE: to 15 cm total length

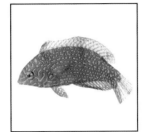

The shortnose wrasse is more than just a pretty fish peacocking about the reef. This wrasse is a formidable predator in the eyes (and eye spots) of small reef creatures. Large, powerful molars line the back of the fish's throat, useful for grinding up hard-shelled reef creatures such as crabs, brittle stars, sea urchins, and snails. The scientific name pays homage to this trait—*Macropharyngodon* refers to large teeth in the pharynx (a muscular organ in the back of the throat). The ornate pattern of golden green and turquoise blue differs slightly between male and female fish. The male shortnose wrasse has squiggly lines decorating his face, while the female has simpler spots, as on the rest of her body. Even the fins are spotted in this species, as well as the colored portion of the eyes. Wrasses (Family Labridae) have more species than any other shallow-water reef fish family in Hawai‘i, with a total count of 43. Family members come in all shapes, sizes, and colors. Some eat plankton, others flip over rocks, a few live in the desert-like sand flats, and juveniles of some species and adults of others make a living by cleaning fish and turtles of parasites. The largest tropical wrasse, the Napoleon, Maori, or humphead wrasse (*Chelinus undululatus*)—depending on which part of the world you're in—grows to over 2 meters in length but does not occur in Hawai‘i.—S.H.

Hawaiian Turban Snail ~ ‘alīlea, pūpū mahina, *Turbo sandwicensis*

p. 81

PHOTOGRAPH: *Hi‘alakai* shipboard studio, French Frigate Shoals, 20 September 2004
RANGE: Endemic
HABITAT: Reef habitats down to ~20 m depth
SCALE: 4 cm tall

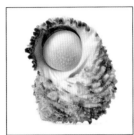

A member of the shallow-reef community, the Hawaiian turban snail is fairly common, although it often goes unnoticed. Its scientific name contains a reference to a whirling eddy or child's spinning top—"turbo"—and to the Hawaiian Islands, once known as the Sandwich Isles. The Hawaiian name, pūpū mahina—moon shell—refers to the rounded operculum that the snail uses as a doorway to seal itself up in its protective shell. Most snail species have a thin, flexible operculum made of a brown fingernail-like material called chiton, but the turban snail has a more substantial operculum composed of calcium carbonate, a polished material similar to bone, which also makes up the snail's shell. Cat's eyes, as the operculum shells are also called, wash up on shore as smooth half-spheres with a thin spiral tracing on their flat side. Along its back, the turban snail sports a strong shell, thick and heavily ribbed, which is mottled with brown, white, and olive-green to provide camouflage as the occupant grazes. The turban snail feeds on algae, scraping it off the surface of the reef with its radula, a mouthpart that has several hard, grinding knobs that move around like a flexible drill bit. Endemic to Hawai‘i, this snail is slightly different from other turban snails, including a similar species (*T. intercostalis*) that occurs throughout the Indo-Pacific. Once a turban snail has met its end, a hermit crab often takes up residence in the shell.—S.H.

Horrid Elbow Crab, *Daldorfia horrida*

p. 82

PHOTOGRAPH: *Hi‘ialakai* shipboard studio, Laysan Island reef, 25 September 2004
RANGE: Indo-Pacific
HABITAT: coral rubble
SCALE: 5.5 cm tall

The elbow crabs distinguish themselves as the oddest collections of crabs. Inelegantly called the horrid elbow crab, this crab must have seemed misshapen and lumpy to the scientist who first described and named it. In a crab's world, however, the strange costume is actually elegant camouflage. The bumpy, odd shape of the carapace and chelipeds (claw-bearing arms), often coated with a thin layer of coralline algae for authenticity, allow the small crab to look exactly like a chunk of coral rubble. The effect is remarkable: The crab is more or less invisible until it moves. This crab is right-handed, with its right claw being beefier than its left. The chelipeds are used in feeding and to impress the girls (of course). Elbow crabs probably subsist on reef garbage that they find at night during their slow forays across the rubble. Other odd and wonderful elbow crabs that live in Hawai‘i include the spindly-legged thorny elbow crab (*Lambracheus ramifer*), the teddy bear-like hairy elbow crab (*Parthenope* sp.), and another strangely shaped rubble-zone resident, the flat elbow crab (*Aethra edentate*) (see portrait, below). Crabs and other arthropods are outfitted with an amazing set of jointed appendages. The horrid elbow crab has special legs for tiptoeing across the uneven reef floor, and others for pinching predators, carving up dead meat, and grappling with other crabs..—S.H.

Flat Elbow Crab, *Aethra edentata*

p. 83

PHOTOGRAPH: *Hi‘ialakai* shipboard studio, French Frigate Shoals, 5 October 2004
RANGE: parts of the Indo-Pacific (Hawaii, Marianas, Japan, Marquesas)
HABITAT: rubble areas of coral reefs
SCALE: 4 cm across

This little crab is barely noticeable, exactly as nature planned. It hides among pieces of coral and algae rubble, and does its best to look like nothing more than another piece of rubble. Sponges grow on the underside of the flat elbow crab's hard shell, and pink coralline algae on the topside—just as they do on a lump of dead coral. The shape of the crab itself resembles an inanimate object rather than a tasty ten-legged crustacean. Its first pair of legs are enlarged and outfitted with pincers, but are flat enough to allow the crab to tuck them in to lie flush with its face. Its body is flatter than seems possible, with just a small hump in the middle to make room for essential internal organs. This slow-moving crab creeps around rubble patches, looking for food; any threat will cause it to bury itself in the rubble until it is completely concealed. First discovered in the 1950s in Hawai‘i, the flat elbow crab originally was considered endemic here, but invertebrate biologists have since recorded it in the Mariana Islands, the Bonin Islands of Japan, Okinawa, and the Marquesas. Its cryptic nature makes it hard to observe, and additional comprehensive surveys may well show that its distribution is broader than currently documented.—S.H.

Spotted Boxfish (male) ~ moa or pahu, *Ostracion meleagris camurum*

p. 84

PHOTOGRAPH: *Hi'ialakai* shipboard studio, Maro Reef, 22 September 2004
RANGE: Indo-Pacific (subspecies endemic to Hawai'i)
HABITAT: clear lagoon and seaward reefs
SCALE: 13 cm total length

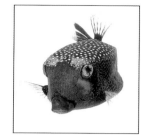

This small, pokey fish has less need and ability to swim fast because it has an internal, box-shaped armor made of fused bone plates. The spotted boxfish has holes for its eyes, mouth, fins, tail, and anus, and keeps the rest of itself inside a protective box. The boxy shape is not without cost, as it makes the fish decidedly less hydrodynamic, but short bursts of modest speed can be accomplished with a few hard strokes of the fan-shaped tail. The fish maneuvers on a finer scale using its large, transparent side, belly, and back fins (pectoral, anal, and dorsal fins) to scull forward, backward, or sideways. This helicopter-style travel comes in handy for hovering over the bottom, where the fish peers into cracks and crevices to search for bottom-dwelling invertebrates and algae. The boxfish uses its petite mouth to suck, bite, chew, or otherwise forcibly remove things such as tunicates, worms, and sponges from the reef, which the boxfish locates with its large mobile, polka-dotted eyes. The female is cocoa-brown with white pebble-shaped dots. The male is larger and more colorful, a peacock-colored sultan with blue and gold accents and a harem of females. The female lays eggs and guards them for the month until they hatch. The young larvae float with the water currents as plankton for a few weeks, and then settle on a reef. The Hawaiian name for the fish is moa, which also means "chicken," or pahu, which means "box."—S.H.

Spoon Worm, Phylum *Echiura* (likely *Ochetostoma* cf. *erythrogrammon*)

p. 85

PHOTOGRAPH: *Hi'ialakai* shipboard studio, Lisianksi—Neva Shoals, 12 October 2004
RANGE: Indo-west-Pacific
HABITAT: sand and other burrowing material
SCALE: 8 cm body length

While not necessarily rare, though rarely seen, the spoon worm (Phylum *Echiura*) is a creature from the underworld, spending its life buried in the sand or burrowing along under reef rock. The worm funnels detritus (reef garbage or waste) and sand into its mouth using the long, shovel-shaped flap of skin. The sand travels in one end and out the other, cleaned of nutrients on the way. Mating can be a bit stranger; in some echiurids, males are only a few millimeters long and live inside the female, or attached to her skin very close to her genitals. We found this spoon worm during the annual replacement of a blocky oceanographic instrument that had been collecting data on ocean currents and water temperature. As we raised the 1,400-pound concrete slab off the bottom with a lift bag, a small, strange worm-like thing lay wriggling in the sand, newly exposed to sunlight. Placing the soft creature carefully in a plastic bag, we brought it back to the ship for its "15 minutes of fame." The small, blind, gray worm was surprisingly popular, with a number of people gathering around the aquarium to check it out. The animal was ever changing, in a slow, subtle manner that was fascinating and unpredictable. The spoon worm alternately grew long and thin, then short and plump, with smooth skin one minute and then a puckered mass of regular squarish bumps.—S.H.

Common Longnose Butterflyfish ~ lau-wiliwili-nukunuku-oi'oi, *Forcipiger flavissimus*

p. 86

PHOTOGRAPH: *Hi'ialakai* shipboard studio, Pearl & Hermes Atoll, 29 September 2004
RANGE: Indo–pan-Pacific
HABITAT: exposed seaward reefs
SCALE: 5 cm tall

Leaf of the wiliwili tree (lau wiliwili) with a nose (nuku nuku) that is long and sharp (oi'oi)—that is what Hawaiians call this fish. The common longnose butterflyfish (*Forcipiger flavissimus*) is a familiar sight on Hawai'i's reefs. The fish uses its long nose like a pair of forceps to reach far into cracks, crevices, and other tight spaces. The petite mouth at the end of the long, narrow snout is capable of considerable suction. Longnose butterflyfish pluck the tube feet off sea stars and sea urchins; they suck small crabs and worms from their hiding holes; and they tug hydroids off the rocks. No invertebrate is safe! The black and white face and bright yellow body serve as a posterboard to other butterflyfish on the reef, helping the longnose butterflyfish find a mate and possibly defend a territory. The black spot near the tail of the fish is a false eyespot, used to confuse predators about which way the fish will dash if attacked. With a deeply compressed body, the butterflyfish is not particularly fast. It does, however, know every nook and cranny of its neighborhood, and can dart into a hole at a moment's notice. Butterflyfish also have several long, sharp spines in their dorsal fin, which they raise if alarmed or provoked. A closely related fish, the rare longnose butterflyfish (*F. longirostris*), has an even longer snout, tinier mouth, and slightly different feeding habits, eating whole organisms more often than parts.—S.H.

Thornback Cowfish ~ makukana, *Lactoria fornasini*

p. 87

PHOTOGRAPH: *Hi'ialakai* shipboard studio, Kure Atoll, 5 October 2004
RANGE: Indo–West-Pacific
HABITAT: clear outer lagoon and seaward reefs
SCALE: 6 cm total length

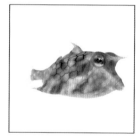

As slow swimmers, thornback cowfish rely on body armor to prevent them from becoming someone's easy snack. Composed of fused bone plates with openings for fins, gills, eyes, mouth, anus, and tail, this armor is covered with mucus-coated skin that the fish can infuse with a powerful toxin when necessary. The cowfish also has horns on its head and thorn-shaped spines along its back, making it a painful object to swallow. A cowfish spends its day hovering over the reef like a miniature helicopter, looking for food. The fish blows jets of water into the sand to uncover a meal of small bottom-dwelling reef invertebrates. Wrasses and other fish have been known to follow cowfish around, hoping to share in the goodies these effective excavators dig up. Male cowfish guard territories on the reef that include one or more females. During mating season, the male nudges, nips, and generally pesters a female until she ascends a few meters off the bottom with him. He hums in a high-pitched tone to coordinate the ascent, and the two fish wrap their tails together as they release eggs and sperm into the water. The fertilized eggs float to the surface of the ocean where the baby fish hatch. Born transparent, larval cowfish float with ocean currents until they are almost adult-sized and ready to settle onto a reef.—S.H.

Oval Butterflyfish ~ kapuhili, *Chaetodon lunulatus*

p. 88

PHOTOGRAPH: *Hi'ialakai* shipboard studio, Pearl & Hermes Atoll, 29 September 2004
RANGE: western Pacific Ocean
HABITAT: coral-rich areas of lagoons and semi-protected seaward reefs
SCALE: 8 cm total length

Bright colors and attractive patterns make butterflyfish the target of aquarium collectors, though species such as the oval butterflyfish feed almost exclusively on live coral polyps and generally starve in captivity. Male and female oval butterflyfish form monogamous pairs early in life, although they sometimes sneak spawnings with other partners. Pairs defend their territory from other butterflyfish, resolving border disputes with such aggressive displays as staring, parallel swimming, and rushing. In serious battles the hostilities can escalate into actual fighting, often resulting in injury and/or loss of territory for the losing pair. Courtship between butterflyfish is colorful and energetic. The two fish chase each other in circles until one fish darts away and the other follows close behind. They chase each other all over their section of the reef, running off any voyeuristic solitary butterflyfish that approaches. Actual spawning takes place at dusk: The fertilized eggs float to the surface where they hatch the next day. Butterflyfish have unique hatchlings, called tholichthys larvae—noted for their almost transparent, silvery-gray color, with armored plates across their heads and down their backs. When the larvae reach about two centimeters in length, they settle onto the reef and turn into tiny little butterflyfish overnight. Moray eels and other opportunistic predators immediately devour most of the newly settled fish, but a few survive, find mates, and establish their own territories on the reef.—S.H.

Ornate Butterflyfish ~ kikākapu, *Chaetodon ornatissimus* — *p. 89*

PHOTOGRAPH: *Hiʻialakai* shipboard studio, Kure Atoll, 5 October 2004
RANGE: Indo-Pacific
HABITAT: clear-water coral-rich reefs
SCALE: 7 cm total length

The diagonal strokes of gold on the flanks of the ornate butterflyfish are a unique variation among the many color patterns in butterflyfish, and serve as a billboard or full-page, color advertisement to other butterflyfish. The ornate butterflyfish often swims in pairs, rarely more than a few meters from its mate. The pair swims around their patch of the reef, casually plucking off a coral polyp here and there. Unlike crown-of-thorns sea stars, which clamber atop a coral and consume the entire thing, these coral-eating butterflyfish just take a few nibbles from any one coral colony and then swim along to the next. The coral is fully capable of regenerating the handful of polyps it loses to a pair of butterflyfish. The butterflyfish are somewhat like Mafia, exacting a payoff the coral can afford, and defending the territory to keep it from being overwhelmed by hoards of unregulated coral pluckers. Coralivore fish tend to be specialists, relying almost exclusively on coral polyps for their nutrition. High in protein, coral also has microscopic algae in its tissues which doubtless add vitamins. Marine aquarists are fond of butterflyfish for their colorful patterns, but coralivores make poor pets since they usually starve; even in a live-reef tank, they will decimate the coral and then starve. Aquariums are seldom anywhere near the size of a butterflyfish's territory and so do not hold enough coral for a sustainable harvest.—S.H.

Portulaca ~ ʻihi, *Portulaca lutea* — *p. 90-91*

PHOTOGRAPH: Tern Island, French Frigate Shoals, 18 September 2004
RANGE: pantropical in the Pacific Ocean
HABITAT: coastal strand
SCALE: flowers 2 cm diameter

Portulaca lutea, or ʻihi in Hawaiian, grows on all of the Northwestern Hawaiian Islands except Kure and Pearl and Hermes Atolls, and in coastal areas on Oʻahu, Lanaʻi, Maui, and Hawaiʻi. ʻIhi's small, 1mm-diameter seeds disperse by way of ocean currents, thus the plant's widespread distribution: from New Caledonia to Pitcairn Island in the South Pacific, and north through Polynesia to Hawaiʻi. ʻIhi is one of seven portulaca species currently found in Hawaiʻi. *P. oleracea*, commonly known as "pigweed," arrived in Hawaiʻi sometime prior to 1871, and now competes with the native ʻihi for shoreline habitat. Differentiating the two can be difficult, as both plants are morphologically similar and occupy the same ecological niche. Pigweed grows on several of the Northwestern Hawaiian Islands, and biologists suspect that hybridization between ʻihi and the introduced pigweed may occur. On Laysan Island, the endemic finch (*Telespiza cantans*) uses its beak to open ʻihi's and pigweed's ovoid seed capsules and feed on the small black kernels, oftentimes dropping as many seeds on the ground as it ingests, which aids in the localized dispersal of both plant species. Traditional Hawaiian use of ʻihi has not been well documented; however, other Polynesian peoples reportedly cooked and ate the plant's large root, and also used it as an ingredient in medicinal concoctions.—A.W.

ohai, *Sesbania tomentosa* — *p. 92*

PHOTOGRAPH: Polihale State Park, Kauaʻi, 10 August 1999
RANGE: Hawaiian Archipelago
HABITAT: dry, lowland areas from sea level to 830 m elevation
SCALE: flowers ~ 5 cm long

Sesbania tomentosa—ʻohai in Hawaiian—grows on Nihoa and Mokumanamana (Necker) Islands in the NWHI, and on all of the main Hawaiian Islands. The plant belongs to the pea family, Fabaceae, a group of about 18,000 species. Hawaiʻi hosts 114 species from the pea family, 14 of which are endemic—including the well known Acacia koa tree and ʻohai. In Hawaii, 14 members of Sesbania, a pantropical genus of about 50 species, grow in various habitats, with ʻohai the only native plant in this group. On Nihoa Island, ʻohai is a commonly occurring shrub, growing on the island's steep southern slopes, and usually in association with *Sida falax* (ʻilima), *Solanum nelsonii* (pōpolo), and *Chenopodium oahuense* (ʻaheahea). On austere Mokumanamana Island, ʻohai is limited to the prominent east-west ridgetop and a small patch on the northwest cape. Red-footed boobies (*Sula sula*) and great frigatebirds (Fregata minor), both shrub-nesting birds, make ample use of ʻohai as nesting substrate. Once abundant in the dry, lowland areas of the main Hawaiian Islands, the plant has been consigned to remnant populations there due to off-road vehicle activity, fire, competition with alien plant species, browsing by ungulates, seed predation by introduced rats and mice, and loss of native pollinating insects. In 1994, the USFWS officially deemed ʻohai an endangered species, and protective measures are now in place to secure and enhance the plant's fragmented populations.—A.W.

Blue Noddy, *Procelsterna cerulea* — *p. 96*

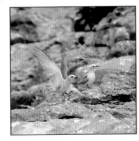

PHOTOGRAPH: Nihoa Island, 13 August 2004
RANGE: Central and South Pacific
HABITAT: pelagic; breeds on small, remote islands
SCALE: wingspan 46 cm; mass 52 g

Not only is the blue noddy smaller than its cousins, the brown noddy and black noddy (*Anous stolidus*, and *Anous minutus*), it is less common and more limited in breeding range. In the Hawaiian Archipelago, blue noddies breed on the high, basaltic Northwestern Hawaiian Islands - Nihoa and Mokumanamana Islands, La Pérouse Pinnacle at French Frigate Shoals, and Gardner Pinnacles. Throughout their range, blue noddies nest in a variety of habitats, from flat, sparsely vegetated islets to crevices in towering cliffs; the Hawaiian breeding population only nests in rocky outcroppings, making loosely woven mats of grass, twigs, and bird bones. Breeding pairs lay one relatively large, mottled egg, and share incubation duty until hatching. The length of the blue noddy incubation period is unknown, though biologists think that the blue noddy is similar in this regard to the white tern (*Gygis alba*) and black noddy, with mean incubation periods of 36 and 35 days respectively. A blue noddy egg represents over 27 percent of the bird's body weight, giving the littlest of marine terns the largest egg-to-body-weight ratio of all seabirds. Chicks are precotial with light-gray down and oversized, pink webbed feet. Adults feed their hastily developing young by regurgitation; they are not known to carry prey in their bills as white terns do. Adults and fledged juveniles feed on small fish, squid, crustaceans, and pelagic insects found at or near the ocean's surface.—A.W.

Nihoa Finch, *Telespiza ultima* — *p. 98*

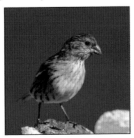

PHOTOGRAPH: Nihoa Island, 31 July 1999
RANGE: Northwestern Hawaiian Islands, endemic to Nihoa Island
HABITAT: Nihoa Island: shrub-strewn slopes, rock outcrops
SCALE: wing span 8 cm, mass 20g

Even more secluded than the closely related Laysan finch (*Telespiza cantans*), the Nihoa finch occurs only on its namesake island. This rare finch first became known to science in 1885 when Sandford Dole visited the island; however, this was not the first time it was observed by humans. From A.D. 1000 to 1700, the finches shared Nihoa Island with Polynesian pioneers, and though the humans significantly modified Nihoa's flora and fauna during their occupancy, the finch persisted. Over the last 40 years, the Nihoa finch population estimates vary from 6,500 to 1,000 individuals; because of its extremely limited range, the Nihoa finch is a federally listed endangered species. This finch is slightly smaller and darker in plumage than the Laysan finch, yet the two birds share similar behaviors, including opportunistic methods of acquiring food. Adults capture and consume insects; forage on leaves, buds, and seeds; and crack open unguarded tern and noddy eggs. Mobs of adult and juvenile finches roam Nihoa, often foraging collectively on the same plant and congregating at freshwater seeps to bathe and drink. Mating pairs build nests of grass, twigs, and seabird feathers exclusively in rock crevices—of which there are plenty, given Nihoa's precipitous topography. Nihoa finch clutch size ranges from two to five, and the incubation period is estimated at 15 days. Both parents feed their young by regurgitating the spoils from their frequent foraging sprees.—A.W.

Nihoa Millerbird, *Acrocephalus familiaris*

p. 98

PHOTOGRAPH: Nihoa Island, 13 August 2004
RANGE: Northwestern Hawaiian Islands, endemic to Nihoa Island
HABITAT: Nihoa Island: shrub-strewn slopes, rock outcrops
SCALE: wing span 6.2 cm, mass 18.2g

Sly and nimble, Nihoa millerbirds pursue insect prey through thickets, up ravines, and across the steep slopes of their namesake island home. Endemic to Nihoa Island, the Nihoa millerbird, taxonomically defined as a reed warbler (subfamily Sylviinae), is the extant member of a genus that island-hopped its way from Asia to Hawai'i. The Laysan millerbird, a slightly smaller cousin of the Nihoa millerbird and endemic to Laysan Island, became extinct after introduced rabbits denuded Laysan in the early 1900s. Two other endemic land birds, the Laysan rail and Laysan honeycreeper, became extinct then as well. In 2002 and 2004, Nihoa experienced population explosions of the alien grasshopper (*Schistocerca nitens*), which resulted in catastrophic vegetative defoliations. While the grasshopper booms provided unlimited food for the endemic millerbird, the epidemics have also threatened the bird's preferred nesting plants—*Cheonopodium oahuense, Solanum nelsonii, Sida fallax* and *Pannicum torridum*. Aside from introduced grasshoppers, the Nihoa millerbird preys on moths, larvae, beetles, and ants. Throughout the last 30 years, its population has fluctuated between 200 and 700 individuals. Because of the Nihoa millerbird's extremely limited range and small population size, it is at risk of extinction and is a federally listed Endangered Species. The USFWS is exploring the feasibility of translocating a small portion of the Nihoa population to Laysan Island, the only other island in the Hawaiian archipelago on which millerbirds have been found.—A.W.

Cone Casebearer, *Hyposmocoma* new sp. 28

p. 100

PHOTOGRAPH: *Searcher* shipboard studio, Nihoa, 2 September 2004
RANGE: endemic to Nihoa and Mokumanamana
HABITAT: coastal and dry shrublands
SCALE: case 1 cm

Human settlement, weeds, and predators have destroyed most of the lowland environment of the main Hawaiian Islands. However, the isolated and long-protected Northwestern Hawaiian Islands, with their immensely important remnants of lowland flora and fauna, provide windows into the archipelago's past. Over 500 kinds of *Hyposmocoma* occur in Hawai'i, showing astounding diversity, explosive speciation, and divergent radiation, compared to their 28 cousins in the 49 other states. Dr. Elwood Zimmerman lamented in his 1978 book on this "complex of complexes" that 630 pages were inadequate to describe it! In 2005, Dr. Daniel Rubinoff, from the University of Hawai'i, is using DNA comparative methods to reveal the family tree of Hyposmocoma with larvae collected on the 2004 expedition, fed and reared until they emerged as adults. On a 1923 voyage to tiny Gardner Pinnacles, researchers found hundreds of "thorn-shaped" cases attached under stones and ledges. On other isles, three differently shaped cases were collected and several tattered moths flew to lanterns. Historically, scientists collected caterpillars by day, and moths—which fly to lights—by night. Although these cone-shaped cases are ubiquitous on the ground and lava cliffs, no one before now has reared them to match moths to specific cases. Using genetic data from newly reared adults, researchers hope to learn whether colonies on each island are unique species, and if any are ancestral to populations on younger Hawaiian Islands, as well as examine evolutionary trends to flightlessness on older islets, as suggested by Dr. Zimmerman after his examination of *H. neckerensis*. —A.M. & S.L.M.

Downy Casebearer Caterpillar, *Hyposmocoma* sp.

p. 101

PHOTOGRAPH: *Searcher* shipboard studio, Mokumanamana, 6 September 2004
RANGE: unknown; probably endemic to Hawaiian Islands
HABITAT: dry shrubland under *Sesbania* (ōhai)
SCALE: case 8-9 mm

Properly called casebearer caterpillars, these creatures are sometimes misleadingly referred to as bagworms. When very young the caterpillars spin themselves silk cases to evade enemies like beetles and micro wasps. In the photograph on page 101, four cases with open doors appear to the upper right. The tiny case of the young can be enlarged as the caterpillar within it grows. These creatures add bits of their surroundings for camouflage; in the cone-shaped cases, this means covering their case with many tiny soil grains as they spin their slender home. Remarkably, these "camo" masters mimic their sourroundings and keep the cone's lower surface pale with extra silk, darkening the cone's upper surface with brown sand grains. These bunkers are fitted with a hinged lid, or operculum, which they pull shut by their mandibles, and weight with larger, heavier grains. Other caterpillars camouflage with snips of dry grass or leaves, flakes of bark, or even a little dirt. Casebearers living amid a seabird colony use downy feather litter as an final decorator's touch for complete disguise. Dr. Daniel Rubinoff, who raised some of the caterpillars collected by the 2004 expedition, reports that after the caterpillars emerged as moths, the feathers eventually fell off the cases. Most likely, the caterpillar needs periodically to refresh the silk binding the feathers. As all homeowners know, a well-maintained structure takes constant attention and upkeep! —A.M. & S.L.M.

Endodontid Snail, *Endodonta* sp.

p. 102

PHOTOGRAPH: *Searcher* shipboard studio, Nihoa, 2 September 2004
RANGE: Nihoa Island
HABITAT: Coastal drylands, 75 -245 m elevation
SCALE: up to 4 mm in diameter

If snails could fly, this unassuming little fellow would have a less dramatic role to play in understanding Hawaiian ecosystems. Today these snails are so rare, except on Nihoa, that experts search for decades and see only one or two alive. In contrast, a stroll on the dunes of south Kaua'i reveals thousands of their petite shells, testimony to their previous numbers. Nihoa endodontids are among the last of 200+ species once inhabiting the main Hawaiian Islands at many elevations. The Endodontidae family, named for tooth-like inner ridges inside the shell, is not the least aquatic and may have reached new isles as eggs or young hitched onto ground-nesting seabirds. First Polynesian agriculture, then large-scale modern plantations of sugarcane and pineapple, altered their lowland habitat. Vast reductions of native plants meant displacement of associated insects, snails, and birds. Some birds and insects could fly to other habitat, but these delicate mollusks, which move slowly even for snails, rapidly declined. On Nihoa this endodontid and a cookeconcha live in small groups in this rare example of an unchanged Hawaiian lowland dry environment. This individual was found in a cluster at the base of 'emoloa bunchgrass (*Eragrostis variabilis*), where these snails may consume old blades, breaking down vegetation to soil. Study of their place in the Nihoa ecosystem will help answer questions about the prehistoric lowlands. —A.M. & S.L.M.

O'ahu Tree Snail, *Tornatellides* sp.

p. 103

PHOTOGRAPH: *Searcher* shipboard studio, Nihoa, 2 September 2004
RANGE: Nihoa Island
HABITAT: bunchgrass (*Eragrostis variabilis*) tuft
SCALE: largest shell 4 mm

Surprising as it might sound, these tiny snails (genus *Achatinella*) live on Nihoa and nowhere else. In the early 1980s, biologist Sheila Conant probed clumps of native bunchgrass, searching for insects preyed on by the Nihoa finch (*Telespiza ultima*) and Nihoa millerbird (*Acrocephalus familiaris kingi*). She discovered seven land snail species hidden at the base of the clumps; five are endemic to Nihoa. Throughout the Northwest Hawaiian Islands, land snails are found only on Nihoa and Necker Islands (Mokumanamana). The main Hawaiian Islands tell a different story, with nearly 800 native non-marine snail speices. Of this group, 42 occur in the same genus as the Nihoan snails, and all of these exist only on O'ahu. Anthropogenic habitat degradation and alien-species introductions caused a near extinction of the entire *Achatinella* genus; only seven or eight species are still extant. O'ahu tree snail shells were used in leis, and the little mollusks found their way into the Hawaiian oral tradition as characters in folklore. Once abundant, all of O'ahu's tree snails are now federally listed endangered species and appear on the International Union for the Conservation of Nature and Natural Resources Red List of critically endangered species. All but two of the O'ahu tree snails are perilously rare in the wild. A captive breeding program at the University of Hawai'i aims to strengthen wild O'ahu tree snail populations by the release of lab-reared offspring, though the snails are slow to reproduce. It can take up to seven years for an O'ahu tree snail to reach reproductive maturity; adults (hermaphroditic) produce one to four living offspring per year.—A.W.

Wolf Spider ~ nanana ʻīlio hae, *Lycosa* sp.

p. 104

PHOTOGRAPH: *Searcher* shipboard studio, Nihoa, 2 September 2004
RANGE: Nihoa; possibly Mokumanamana and other Hawaiian Islands
HABITAT: coastal mesic and dryland areas
SCALE: 35 cm across

It always helps to get a leg up, to start out your life with the benefit of family connections. Being born a wolf spider certainly has its benefits—your mom can eat almost every other arthropod mom on the island. It helps that she has multiple sets of eight eyes looking both forward and up. Still, even at the top of the food chain, life can be hazardous. Wolf spiders begin their lives as eggs riding in a silk baby carriage woven by their mother, but things get harder after that. Once they hatch, they have to bite their way out and then scramble onto mom's back. Riding on the mom-mobile has its advantages: The babies gain protection from birds, other wolf spiders, and trap-door spiders, and they can dine off scraps of the prey mom brings down. She does not, however, settle spiderling sibling rivalries, and some cannibalism is normal in the riding-with-mom school of hard knocks. Growing spiderlings drop off mom's back in order to hide alone by day and hunt by night. As with all predators, they have to establish their hunting territories; dropping off to hunt and explore solo probably serves to distribute the spiderlings in many different locations. Spider watchers: The two short, club-like "arms" on either side of the head are called pedipalps. Compare the pedipalps of the two wolf spiders to the much larger ones on the trap-door spider. —A.M. & S.L.M.

Necker Click Beetle ~ kānepaʻina, *Itodacnus novicornis*

p. 104

PHOTOGRAPH: *Searcher* shipboard studio, Mokumanamana, 6 September 2004
RANGE: endemic to Mokumanamana Island
HABITAT: coastal mesic and dryland shrub areas
SCALE: 2 cm long

Click beetles have solved a problem shared by most insects, turtles, and small children: how to get back on your feet when you end up on your back. A click beetle's first thorax segment has a rod that slides along a groove in the next segment when the body is flexed. Lying on its back, the beetle arches its body, building up muscular tension. When this tension is suddenly released, the insect bounces, flipping through the air and landing on its feet. The refitting parts make the name-giving "click" sound. Kānepaʻina, the beetle's Hawaiian name, recalls one form of the major god Kāne, in which he manifests himself as the distinctive sound made by these beetles. The 1926 scientific description terms the subtly handsome male beetle "fairly slender"; the female egg bearer is described as "more robust." Searchers find it by day under stones and bark at the base of plants. The eggs hatch into wireworm larvae thought to prey on smaller creatures. With ten sister species, these beetles are found on nearly every other younger Hawaiian isle; with so many things setting them apart, each is uniquely named. The individuals on tiny Mokumanamana Island are safe from children and scientists turning them over to hear them click. Their click-and-flip trick might offer some protection if ants or rodents were accidentally introduced, since the flips may also help them escape predators. —A.M. & S.L.M.

Nihoa Trap-door Spider, *Nihoa mahina*

p. 105

PHOTOGRAPH: *Searcher* shipboard studio, Nihoa, 2 September 2004
RANGE: Nihoa Island
HABITAT: island-wide
SCALE: 5 cm across

A husky, robust wrestler's body makes this spider a heavyweight capable of subduing insects or other spiders, even a small lizard. Its unusually large pedipalps give it the appearance of having an extra set of legs held in front of its mouth. Not true legs, they are used to bring food into the spider's mouth; males also use them in courtship to stroke the female, and then transfer sperm packaged in silk. Like other trap-door spiders, Nihoa mahina creates a silk-lined burrow, complete with hinged trapdoor and a lid camouflaged with bits of dirt and leaf. Amazingly, these spiders dig their burrows with their jaws. On Nihoa, they build near rocks where many insects hide from the sun's heat. When it's time for dinner, this spider prefers to order in: Alerted by the vibrations of insects treading near the burrow entrance, *N. mahina* springs out from the trapdoor and—zap, it's dinner time. The spider's name, Nihoa, labels it as a genus found only on that island, distinct even from its neighbor on Mokumanamana Island. The species name mahina, Hawaiian for "moon," refers to the fact that University of Hawaiʻi bird biologist Dr. Sheila Conant discovered the spider by moonlight. The trap-door spiders on the NWHI are the last remaining Hawaiian trap-door spiders; their possible relatives on Oʻahu and Kauaʻi became extinct 100 years ago, prey to rats and mongoose. On remote Nihoa, isolation from predators protects these moonlight camouflage artists. —A.M. & S.L.M.

Native Hawaiian Sedge, *Pycreus polystachyos* ssp. *polystachyos*

p. 106

PHOTOGRAPH: Sand Island, Midway Atoll, 21 August 2004
RANGE: tropical and subtropical, worldwide
HABITAT: open grassy or disturbed areas, from coastal to mesic forest 1,420 m in elevation
SCALE: up to 50 cm tall

A slender annual herb, *Pycreus polystachyos* subsp. *polystachyos* grows on Hawaiʻi, Maui, Molokaʻi, Oʻahu, and Kauaʻi in the main Hawaiian chain, and on Midway Atoll but on none of the other Northwestern Hawaiian Islands. The genus *Pycreus* is in the sedge family (Cyperaceae), and is often associated with the genus *Cyperus*; the name *Pycreus* is an anagram of *Cyperus*. *Pycreus* contains 70 species, two of which grow in Hawaiʻi—one indigenous, one a naturalized introduction. *Pycreus polystachyos*, the indigenous one, has two subspecies, *holosericeus* and *polystachyos*. The two subspecies have only minor differences, which may be difficult to discern in the field: *holosericeus*'s flowers are open and its glumes (small, dry membranous bracts found in the inflorescences) are yellowish brown; *polystachyos*'s flowers are contracted and its glumes are reddish brown. Subspecies *holosericeus* does not grow in the NWHI. On Midway, subspecies *polystachyos* occurs in disturbed and wet areas, and the plant germinates, matures, fruits, seeds, and senesces between the months of March and November. *Pycreus polystachyos* subsp. *polystachyos* is one of 249 plant taxa recorded at Midway Atoll. Of this collection, 119 species are cultivars, 104 are naturalized introductions, and 24 are native to the atoll. The fact that *Pycreus polystachyos* subsp. *polystachyos* occurs only on Midway in the NWHI, in spite of being indigenous to the main Hawaiian Islands, may indicate that it was intentionally or inadvertently introduced to Midway.—A.W.

ʻena ʻena, *Gnaphalium sandwicensium*

p. 107

PHOTOGRAPH: Sand Island, Midway Atoll, 5 March 2003
RANGE: Hawaiian Archipelago
HABITAT: dry areas from shoreline to 3,000 m elevation
SCALE: 7.5 cm section

Gnaphalium sandwicensium, or ʻena ʻena in Hawaiian, grows on Kure and Midway Atolls in the Northwestern Hawaiian Islands, and on all of the main Hawaiian Islands except Kahoʻolawe. ʻEna ʻena is a member of the sunflower family, Asteraceae. Containing more than 20,000 species, or 1 in 4 of every plant species on Earth, Asteraceae ranks as the largest family of flowering plants. Members of the sunflower family are characterized by their capitulum (flower head) that appears to be a single flower, yet is a composite of many ray flowers, disk flowers, or ray and disk flowers. As a member of the sunflower family, ʻena ʻena is closely related to such common plants as daisies, dandelions, and (of course) sunflowers. On Midway, ʻena ʻena occurs along the coast, and inland in patches of consolidated sand. Flexible enough to persist in the varying habitats throughout its range, the plant grows in sandy soil along the shoreline, and also in small soil pockets in lava fields up to 3,000 meters in elevation. Because ʻena ʻena has both a littoral and mountain distribution, it is considered a facultative rather than obligate member of the coastal-strand plant community. The small ʻena ʻena seeds measure less than 1 mm long; their winged design allows wind to serve as the primary dispersal agent. Ancient Hawaiians wove the fragrant, dried ʻena ʻena leaves into kahili (poles topped with a cylindrical plume of feathers) to repel insects.—A.W.

Goosefoot ~ ʻaheahea, *Chenopodium oahuense*

p. 108–109

PHOTOGRAPH: Tern Island, French Frigate Shoals, 18 September 2004
RANGE: endemic to the Hawaiian Archipelago
HABITAT: from low, sandy beach fronts to shrubland at 2,500 meters
SCALE: 11 cm section

Common throughout the main Hawaiian Islands, the goosefoot has several Hawaiian names, including ʻaheahea, ʻāhea, ʻāhewahewa, ʻāweoweo, kāha ʻiha ʻi, alaweo, and, on Niihau, alaweo huna. ʻaheahea is found in dry habitats, from coastal planes to subalpine shrubland. In the Northwest Hawaiian Islands, it grows on Lisianski, Laysan, Mokumanamana (Necker), and Nihoa Islands, and on French Frigate Shoals. In these remote places, goosefoot shrubs become nesting platforms for brown noddies (*Anous stolidus*), red-footed boobies (*Sula sula*), and great frigatebirds (*Fregata minor*), while burrowing petrels and shearwaters find refuge beneath the plant. ʻĀheahea is dominant on Necker and Nihoa; on the latter, the endemic finch (*Telespiza cantas*) feeds on the flowers and fruit of the goosefoot, which also hosts insect populations that become food for the endemic millerbird (*Acrocephalus familiaris kingi*). Ancient Hawaiians ate both goosefoot seedlings and leaves from adult plants, often wrapped in ti leaves and cooked over a fire. The plant's foliage has little or no scent, making it unique among members of its genus. It is one of several native plant species undergoing restoration on Laysan Island. Even though 80 years stand between the present day and the complete defoliation of Laysan Island by introduced rabbits, many members of Laysan's native plant community remain underrepresented. In 2000, the U.S. Fish and Wildlife Service launched a progressive program of native plant propagation and out-planting; goosefoot represents one of the early success stories, with a current distribution on Laysan substantially greater than it was just four years ago.—A.W.

Red-footed Booby ~ aʻ, *Sula sula rubripes*

p. 111

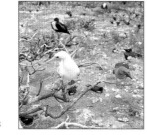

PHOTOGRAPH: Tern Island, French Frgate Shoals, 11 August 2004
RANGE: tropical Pacific, Atlantic and Indian Oceans, and Caribbean Sea
HABITAT: pelagic; breeds on offshore and remote islands
SCALE: wingspan 152 cm; mass 1–1.2 kg

The booby family, Sulidae, originated in the Southern Hemisphere some 50 million years ago; it now contains six members, three of which are found in the Northwestern Hawaiian Islands. In size, red-footed boobies weigh noticeably less than the other two Hawaiian Sulids (brown booby—*Sula leucogaster*, and masked booby—*Sula dactylatra*). All three boobies share breeding sites and feed on the same fish and squid species. Red-footed boobies nest on all of the Northwestern Hawaiian Islands, where they compete with great frigatebirds (*Fregata minor*) for nesting habitat and materials throughout the January to June breeding season. These two species steal twigs from each other's nests and play aerial tug-of-war over the colonies. Male and female red-footed boobies cooperate in nest construction: He brings sticks, grass, algae; she carefully weaves the materials into a wide-rimmed nest that lasts until the chick nears fledging age. Whether plunge-diving from several meters above the surface or deftly snatching flying fish in mid-flight, the smallest of the boobies is a formidable predator, swallowing prey directly for nourishment or regurgitating it to a hungry chick when back at the nest. As do all seabirds, red-footed boobies waterproof their feathers with waxy esters excreted from the uropygial gland, located on the back just forward of the tail. They use their bill to work the substance through flight and body feathers, a functional massage that allows them to plunge into the ocean or rest on its surface and take off again, all without becoming soaked: water off a booby's back.—A.W.

puaokama, *Sicyos maximowiczii*

p. 120

PHOTOGRAPH: Green Island, Kure Atoll, 18 July, 2004
RANGE: Northwestern Hawaiian Islands
HABITAT: coastal strand
SCALE: 6 cm section, stems up to 10 m long

With its long, grasping vines, the annual *Sicyos maximowiczii* seasonally dominates patches of bunchgrass and herbaceous plants throughout its native range: Kure and Pearl and Hermes Atolls, and Lisianski, Laysan, and Niʻihau Islands. Called puaokama in Hawaiian, the plant is endemic to the Hawaiian Archipelago; though its range is now limited to the Northwestern Hawaiian Islands and the island of Niʻihau, the plant grew on Oʻahu prior to its suspected modern extirpation from that island. *S. maximowiczii* prefers coastal, sandy habitat, and has widespread distribution on Laysan and Lisianski, as both these islands have a sand-based soil structure. *S. maximowiczii* belongs to the gourd family, Cucurbitaceae, which includes 120 genera and 850 species distributed throughout the world's tropical and temperate regions. Hawaiian representatives of Cucurbitaceae include one indigenous genus, *Sicyos*, and four introduced genera that contain well-known cultivars, such as cantaloupe and honeydew melons, pumpkin, squash, and the bottle gourd. The latter species, bottle gourd, or ipu in Hawaiian (*Lagenaria siceraria*) is a Polynesian introduction and has many functional and artistic applications. Of the 50 species belonging to the genus *Sicyos*, 14 are endemic to Hawaiʻi; the remaining 36 species within the genera are indigenous to the Southwestern Pacific, New Zealand, and Australia.—A.W.

Sea purslane ~ ʻākulikuli, *Sesuvium portulacastrum*

p. 121

PHOTOGRAPH: Sand Island, Midway Atoll, 15 October 2003
RANGE: pantropical
HABITAT: coastal strand
SCALE: 5 cm section

Sesuvium portulacastrum, called ʻākulikuli in Hawaiian, is one of eight halophytic, or salt-tolerant, species in the genus *Sesuvium*. Salt tolerance in plants is, in this circumstance, a complex adaptation to the hostile habitat occurring at the land-sea interface. The ultimate effect of a saline-rich environment on plants manifests in shrinkage of leaf tissue, which leads to leaf death, and finally plant death. Halophytes have adapted metabolisms that counteract the deleterious effect of excessive salt exposure, thus allowing them to occupy a habitat niche unavailable to other plants. *S. portulacastrum*, commonly called sea purslane, is the only member of its genus found in the Hawaiian Archipelago. This prostrate, purple- and pink-flowered succulent grows in a variety of coastal habitats, from seemingly inhospitable coralline-limestone rock shelves, to sand dunes, to wetlands. Sea purslane grows on all of the main Hawaiian Islands, and on Pearl and Hermes Atoll and Lisianski, Laysan, and Mokumanamana (Necker) Islands in the Northwestern Hawaiian Islands. On Laysan, sea purslane forms a dense mat around the south, north, and northeast periphery of the island's hypersaline lake. Both of Laysan Island's endangered, endemic birds—the Laysan duck (*Anas laysanensis*) and Laysan finch (*Telespiza cantans*)—regularly forage in patches of sea purslane, rooting through the dense carpet of twisted, green stems for invertebrate prey.—A.W.

Laysan Finch, *Telespiza cantans*

p. 123

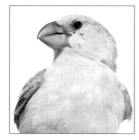

PHOTOGRAPH: Southeast Island, Pearl & Hermes Atoll, 6 June 2004
RANGE: Laysan Island, translocated to Pearl & Hermes Atoll
HABITAT: nests and forages in varied habitats on low, sandy islands
SCALE: wingspan 18 cm; mass 33 g

Quick and endlessly mischievous, the Laysan finch leaves no stone unturned. The large finch-like honeycreepers (19 cm from tip of beak to point of tail) eat, or try to eat, nearly everything, including earlobes—as I discovered while stationed at Pearl and Hermes Atoll. Truly omnivorous, Laysan finches will commonly eat grass and sedge seeds, insects, ground-nesting tern and petrel eggs, and even senescing albatross chicks. Though endemic to Laysan Island, translocated populations have been established elsewhere in the NWHI. The Laysan Finch was introduced to Midway Atoll in 1905; World War II activities brought rats to Midway, and by 1944 all of the introduced finches were gone. In 1967, the USFWS captured 108 finches on Laysan and introduced them to Pearl and Hermes Atoll. This satellite population persists today despite the stark, ephemeral nature of the islets. The plant, seabird, and terrestrial arthropod communities at Pearl and Hermes Atoll are limited compared to those on Laysan Island; thus, the translocated finch population had to adapt to a new diet, and adapt they did. Less than 25 years after the translocation, scientists noticed differences in genetics and bill morphology between the parent population on Laysan Island and the finches introduced to Pearl and Hermes Atoll. After spending several field seasons with the Pearl and Hermes finches, NOAA fisheries biologist Chad Yoshinaga summarized the Laysan finch's adaptability and cleverness by saying, "If the finches ever make it off these islands, we're done for. They'll take over the world!"—A.W.

Brown Noddy ~ noio koha, *Anous stolidus*

p. 125

PHOTOGRAPH: Laysan Island, 25 July 1999
RANGE: pantropical
HABITAT: pelagic, breeds on remote and offshore islands
SCALE: wingspan 80 cm; mass 140—275 g

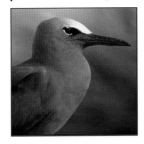

In the same family as gulls (*Laridae*) and subfamily as terns (*Sterninae*), noddies share characteristics of both relatives. Brown noddies fly with stiff, gull-like wing beats and often scour the ocean's surface for small fish, squid, and crustaceans, foraging with terns in mixed-species flocks. Of the three noddy species, browns are the biggest and widest-spread; their breeding range encompasses remote and offshore islands around the globe from 30° North to 30° South of the equator. The common name "noddy" derives from the bird's frequent habit of nodding its head, or looking at its feet while at roost. On a less neutral note, the scientific name, *Anous stolidus*, means "silly" (from the Greek *anous*), and "dull" or "slow minded" (from the Latin *stolidus*). Brown noddies breed on rocky, sandy, and forested islands, where they form colonies that vary in size from a few pairs to several thousand. They nest on the ground or in low-lying shrubs when not threatened by terrestrial predators, and in coconut palms (*Cocos nucifera*) or other trees in areas frequented by cats, dogs, rats, and the like. Ground-nesting brown noddies often adorn their nests with bits of plastic, pebbles, and bird bones and skulls from less fortunate neighbors. On Laysan Island, a roguish adult brown noddy built its nest near the kitchen tent in the USFWS field camp; the nest was festooned with three outward-pointing skulls from albatross chicks, and the noddy regularly bolted out of it to peck the ankles of passing field biologists.—A.W.

Laysan Duck, *Anas laysanensis*

p. 130

PHOTOGRAPH: Laysan Island, 21 July 1999
RANGE: endemic to Northwestern Hawaiian Islands: Laysan Island, recently introduced to Midway Atoll
HABITAT: low-elevation coastal areas
SCALE: wingspan 40-50 cm; mass 450-460 g

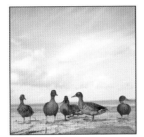

Fossil evidence from Maui and O'ahu indicates that this small, brown, dabbling duck once lived on the main Hawaiian Islands, although at present Laysan ducks are only found on Laysan Island and Midway Atoll. The small Midway population (19 individuals), translocated from Laysan Island in 2004, results from a successful, precautionary effort to expand the duck's range. In 1967, the U.S. Fish and Wildlife Service translocated 12 Laysan ducks to Southeast Island, at Pearl and Hermes Atoll; these ducks did not survive. Between 1905 and 1923, introduced rabbits completely denuded Laysan Island, causing the extinction of three endemic species of land bird and several plant species. Narrowly surviving the rabbit epidemic, the Laysan duck population recovered to its current size of 500 to 600 individuals, probably the island's carrying capacity for this species. Laysan Island's 370 hectares encompass a large, hypersaline lake; around the lake's muddy edge, Laysan ducks scamper through dense swarms of tiny brine flies (*Neoscatella sexnotata*), gobbling as many of the poppy seed-sized insects as their clapping bills can manage. Laysan ducks also dabble for brine shrimp, catch and eat moths, and feed on beetles and larvae found within seabird carcasses. Females lay clutches of three to six eggs and take full responsibility for them, as males do not assist with incubation or brood rearing.—A.W.

Dwarf eragrostis, *Eragrostis paupera*

p. 132

PHOTOGRAPH: Green Island, Kure Atoll, 20 July 2004
RANGE: pantropical throughout the Pacific Ocean
HABITAT: coastal
SCALE: 10 cm across

Small, uncommon, and usually found growing in exposed areas strewn with coral rubble, sand, and gravel, *Eragrostis paupera* is at first glace an implausible relative of the robust, widespread bunchgrass, *Eragrostis variabilis* ('emoloa). Both species belong to the lovegrass genus; the name *Eragrostis* draws from the Greek word *eros* and the Latin name for fodder grass, *Agrostis*. *E. paupera* is native to the equatorial region of the Pacific Ocean and, in the Hawaiian Archipelago, it grows at Kure, Midway, and Pearl and Hermes Atolls, and at French Frigate Shoals. The small lovegrass was recorded at Barber's Point on O'ahu, but is no longer found at this location, nor does it occur on any other main Hawaiian Island. On Midway, *E. paupera* flowers and sets seed from May through November, growing in abundance only on Spit Island. At Pearl and Hermes Atoll, the endangered Laysan finch (*Telespiza cantans*) readily eats *E. paupera* seeds, often spilling more on the ground than it consumes. Considered a pioneer species, the plant can invade bare sites—that is, newly exposed soil—and persist there until supplanted by successional species. *E. paupera* shares a proclivity for open habitat with other pioneer plants, which are generally shade intolerant and require ample sunlight.—A.W.

pu'uka'a, *Mariscus pennatiformis* ssp. *bryanii*

p. 133

PHOTOGRAPH: Laysan Island, 21 July 1999
RANGE: Laysan Island
Habiat: coastal strand
SCALE: 9 cm section

The large genus *Mariscus* comprises 200 species spread across the tropical, subtropical, and temperate regions of the world. All ten *Mariscus* species found in Hawai'i are endemic. The two subspecies of *Mariscus pennatiformis* include subspecies *pennatiformis*, a rare inhabitant of open, low-elevation grasslands and mesic forest on Kaua'i, O'ahu, Maui, and Hawai'i; and subspecies *bryanii*, limited to Laysan Island and one of the rarest and most endangered plants in the Hawaiian Archipelago. In the early 1900s, introduced rabbits completely denuded Laysan of vegetation, causing the extinction of three endemic land birds and at least one endemic plant species. A scattered seedbank restored Laysan's plant community, though with a smaller species compilation. In the 1960s, common sandbur (*Cenchrus echinatus*), a noxious weed grass, was inadvertently introduced to Laysan. Starting in the late 1970s, increased visitation to the island, primarily by field biologists, facilitated the distribution of sandbur through its hooked seed pods which readily adhere to clothing and skin. By 1990 sandbur colonized 30 percent of Laysan's vegetated area, and critical nesting habitat for the endemic and endangered Laysan duck (*Anus laysanensis*) and Laysan finch (*Telespiza cantans*) vanished as sandbur displaced clumps of native bunchgrass (*Eragrastis variabilis*). Since 1991, the USFWS has conducted successful sandbur eradication and native vegetation restoration programs. Subspecies *bryanii* only just survived the rabbit and sandbur catastrophies; in 1980, ten plants were observed northeast of Laysan's central lake. Now, subspecies *bryanii* grows throughout the island and successfully regenerates through natural seeding.—A.W.

Caltrop ~ nohu, *Tribulus cistoides*

p. 134–135

PHOTOGRAPH: Green Island, Kure Atoll, 20 July 2004
RANGE: pantropical
HABITAT: coastal strand
SCALE: flower 4 cm diameter

A prostrate, perennial herb that's indigenous to Hawai'i, nohu belongs to the creosote bush family (Zygophyllaceae). It grows on all the main Hawaiian Islands, and all the Northwest Hawaiian Islands except for Gardner Pinnacles and Mokumanamana Island (Necker). On Pearl and Hermes Atoll and Laysan Island, Laysan finches (*Telespiza cantans*) use their powerful beaks to break into nohu seedpods and pick out the seeds. Sphinx moths (*Sphingidae*) and other flying insects carry nohu pollen from one plant to the next as they visit the yellow, fragrant flowers for a sip of nectar. Caltrop, the common name for plants within the genus *Tribulus*, refers to a likeness between the plant's fruit and a "caltrop," an iron ball with four projecting spikes, one of which always points skyward when the ball is on the ground; unlike the plant, its namesake has a military origin and application. The Hawaiian name for *Tribulus cistoides*—nohu—is the same name given to the venomous scorpionfish (*Scorpaena* ssp.), and there's no coincidence to this association with pain. Nohu's easily dispersed seedpods come equipped with two spines apiece, each five to ten millimeters long, all the better to torment barefoot beachgoers. From an adaptive point of view, nohu's spines play an important role in secondary seed dispersal. Albatross and other ground-nesting seabirds frequently transport these seeds stuck to their webbed feet. And every human who ventures barefoot into a nohu patch aids in dispersal when the spiky seedpod is pulled from a toe, with or without profanities, and thrown forcefully aside.—A.W.

Bristle-thighed Curlew ~ kioea, *Numenius tahitiensis*

p. 136

PHOTOGRAPH: Sand Island, Midway Atoll, 23 August 2003
RANGE: breeding—western Alaska between Yukon River and north Seward Peninsula; wintering—islands in the North, Central, and South Pacific Ocean
HABITAT: breeding—shrub and hummock-ridge tundra; wintering—shoreline, tidal flats, shrub and grassland, forests
SCALE: wingspan 84cm; mass 310-485 g

The bristle-thighed curlew (kioea in Hawaiian) is one of the world's most remarkable birds. All bristle-thighed curlews fly at least 4,000 km from their summer breeding grounds in Alaska to the Northwestern Hawaiian Islands, and many pass the Hawaiian Archipelago on their way to islands in the Central and South Pacific, flying 6,000 kilometers or more without rest. This epic migration places the bristle-thighed curlew near the top of the list for the longest nonstop flight of any bird. The bristle-thighed curlew is the only shorebird that winters exclusively on oceanic islands, the only shorebird that becomes flightless while molting feathers, and the only shorebird known to use tools while foraging. Tool use has only been observed on Tern Island in French Frigate Shoals and on Laysan Island, where bristle-thighed curlews use their dexterous beaks to throw pieces of coral at abandoned albatross eggs in order to fracture the thick shell. Bristle-thighed curlews enjoy a varied diet while wintering in the NWHI; aside from seabird eggs, they eat ghost crabs, spiders, roaches, moths, carrion (dead seabirds), fish and squid (regurgitated by seabirds), introduced lizards, and naupaka (*Scaevola sericea*) fruit. At the summer breeding grounds in Alaska, bristle-thighed curlews primarily forage on berries and insects. While relatively safe in the tundra, they suffer predation from introduced mammals on oceanic islands. Recent estimates suggest that fewer than 3,500 breeding pairs exist; if juveniles that over-summer in Oceania are included, the total population is probably less than 10,000 birds.—A.W.

Pacific Golden Plover ~ kolea, *Pluvialis fulva*

p. 137

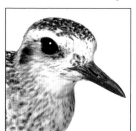

PHOTOGRAPH: *Searcher* shipboard studio, Mokumanamana, 6 September 2004
RANGE: Arctic regions of eastern Asia and western North America; coastal California, Pacific Ocean, Australia, Southeast Asia, and northeast Africa
HABITAT: tundra, coastal flats; near-shore areas, meadows and grass fields, ponds
SCALE: wingspan 60 cm; mass 150-185 g

The Pacific golden plover, kolea in Hawaiian, is a common visitor to the Hawaiian Archipelago. In August, adult kolea leave their Artic breeding grounds and fly 3,000 miles, nonstop, to Hawai'i, averaging 50-60 mph during the migration. Hatch-year birds follow suit a few months later. Considering that the Hawaiian Archipelago is 2,000 miles south of the Aleutians, 2,000 miles west of Baja California, and nearly 4,000 miles from Japan, kolea and other shorebirds make a do-or-die commitment when migrating to or from Hawai'i, as they are unable to land on the ocean's surface to rest, eat, or drink. From their arrival in August to their departure on April 25 (to be exact), kolea search for insects, worms, and food scraps in grassy fields, backyards, parking lots, and beaches on the main Hawaiian Islands. The same bird will return to and defend the same foraging grounds, year after year. Kolea's omnipresence and foraging-site fidelity have made the bird a favorite of people living in Hawai'i, and also greatly facilitate research projects, from the elementary-school to post-graduate level. In the NWHI, kolea forage along shorelines and in vegetated areas, and even manage to find sustenance on the seemingly bare Gardner Pinnacles. The omnivorous kolea feed on a wide variety of insects, small reptiles, crustaceans, and unguarded bird eggs. While kolea wintering in the NWHI are safe from predators, those on the main islands run a gauntlet of dangers—cats, dogs, and airplanes, to name a few.—A.W.

Gray-backed Tern ~ pākalakala, *Sterna lunata*

p. 140

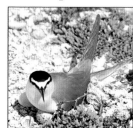

PHOTOGRAPH: Southeast Island, Pearl & Hermes Atoll, 20 May 2003
RANGE: Central Pacific Ocean
HABITAT: pelagic; breeds on small, remote islands
SCALE: wingspan 74 cm; mass 130 g.

Unlike its well-known, gregarious cousin, the sooty tern (*Sterna fuscata*), the shy gray-back is seldom seen near islands with significant human populations. In the Hawaiian Archipelago, gray-backed terns breed on all of the Northwestern Hawaiian Islands, as well as Moku Manu and Kaula in the main Hawaiian Islands. Outside the breeding season (December to September), gray-backs are entirely pelagic, flying alone or in small flocks, dipping and plunging for small fish, crustaceans, and marine insects. When on land, gray-backed terns occasionally consume terrestrial insects and even skinks. Hawaiian populations favor the thornback cowfish (*Lactoria fornasini*)—in fact, the Hawaiian name for gray-backed tern, pākalakala, implies "thorniness," a possible alliteration of the bird's diet. Gray-backed terns tend a single-egg clutch in a simple nest that is little more than a depression in the sand. Mates affirm pair-bonds by parading and dancing, with drooped wings held away from the body while they circle each other. During this display, the birds angle their necks toward the ground and raise their hindcrown feathers, giving the dancers' heads a "flat-top" look. Parents alternate incubation bouts until hatching, about 30 days after the egg is laid. Precotial, cryptic chicks are gray with black speckles, enabling them to blend perfectly with the gray-backs' preferred nesting habitat of sand and coral rubble. Despite the camouflage, chicks are occasionally taken by frigatebirds (*Fregata* sp.), and, where humans and gray-backs mix, by introduced predators—cats, rats, and dogs.—A.W.

Ruddy Turnstone ~ 'akekeke, *Arenaria interpres*

p. 142

PHOTOGRAPH: Southeast Island, Pearl & Hermes Atoll, 26 September 2004
RANGE: breeding—Arctic regions of North America, Asia, and Greenland; wintering—coastal regions of North America, Western Europe, and remote islands in the Pacific and Atlantic Oceans
HABITAT: breeding—tundra and coastal flats; wintering—near-shore areas, meadows and grass fields, ponds
SCALE: wingspan 45 cm; mass 115 g

The ruddy turnstone, a small, stout shorebird, breeds in the tundra regions of Greenland, North America, and Siberia during the summer, and winters along coastal North America and southwestern Europe, on islands in the Caribbean and the North, Central, and South Pacific. Ruddy turnstones arriving in Hawai'i likely flew nonstop from breeding grounds in the Bering Sea, 2,000 miles to the north. This north-to-south passage is just one leg in the turnstone's elliptical migration route, which continues from the Hawaiian Islands (or other islands in the Central and South Pacific) northeast to coastal Asia, and then west to the bird's Bering Sea breeding grounds. Ruddy turnstones winter on all of the Hawaiian Islands, showing up in late August and departing for the north in May. While in Hawai'i, they opportunistically forage along the shoreline for small crustaceans, mollusks, fish, abandoned seabird eggs, and insects, frequently tipping small rocks to expose food items and thus earning the name "turnstone." Enterprising ruddy turnstones will even hop on the backs of sleeping monk seals to pick at scabs and snap at flies. Fattened from eight months of feeding in the tropics, Hawai'i's turnstones leave the islands in spring and fly nonstop to their Arctic breeding grounds. They have strong mate and nest-site fidelity, and aggressively defend these bonds against interlopers. Females usually lay four eggs in a feather-lined depression in the tundra. Chicks hatch after 24 days, and fledge 23 days after that.—A.W.

Black-footed Albatross, *Phoebastria nigripes*

p. 146–147

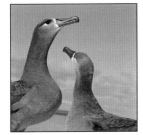

PHOTOGRAPH: Southeast Island, Pearl & Hermes Atoll, 20 May 2003
RANGE: North Pacific Ocean
HABITAT: Pelagic; breeds on small remote islands
SCALE: wingspan 230 cm; mass 3-3.5 kg

Some 96 percent of the world's 61,000 breeding pairs of black-footed albatrosses nest in the Northwestern Hawaiian Islands. With 22,000 breeding pairs, Midway Atoll hosts the world's largest black-footed albatross colony. Other breeding grounds include Kaula Rock and Lehua Island (main Hawaiian Islands), and Torishima Island, Bonin Island, and Senkaku Island in the Western Pacific. In the Northwestern Hawaiian Islands, black-footed and Laysan albatrosses (*Phoebastria immutabilis*) share breeding grounds, sometimes in dense, mixed colonies, although black-footed albatrosses prefer open, sandy areas while Laysans associate nests sites with vegetation when possible. Black-footed albatrosses are monogamous, though if a mate disappears or dies, the survivor will seek out a new partner. Nests are cup-shaped depressions dug in the sand, or formed by pushing sand or soil into a pile that is deftly shaped by the bird's large, webbed feet and nimble bill. Bits of surrounding vegetation line the nest cup, in which one large egg is incubated for 65 days.

Breeding season begins in early November, about two weeks earlier than for Laysans, and chick hatching starts in mid-January. From brand-new to nearly fledged, chicks fatten on a rich diet of flying fish eggs, squid, and nutrient-laden stomach oil. Both adults feed their chick, though several days may pass between feeding bouts. When a parent returns from the high seas, its ravenous chick—wasting no time on small talk—goes straight for the groceries, pecking incessantly at the parent's lower beak to stimulate a regurgitation response. Insatiable, chicks will continue to peck and cry at parents long after the adult's regurgitations produce nothing but noise. Fledging occurs four to five months after hatching, in June and July. Parents usually leave the breeding grounds before their chicks fledge, and the young practice take-offs and flapping while relying on their fat reserves. Nearly fledged chicks migrate to the beaches where they flap their full-sized wings in the strong breeze and make short flights. Like clockwork, tiger sharks (*Galeocerdo cuvier*) begin routine patrols along the shoreline as the first fledgling albatrosses splash into the near-shore waters during practice flights. It's a spectacle like no other: 15-foot sharks lunging at seemingly oblivious, bobbing albatross chicks. Surprisingly, tiger sharks often miss their mark. When they charge, their large, square snouts produce a "bow wake" that pushes the albatross fledglings to the side. While some chicks survive a tiger-shark encounter with less than a scratch, many feathers and severed wings wash up on NWHI beaches during June and July.

Black-footed albatrosses return to their natal breeding grounds after three years of pelagic wandering, but will not successfully mate until they're at least five years old. Unlike the Laysan albatross, whose retinas possess a high level of rhodopsin which enables night vision, the black-foots have limited nocturnal eyesight and mostly feed during daylight hours. Black-footed albatrosses primarily eat flying fish eggs which are easily located during the day; occasionally they include squid and crustaceans in their diet, although these two prey items, usually found at night, are more often eaten by the rhodopsin-endowed Laysan albatross. The incongruity of diet and foraging behavior between the Laysan albatross and black-footed albatross reduces competition for limited food resources.

Albatrosses and other Procellariforms (petrels, storm petrels, and shearwaters) developed similar renditions of a highly efficient, low-level flight pattern termed "dynamic soaring," which takes advantage of the discrepancy between wind velocities at different elevations above the ocean's surface. An albatross wanting to fly into a strong westerly head wind will climb 20 or so meters while gliding north—perpendicular to the wind and the desired heading. At the climb's apex, the albatross will bank into the wind and quickly descend to take advantage of the lighter head wind at the ocean's surface, which can be half the velocity of winds 15 meters above. Carrying speed from the dive, the albatross can then soar west along the wave tops. This turning-climbing-diving-gliding pattern, repeated for hundreds and possibly thousands of miles, can carry the albatross along with little or no flapping of its wings—a remarkable feat that has long ensnared the imagination and envy of mariners.

Commercial fishing operations now threaten these birds; in 1990 alone, 4,500 black-footed albatrosses were killed in high-seas drift nets. An estimated 40,000 southern-hemisphere albatrosses are killed every year by longline fisheries, and many thousand black-footed albatrosses perish by hook or entanglement in the North Pacific. Up to 2,000 black-footed albatrosses are thought to be lost each year from U.S. fishing operations, and as many as 8,000 are lost to Japanese fisheries. By using estimated bird losses through fishing by-catch, conservationists predict a sixty-percent reduction in the black-footed albatross population over the next three generations. Increasing levels of industrial toxicants (PCBs, DDT, and others) appear in samples taken from dead Laysan and black-footed albatrosses, and plastic offal mistaken for food gets picked up by adults and fed to chicks. Black-footed albatrosses are listed as endangered by the International Union for the Conservation of Nature (IUCN). As in Samuel Coleridge's famous poem, *The Rime of the Ancient Mariner*, an albatross may hang around all our necks if we continue to value short-term economic progress over the long-term preservation of our valuable marine systems.—A.W.

Great Frigatebird ~ 'iwa, *Fregata minor palmerstoni*

p. 149

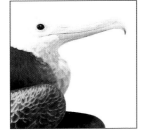

PHOTOGRAPH: Green Island, Kure Atoll, 4 August 2003
RANGE: pantropical
HABITAT: pelagic; breeds and roosts on remote or offshore islands
SCALE: wingspan 205-230 cm; mass 1-1.8 kg

Great frigatebirds reign supreme in their flying abilities. Several morphological advantages give firgatebirds an edge on their fellow seabirds: They have 40 percent more wing area and 25 percent more flight feathers than any other seabirds of comparable mass, a skeleton that's less than 5 percent of an adult's body mass, and a strengthened breastbone that accommodates large flight muscles. Their Hawaiian name—'iwa, meaning "thief"—appropriately but incompletely describes this large and talented seabird. Great frigatebirds are known to kleptoparasitize (steal food from) other seabirds, including boobies (*Sula* ssp.), tropicbirds (*Phaethon* ssp.), petrels (*Pterodroma* ssp.), and even fellow frigatebirds. At breakneck speed, adult and juvenile great frigatebirds chase down and easily outmaneuver other birds returning from their fishing grounds, persuading their quarry to give up the day's catch. When the harassed bird regurgitates, the frigatebird plunges after the booty, often catching and swallowing it in midair without missing a beat. Though kleptoparasitism is closely associated with frigatebird foraging behavior, these seabirds are nonetheless practiced at procuring their own meals. At sea, frigatebirds feed by using their long, hooked beaks to grab prey at or near the surface, and even catch flying fish (*Exocoetidae* ssp.) on the wing. During breeding season (February to June in the Northwestern Hawaiian Islands), male frigatebirds advertise their worth to passing females by inflating their large red gular sacs, shaking their outstretched wings, and pointing their beaks skyward while warbling.—A.W.

Beach Morning Glory ~ pohuehue, *Ipomoea pes-caprae* ssp. *brasiliensis*

p. 150

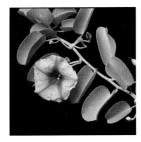

PHOTOGRAPH: Sand Island, Midway Atoll, 20 October 2003
RANGE: endemic to islands in the Pacific Ocean
HABITAT: coastal strand
SCALE: flower ~ 7 cm diameter

With nearly 500 species, *Ipomoea* is the largest genus in the family Convulvulacae, or morning glory. The beach morning glory is pantropical, though plants growing throughout the Pacific have smaller flowers and less deeply lobed leaves than those found elsewhere, and were distinguished as subspecies *brasiliensis* by Carolus Linnaeus. Beach morning glory grows on all of the Northwestern Hawaiian Islands except Gardner Pinnacles and Mokumanamana (Necker), and on all of the main Hawaiian Islands. A white-flowered form occurs on Laysan Island, O'ahu, and Hawai'i. As its name suggests, beach morning glory occupies the littoral zone, covering sandy areas with long stems running from a thick taproot; its long, twisting vines set root at every leaf node that touches the ground. Beach morning glory holds down sand that would otherwise disperse with wind, making it an important contributor to shoreline conservation. On Laysan Island, it constitutes a significant monospecies association that surrounds much of the inland, hypersaline lake. Most of the island's population of Tristram's storm petrel (*Oceanodroma tristrami*) breed in burrows dug under twisting pohuehue vines. Endemic Hawaiian sphinx moths (*Sphingidae*) sip nectar from the vine's flowers, and transport pollen from one plant to the next. Pohuehue produces dry, grape-sized pods containing up to four brown, triangular seeds; these can survive pelagic seed dispersal, thanks to their buoyancy and their ability to withstand long periods of immersion in salt water.—A.W.

pōpolo, *Solanum nelsonii*

p. 151

PHOTOGRAPH: Spit Island, Midway Atoll, 27 February 2003
RANGE: endemic to the Hawaiian Archipelago
HABITAT: coastal habitat up to 150 meters
SCALE: flower 1.5 cm diameter

The nightshade family, Solanacea, boasts some big players on the stage of human cultural evolution: potatoes, tobacco, tomatoes, peppers. Worldwide, Solanacea represents 90 genera and 2,700 species, though only 35 species grow in Hawai'i, and only 9 of these are native. *Solanum nelsonii* and *Solanum sandwicense*, both endemic to the remote Hawaiian Archipelago, have similarly unusual flower morphology. The anthers of both species curve inward, a likely adaptation to a distinct pollinator. *S. nelsonnii*, or pōpolo, historically occured in all the main Hawaiian Islands except Lāna'i and Kaho'olawe. Today, only a remnant population remains along the coastline at Mo'omomi, on Moloka'i; pōpolo has little resistance to urban development and grazing. Northwest of the main Hawaiian Islands, pōpolo grows on Kure, Midway, and Pearl and Hermes Atolls, and Nihoa and Laysan Islands, having been reintroduced on the latter in 2001. A sprawling shrub that stands little more than one meter tall, pōpolo has densely pubescent leaves, small purple flowers, and small tomato-like fruit that turns black when ripe. Comfortable on the flat, coral-rubble islets of Pearl and Hermes Atoll, and on the sheer slant of Nihoa's south-facing slopes, pōpolo makes an important nesting substrate for great frigatebirds (*Frigata minor*), red-footed boobies (*Sula sula*) and, on Nihoa, the endemic and endangered Nihoa millerbird (*Acrocephalus familiaris kingi*). The species name *nelsonii* credits David Nelson, the apprentice botanist on Captain Cook's third voyage to Hawai'i. *Solanum nelsonii* probably derived from a single, ancient introduction of Mexican or Central American origin.—A.W.

Button Sedge ~ mau'u 'aki 'aki, *Fimbristylis cymosa*

p. 152–153

PHOTOGRAPH: Sand Island, Midway Atoll, 23 October 2003
RANGE: tropical Pacific
HABITAT: coastal strand up to 60 m in elevation
SCALE: 20 cm tall

A mnemonic aid for naturalists: "Sedges have edges; rushes have brushes." Hawai'i hosts 69 sedge species (family Cyperaceae): 28 indigenous, and 17 endemic. The Hawaiian names mau'u or kāluhāluhā apply to all sedges growing in the islands. *Fimbristylis*, a genus of small sedges with short, narrow, pointed leaves, contains over 200 species throughout tropical regions worldwide. Of the three *Fimbristylis* species found in Hawai'i, two are indigenous, including *F. cymosa*, which grows in coastal habitats on all of the main Hawaiian Islands except Kaho'olawe, and on Kure and Midway Atolls, Laysan Island, and French Frigate Shoals in the Northwestern Hawaiian Islands. A testament to its hardiness, *F. cymosa*, or mau'u 'aki 'aki, is the dominant plant growing on the abandoned concrete airstrip at Kure Atoll and, despite persistent grading, continues to encroach on the edges of the crushed-coral airstrip at French Frigate Shoals. Nesting Laysan and black-footed albatrosses (*Phoebastria* sp.) pick at mau'u 'aki 'aki clumps, often reducing nearby plants to a few leaves poking through the sand. If the plant's root structure remains intact, it will likely regenerate vegetative parts within a few months; *F. cymosa* is a perennial sedge, meaning that individuals persist through several years or growing seasons. As a member of the coastal strand plant community, mau'u 'aki 'aki plays a key role in preventing shoreline erosion.—A.W.

White Tern ~ manu-o-ku, *Gygis alba rothschildi*

p. 164–165

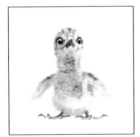

PHOTOGRAPH: Sand Island, Midway Atoll, 5 June 2003
RANGE: pantropical
HABITAT: small tropical islands throughout the Pacific, Indian, and Atlantic Oceans
SCALE: chick 8 cm tall: adult wingspan 70-87 cm; mass 77-157 g

White terns breed on all of the Northwestern Hawaiian Islands except Pearl and Hermes Atoll, and on only one of the main Hawaiian Islands—O'ahu—and are seen hundreds of miles from land. With dazzling white plumage, quick black eyes, and a dartlike bill, the white tern unites angelic poise with predatory prowess. Comfortable in both calm and storm, white terns deftly snatch small fish and squid from the ocean's surface. Most of their foraging occurs in waters near shore, and around shoals and banks. Like sooty terns (*Sterna lunata*), brown noddies (*Anous stolides*), and great frigatebirds (*Fregata minor*), white terns benefit from the feeding activities of large pelagic fish and dolphins, waylaying small prey that rushes to the surface while escaping these marine predators. Prey is either swallowed on the spot, or carried crosswise in the bill for delivery to an ever hungry chick. Adults breed year-round, and will raise up to three single-chick broods in a given year. White terns do not build nests, which might be an adaptation to reproducing on islands with little or no vegetation. In lieu of nesting, breeding pairs carefully select rock ledges or crooks in branches, upon which they balance a single mottled egg throughout the 36-day incubation period. A quick return to reproductive activities after loss of egg or chick compensates for the risk of nesting on small, exposed islands subject to the ever variable ocean environment.—A.W.

Eragrostis ~ 'emoloa, *Eragrostis variabilis*

p. 166–167

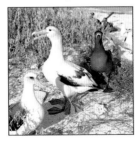

PHOTOGRAPH: Sand Island, Midway Atoll, 28 February 2003
RANGE: Hawaiian Archipelago
HABITAT: sand dunes, grasslands, and open sites in dry forest, from sea level to 1,130 m elevation
SCALE: 10 cm section: plant up to 1 m tall

Eragrostis variabilis, a robust bunchgrass with numerous seed heads lifted on tall stems, grows on Kure, Midway (Sand Island), and Pearl and Hermes Atolls; Lisianski, Laysan, and Nihoa Islands; and all of the main Hawaiian Islands. Found nowhere else in the world, *E. variabilis* is one of 39 grass species (family Poaceae) endemic to the Hawaiian Archipelago. Possibly more than any other plant in the Northwestern Hawaiian Islands, *E. variabilis* provides birds, insects, and mollusks with nesting material, food, and shelter. On Laysan Island, the endangered, endemic Laysan finch and Laysan duck nest almost exclusively in *E. variabilis* tussocks, and the finch commonly forages on *E. variabilis* seeds. On Nihoa Island, the endangered, endemic *Endodontid* and *Achatinellid* snails find refuge at the base of *E. variabilis* leaf blades. Wherever *E. variabilis* grows in the NWHI, seabirds incorporate the plant into the terrestrial portion of their lives. Both black-footed and Laysan albatrosses (*Phoebastria* sp.) seek asylum from the unrelenting sun in the shadows cast by tall bunches of *E. variabilis*, and brown noddies stomp down secure nest platforms in the plant's center. Gray-backed and sooty tern chicks (*Sterna* sp.) seek shelter from the sun and hide from predatory frigatebirds (*Fregata* sp.) in *E. variabilis* tussocks, while Bonin petrels (*Pterodroma hypoleuca*) and wedge-tailed shearwaters (*Puffinus pacificus*) dig burrows in sandy soil that is stabilized by *E. variabilis* roots. Even Hawaiian monk seals (*Monachus schauinslandi*) enjoy the shade and windbreak provided by *E. variabilis*.—A.W.

Short-tailed Albatross, *Diomedia albatrus*

p. 169

PHOTOGRAPH: Eastern Island, Midway Atoll, 8 November 2004
RANGE: North Pacific
HABITAT: pelagic; breeds on Northwestern Hawaiian Islands and small islands offshore from Mexico and Japan
SCALE: wingspan 208 cm; mass 2.5—3.3 kg

Largest of the three North Pacific albatross species, the short-tailed albatross is also the least common. As the sun rose on the 20th century, feather hunters scoured island after island to supply the demands of a world hungry for fashionable hats, leaving millions of dead, plucked birds behind on silent beaches. Entire colonies were wiped out and several species neared extinction. Prior to the feather-hunting holocaust, the short-tailed albatross's breeding range encompassed nearly all the islands in the western North Pacific; by 1932, Torishima Island supported the only remaining colony. Despite the Japanese government's efforts to protect the albatrosses, the island's human inhabitants turned the colony over to the feather hunters—and Torishima's short-tailed albatrosses were no more. Then, in 1939 and 1941, Torishima's volcano erupted, destroying the village and filling in the island's only anchorage. A few immature and nonbreeding adult short-tailed albatrosses, at sea during the hunters' final raid, returned and began a new colony. Today, approximately 1,800 short-tailed albatrosses breed on Torishima Island and Minami Ko-jima. Now rigorously protected in their breeding grounds, short-tailed albatrosses face the same entanglement threats posed to Laysan and black-footed albatrosses by longline and high-seas driftnet fisheries. Short-tails begin their reproductive season in the fall; first-time breeders and hopefuls dance to impress each other, and established pairs reaffirm their bond through reciprocal preening. Females lay one large egg which is incubated for 65 days; chicks fledge after five months of parental care. Since 1941, up to three short-tailed albatrosses have paid annual visits to Midway Atoll, though the birds have not successfully nested there.—A.W.

Midway Sea Slug, *Hypselodoris insulana*

p. 170

PHOTOGRAPH: Sand Island field studio, Midway Atoll, 8 March 2004
RANGE: endemic
HABITAT: shallow lagoon waters
SCALE: 3 cm long

In all the world, these small, brightly patterned creatures reside only in the far northern end of the NWHI, occurring solely on Midway and Kure Atolls. The Midway sea slug was first officially described in a scientific publication in 1999. A much smaller sea slug with similar coloration had been discovered a century earlier near the southern end of the archipelago, occurring only on Maui and O'ahu. This sea slug is a nudibranch, which means "naked gills" in Latin. In this species the gills have orange coloring with white feathery structures arranged in the shape of a sliced orange. Resembling the horns on a snail, the two projections on the slug's head, called rhinophores, can detect certain chemical signals. Like other sea slugs, Midway sea slugs are hermaphrodites with both male and female organs in each slug. Mating involves mutual swapping of sperm, whereupon each nudibranch lays a ribbon of eggs held together with mucus, often in a coiled rosette. The bright magenta stripes and orange accents are known as conspicuous coloration, warning potential predators that this animal is toxic. Nudibranchs gain the toxins from their diet, which includes a range of poisonous or distasteful animals such as tunicates, sponges, bryozoans, and hydroids. This defense works well and few animals attempt to eat brightly colored nudibranchs. An inexperienced, curious fish such as a juvenile wrasse may take a bite of nudibranch, but immediately and forcefully spits it out. Thus the lesson is learned, and the nudibranch regenerates its lost tissue.—S.H.

Golf Ball Sponge ~ hu'akai, 'ūpī, Family Tetillidae

p. 170

PHOTOGRAPH: Sand Island field studio, Midway Atoll, 17 March 2004
RANGE: temperate to tropical regions of the oceans
HABITAT: harbors, bays, and open reefs
SCALE: body 2 cm diameter

While Susan and David were working on Midway, the manager of the USFWS refuge brought this strange orange ball to the photographer's field studio. No one was even sure what it was—animal or vegetable? It was just a smooth lump at that point. They placed it in an aquarium and the next morning were surprised to see sticky tentacles radiating from its body. The long, stringy hairs grew overnight, and the creature changed shape several more times after that. Not an alien or life form from outer space, this orange ball with wild hair is a living sponge. This kind of sponge can re-invent itself on a daily basis, a trick made possible by the simplicity of being a sponge. Sponges are considered one of the oldest and simplest animals—the "pore bearers," Phylum *Porifera*. Only single-celled animals are considered more basic. Sponges claim multi-cellular status, but unlike more complex creatures, their cells are not specialized. Sponges have no organs—no stomach, brain, eyes, or mouth. Scott Godwin, invertebrate biologist at the Bishop Museum in Honolulu, has come across similar sponges while inspecting pier pilings in Pearl Harbor for introduced species. He guesses that this mysterious sponge is most likely a golf ball or puff-ball sponge (Family Tetillidae), probably a species of *Craniella*.—S.H.

Spanish Dancer, *Hexabranchus sanguineus*

p. 171

PHOTOGRAPH: Sand Island field studio, Midway Atoll, 12 March 2004
RANGE: Indo-Pacific and tropical Atlantic
HABITAT: shallow reef habitats, especially with caves and ledges
SCALE: 11 cm across

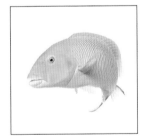

Fluttering like the red dress for which it is named, the Spanish dancer is one of the few accomplished swimmers among nudibranchs. Largest and most visible of Hawai'i's nudibranchs, the Spanish dancer swims in the water above the reef without any trace of shyness. Its confidence comes from being infused with sponge-based toxins acquired while feeding. The nudibranch attaches red or pink ribbons of eggs to the reef in a coil that resembles a rose. The egg masses are also infused with protective toxins to keep them from becoming someone's snack. Spanish dancers live in many of the world's warm oceans. The most common color pattern in the Indo-Pacific is a streaky red and white (like the animal in the portrait), but dancers range from light pink to dark red, and Hawai'i has a rare yellow form. Dark-red rhinophores (sensory tentacles) protrude from the head, and the mouth has unusual oral tentacles with finger-like projections. The hind end of the nudibranch has six frilly gills, which retract into separate slots rather than one big gill pocket, as they do in most other dorid nudibranchs. The Spanish dancer travels across the reef on foot most of the time, and only swims with a dramatic dancing motion when disturbed. The animal flashes the bright-red and white warning colors that lie under the hem of the darker mantle, a trait called aposematic coloration. The species name, *sanguineus*, comes from the Latin for "blood."—S.H.

Blacktail Wrasse ~ hinālea lauhine, *Thalassoma ballieui*

p. 173

PHOTOGRAPH: Sand Island field studio, Midway Atoll, 28 March 2004
RANGE: endemic
HABITAT: lagoons and seaward reefs
SCALE: 25 cm total length

The blacktail wrasse is endemic to Hawai'i, and while not uncommon on the reefs in the main islands, this species is especially abundant in the NWHI. The individual in the portrait is an initial-phase blacktail wrasse, either a female or a natural-born male. Like other wrasses, this species has supermales (also called terminal-phase fish) that start out life as females. The supermale blacktail wrasse is substantially larger and has more a complicated color pattern—gray head, yellow body, and black band across the tail. Both females and males dine on the same prey, namely sea urchins, crabs, and small fishes. The strong fleshy lips and hard ridges inside the mouth are used to pluck prey from their hiding places on the reef and then macerate them into digestible pieces. The pupils in this fish's eyes are teardrop-shaped rather than round, an adaptation that enhances the fish's perception of depth of field. The teardrop-shaped pupil increases the accuracy of attempts to grab prey, a quality that is even more pronounced in ambush predators such as groupers, hawkfish, and snappers. While cruising the reef, the blacktail wrasse peers into nooks and crannies with its mobile head, or swivels its eyes to look upward for potential predators. This fish does not have any specialized defense mechanisms- no toxins, sharp spines, or other elaborate devices. If pursued, the wrasse simply swims as fast as it can and tries to duck into a hole. The Hawaiians call it hinālea lauhine—wrasse that acts like or dresses like an old woman.—S.H.

Saddle Wrasse ~ hinālea lauwili, *Thalassoma duperreyi*

p. 174

PHOTOGRAPH: Sand Island field studio, Midway Atoll, 29 March 2004
RANGE: Hawai'i and Johnston Atoll
HABITAT: clear lagoons and seaward reefs
SCALE: to 18 cm total length

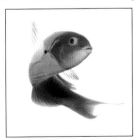

The saddle wrasse occurs nowhere in the world but the waters around Hawai'i and Johnston Atoll, where it is one of the most abundant fish on the reef. Like most wrasses, this species mates on a daily basis, year-round. It also has the thickened lips and cigar-shaped body typical of its family, as well as the ability to change sex. The fish in this portrait is a terminal-phase male that was once a female. Initial-phase wrasses include females and natural-born males; they're generally smaller and have a completely different color pattern than the terminal phase. This fish would have started out with a black back, yellow belly, and white stripe along its midline. For the first part of its life, the wrasse dedicates its energy to growth and the production of eggs. If a female survives long enough, she eventually earns the opportunity to join "the big boys." During the transition from initial phase to terminal, the fish invests all of its energy into growth and the physiological changes required to morph into a male. The terminal-phase saddle wrasse makes a handsome fish, with a blue-green head, orange saddle, and green body. These freshly minted males mate one-on-one with successive females. Alternatively, the smaller, drab natural-born males mate with females in group spawning events, where fish dart up into the water column together to release a cloud of eggs and sperm. Hawaiians called this fish hinālea (wrasse) lauwili (leaf that twists and turns).—S.H.

Surge Wrasse ~ hou, *Thalassoma purpureum*

p. 175

PHOTOGRAPH: Sand Island field studio, Midway Atoll, 28 March 2004

RANGE: Indo-Pacific

HABITAT: surge zone and shallow reef flats

SCALE: 16 cm total length

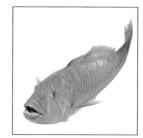

When a large, brightly colored fish darts past your feet as you wade through the shallows in Hawai'i, it is usually a surge wrasse. The surge wrasse spends its day swimming around the reef, scrounging for edibles and trying to avoid the large number of predators that consider it edible in its own right. The reefs of the NWHI abound with jacks, groupers, snappers, and sharks that enjoy munching on juicy, tender wrasses like this one. The surge wrasse does not have any special defenses, other than its preferred habitat: It spends much of its time in shallow water, often barely deep enough for it to swim upright, which by design excludes predatory fish larger than itself. The wrasse uses its broad mouth and blunt teeth to grab and chew small invertebrates such as crabs, sea urchins, brittle stars, mollusks, and segmented worms. The fish in the photograph is a terminal-phase surge wrasse, also called a supermale. A few supermales usually "supervise" a loose aggregation of females (initial-phase wrasses) as they spread across a large area of the reef flat to feed. Every day in the late afternoon, the surge wrasses travel to slighter deeper water and the males mate with as many of the females as possible. Swimming up into the water column repeatedly puts the male at greater risk of being eaten by a predator, but the payoff is worth it. Wrasses are prolific spawners, and each day the supermale cheats death represents the chance to fertilize tens of thousands of eggs.—S.H.

Blue-black Urchin ~ wana, *Echinothrix diadema*

p. 176

PHOTOGRAPH: Sand Island field studio, Midway Atoll, 11 March 2004

RANGE: Indo-Pacific

HABITAT: reef flats and shallow reef slopes

SCALE: 15 cm including spines

Needle-sharp hollow spines radiate from this urchin's body, imbued with a deep cobalt blue and serving as an effective defense against any animal equipped with nerves to feel pain. The blue-black urchin is known in Hawai'i as wana (pronounced "vah-nuh")—a word uttered with a certain respect, since most locals have experienced firsthand the special pain of urchin spines broken off in their skin, coloring it purple for several weeks until the fragments dissolve. The shorter of these brittle spines add venom to their arsenal. Common throughout much of the Indo-Pacific, including Hawai'i, this species crawls around wave-swept reef flats and shallow reef slopes, scavenging for natural edible reef garbage such as molted lobster shells. The urchin reacts to potential threats by waving its long, sharp spines in an agitated fashion; if touched, it will orient its spines toward the trespasser. A few creative tough-skinned fishes are able to prey on wana—mainly triggerfish, with their rough, armor-like scales and eyes set far back from their beak-shaped mouth. Even a triggerfish prefers not to tackle a spiny urchin head-on: The fish squirts water at the urchin in an attempt to flip it over and expose its unprotected belly. As in many other coastal cultures, Hawaiians eat the gonads of urchins. The bright orange, grainy substance is cooked, dried, mixed into a sauce, or simply enjoyed raw.—S.H.

Banded Coral Shrimp ~ 'ōpae-ohuna, *Stenopus hispidus*

p. 177

PHOTOGRAPH: Sand Island field studio, Midway Atoll, 16 March 2004

RANGE: worldwide in warm oceans

HABITAT: tide pools to 30+ m in habitats with coral

SCALE: view 5.5 cm

This animal's talents include casting out demons (for Hawaiians) and removing ecto-parasites (for reef fishes). The banded coral shrimp, called 'ōpae-ohuna or "small shrimp" by Hawaiians, spends much of its time perched on the underside of a coral colony, the roof of a cave, or under a small ledge. The extravagantly long white antennae advertise its presence to fish that could use a good cleaning. Lacking hands or a flexible neck, fish have no way of ridding themselves of ecto-parasites, and rely on other small fish such as cleaner wrasses and small shrimp to remove the pesky blood-sucking, hitch-hiking critters. The cleaner, of course, benefits from the protein acquired by eating the parasites and dead skin, though it has the tricky job of avoiding being eaten itself while crawling around a large fish. Fish generally assume a harmless posture to communicate their good intensions—head down, body tilted slightly to one side, tail diagonal, and mouth open (for dental hygiene). The banded coral shrimp almost always live in pairs. Mated pairs feed each other, guard one another during the vulnerable time of molting, and solidify their bond with an elaborate courtship dance before mating. The female carries the eggs on her abdomen under special appendages called swimmerets. Under duress, the shrimp drops one or both of its red-and-white-striped arms and scuttles backward into its cave. The limbs grow back during the shrimp's next molt.—S.H.

Calf Cowry ~ leho, *Cypraea vitellus*

p. 178

PHOTOGRAPH: Sand Island field studio, Midway Atoll, 16 March 2004

RANGE: Indo-Pacific

HABITAT: intertidal and shallow reef among algae and under coral slabs

SCALE: 5 cm tall

The calf cowry, once common in the Hawaiian Islands, is rare these days except in the NWHI, where it appears with relative abundance. This cowry has a fawn-brown shell with round, milky spots of various sizes, and a mantle of dark gray with white papillae that look like tiny boabab trees. As the snail crawls forward on its foot, it produces mucus to decrease friction. The slippery mucus helps the snail slide across the reef with speed and efficiency, and without tearing up its soft body. The branched papillae (skin projections) on the mantle are thought to help with camouflage as well as with the absorption of oxygen from the water. When it encounters food such as algae or sessile reef invertebrates, the cowry crawls onto the edible item and starts working on it with its radula, which has grinding teeth. Beyond that, the cowry's main job is to stay hidden. The Hawaiians had a saying, "Moe a lehi—lie still like a cowry," if you do not want to be noticed. The Hawaiians ate cowries and used the shells to catch octopus, which also are very fond of cowries. Another saying, in reference to old men who stared at young girls, stated "The octopus notices the little cowries." Hawaiians also used the shell in food preparation, wielding the large flat-toothed side as a scraper to clean taro, a starchy tuber that was a staple in their diet.—S.H.

Alison's Cowry ~ leho, *Cypraea alisonae*

p. 179

PHOTOGRAPH: Sand Island field studio, Midway Atoll, 14 March 2004

RANGE: Indo-Pacific

HABITAT: shallow reef flats and rock walls

SCALE: 4 cm long

The translucent red-orange mantle of Alison's cowry gives it a lava-like glow. The gorgeous mantle has widely spaced papillae (skin projections) and covers a pale shell flecked with brown marks, including a squarish mark in the center. This nocturnal animal lives within a small home-range on the reef with its mate, venturing out mostly at night and hiding during the day in a crevice or between dead coral branches. If attacked, this cowry drops the rear part of its foot to escape, regenerating it later. Mating involves internal fertilization, accomplished by a rudimentary embrace where the two cowries clutch each other and sperm is transferred from the male to the female. The female lays a cluster of eggs on the reef floor, and dutifully covers them with her foot until they hatch, up to a month later. The young emerge as small, swimming larvae, called veligers, that join the plankton for a time and then settle out on a reef or rocky area. As a juvenile, the cowry looks more like a typical snail with a spiral shell. Once the final whorl is complete, giving it the rounded hump of a shell with a flat foot and a toothed opening, the cowry has achieved adult status and will grow very little after that. This cowry is named for Dr. Alison Kay, a professor at the University of Hawai'i who spent many years on the scientific study of cowries and other marine snails. Leho, the Hawaiian word for cowries, means "covetous."—S.H.

Bubble Algae (with a red alga), Sea Pearl ~ limu, *Ventricaria ventricosa* (with *Centroceras clavulatum*) p. 180

PHOTOGRAPH: Sand Island field studio, Midway Atoll, 29 March 2004
RANGE: tropical oceans worldwide
HABITAT: hard bottom reef habitats
SCALE: bubble 2 cm

This green sphere with a reflective silver sheen is *Ventricaria ventricosa* (Division Chlorophyta), commonly called sea pearl or bubble algae. These green baubles are found throughout the world's warm oceans, off the coast of Africa and within the Caribbean, and also in much of the Indo-Pacific region including Hawai'i. The bubble alga in the portrait was growing on a shallow reef flat in the lagoon at Midway Atoll. Each bubble alga is a single big cell, and biologists assumed the center was filled with a simple sack of fluid called a vacuole. Micro-technology has recently allowed scientists to peek inside the bubble and they now describe the vacuole as more like a sponge than a balloon, completely interlaced with the rest of the cell. If fractured or wounded, the material inside the mega-cell paritions into hundreds of subunits, each forming a cell wall over the course of a couple of hours. To quote an algal biologist in Austalia, "The organism has an astonishing capacity for self-regeneration." The nest around the base is a species of filamentous red algae, *Centroceras clavulatum*, which has rows of microscopic spikes and claw-tipped branches. These features probably function as anti-herbivore devices among the reef microcosms. Despite the peaceful egg-in-a-nest facade, the two algae in the portrait are battling for space on the reef floor and unshaded access to sunlight. The red alga is creeping up the sides of the green sphere, which stays ahead of the game by replicating itself and has already budded two small bubbles.—S.H.

Red Pencil Urchin ~ hā'uke'uke 'ula'ula, pūnohu, *Heterocentrotus mammillatus* p. 181

PHOTOGRAPH: Sand Island field studio, Midway Atoll, 22 March 2004
RANGE: Indo-Pacific, but abundant only in Hawai'i
HABITAT: shallow, complex reef habitats with clear water
SCALE: 15 cm across, including spines

Gorgeous deep-red spines adorn the red pencil urchin, which keeps its spines clean and shiny with a thin layer of live tissue. The Hawaiians carved designs into the beach-cast spines, and used them like pencils. Pūnohu, an old Hawaiian name for the animal, referred to a rainbow lying close to the Earth. The more common name, hā'uke'uke 'ula'ula, means "red, red, thick-spined urchin." The red pencil urchin spends its day tucked into a secure corner of the reef. If disturbed, the urchin wedges its spines firmly into the nooks and crannies around it, making it virtually impossible to pry free. This species has three types of spines—long spines that are triangular in cross-section, medium-length flattened spines, and short stubby spines that cover the rest of the globe-shaped shell (called a test). Stretchy, flexible tube feet protrude from the underside of the animal. The round mouth of an urchin has five small, sharp, triangular teeth, visible in the photograph. The teeth are controlled by a sophisticated apparatus called Aristotle's lantern; it includes 60 muscles and a delicate lantern-like bony structure. A devout herbivore, the red pencil urchin uses its teeth to scrape algae from the reef floor. It ventures out to feed at night when most of the wrasses, triggerfish, and other reef fish that would harass or eat it are in hiding, avoiding their own demise.—S.H.

Blue Rice Coral, *Montipora* cf. *turgescens* p. 182–183

PHOTOGRAPH: Sand Island field studio, Midway Atoll, 22 July 2003
RANGE: endemic
HABITAT: shallow areas with good water flow
SCALE: 2 cm section

Patches of bright color give away the presence of the blue rice coral. This coral is similar to *M. turgescens* but does not match exactly, and is probably an endemic species found only in Hawai'i. Some of the stunning clear-water habitats in the NWHI are thickly carpeted in shades of rice coral ranging from sky blue and pale violet to a deep bluish purple that approaches indigo. The unusual color comes from a combination of coral and algal pigments; the coral pigments may protect the tissue from sunburn, while the algal pigments allow the symbiotic algae living in the coral tissue to harness the energy of sunlight and make food. Like other reef builders, rice coral is colonial, with one coral plate created by hundreds to thousands of polyps. Each of the tiny flower-shaped structures in this photograph is an individual polyp, with stinging tentacles surrounding a mouth. The polyp has a simple gut, shaped like a sack with one opening. The foot of the polyp merges with the flesh of its neighbors, allowing a limited amount of nutrient sharing. Overexposure to sun is a definite issue for this animal. High levels of ultraviolet radiation typify the clear, shallow habitats where this coral grows. Vast fields of rice coral bleached, or lost their zooxanthellae and related color, in the NWHI in 2002 in response to water that was warmer than normal. Most of the bleached rice coral died. Fortunately, a few colonies tucked into slightly deeper shady spots survived and have already begun to re-seed the reef.—S.H.

Lobe Coral ~ pōhaku puna, *Porites lobata* p. 184

PHOTOGRAPH: Sand Island field studio, Midway Atoll, 22 July 2003
RANGE: Indo-Pacific and eastern Pacific
HABITAT: most often 3 to 15 m; as deep as 70 m
SCALE: 2 cm section

Buttery yellow to spring-green mounds of lobe coral feature prominently in the underwater landscape of the NWHI. Lobe coral is a major reef builder in much of the tropical Pacific, but plays an especially important role in the Hawaiian Archipelago, along with an endemic sibling, Evermann's coral (*P. evermanni*). Hawai'i has relatively few coral species compared to the rest of the highly diverse Indo-Pacific, although a quarter of them are endemic. Our reefs are a long "uphill" swim for coral spawn traveling as plankton on ocean currents; only the hardy and lucky ones make it all the way out to Hawai'i, sometimes evolving into new species. The tiny coral polyps visible in the photograph are the architects and stonemasons that lay down layer on layer of calcium carbonate that is first a coral head, and eventually forms the reef itself. In turbulent habitats, lobe coral often lays down a low-profile crust instead of building itself up into a mound. In calmer waters the coral makes rounded heads and mounds of all sizes. Neva Shoals has unusual reef structures shaped like tall sandcastle spires, formed by generations of lobe coral laying down layer after layer of white cement. The quiet backreef of Pearl and Hermes Atoll has huge, old heads of lobe coral in shallow water. A few of these grandfather coral heads have hollowed-out centers that are big enough for a person to swim in. These "micro-atolls" are well populated with small, colorful fishes that enjoy the fortress effect that keeps large predators out (at least those unable to climb over the top).—S.H.

Nicobar Triton ~ naunau, *Cymatium nicobarium* p. 185

PHOTOGRAPH: Sand Island field studio, Midway Atoll, 22 March 2004
RANGE: Indo-Pacific and Atlantic Oceans, and Red Sea
HABITAT: reef habitats, especially shallow areas
SCALE: 9 cm long

The spotted creature stretching for the floor is a Nicobar triton, a soft snail that forms a burly shell on its back as a passive but effective defense mechanism. Predators must have special tools or techniques to breach the thick fortress of a triton's shell. Octopus can drill into some shells, although they tend to prefer the thinner-shelled cowries (less work, same tender boneless meat). Carnivorous snails hunt snails as well—it's a snail-eat-snail world out there! The Nicobar triton is well equipped for the job of predator: Like its bigger cousin, Triton's trumpet, this snail moves fast, at least in the world of snails. It chases down its prey, even the textile cone snail, which is also a fearsome snail predator. Rather than take the time and effort to drill through the prey's shell, the Nicobar triton attacks the soft part, anaesthetizing its victim with venomous saliva. Once the prey is debilitated, the triton consumes it. The outer surface of this snail's shell, referred to as the periostracum, has a covering of coarse hairs, a common trait of tritons, as is the spotted body and the colorful white-striped lip of the shell. The triton's Hawaiian name, naunau, means "to munch one's words," or "mumble." The English common name comes from Nicobar Island in the West Indies, presumably where a biologist first collected this species.—S.H.

Simple Collector Crab ~ kumulīpoa, pāpaʻi limu, *Simocarcinus simplex*

p. 186

PHOTOGRAPH: Sand Island field studio, Midway Atoll, 14 March 2004
RANGE: Indo-Pacific
HABITAT: near shore habitats with algae
SCALE: 3 cm tall

"Excuse me, sir, but you seem to have a bit of algae stuck to your head," you might want to say to this odd-looking crab. The simple collector crab has small hooks that secure scraps of algae, sponge, soft coral and other adornment to its shell. The crab applies these decorative items as camouflage and perhaps also to impress the girls. Males seem especially fond of sporting a large tuft of algae or other flotsam on their rostrum. Collector crabs of different genders have slightly different shapes. Female collector crabs are more oval while males have a more pronounced teardrop shape and slightly larger claws. This slow-moving crab hides in the algae near shore and decorates itself with the same algae. Hawaiians call this crab pāpaʻi limu—seaweed crab. Another name for the small crab is kumulīpoa; līpoa indicates a type of seaweed while kumu means "master" or "teacher." Collector crabs are in the Family Majidae, or spider crabs, which have a triangular carapace (body shell), pointy nose, and dramatically long, slender legs. Hawaiʻi has 20 species of spider crabs, most of which are small like this simple collector crab. Snow crabs and tanner crabs, cold-water members of the same family harvested in the seafood industry, can weigh up to five pounds and have an arm span of three feet.—S.H.

Shaggy Sponge Crab, *Cryptodromiopsis plumosa*

p. 187

PHOTOGRAPH: Sand Island field studio, Midway Atoll, 11 March 2004
RANGE: Hawaiʻi, Seychelles, and New Caledonia
HABITAT: coral reef habitats
SCALE: 4 cm across

The shaggy sponge crab is paranoid about being seen. This slow-moving crab comes out only at night, and always wears a sponge disguise or some other bulky costume, such as a rubber beach slipper. High-quality thick sponge, like the orange one in this portrait, grows mostly in areas with relatively calm water. The crab finds a sponge that it likes, cuts its choice from the reef, and then uses its white-tipped claws to sculpt a custom fit for its carapace (the body shell of the crab). The crab then does a few strenuous gymnastics, including back rolls and somersaults if necessary, to get the awkward item up onto its back. The last two pairs of legs grip the sponge and hold it in place with special fine pincers that work like hatpins. Once it has outfitted itself with a suitable, comfortable sponge, the crab is loathe to lose it and will go to great lengths to retrieve a covering that is knocked off. The sponge offers dual protection to the crab: impeccable camouflage and a noxious taste. Only a few reef animals are able to stomach the chemical-laden sponge as food. Most fish find sponges unpalatable and distasteful—nothing like crabs, which are generally considered tasty by fish and humans alike. Along with its larger cousin, the sleepy sponge crab (*Dromia dromia*), this crab was probably considered inedible by the Hawaiians, who called the larger sponge crab makua-o-ka-līpoa.—S.H.

Turbinaria ~ limu, *Turbinaria ornata*

p. 188

PHOTOGRAPH: Sand Island field studio, Midway Atoll, 21 July 2003
RANGE: Indo-Pacific
HABITAT: rocky intertidal to 30+ m in a variety of reef habitats
SCALE: 5.5 cm section; to 30 cm tall

"Spiky little ball of pain!" is what Kim Page calls this algae. As a graduate student at the University of Hawaiʻi studying algae in the NWHI, she sometimes has to collect *Turbinaria ornata* and reports that it is prickly enough to cut her hand. A tough, scrappy plant that occupies shallow as well as deep parts of the reef, *Turbinaria* protects itself from herbivores with thick leathery skin, prickly bumps, sharp edges, and other traits that make it unpleasant to eat. Ironically, these defenses work well enough against herbivores but do not protect *Turbinaria* from epiphytes, the tiny filamentous algae that grow on top of a larger alga, using its structure to elevate themselves off the bottom. While epiphytes do not consume their host plant, they block its access to sunlight and nutrients. Because it is often heavily epiphytized, *Turbinaria* can appear quite scruffy; the exceptionally clean individual in the portrait may be a relatively new plant. New upright plant structures grow from the low-lying, thin layers of algae that remain year after year, known as perennial crusts. The upright part can get ripped off by rough water, and stalks of *Turbinaria* often appear drifting freely in the water column. *Turbinaria ornata* is a brown alga related to *Sargassum*, another common genus of algae in the Hawaiian Islands.—S.H.

Octopus ~ heʻe, *Octopus* sp. (juvenile)

p. 189

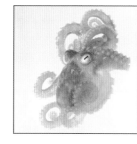

PHOTOGRAPH: Sand Island field studio, Midway Atoll, 21 March 2003
RANGE: worldwide distribution of genus
HABITAT: reef and other hard-bottom habitats with hiding places
SCALE: 4 cm long

If it avoids the hungry mouths on the reef, this small golden-orange octopus will grow into a full-sized adult over the course of a few months. Most of the octopus species in Hawaiʻi live only a year or two, and die soon after reproducing. Males and females live independently, and look alike except for one detail. The male has a special arm with modified suckers, called the hectocotylus arm, that he uses to transfer sperm into the female's mantle cavity. The young hatch from a cluster of eggs laid on the reef floor by the female; in some species, she carefully tends and guards them. The mother octopus cleans the eggs of algae and parasites and attempts to keep reef creatures from snacking on them. When the babies are ready to hatch she helps them by shaking and pulling away the skin of the egg sack. Once they emerge, the baby octopuses are on their own. Their first, urgent task is to find a place to hide, and their second task, less urgent but no less important, is to find things to eat. That's pretty much all there is to it until they grow big enough to have adult octopus concerns, like cracking open large cowries, finding a cave to make into an octopus lair, and making friends with an octopus of the opposite sex when the time is right.—S.H.

Christmas Wrasse ~ ʻawela, *Thalassoma trilobatum*

p. 190

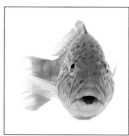

PHOTOGRAPH: Sand Island field studio, Midway Atoll, 29 March 2004
RANGE: Indo-Pacific
HABITAT: shallow exposed reef flats to 10 m depth
SCALE: 4 cm height; adults to 30 cm total length

This female wrasse will eventually turn into a male, if she is lucky. Many wrasses are sex changers, with fish starting out life as females. The fish in this portrait is a young Christmas wrasse; its coloration indicates an initial phase. Most initial-phase wrasses are female, though there are natural-born males in some species. The life of an initial-phase female is relatively simple—eat food to grow bigger, try not to get eaten, and squirt out some eggs for males to fertilize during the late afternoon spawning event. A few terminal-phase fish, which are sex-changing females that have become male, often "supervise" an area of the reef where initial-phase wrasses feed. The terminal-phase fish, also called a supermale, is bigger, flashier, and has a high-risk lifestyle compared to initial-phase fish. He mates with a number of females every afternoon, darting up into the water column at the edge of the reef with each one of them, a dangerous activity if there are predators around. The supermale spends a substantial amount of energy defending his group of females from other males, another distracting activity that puts him at greater risk of being nabbed by a predator. The supermale also expends energy exerting pressure on the initial-phase fish to stay female. The payoff, however, is substantial. The compensation for all this extra risk and energy expenditure is the chance to fertilize hundreds of thousands of eggs, a worthwhile investment in terms of kids and grandkids.—S.H.

Stocky Hawkfish ~ po'opa'a, *Cirrhitus pinnulatus*

p. 191

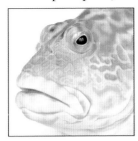

PHOTOGRAPH: Sand Island field studio, Midway Atoll, 28 March 2004
RANGE: Indo-Pacific
HABITAT: shallow (0 to 3 m) surge zones on reefs or rocky bottoms
SCALE: view 5.5 cm; adults to 30 cm total length

The stocky hawkfish hunkers down on a coral head or other firm perch and remains motionless against the turbulence of the water in the surge zone. As a lie-in-wait predator, it waits for a hapless fish to get washed in or wander by, disoriented, in the confusion of the rough water. The hawkfish holds completely still until the prey is within striking distance and then lunges forward like a bolt of fish lightning, sucking the prey into its generously sized mouth. The gold scrawled markings on the face of the fish and the checkerboard pattern on its sides help it blend in with the mottled golden-brown surface of the shallow reef. The fish's mobile eyes are close-set and have a teardrop-shaped pupil, increasing the precision of the fish's depth perception. These features give the hawkfish the ability to assess exactly how far away that juicy little fish is from its mouth. The hawkfish uses this information to execute its predatory lunge at just the right time and with just the right amount of thrust. The small, feathery appendages on the fish's face are called cirri. The scientific name, *Cirrhitus*, comes from the Latin word *cirrus*, which means "a curl of hair" or "fringe." Hawaiian's called this fish po'opa'a, meaning "hard head," and speared it for food.—S.H.

Threadfin Butterfly Fish ~ kikākapu, *Chaetodon auriga*

p. 192

PHOTOGRAPH: Sand Island field studio, Midway Atoll, 13 March 2004
RANGE: Indo-Pacific
HABITAT: variety of reef habitats from rich coral areas to rubble zones
SCALE: 4 cm high

Named for the delicate fin filament that streams out at the end of the dorsal fin in adults, the threadfin butterflyfish is found throughout the Indo-Pacific. This species has a thick black band on its head to disguise its real eyes, and a black spot near the tail that acts as a false eye. Both bits of trickery are meant to confuse potential predators about the butterflyfish's direction of travel—as in "I'm going this way—just kidding!"—causing the predator to lunge in the wrong direction. The crisscrossed lines, and the effect of yellow fading into white, serve to break up the outline of the fish; they also advertise the presence of a threadfin to other butterflyfish on a certain patch of reef. Like other butterflyfishes, the threadfin defends its territory. A monogamous pair occupies a section of reef that holds enough food resources to sustain them. Worms, coral polyps, hydroids, and certain kinds of algae all count as food for threadfin butterflyfish. The fish yanks, sucks, and chews these edible items from their attachment points to the reef floor. Like butterflyfish in general, the threadfin has tiny bristle-like teeth inside its small mouth; hence the family name Chaetodontidae, which means "bristle-toothed" in Latin. Hawaiians call this and several other butterfly-fishes kikākapu (kapu means "off-limits" or "taboo"), and considered it a food fish only in times of famine.—S.H.

Moorish Idol ~ kihikihi, *Zanclus cornutus*

p. 193

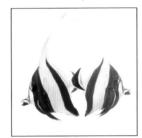

PHOTOGRAPH: Sand Island field studio, Midway Atoll, 16 March 2004
RANGE: Indo-Pacific and tropical eastern Pacific Ocean
HABITAT: areas with hard substrate
SCALE: 15 cm tall

Kihikihi, the Hawaiian name for this fish, means "zigzag," or "with many corners," probably referring to its angular shape and bended bands of color. The Moorish idol is a distinctive fish, unique enough to warrant its own family (Family Zanclidae). The bold black, white, and yellow color pattern serves an important purpose. Bands of contrasting colors—what biologists call disruptive coloration—mean that the fish has an outline not easily recognized by predators. The blocks of color help the fish show up as several disjunctive shapes rather than as a tasty fish form. While Moorish idols resemble butterflyfish, they are more closely related to surgeonfish and tangs. A head-on view of the fish shows its tang-like face well. Moorish idols feed by plucking sponges and other tidbits off the reef with their tubular snouts and long, bristle-like teeth. This social fish often swims in small groups. Moorish idols seem especially fond of caves and ledges in areas with strong currents, prime habitat for sponges. The extremely thin profile of the fish when it turns head-on allows it to remain stationary in a strong current. The fish are hardy in the wild (in captivity they are notoriously hard to feed and often starve), and can be seen swimming in dirty harbors, nipping the invertebrates from pilings, as well as on shallow, turbulent reef flats and down to 180 meters (600 feet) on clear-water reefs.—S.H.

naupaka kauhakai, *Scaevola sericea*

p. 194–195

PHOTOGRAPH: Green Island, Kure Atoll, 19 July 2004
RANGE: pantropical throughout the Pacific and Indian Oceans
HABITAT: coastal strand
SCALE: flower 4cm across

The genus name *Scaevola* comes from a Greek word, meaning "awkward" or "left-handed," which refers to the half-flowers found on all species within this group. The "awkwardness" of the *Scaevola* or naupaka flower echoes in a popular Hawaiian legend that underlines the genus's irregularity. In ancient times there lived a beautiful princess named Naupaka, who deeply loved a common man, Kaui. Marriages between people of royal birth and commoners were strictly forbidden; Naupaka and Kaui were grief struck by their predicament. The two traveled to all the islands in search of a solution to their problem, and finally sought guidance from a kahuna (holy man) who lived in a mountaintop heiau (temple). The kahuna suggested prayer, but could offer no immediate solution to their dilemma. So Naupaka and Kaui prayed, and it rained. After embracing for the last time, Naupaka took a flower from her ear, tearing it in half before giving it to Kaui. "The gods won't allow us to be together," she said. "Take half of this flower which represents all of my heart, and go live by the ocean. I will remain in the mountains." A nearby patch of naupaka plants felt the lovers' incredible sadness, and from that day on naupaka blooms only in half-flowers. Of the nine *Scaevola* species found in Hawaii, eight are endemic, *S. sericea* being the only nonendemic species. Naupaka kauhakai grows in coastal habitats on all islands in the Hawaiian Archipelago except Gardner Pinnacles, Nihoa, and Mokumanamana (Necker).—A.W.

Black Noddy ~ noio, *Anous minutus melangogenys*

p. 196

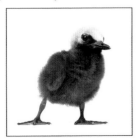

PHOTOGRAPH: Sand Island, Midway Atoll, 14 June 2003
RANGE: pantropical
HABITAT: pelagic; breeds on remote or offshore islands
SCALE: chick 8 cm tall; adult wingspan 65–72 cm; mass 110 g

Black Noddy breeding colonies are located on islands throughout the tropical reaches of the Pacific Ocean, Caribbean Sea, tropical Atlantic Ocean, and the northeastern Indian Ocean. While easily confused with their brown noddy cousins (*Anous stolidus*) when seen from afar, the black noddy's slighter build, darker plumage, whiter crown, and chattering call easily distinguish it from the brown when it's observed close at hand. The black noddy is the only member of the tern family (Sterninae) that builds a significant nest and, aside from the white tern (*Gygis alba*), is the only tree- and shrub-nesting bird in the group. These small, black terns are colonial and highly gregarious, nesting in dense colonies usually containing thousands of nesting pairs and non-breeding birds. They are opportunistic in selecting nest materials: leaves, seaweed (limu), feathers, bits of fishing net, and short lengths of monofilament line are commonly used. While working for the USFWS at Tern Island in French Frigate Shoals, I placed a shell necklace that a camp mate had given me on the sill of an open window, and noticed that it was gone the next day. Several weeks later I came across the missing necklace while conducting a black noddy nest survey near the field station barracks. Neatly woven into an active nest, the necklace looked better around the incubating black noddy than around my neck. Breeding pairs usually lay two single-egg clutches per year, the second reproductive effort occurring five months after the first.—A.W.

Wedge-tailed Shearwater ~ ʻuaʻu kani, *Puffinus pacificus chlororhynchus*

p. 197

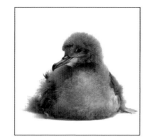

PHOTOGRAPH: Sand Island, Midway Atoll, 23 October 2003
RANGE: tropical and subtropical Pacific and Indian Oceans
HABITAT: pelagic; breeds on small offshore and remote islands
SCALE: sitting chick ~ 8 cm tall; adult wingspan 85 cm; mass 320-510 g

ʻUaʻu kani, the Hawaiian name for wedge-tailed shearwaters, means "moaning petrel," and moan they do. Breeding adults serenade potential mates, or reaffirm bonds to long-term partners with long, groaning vocalizations that fall somewhere between the cry of a human baby and that of an amorous tomcat. As burrow-nesting seabirds, wedge-tailed shearwaters spend most of their earthbound time digging and occupying deep tunnels—sometimes several meters long and over a meter deep. Compact sand or soil is loosened with the digger's bill and passed under its breast; the bird then scoops up the loose soil and uses its long, powerful legs to send it flying at a rate of two kicks per second. In habitat unsuited to digging, the wedge-tailed shearwater makes do with a depression under a low shrub or a crevice between two rocks. Breeding females lay a single white egg in a grass-and-feather-lined nest chamber that measures twice as wide as the 20-cm burrow entrance. A bird relieved from an incubation shift will often remain by its mate's side for some time. In Hawaiʻi, wedge-tailed shearwaters breed on all the islands of the northwestern archipelago, and also on Kauaʻi, Oʻahu, and offshore islets around Oʻahu and Maui. Early Hawaiians had a taste for wedge-tailed shearwater chicks, as did servicemen stationed on Midway during World War II.—A.W.

Red-tailed Tropicbird ~ koaʻe ula, *Phaethon rubricauda rothschildi*

p. 198–199

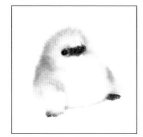

PHOTOGRAPH: Sand Island, Midway Atoll, 7 June 2003
RANGE: Pacific and Indian Oceans
HABITAT: pelagic; breeds on remote and offshore islands
SCALE: chick 8 cm tall; adult wingspan 80–102 cm; mass 650–780 g

Least common of the three members of the tropicbird genus, red-tails still enjoy a widespread breeding range that spans the tropical Pacific and Indian Oceans. These birds nest on all of the Northwestern Hawaiian Islands, and on Niʻihau, Kaʻula, Lānaʻi, Kahoʻolawe, and Manana Islands in the main Hawaiian chain. Tropicbirds distinguish themselves from other members of the Pelecaniformes order (pelicans, boobies, and frigatebirds) in several ways: They lay splotched rather than white eggs; their young are precotial rather than altricial; and adults feed regurgitated food to their young by sticking their bill down the chick's throat, instead of the opposite scenario. Red-tailed tropicbirds plunge-dive for small, shallow-swimming fish, which constitute 80 percent of their diet, and for squid, which make up the rest. Incapable of normal bipedal ambulation, all tropicbirds have short legs set toward the back of their bodies. Rather than walk, a tropicbird will use its squat legs to lunge forward. Red-tailed tropicbirds form monogamous pairs and, as part of their courting ritual, engage in a comical aerial display where two or more hopefuls fly slow backward loops around each other—picture a Ferris wheel loaded down with squawking seabirds going in reverse. Nest construction constitutes little more than a scrape under a bush or next to a clump of bunchgrass. Mates swap incubation responsibilities during the 44 days between egg laying and the hatching of downy chicks, who remain under the incubating adult for several days.—A.W.

Brown Booby ~ ʻa, *Sula leucogaster*

p. 200

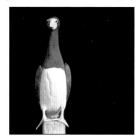

PHOTOGRAPH: Green Island, Kure Atoll, 4 August 2004
RANGE: pantropical
HABITAT: pelagic; breeds on remote and offshore islands
SCALE: 48 cm tall; wingspan 132 –155 cm; mass 1–1.5 kg

Pantropical in distribution throughout the Atlantic, Pacific, and Indian Oceans, the Caribbean and Red Seas, and seas north of Australia, brown boobies take their name from Spanish sailors who thought them clownish, or "bobo." Brown, red-footed (*Sula sula*), and masked (*Sula dactylatra*) boobies have similar diets—fish and squid—and often share roosting and breeding grounds; all are found in Hawaiʻi. While fully terrestrial in nesting behavior, brown boobies frequent elevated roosts, often standing wing to wing with their red-footed cousins. Aptly named *leucogaster*, or "white stomach" in Latin, adult brown boobies fit between red-footed and masked boobies in size and weight. Some 400 breeding pairs exist in colonies throughout the NWHI; they also occur on Lehua Island and Kaula Rock in the main Hawaiian Islands. When their habitat permits, browns construct formidable nests, often decorated with interwoven strands from derelict fishing nets. Both masked and brown boobies tend to lay a two-egg clutch in which the first egg appears several days before the second. Freshly hatched, pink and naked brown booby siblings battle for control of the nest; the evicted loser usually dies from exposure or predation. Occasionally nestlings strike an accord, forcing their parents to work double time feeding two bottomless stomachs. Unlike masked boobies, brown booby breeding pairs can successfully fledge two chicks from the same brood. Widespread habitat disturbance and introductions of terrestrial predators have forced brown boobies to restrict colonies to remote and offshore islands, with populations perhaps a tenth of what they were 200 years ago.—A.W.

Christmas Shearwater, *Puffinus nativitatis*

p. 207

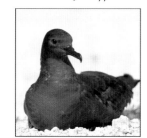

PHOTOGRAPH: Green Island, Kure Atoll, 13 July 2004
RANGE: tropical Pacific Ocean
HABITAT: pelagic; breeds on remote and offshore islands
SCALE: wingspan 71–81 cm; mass 350 g

This medium-sized, dark-chocolate-colored shearwater nests in small colonies throughout the tropical Pacific Ocean. All of the Northwestern Hawaiian Islands, except Mokumanamana and Gardner Pinnacles, serve as Christmas shearwater breeding grounds, and Kaʻula Rock, Lehua, and Moku Manu—offshore islands in the main Hawaiian chain—host small colonies as well. All told, 2,500–3,300 Christmas shearwater pairs nest in the Hawaiian Archipelago, with 60 percent breeding on Laysan Island; these small numbers merit a High Conservation Concern listing by the U.S. government. Christmas shearwaters build their nests in a casual fashion, using their feet to scrape shallow depressions underneath clumps of bunchgrass (*Eragrostis variabilis*), naupaka (*Scaevola sericea*), rock overhangs, and beach debris. On occasion, abandoned wedge-tailed shearwater (*Puffinus pacificus*) burrows get pressed into service by the smaller Christmas shearwater. Females lay one all-white egg in the spring, and go halves with males on incubation duty during the 52-day stretch between egg laying and hatching. In three months, precotial Christmas shearwater chicks transition from soot-colored, beaked cotton balls to slightly darker replicas of mom and dad—all the while being fed small squid, flying fish, and larval goatfish captured during their parents' pelagic foraging sprees. Christmas shearwaters rely to some degree on small fish driven to the surface by large marine predators like tuna and dolphins; they constitute one of many seabird species dependant on symbiotic foraging relationships, making non-sustainable commercial harvesting of predatory pelagic fish a concern.—A.W.

Calf Cone Snail ~ pupu ʻalā, *Conus vitulinus*

p.214

PHOTOGRAPH: Green Island field studio, Kure Atoll, 3 July 2004
RANGE: Indo-Pacific
HABITAT: reef flats and shallow slopes
SCALE: 5 cm tall

The calf cone is a relatively mild member of the 500-species-strong genus *Conus*. Cone snails are the hottest new thing in biomedical research these days because of the potent venoms they produce. The venoms block neurotransmitters in very specific ways, and show great promise in treating chronic pain and other nerve-related medical issues. The first drug produced from a synthetic version of a cone snail peptide is currently on its way through the FDA's approval process; reports claim it's more effective than morphine without being addictive. Ironically, the cone snails most sought after for biomedical research are often the species that can kill people. Fish-eating cone snails tend to have the strongest and most creative cocktail of toxins. The calf cone in the portrait hunts marine worms, which require less potent venom to subdue. In fish hunters and worm hunters alike, the snail spears its prey with a barbed harpoon-like spine that injects paralyzing agents. The snail rapidly retracts a thin filament attached to the harpoon, reeling the immobilized prey into its mouth, and engulfing it as a snake does a mouse. The banana-yellow body of this species is unique among Hawaiian cone snails, most of which are light to mottled brown. The Hawaiian words for cone snails are pupu ʻalā, for those with a mild sting, and pupu pōniuniu—dizzy snail—for those that are dangerous to handle.—A.W.

Microdictyon ~ limu, *Microdictyon setchellianum*

p. 215

PHOTOGRAPH: Green Island field studio, Kure Atoll, 6 July 2004
RANGE: Indo-Pacific
HABITAT: intertidal, subtidal, and deep water to 75 m
SCALE: 1.8 cm section

Vast fields of this gauzy green alga grow on the gently sloping reef pavement and rubble fields of the NWHI. *Microdictyon* means "tiny net" in Latin, and the individual in the photograph is *M. setchellianum*, one of two species found in Hawai'i. The other species, *M. umbilicatum*, has finer filaments and forms an even more delicate mesh with a slightly different branching pattern. Stellate branching, with branchlets intersecting in a star-like pattern, characterizes *Microdictyon*. The large, cylindrical cells, easily visible in the photograph, each contain thousands of nuclei and are linked together like a set of tinker toys. The thread-like building blocks are one cell thick, resulting in every cell having full access to water, nutrients, and sunlight. Although not as highly visible as tall fleshy algae, *Microdictyon* is very successful and ranks among the ten most prevalent reef algae in Hawai'i. Its bumpy, uneven mesh provides nursery habitat for lobsters and juvenile reef fishes, as well as a growing surface for other algae. The scrap of alga in the portrait is unusual in that it is unencumbered by a heavy load of epiphytes (algae that grow on top of other algae). The photographers found this small clean piece during their last day at Kure Atoll field station, after having searched for such a specimen for weeks.—S.H.

Coral close-up, *Leptastrea* sp.

p. 216

PHOTOGRAPH: Green Island field studio, Kure Atoll, 27 June 2004
RANGE: Indo-Pacific
HABITAT: wide variety of reef habitats
SCALE: 2 cm section

This portrait highlights some of the remarkable features of the living, reef-building animal that we call coral. A portion of this colony has died—the fleshy coral polyps no longer occupy their tiny calcium carbonate fortresses. Pink crustose coralline algae has already begun to colonize the hard surface vacated by the coral itself, as has what appears to be a red sponge. A miniscule worm tube is also visible in the upper right quadrant, and doubtless dozens of other opportunistic reef algae and invertebrates will colonize the surface as time goes on. The living portion of coral shows the coral polyps, with outstretched tentacles surrounding a small slit-shaped mouth. Each polyp is considered an individual of sorts. The flesh of one merges with that of its nearest neighbors, forming a colonial animal that lives in a cooperative manner. Each polyp catches its own food, as corals are micro-carnivores; in addition, it houses its own collection of symbiotic microscopic algae that produce sugar. The growth of the colony, however, is a group effort, with the mound expanding laterally and upward imperceptibly as the polyps lay down layer after thin layer of calcium carbonate. As there is space for new polyps, the existing polyps clone themselves. In fact, the entire colony consists of hundreds of clones of a single coral larva that found a bare spot to settle, attached itself, and then gradually grew into an entire city of genetically identical copies of itself.—S.H.

Lace Coral ~ 'ako'ako'a, ko'a, puna kea, *Pocillopora damicornis*

p. 217

PHOTOGRAPH: Green Island field studio, Kure Atoll, 13 August 2003
RANGE: Indo-Pacific and eastern Pacific
HABITAT: shallow protected reef flats
SCALE: 2 cm section

One of the daintier corals on the reef flat, lace coral nonetheless competes like a champ. This species is an extremely successful member of many tropical reefs throughout the Indian and Pacific Oceans, dominating shallow reefs flats in some ecosystems. In Hawai'i lace coral plays more of a decorative role, with small heads scattered throughout many of the shallow back-reef areas as well as clear-water habitats on semi-sheltered forereefs. Lace coral is closely related to the more robust cauliflower coral (*P. meandrina*), one of several major corals in the NWHI along with lobe coral (*Porites lobata*), finger coral (*P. compressa*), and rice coral (*Montipora capitata*). The colony in this photograph likely came from shallow water since it has somewhat thickened branches. In habitats with heavy wave action, lace coral forms stubby branches out of dense calcium carbonate. In calm protected waters the coral grows fine, delicate branches. The golden-brown body of the living coral animal is translucent to ensure the symbiotic algae living inside the coral tissue receive sunlight. The fleshy polyps each have a small, round buttressed hole to retreat into when a fearsome butterflyfish or other coralivore tries to nip off their soft juicy tentacles. In 1758, lace coral had the privilege of being the first reef coral described, and by Linnaeus himself—the famous naturalist who designed our current, worldwide scientific system identifying plants and animals with genus and species names. Curiously, Hawaiians named living organisms in their world with a remarkably similar system.—S.H.

Finger Coral ~ pōhaku puna, *Porites compressa*

p. 218

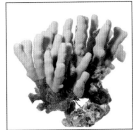

PHOTOGRAPH: Green Island field studio, Kure Atoll, 1 July 2004
RANGE: endemic
HABITAT: wave-protected areas to 50 m depth
SCALE: fingers 5 to 10 cm long

Extremely prolific, finger coral comprises whole sections of the reef in certain areas, such as the inner maze of Pearl and Hermes Atoll and the innermost patch reefs in the Kure lagoon and Kaneohe Bay on O'ahu. The delicate structure of the coral does best in protected waters, and even then finger coral donates large contributions to the reef rubble collection after major storm events. Nonetheless, this fast-growing endemic coral often takes over protected habitats, forming somewhat friable monoculture reefs that are long, snakelike hills of nothing but finger coral. Its thin-branched, porous structure allows it to grow more quickly than corals that lay down layer after layer of dense calcium carbonate in a solid mound. The growth form also makes it extremely breakable, and storm damage is obvious in many stands of finger coral. Whole slabs of it topple over and tumble down the reef slope into the sediment, but more often, finger tips break off and grow back again. Dense thickets of finger coral shelter small fish, shrimp, and other reef creatures. Finger coral is closely related to the yellowish-green lobe coral (*P. lobata*), the main difference being the growth form—finger coral makes tall, skinny mini-mounds, and lobe coral makes wide, hill-shaped megamounds. The Hawaiian name—pōhaku puna—means simply "stony," as in lithified, or mineralized, coral, though pōhaku also connotes being petrified, stubborn or staying long in one place.—S.H.

Keferstein's Sea Cucumber, *Polyplectana kefersteini*

p. 219

PHOTOGRAPH: Green Island field studio, Kure Atoll, 30 July 2003
RANGE: Indo-Pacific
HABITAT: reef flats and slopes, more common in 6+ m depth
SCALE: 7 cm long

This is a small Keferstein's sea cucumber, a species of thin-walled sea cucumber. These delicate sea cucumbers are mostly aqueous and will collapse if lifted out of the water. This stretchy animal can make itself long and skinny or short and stubby. It emerges mostly at night, sweeping up detritus and other small nutritious particles with the tentacles around its mouth. The bumpy body of the sea cucumber is outfitted with tiny hooks that help it stick to the reef, like velcro. If disturbed, the sea cucumber will contract to a fraction of its former length, pulling itself backwards as it shrinks. This species has a larger, pink- or orange-striped cousin called weli (*Opheodesoma spectabilis*) that is abundant on the patch reefs of Kaneohe Bay and the shallow flats of Pearl Harbor, on O'ahu. Good deeds if not good looks were attributed to this creature by a Hawaiian man named Kepelino, who wrote: "It dwells under water-worn rocks and drinks seawater until it is full. If it is tossed on dry land, the water runs out of it and it dies. It is so bad that it is never eaten but its deeds are very good. It sucks in all the filth in the sea until it fills its belly….Therefore it is an ugly creature but good in deeds. It cleans the filth under water that the lives of fishes and man may be spared."—S.H.

Lobster Larva ~ ula, *Panulirus* sp.

p. 219

PHOTOGRAPH: Green Island field studio, Kure Atoll, 30 July 2003
RANGE: tropical Pacific
HABITAT: warm ocean waters
SCALE: 3.5 cm long

This spiny lobster larva has survived for over a year in the open ocean, drifting with the plankton and changing body forms every few weeks, moving through a complex set of about 20 larval stages. It started out as a tiny fertilized egg on its mother's abdomen. The female lobster uses a special small claw on her last pair of walking legs to clean the eggs; with her paddle-shaped swimmerets, she fans them with oxygenated water. After about three weeks, the eggs darken to brown from their original translucent orange or red, and the young larvae hatch a week later. The larvae float away from their mother and become part of the plankton, which includes all the plants, animals, and single-celled organisms that drift with ocean currents. A lobster larva's main job is to catch and eat smaller plankton so it can grow bigger, all the while avoiding predators who would like to eat it. Whales, manta rays, whale sharks, the many coral reef fishes, corals, and invertebrates, are interested in eating the small lobster while it is part of the plankton. After 12 to 18 months of drifting around in the ocean, the larva finally turns into a miniature transparent lobster, as in the photograph, and settles on a coral reef or deep bank. It will take another 12 months to fully acquire the characteristics of a juvenile lobster, and another several years to reach sexual maturity, when it can produce its own young.—S.H.

Laurencia ~ limu, *Laurencia galtsoffii*

p. 220

PHOTOGRAPH: Green Island field studio, Kure Atoll, 5 August 2003
RANGE: Hawai'i and Indo-Pacific region
HABITAT: sand and coral bottoms, shallow areas to 10 m
SCALE: 1.8 cm long

The distinctive rusty-orange color of this alga immediately declares its presence to algal biologists in the NWHI. *Laurencia galtsoffii* has a unique combination of accessory pigments, giving it an unusual color for a red reef alga. While this species is relatively uncommon in the main Hawaiian Islands, it is among the most abundant of *Laurencia* species in the NWHI. This particular alga seems to grow especially well at the three northern atolls, Pearl and Hermes, Midway, and Kure, where it thrives on shallow reef flats and slopes. As it grows, the brownish-orange alga forms dense cushions a few centimeters thick, with each individual plant attached to the reef floor by a small holdfast. These low-lying thickets probably provide hiding places for small invertebrates and perhaps even juvenile fish. At the tips of the forked branches, extremely fine thread-like structures appear as a fuzzy yellow haze. The thin yellow hairs are extensions of the plant's internal cellular architecture, and possibly serve to increase its absorption of nutrients and trace minerals from the ocean water. The overall branching pattern also extends the plant's surface area, allowing it to fill a three-dimensional space with many small round branches. Hawaiians named another *Laurencia* (*L. dotyi*) limu līpe'epe'e—hidden—because of its creeping body form. Although its flavor and texture make it a savory addition to chopped fish, it traditionally was forbidden to hula dancers, in the belief that the secrets of the hula would be hidden from those who ate it.—S.H.

Leopard Blenny ~ pō'o kauila, *Exallias brevis*

p. 221

PHOTOGRAPH: Green Island field studio, Kure Atoll, 27 June 2004
RANGE: Indo-Pacific
HABITAT: reef habitats with live coral
SCALE: 4 cm tall

The leopard blenny uses its comblike teeth to pull, scrape, yank, suck, or otherwise remove coral polyps from their calcium carbonate fortresses. When it comes to eating, leopard blennies have a one-track mind: coral. They dine on table coral (*Acropora* sp.), lobe coral (*Porites lobata*), finger coral (*P. compressa*), and cauliflower coral (*Pocillopora meandrina*). Being an obligate coralivore makes the leopard blenny unusual, as most blennies are herbivores or scavengers. The fish's honeycomb pattern appears showy out of context, but provides excellent camouflage on the sun-mottled reef. A leopard blenny occupies a small crevice or hides between branches of coral, swimming with a wiggling motion between hiding places and feeding areas. The large eyes placed high on its face pivot to watch for predators, while the downturned mouth mows coral polyps. The blenny often perches on its pelvic and pectoral fins while it watches the world go by, a favorite pastime of this curious fish. Leopard blennies mate in pairs. The male clears space on a coral colony by overgrazing it, and the female lays a clutch of eggs. The male fertilizes the eggs and then guards the nest for several weeks until the young hatch. Hawaiians call this fish pō'o kauila—pō'o being the word for blenny and kauila for a native tree (*Colubrina oppositifolia*). This endemic hardwood was used to make mallets, poles, spears, and fishing tools. The wood is dark reddish-brown, a color perhaps similar to the male leopard blenny, which has a reddish face.—S.H.

Psammacora ~ 'ako'ako'a, *Psammacora stellata*

p. 222

PHOTOGRAPH: Green Island field studio, Kure Atoll, 27 June 2004
RANGE: tropical Pacific
HABITAT: shallow wave-washed reef flat
SCALE: view 5 cm

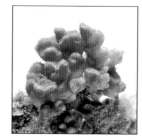

Psammacora (pronounced sam-o-cor-a) is a relatively uncommon coral with a distinct physical personality, not easily confused with other corals. This particular species has blunt molar-like branch tips and usually grows in unattached small clusters, often no bigger than the colony in the portrait. The fawn-brown-colored "fur" is extended tentacles of the living coral animal—a thin soft layer of tissue that is filled with a gel-like substance and has a slippery surface coated with protective mucus. The individual animals are relatively simple—each polyp has a mouth, a sack-shaped gut, and finger-like tentacles outfitted with stinging cells for capturing microscopic animals. Psammacora corals commonly extend their tentacles at night, when the zooplankton is generally thicker and many of the coral-eating butterflyfish are asleep. The golden brown color comes from symbiotic algae called zooxanthellae that live within the tissue of the coral. The coral hosts the algae, acting as their greenhouse, and the algae share the sugar they produce via photosynthesis. The arrangement is a win-win for both parties, and is often touted as an excellent example of symbiosis. The extra boost the coral receives by hosting zooxanthellae somehow helps the coral accrete a calcium carbonate skeleton more quickly. A lace-like pattern of grooves and small incisions in the hard skeleton gives the soft coral animal room to pull back into a protective home, while still allowing the algae access to sunlight.—S.H.

Goose barnacles & small crabs ~ pī'oe'oe, *Lepas anserifera* & *Planes* sp.

p. 223

PHOTOGRAPH: Green Island field studio, Kure Atoll, 28 July 2003
RANGE: worldwide
HABITAT: usually attached to drifting objects
SCALE: view 9 cm

Derelict fishing nets pose a real problem in the NWHI, arriving there on ocean gyres that bring them and other castaway human garbage from the North Pacific. The nets catch on the shallow reef, smothering it, ripping up corals, and entangling sea turtles, monk seals, and rays. For a few select marine creatures, however, the drifting nets are heaven on earth. Goose barnacles—the mariners of the barnacle world—travel the world's oceans on logs, nets, and anything else adrift in the high seas. Although they have a hinged shell that resembles that of a clam or other bivalve, barnacles are arthropods, related to insects, crabs, lobsters, and shrimp. Arthropods often have eyes, legs, and can opener-style mouth parts. The goose barnacle has none of these advanced features, but it is beautifully outfitted for filtering microscopic food particles from the water. The animal bends its rubbery neck to the best position for catching food, and combs the water with feather-like cirri. The delicately barbed appendages swipe through the water rhythmically during feeding, and get locked up safely inside the shell if the animal is disturbed or resting. As crustaceans, the two small crabs in the portrait are mobile cousins of the barnacles, possessing the eyes, legs, and other advanced features that barnacles lack. These small grapsid crabs (Family Grapsidae) have short claw-bearing arms and a flattened squarish carapace. Commonly found on flotsam throughout the world, they occasionally venture ashore, although they prefer life on the open sea.—S.H.

Imperial Nudibranch, *Risbeca imperialis*

p. 224

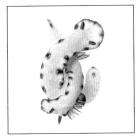

PHOTOGRAPH: Green Island field studio, Kure Atoll, 6 July 2004
RANGE: endemic (with a sister species in the Marshall Islands)
HABITAT: channels and reef flats
SCALE: 3 cm (height of posture pictured)

The imperial nudibranch much prefers the company of its own kind. A pair of nudibranchs will literally follow each other around the reef. The two animals are so intent on not losing track of one another that they practically hold hands when they're in a traveling mode. The behavior is known as trailing among sea slug biologists, and is a common trait of nudibranchs in the genus *Risbeca*. One sea slug leads and the other follows, with the second slug so hot on the tail of the first that they look like one long sea slug. The pair crawls in tandem from one feeding site to the next, searching out their preferred food—the blue-gray sponge (*Dysidea fragilis*). While usually in twosomes, nudibranches can be found in groups of three or four in areas where they occur in abundance. It would be nice to think the pairs are mates who stay together out of affection and attachment, but it may be simpler than that. A biologist who managed to identify individuals based on their unique spotting patterns (using the dark spots along the margin) observed a pair of trailing nudibranchs intersect another such pair. As their paths crossed and the four nudibranchs got all mixed up, the pairs swapped mates, intentionally or unintentionally, and continued on. Apparently being with a buddy, any buddy, is what matters.—S.H.

Crust Coral, *Leptastrea* cf. *Favia hawaiiensis*

p. 225

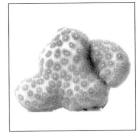

PHOTOGRAPH: Green Island field studio, Kure Atoll, 27 July 2003
RANGE: endemic
HABITAT: shallow reefs with wave action
SCALE: 5 cm across

While large, showy brain corals are abundant in other parts of the Indo-Pacific, this small nubbin is more typical of corals in the Family Faviidae that occur in Hawai'i. Fossils of larger, "brainier" corals are evidence that Hawai'i once had its share, but only two genera and about seven species in this family are present in the current reef communities here. The coral in the portrait is most likely *Leptastrea* cf. *Favia hawaiiensis*, which is unique to Hawai'i. Corals in the brain coral family have large, distinctive calyces (the stony structures that house the polyp). In this species the calyces are well separated by smooth spaces, giving each polyp plenty of room to feed. This coral rarely grows very large, and is usually content to form small colonies and occupy inconspicuous corners of the reef. The entire family is relatively rare in Hawai'i. This species occurs most often on shallow reefs and lagoon reefs with decent wave action. When a *Leptastrea* larva settles on the reef, it first grows in a flat, rug-like form with a single anemone-like polyp. If the coral grows well and the water is not too turbulent, the mat will start to swell up and the polyps multiply as the colony grows, forming hemispheres, mounds, and rounded lobes. In some habitats it grows in an encrusting form that can spread across large areas. Both the family and the species name for this coral come from the Latin word for honeycomb.—S.H.

Live Rock

p. 226

PHOTOGRAPH: Green Island field studio, Kure Atoll, 14 August 2003
RANGE: worldwide
HABITAT: underwater habitats with rock or hard substrate
SCALE: this piece 20 cm high

This colorful amorphous object is what is known as "live rock," a conglomeration of plants and animals that have overgrown a chunk of coral rubble. Most of the reef floor is covered with growing things, including live rock, which differs entirely from geological rock. This piece of live rock was collected at Kure Atoll under a special permit allowing the photographers to borrow it from the reef for a short time. Live rock is so important to the reef that it cannot legally be collected or sold in Hawai'i, and the marine aquarium industry has to make do with substitutes or grow their own. This particular rubble chunk has at least eight kinds of algae growing on it, as well as several kinds of sponge. The clear brownish alga on top is a species of *Laurencia*, as is the translucent red alga, top right (*Laurencia parvipapillata*). The wine-colored tubes in the center gap are *Hypnea spinella*. The scruffy, green mesh on the left is *Microdictyon setchellianum*, an alga that covers vast areas of reef pavement in parts of the NWHI. The dark pink areas are *crustose coralline* algae, which act as reef cement. Purple, green, brown, black, and orange sponges cloak the surface that was face down; sponges tend to grow on the undersides of objects, out of the way of nibbling fish mouths. The original identity of this chunk can be detected in the bottom right corner, where a small white oval reveals the shape of a broken coral branch.—S.H.

Coral Rubble

p. 227

PHOTOGRAPH: Green Island field studio, Kure Atoll, 14 August 2003
RANGE: world's tropical oceans
HABITAT: near living coral
SCALE: 12 cm section

From the surface of the water, rubble looks like nothing more than dead and broken coral pieces, the wreckage from storms swept by waves and currents into a reef rubbish pile. In contrast to the golds, browns, purples, and greens of the coral and macro-algae reefs nearby, rubble looks deceptively pale and gray from the surface. It is a whole different story once you jump in the water and dive down to get a closer look: Each chunk of rubble is covered in a unique mosaic of living color. Many kinds of algae, including crustose pinks, fleshy and mesh-like greens, and delicate filamentous reds, make a small forest on sections of the rubble exposed to sunlight. The underside is often more brightly painted than the topside, populated with sponges, hydroids, tunicates, and other strange, wonderful creatures. In coral reef habitats no hard surface stays bare for long. Hard substrate is premium real estate, and although rubble jostles around too much for some settlers, like corals, it is perfect for space fillers, like turf algae and sponges, or cement makers, like coralline algae. Truly bare calcium carbonate exists only in the rare case of strong and continuous turbulence that scours the surface of living things with constant motion, like a rock tumbler. In all other cases of healthy ecosystems, rubble chunks gradually accumulate mass and populace until they host a thriving metropolis of secretive but colorful reef creatures.—S.H.

Coralline Algae on Marine Debris, Order Corallinales

p. 228–229

PHOTOGRAPH: Green Island field studio, Kure Atoll, 2 August 2003
RANGE: worldwide
HABITAT: any solid underwater surface that is stationary or slow-moving
SCALE: 7.5 cm section

While reef-building corals may be the original architects of the grand and elaborate kingdoms we think of as coral reefs, coralline algae play an essential role as reef cement. For reefs to endure hundreds to thousands of years, the unifying and strengthening qualities of cement are crucial. Elegant coral spires topple over; huge coral mounds become porous and riddled with burrows drilled by worms and clams; and innumerable branches and delicate plates break off and become rubble. Coralline algae grow over this jumble like smooth pink cloaks, uniting the mess of broken parts into a solid foundation. The cement holds the rubble together and keeps dead coral from being swept into the deep abyss or up onto shore. As important as it is, coralline algae have proven elusive to scientific study, due to the difficulty of identifying species. In the large, diverse group of red algae (Division Rhodophyta), they capture the energy of sunlight to make sugar, as do other plants. While they use chemical defenses in an attempt to keep their surface clear, they often end up providing hard substrate for a number of reef creatures, such as sponges, corals, and hydroids, as well as other algae. This kind of algae was believed to be a slow grower until relatively recently, when biologists discovered its ability to colonize rapidly in favorable conditions. In all conditions, coralline algae is a remarkable survivor, growing on just about anything underwater that isn't moving too quickly, including rocks, rubble, turtle shells, and even discarded fraying plastic nets.—S.H.

Stypopodium ~ limu, *Stypopodium flabelliforme*

p. 230

PHOTOGRAPH: Sand Island field studio, Midway Atoll, 27 July 2003
RANGE: Indo-Pacific
HABITAT: tide pools, intertidal areas, and shallow reef flats
SCALE: 7.5 cm across

The blue-green bands of iridescence transform what would otherwise be a ragged scrap of brown algae into a small, showy peacock of the shallow intertidal zone. This alga, *Stypopodium flabelliforme*, has a look-alike cousin named padina (see profile, p.245). Both genera are in the same family of brown algae (Family Dictyotaceae) and have similar rosettes of fan-shaped blades. The two species have a few key differences, however. Most notably, while padina has lightly calcified blades, stypopodium does not amass any calcium carbonate. Likewise, while padina has in-rolled margins to protect its new growth, stypopodium does not, leading to the ragged edges that characterize this plant. When a herbivore takes a bite of the blade margin, which is where all new growth takes place, the blade ends up splitting as growth occurs to either side of the missing bite. Another difference is the iridescence, a distinctive feature of stypopodium. The function of the iridescence is not known, though it may protect the plant's tissues from getting sunburned in the strong sunlight of the shallows. This alga occurs throughout the main and northwestern Hawaiian chain, though never abundantly, as a rule. Kure Atoll presents a notable exception; stypopodium is extremely prevalent here, on the backreef and on some of the shallow patch reefs in the lagoon.—S.H.

Hydroclathrus ~ limu, *Hydroclathrus clathratus*

p. 230

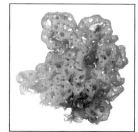

PHOTOGRAPH: Green Island field studio, Kure Atoll, 30 June 2004
RANGE: pan-tropical and warm/temperate waters
HABITAT: tide pools and shallow reef, less common deeper
SCALE: 6 cm across

This alga starts out small and round, folds and twists itself into a convoluted sheet by the time it is two cm across, and, as it grows larger, develops a severe case of holes. *Hydroclathrus clathratus* is a type of brown algae (Division Phaeophyta), and grows in tide pools and shallow reef habitats throughout the Indo-Pacific. The adult alga, pictured here, has a spongy, well-perforated interface with the aqueous world around it. The elaborate wrinkles and holes encourage sea water to flow through the entire alga and keep the innermost part from being isolated from the source of nutrients and minerals. The alga attaches itself to the reef floor by means of tiny strings of cells called rhizoids. Some algae attach to the reef by a single stalk; in this species, the tissue balloons out from the numerous attachment points to form hollow dome-shaped sections. Hawai'i has one other species of Hydroclathrus (*H. tumulis*), which is endemic to the NWHI and occurs mostly in deeper water. The endemic species occurs most commonly at about 32 m depth (~100 ft), near the depth limit of *H. clathratus*, but also can be found at least as deep as 82 m (~250 ft). The holes are more widely spaced in *H. tumulis*, and the color varies from olive green to chocolate brown, adaptations which are probably favorable in the deeper habitat where the light is muted and nutrients are used up more slowly.—S.H.

Pied Brittle Star ~ pe'a, *Ophiocoma pica*

p. 231

PHOTOGRAPH: Green Island field studio, Kure Atoll, 1 July 2004
RANGE: Indo-Pacific
HABITAT: under rocks, in crevices, and among coral branches
SCALE: to 10 cm arm span

In the understated world of brittle-star fashion, the pied brittle star appears downright flashy with its yellow spotted legs and a flower-like pattern on its disk. The scientific name *pica* refers to the magpie, a boldly patterned bird with black-and-white pied plumage. Like its fellow brittle stars, the pied hides in and under other objects, rubble included, reaching out with an arm or two to scavenge edible "garbage" that has fallen to the reef floor. It can spare a leg more readily than the central disk which houses all of its internal organs, so it hides under a rock to keep its vital parts out of reach, sweeping for food with a few of its arms. If an arm gets bitten off, it's no big loss; the brittle star regenerates a new one. This species has short, stout arms in comparison to other common brittle stars in Hawai'i, and is covered in blunt spines. The spines are like a hundred small, stiff fingers, wedging the brittle star in place to keep it from being easily extracted from its hiding place. Sticky tube feet line the underside of each leg; they pick up and transport food to the mouth in the center of the disk. Brittle stars have a relatively simple digestive system, with food ingested and waste ejected from the same hole on the underside of the central disk.—S.H.

Spotted Linckia ~ opu'ape'a, pe'ape'a, hoku-kai, pe'a, *Linckia multifora* (on *Turbinaria ornata*)

p. 232

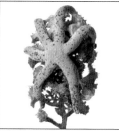

PHOTOGRAPH: Green Island field studio, Kure Atoll, 15 August 2003
RANGE: Indo-Pacific
HABITAT: hard bottoms, usually with coralline algae
SCALE: to 12 cm arm span

The name of this sea star—*Linckia multifora*—honors field biologist J.H. Linck, who carefully collected and described sea stars in the 18th century, a time when most people gave these inedible sea creatures little consideration. A common sea star in Hawaii, spotted linckia varies in its color, size, and number of spots. The animal is usually pale pinkish gray or orangish brown with round red spots scattered across its body. The tips of the arms often appear blueish, and have a photosensitive tube foot that emerges from the end to serve as a simple eye. Although this eye-spot detects only light and shadow, the sea star finds even this rudimentary visual information useful in maneuvering around its environment. Linckia can drop an arm, which will then grow into an entire sea star—one of this animal's special gifts. Most sea stars can regenerate an arm, as a lizard does with its tail, but it is a much bigger deal to grow a whole new animal from one small piece. The severed arms (commonly called comets) walk around the reef while they slowly grow another four arms, looking strange until they complete the process. The sea star in this portrait perches on a prickly sprig of brown algae (*Turbinaria ornata*), probably because there was little else to cling to in the bucket when it was collected.—S.H.

Jeweled Anemone Crab & Anemones ~ unauna & 'ōkole emiemi, *Dardanus gemmatus* & *Calliactis polypus* and *Anthothoe* sp.

p. 233

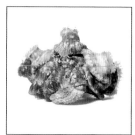

PHOTOGRAPH: Green Island field studio, Kure Atoll, 16 August 2003
RANGE: Indo-Pacific
HABITAT: reef habitats, intertidal zone to 30+ m
SCALE: 7 cm tall

These partners in crime have a good deal going. Jeweled anemone crabs enjoy the protection of their passengers' stinging tentacles, and the anemones get to hitch a ride to new places. Related to jellyfish, anemones have tentacles equipped with nematocysts that sting on contact. As backup, the white bumps on the larger anemone (*Calliactis polypus*) can squirt out sticky pink threads that also sting. The small white anemones are a different species (*Anthothoe* sp.); the jeweled anemone crab arranges them on the lip of its shell. When the crab outgrows its old home and moves into a bigger one, it carefully transfers the anemones as well, gently prying them off with its claws and moving them over to the new shell. Colorful as a circus tent, the jeweled anemone crab boasts an orange carapace, red-and-white-striped eye stalks, and bright green eyes; rounded bumps cover its claws. Its family of hermit crabs, Diogenidae, shares the trait of being "lefties," with a left claw that is bigger than the right. The anemones can be pink, yellow, orange, or light brown, and are often striped. They scavenge scraps of food that float up from the hermit crab's feeding activity as well as catching their own prey, stinging and then consuming any tiny animal that strays too close to their tentacles.—S.H.

Christmas Tree Worm ~ kio, *Spirobranchus giganteus* *p. 234*

PHOTOGRAPH: Green Island field studio, Kure Atoll, 30 July 2003
RANGE: tropical seas worldwide
HABITAT: tropical reef habitats with hard substrate
SCALE: crown 1.5 cm across

If this creature does not resemble a worm, it is because the worm's body is hidden inside a tube with only a pair of bright-blue gills visible. Christmas tree worms are segmented worms (Phylum *Annelida*), the same general group as earthworms. Terrestrial segmented worms have only minor diversity compared to that of marine species, especially the polycheates, also called bristle-worms. As a polycheate, the Christmas tree worm uses its soft-bristled gills to breathe as well as to catch tiny food particles. The spiral gills can be yellow, orange, tan, or blue. At the slightest touch or unexpected water motion, the gills disappear instantly into the tube and a trap door is slammed shut. Otherwise, the trap door, also called an operculum, remains just to the side of the gills. A tiny rack of antler-like prongs, barely visible in the photograph, perch on the outside of the operculum. The worm's body measures about four cm long and is encased in a hard, smooth tube made by the worm out of calcium carbonate. The Christmas tree worm in the portrait has made its home in a piece of rubble, although more often these worms drill into live coral, especially lobe coral (*Porites lobata*). Coral colonies with Christmas tree worms may gain some small protection against crown-of-thorns sea stars (*Acanthaster plancii*), which crawl on top of coral colonies and consume them; the worms may somehow pinch or poke the soft underbelly of the sea star, driving it away.—S.H.

White Spotted Hermit Crab ~ unauna, *Dardanus megistos* *p. 235*

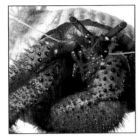

PHOTOGRAPH: Green Island field studio, Kure Atoll, 11 August 2003
RANGE: Indo-Pacific
HABITAT: reef habitats
SCALE: 9 cm section

While most of Hawai'i's hermit crabs reach a maximum of one or two inches in length, the white spotted hermit crab can grow to be a foot long, earning it the species name *megistos*, meaning "greatest." The hermit crab often occupies a Triton's trumpet shell, the largest shell in Hawai'i and a veritable hermit crab mansion. Found only in deep water (50 meters or more) in the main Hawaiian Islands, the white spotted hermit crab inhabits shallower water in other parts of its range, including the Northwestern Hawaiian Islands. The walking legs and chelipeds (claws) of this hermit crab are covered in red bristles. It has long white antennae and a characteristic white band at the base of its eye stalks. As white spotted hermit crabs grow from small crabs into impressive foot-long giants, they have to change shells a number of times. Always on the lookout for vacant snail shells, hermit crabs will often try any available shell on for size. Absent any vacancies, hermit crabs in search of a new home resort to barter or even intimidation and violence. A hermit crab whose quarters have become too tight will tap against a roomier occupied shell, in an attempt to convince the occupant to relinquish it. In the end, the bigger or more aggressive crab gets the disputed shell. Hermit crabs complete the exchange quickly, as neither crab is comfortable exposing its soft, vulnerable abdomen.—S.H.

Corrugated Coral, False Brain Coral, *Pavona varians* *p. 236*

PHOTOGRAPH: Green Island field studio, Kure Atoll, 13 August 2003
RANGE: Indo-Pacific
HABITAT: most reef environments
SCALE: 2 cm section

While it looks buttery soft like folded golden-brown velvet, this coral like other reef-builders is as hard as rock, and generally sharper. The ridges and valleys are formed by uneven accretion of calcium carbonate, the same substance that is in human bones and teeth and snail shells. The valleys give the coral polyps a protected place to sequester themselves, each one having its own little castle, called a corallite. The center of individual corallites (where the coral polyp's mouth resides) are visible in the portrait as small holes or indentations, with the corduroy-like ribs (called septae) converging to these points. The septae are paper-thin walls of calcium carbonate that are often razor-sharp and protect the coral flesh the same way the larger folds or ridges do, just on a smaller scale. Corals in the genus *Pavona* are widely distributed and relatively abundant in the Indo-Pacific region, and often contribute substantially to the reef-building process. Hawai'i has four species of *Pavona*, out of 14 worldwide, and although the genus is not uncommon in the NWHI, it is overshadowed by the abundance of *Porites*, *Pocillopora*, and *Montipora* species. The species in the portrait was named *varians* for its propensity to vary its morphology depending on local environmental conditions. This adaptable coral can form low-profile, corrugated crusts, bumpy mounds, wavy stacks of plates, or any combination of these forms, which can make it challenging to recognize.—S.H.

Juliana's Sea Hare & Black-Lipped Pearl Oyster ~ pā & kualakai, *Aplysia juliana & Pinctada margaritifera* *p. 237*

PHOTOGRAPH: Green Island field studio, Kure Atoll, 14 August 2003
RANGE: Eastern Pacific & Indo-Pacific
HABITAT: reef habitats
SCALE: 12 cm section

The black-lipped pearl oyster is a soft animal that protects itself with a two-piece shell that opens and closes. The oyster lines the inside of its shell with smooth pearly lacquer, much admired by button-makers. On rare occasions a grain of sand or other irritant intrudes into the oyster's soft parts and is coated with layers of dark pearl. In Tahiti, this same species is cultured to produce lustrous black pearls. Black-lipped pearl oysters were harvested to near extinction from the lagoon of Pearl and Hermes Atoll in the 1930s. Over 70 years later, the pearl oysters are just beginning to recover in the very heart of the atoll with its maze-like reef. Hawaiians had no use for pearls, though they savored the tasty meat and held in high esteem the iridescent shell of pipi, a smaller pearl oyster (*P. radiata*) for fishhooks. "The best shells had markings like the arch of a rainbow....It was to the aku [a small tuna] as a beautiful chiefess," writes Kamakau, a Hawaiian well-versed in traditional ways. In the rainbow world of magenta, gold, blue, purple, pink, and orange sea slugs, the mottled brown Juliana's sea hare has its own special charm. Called sea hare for the rabbit ear rhinophores (sensory tentacles) on its head, these sea slugs cruise across the shallow reef flats with an inquisitive posture. Sea hares graze on algae, often in large social groups, scraping it from the reef with a scouring mouthpiece called a radula.—S.H.

Dasya ~ limu, *Dasya iridescens* *p. 238*

PHOTOGRAPH: Green Island field studio, Kure Atoll, 27 July 2004
RANGE: Hawai'i and Fiji
HABITAT: shallow reef flats, eroded coral platforms
SCALE: 2.5 cm section

Adorned with silky pink and gold hairs, *Dasya iridescens* is a red alga (Division Rhodophyta) in the order Ceramiales, a group that includes a number of strikingly beautiful algae with wild hair. The Latin name *Dasya* means "hairy" or "shaggy," and iridescens refers to the iridescent luster of the silky hairs. The iridescent sheen on the hairs most likely deflects some of the overly strong sunlight of the shallow reef. The fine hairs increase surface area and slow the flow of water as it passes, allowing the alga to absorb vital nutrients and minerals. The alga makes its own food by capturing the energy of sunlight, but it still needs raw materials such as carbon, nitrogen, and oxygen. This species of dasya is not uncommon on reefs in the NWHI, but it occurs at well-spaced intervals with isolated individuals scattered across a reef. This alga prefers a bit of hard substrate to anchor its basal stalk, and often attaches itself deep within dead coral branches where it is harder for fish mouths to nibble. It grows from the delicate tips of its branches and hair, which means heavy grazing can be disastrous for an individual. The other way this alga loses its glorious mane of hair is through simple aging. It is "deciduous with age," meaning it eventually loses its hair (which puts it in good company). The bare specimen with a form reminiscent of winter trees could be an older plant that has survived past its wild-haired youth.—S.H.

Octopus ~ heʻe, *Octopus* sp. (juvenile)

p. 239

PHOTOGRAPH: Green Island field studio, Kure Atoll, 28 July 2004
RANGE: worldwide distribution of genus
HABITAT: reef and other hard-bottom habitats with hiding places
SCALE: 5 cm across

Being a quick-change artist comes naturally to an octopus. The animal accomplishes this chameleon-like feat in the blink of an eye, and will often change its color pattern several times, as if searching for the right combination to become invisible against the backdrop of the reef. Special cells in the skin, called chromatophores, make it possible for the octopus to change the color of its skin. The cells hold colored pigment, which they spread or gather up into a small area, effectively hiding it. The octopus usually has three to five colors stored in sacks in each chromatophore. Since hundreds of chromatophores are present in every square centimeter of skin, myriad color patterns are possible. In addition, a network of tiny muscles controls the skin texture and can mimic an endless variety of smooth, bumpy, puckered, and ridged surfaces to match the reef. An octopus also uses color and texture changes to communicate. A pale look with dark spots usually indicates that the octopus feels threatened or aggressive, while dark reddish-brown shows surprise or alarm. Light to medium brown is thought to be a sign of a relaxed octopus. A fairly large brain is required to run these complex behaviors, and the octopus is well-known as the Einstein of the invertebrate world. A portion of its nervous system is housed in the legs, causing them to continue wiggling and changing color after they have been detached from the body—a good trick for keeping the predator's attention while the octopus slinks into a small hole.—S.H.

Monk Seal ~ ʻīlioholoikauaua, *Monachus schauinslandi*

p. 241

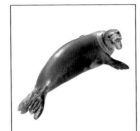

PHOTOGRAPH: Sea life Park, Oʻahu, 3 February 1993
RANGE: endemic
HABITAT: banks, reefs, pinnacles, and sand islets
SCALE: to 2.1 m total length

The Hawaiian monk seal hails from an ancient but dwindling lineage of seals, with only one other surviving species, the Mediterranean monk seal (*M. monachus*). As recently as the 1920s, a third species occupied the Caribbean (*M. tropicalis*), but it has since become extinct. The Hawaiian monk seal nearly went extinct as well, after 19th century sealing ships mass-harvested monk seals resting on the beaches, continuing the practice until they believed there were none left. Fortunately, a small proportion of monk seals, out to sea on long foraging trips, survived to repopulate the region. The current population hovers at approximately 1,300 animals, most of which live in the NWHI.

A monk seal begins life as a tiny wrinkled pup with coal-black fur and an extremely protective mother. The mother monk seal can clear a beach full of sun-basking monk seals with a single bellow. Large males and juvenile seals alike scramble out of the way to make room for the royal mother-and-pup pair, the mother perfectly willing to add bite to her bark if there are any stragglers. The pup spends its first days in peaceful oblivion, suckling rich fatty milk every few hours. After about five or six weeks of this, the pup is plump and the mother is practically a bag of bones. Just before weaning, the pup molts into a sleek silver coat. By then the mother has taken the pup on field trips into the shallow waters near shore. Pups usually love to play in the water, and one day when it ventures into the water on its own, its mother slips away in search of food, leaving the pup to fend for itself. Its blubber layer, laid down after weeks of drinking high-fat milk, sustains it for a while, but eventually the pup gets motivated to root around the shallow reefs near the island where it was born, looking for things it can catch and eat. Unlike adult monk seals, which tolerate company but are not particularly social, young monk seals play together and sometimes shadow another monk seal, perhaps to learn how and where to catch food. Surviving the first year is difficult, as there is a lot to learn. As the seals gain experience and mature physiologically, they can access depths of 500 meters or more—a remarkable feat. Human divers, with air-filled scuba tanks, are generally limited to about 60 meters, and the world's top free-divers make it unassisted to about 100 meters.

Adult monk seals are amazingly well-versed in their aquatic environment. They have extensive practical knowledge of feeding grounds and predation techniques, and can navigate to submerged features, often traveling for several days without any land or shallow reef in sight. Monk seals feed on the ocean floor, taking octopus, conger eels, reef fish, lobsters, and other tasty items. These mammals can survive attacks by tiger sharks, and a number of them have huge scars across their bellies where the shark jaws wounded but did not kill them. Measuring up to 2.1 meters (7 feet) long and weighing up to 270 kg (600 lbs), an adult monk seal is a strong, agile adversary with a sharp bite, posing a substantial challenge even for large tiger sharks.

Adult survival is very high in monk seals, once they make it past the difficult first few years when predators view them as comparatively easy fare, and their own skills at finding and catching food are still somewhat limited. Once a monk seal has mastered the twin skills of foraging and avoiding predators, its next challenge is to mature socially so it can successfully mate. Adult males stake out a section of beach, usually with a female present, and guard it with considerable fanfare in hopes of winning the girl. Males without territories cruise along in the water, clambering up on the beach to pick a fight if they think they can displace the current suitor. In most cases, the actual mating takes place in the water, with male and female wrestling and administering playful love bites, leading up to copulation. The fertilized egg remains inside the female in a suspended state for several months, implanting and beginning to grow only if and when the female gains sufficient fat reserves.

In recent years, the small number of monk seals in the main Hawaiian islands seems to be making a comeback, with increasing numbers appearing on all the main islands, and births recorded on all of them except Lānaʻi. More often, monk seals in populated areas have difficulty finding quiet resting beaches, and barking dogs or overzealous sightseers end up chasing them back into the water, deliberately or not. A healthy monk seal population depends on undisturbed beaches for a number of reasons: Monk seals need a place to rest out of danger of tiger sharks; they need the opportunity to dry their skin, so that it stays healthy and in good repair; and, of course, whelping requires a quiet, safe place, as it represents a vulnerable time for both mom and baby. The two thousand kilometers of remote, virtually unpeopled waters and beaches of the NWHI is exactly what they need to continue to survive and play their role as skilled hunter (and professional sun-basker) in this ecosystem.—S.H.

Spinner Dolphin ~ naia, *Stenella longirostris*

p. 204, p. 275

PHOTOGRAPH: Kure Atoll Lagoon, 10 August 2003
RANGE: tropical and subtropical Pacific, Atlantic, and Indian Oceans
HABITAT: open ocean and coastal areas
SCALE: to 2 m long

Spinners spin, twist, and flip end over end—and not just for some pony-tailed girl in a pink wetsuit holding a dead, half-frozen mackerel. Spinners spin in the wild, and although biologists have studied the behavior extensively, they can still only guess why. Renowned cetacean biologist Dr. Ken Norris observed spinners in Kealakekua Bay on the Big Island for many years. During the day the spinners participate in a big group-napping session. When it is time to travel to the evening foraging grounds, or between naps, the dolphins begin to leap. And what a performance—they leap, spin, pirouette, somersault, and display every other creative combination that can be accomplished with a strong tail thrust and a limber, lithe body. Meanwhile, the level of excitement rises and the dolphins collectively shake off their sleepiness and get ready for the next activity. Thus, one function of spinning appears to be group cohesion, the unification of the group. Spinners in the NWHI have a different social structure than those in the main Hawaiian Islands, according to a recently published study by Dr. Leszek Karczmarski. In the main islands, a spinner dolphin may join a different feeding group every night. Biologists dubbed this behavior fission-fusion, since groups form and split up repeatedly. Life is much simpler in the NWHI, where a single group of dolphins at Kure Atoll rests and socializes in the lagoon and feeds together offshore. Another group of dolphins lives at Midway, and a different set at Pearl and Hermes Atoll, with very limited crossover between groups.—S.H.

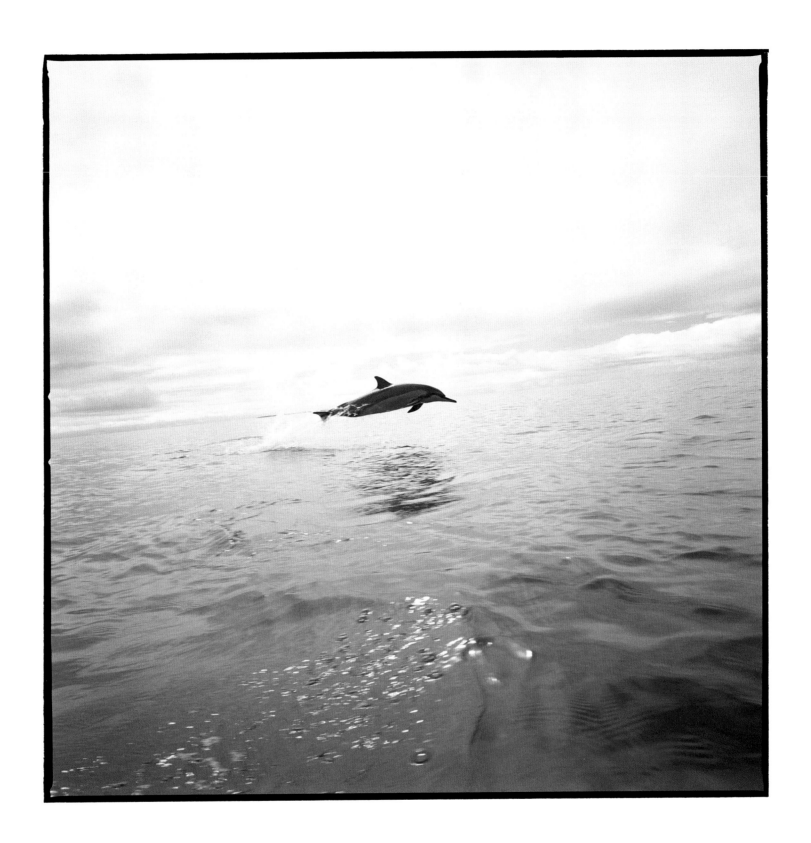

Spinner Dolphin ~ naia
Stenella longirostris

Acknowledgments

and Technical Notes

We would like to express our appreciation to:

George Ellis, for believing in the project when it was an idea, and for his unwavering support in bringing it to fruition.

FINANCIAL SUPPORT
National Geographic Expeditions Council
Susan O'Connor, Charles Engelhard Foundation
The Strong Foundation
David and Lucile Packard Foundation
Kimo Campbell, The Pohaku Fund
The Harold K. L. Castle Foundation
Michael E. O'Neill
The Cooke Foundation
The Bay and Paul Foundations
United States Fish and Wildlife Service Foundation
National Marine Sanctuary Foundation

Timothy Choy
HONOLULU ACADEMY OF ARTS
Stephen Little
Eric Watanabe
Karen Sumner

IN-KIND AND LOGISTICAL SUPPORT
United States Fish and Wildlife Service
National Oceanic and Atmospheric Administration,
 Office of National Marine Sanctuaries
State of Hawai'i, Department of Land and
 Natural Resources

Stephani Holzwarth, Alexander Wegmann, and Cynthia Vanderlip for their inspiration, knowledge, and devotion to the Northwestern Hawaiian Islands.

U.S. FISH AND WILDLIFE SERVICE, HONOLULU: Don Palawski, Jerry Leinecke, Barbara Maxfield, Cindy Rehkemper, Jim Maragos, Dominique Aycock Horvath, Steve Barclay
NOAA OFFICE OF NATIONAL MARINE SANCTUARIES: Dan Basta, Robert Smith, Rusty Brainard, Dana Wilkes, Lori Arguelles, Matt Stout, Aulani Wilhelm, Andy Collins, Naomi Sodetani, Hans Van Tilburg
STATE OF HAWAI'I: Dave Smith
WE WOULD ALSO LIKE TO THANK: Tom and Maria Eisner, Jane Lubchenco, William and Paula Merwin, Peter and Pat Raven, Maile Sakamoto, Richard Duggan, Susan Gabaree, Betsy Gagne, John Culliney, Sue Garner, Bill Gilmartin, Karen Ciabattoni, Karla McDermid, Barbara Pope, Pi'ikea Miller, Samuel A. Cooke, Terry George, Mitch D'Olier, Susan O'Connor, William Y. Brown, Michael and Trish O'Neill, Robert Neubert, Dave Boynton, David Carriere, John Thompson, Larry Kimura, Ron Hunter, Rick Warshauer

Mahalo to everyone we worked with in the field.

MIDWAY ATOLL: Mike Johnson, Norm Garon, Tim Bodeen and family, Leona Laniawe, John Klavitter, Greg Schubert, Barbra Mayer, Katie Stadler, Chavensak Phosri, Chatchai Moomiang, Wiset Julmuang, Sathaphorn Phianntham, Chugach Band, the Thai community, Pete Stucki, George Harris, Benjamin Hawks, Cassandra Sablan, John Hanna; **KURE ATOLL**: Cynthia Vanderlip, Michael Holland, Robert Marshall, Tracy Wurth, Amarisa Marie; **LAYSAN ISLAND**: Stefan Kropidlowski, Mark Vekasy, Michelle Reynolds, Rebecca Woodward; **FRENCH FRIGATE SHOALS**: Chris Eggleston, Cari Eggleston, Kim Andrews, Risha Sparhawk, Evan Jorgensen, Scott Owen; **PEARL AND HERMES ATOLL**: Jon Sprague, Maire Cahoon
NIHOA ISLAND AND MOKUMANAMANA ISLAND: Beth Flint, Jennifer Tietjen, Steve Perlman, Mike Richardson, Steve Montgomery, Benton Pang, John Culliney

M/V Casitas: Ted Blenkers, Modou Ndiaye, Joe Chojnacki, Suzy Cooper Alletto, Oliver Damaron, Suzie Holst, Bonnie De Joseph, Jennifer Stephenson, Suzie Tharratt, Jake Asher, and the entire Marine Debris Team.

Manacat: Don Moses, Tony Sarabia

Oscar Elton Sette: Ken Barton, Sarah Scherer, Mike Francisco, Monty Spencer, Kelley Stroud, Ben Sniffen, Leah Harman, Kenneth Motoyama (Kenji), Jonathan Saunders, Bruce Mokiao, Doug Roberts, Kevin Sund (Mario), Wade Poor, Huntley Brownell, Harry Cane, Frank Dunlop, Nathan Elrod, James McDade, Todd Van Dyke, Jeff Hill, Kim Belveal, Phil White

Searcher: Richard and Barbara Littenberg, Jon and Jennifer Littenberg, Noah Nugent

Hi'ialakai: Officers and Crew; Scott Kuester, John Caskey, Matthew Wingate, Steve Kroening, Sarah Jones, Albert Exner, Michael Thomala, Robert Dennis, Jesse Duncan, Ricardo Gabona, Angelo Grant, Dayton Ho, Mark O'Connor, Keith Lyons, Merlyn Gordon, Gaetano Maurizio, Jeremy Taylor, Gregory Wells, Charles Sanford, David Tipton, Allen Gary, Susan Parker, Andrew Rapp, Michael Crumley Jim Bostick Scientists; Randall Kosaki, Peter Vroom, Greta Aeby, Jean Kenyon, Erin Looney, Ranya Henson, Craig Musberger, Darla White, Brian Zgliczynski, Joe Laughlin, Molly Timmers, Casey Wilkinson, Elizabeth Keenan , Danny Merritt, Kyle Hogrefe, Scott Ferguson, June Firing, Daniel Suthers

NATIONAL GEOGRAPHIC SOCIETY: Nina Hoffman, Kevin Mulroy, Marianne Koszorus, Chris Johns, John Echave, Jane Vessels, David Whitmore, Rebecca Martin, Susan Norton, John Francis, Gregory McGruder, Ed Samuel. We are especially grateful to Lisa Lytton for initiating this collaboration with National Geographic and for her continuous enthusiasm and support throughout this project.

SPECIAL THANKS TO: Margo Browning, text editor, for her expertise and attentiveness; and to designers Juliette Robbins, Spike Lomibao, and Hae Yuon Kim, for bringing the book to completion with grace and finesse.

PHOTOGRAPHIC, TECHNICAL AND LOGISTICAL ASSISTANCE: Brook Dillon, Veronica Andrew, Sarah Kobrinsky, Carolyn Carcione, Geneva Bumb, Caroline Kern, Son Do, Erica Aiken, David Troutt, Jennifer Wills. Tyler Andrew, Russell Brown, Bob Tamura

ADDITIONAL SUPPORT FROM: The New Lab, Just Film, Xrite, Extensis, Calumet Photographic, Rods and Cones, Adobe, National Geographic Photo Engineering, Patagonia, Kodak

AND FROM SUSAN: Deidre Kernan, Robert Bettencourt, Demetrios Scourtis, Patricia Burke, Walter Sorrell, Mary Richardson, Ted Richardson, the Richardson families, Gus Bodner, Richard and Virginia Bodner, the Hiner families, Mark Alsterlind, Lydia Modi Vitale, Tom Marioni and SIA, Alika Odom, Suzanne Fritch, Chris Jones, Rodney Marzullo, Terry and Jody Grundy, Mary Koerner

AND FROM DAVID: Elisa Kroeber, Roy and Betsy Eisenhardt, Adam Block, Panos Koutsoyannis, Dan Oshima, David and Leigh Kirk, Kerry Tepperman, S.B. Master, Beth Hughes, August Kleinzahler, Fran and Jack Williams, Jean and Terry Liittschwager, and especially Suzie Rashkis

In memory of Richard Avedon with gratitude and affection

TECHNICAL NOTES:
The photographic work was done with Hasselblad cameras, a Phillips 8 x 10 field camera, Nikon and Leica 35mm cameras, and an assortment of digital cameras — using primarily Kodak Portra 160NC film and scanned with a Hasselblad/Imacon scanner. The image processing was done with Apple Macintosh computers, Adobe PhotoShop and Adobe InDesign software. The ICC Profiles were provided by X-Rite color management solutions.

DESIGN NOTES:
The fonts used in this book are electronic "cuts" of Sabon and Univers.

Species Index

Founded in 1888, the National Geographic Society is one of the largest nonprofit scientific and educational organizations in the world. It reaches more than 285 million people worldwide each month through its official journal, National Geographic, and its four other magazines; the National Geographic Channel; television documentaries; radio programs; films; books; videos and DVDs; maps; and interactive media. National Geographic has funded more than 8,000 scientific research projects and supports an education program combating geographic illiteracy. For more information, log on to nationalgeographic.com; AOL Keyword: NatGeo. For more information, please call 1-800-NGS LINE (647-5463) or write to the following address: National Geographic Society 1145 17th Street N.W. Washington, D.C. 20036-4688 U.S.A.

Archipelago:
Portraits of Life in the World's Most Remote Island Sanctuary
Produced by David Liittschwager and Susan Middleton

Published by the National Geographic Society
 John M. Fahey, Jr., President and Chief Executive Officer
 Gilbert M. Grosvenor, Chairman of the Board
 Nina D. Hoffman, Executive Vice President
Prepared by the Book Division
 Kevin Mulroy, Senior Vice President and Publisher
 Kristin B. Hanneman, Illustrations Director
 Marianne R. Koszorus, Design Director
Staff for this Book
 Lisa Lytton, Senior Project Editor
 Margo Browning, Text Editor
 Carl Mehler, Director of Maps
 Nicholas P. Rosenbach, Gregory Ugiansky and
 NG Maps, Map Research and Production
 Gary Colbert, Production Director

Creative Director: Melanie Doherty
Designers: Melanie Doherty Design, San Francisco, and Tobi Designs, Oakland
Art Director and Production Supervisor: Juliette Robbins for Danielseed, Inc.
Design and Production at Tobi Designs: Lloyd Dangle, Hae Yuon Kim,
 Spike Lomibao, and Sasha Soukup.

Library of Congress Cataloging-in-Publication Data availible upon request.
ISBN 0-7922-4188-6

Printed in Italy

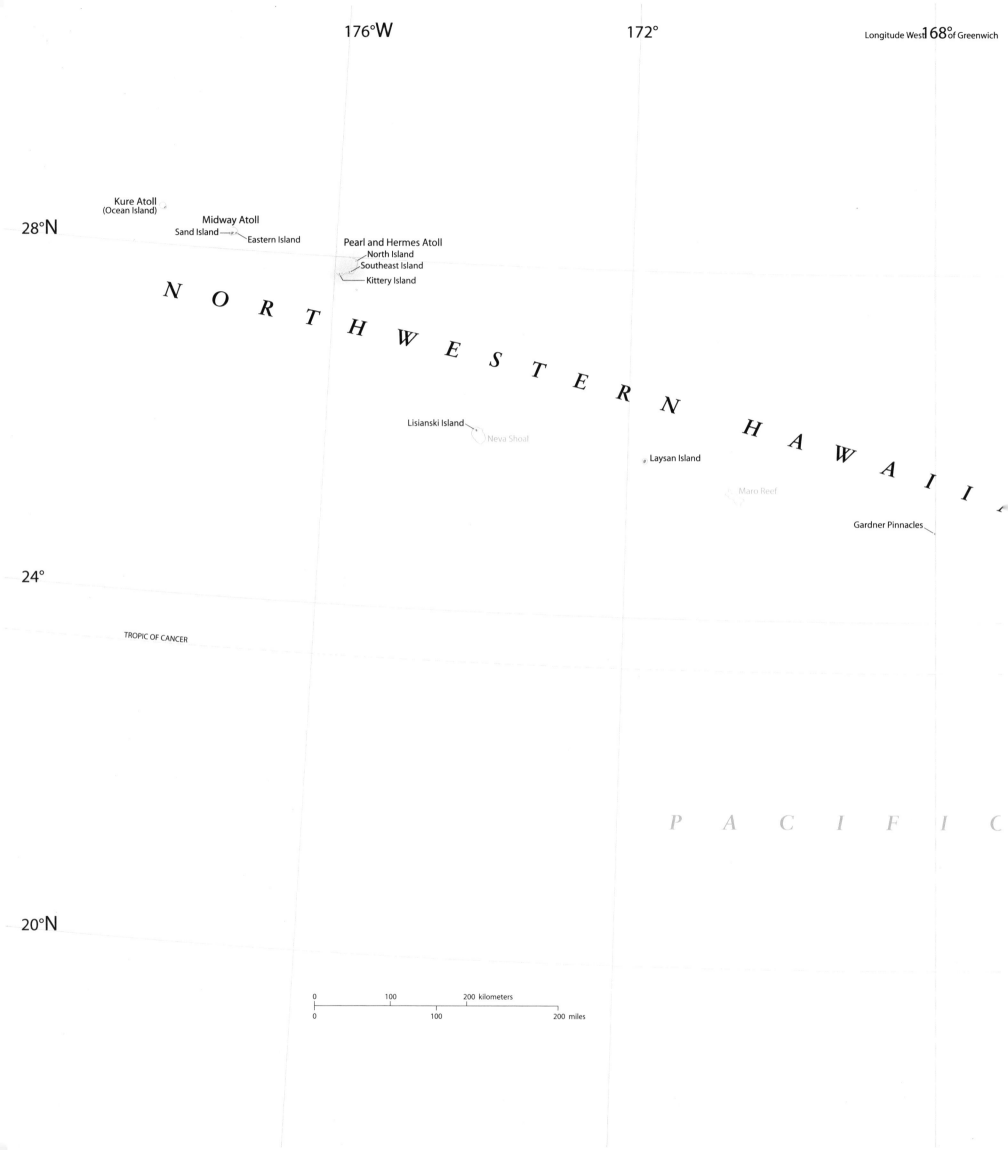

28°N

Kure Atoll
(Ocean Island)

Midway Atoll
Sand Island ——— Eastern Island

Pearl and Hermes Atoll
North Island
Southeast Island
Kittery Island

N O R T H W E S T E R N H A W A I I

Lisianski Island
Neva Shoal

Laysan Island

Maro Reef

Gardner Pinnacles

24°

TROPIC OF CANCER

20°N

P A C I F I C

0 100 200 kilometers
0 100 200 miles